MW01075043

THE COMPENDIUM OF
FORGOTTEN SECRETS

AWAKENING

Genuine
Fantasy
Press LLC

Hey Folks!

I'm going to do something a little different here, and break character just for a moment. I've got the rare opportunity to speak directly to my whole audience, so I want to thank you!

I'd like to dedicate this book to every single author whose works I've read, every single artist whose art I have enjoyed, and every single musician whose sounds have touched my ears. Your work has given me the inspiration that made this book possible. I hope that it will inspire you in turn! Of course, I can't forget all the people who've helped directly to make this possible. I'd like to make some special mentions: I'd like to thank my father, for pushing me to make this happen, and my mother, for supporting my dreams. I'd like to thank my girlfriend, for standing by my side even when she didn't understand, and my friends, for indulging my constant discussions and ramblings and for inviting me to play this wonderful game.

I couldn't have done it without you.

-William Hudson King

Now for a more formal list of credits:

THE GENUINE FANTASY PRESS LLC FOUNDER, LEAD WRITER, HEAD DESIGNER, CHIEF EDITOR, AND PUBLISHER: WILLIAM H. KING

THE PARENTS: WILLIAM "BEARD" & ELKA KING | THE BEST GIRL: MACKENZIE MOHLER | THE BOYS: MASON "XANDITH" BELL, JEFFERSON INGRAM, LUCAS DOOLEY, BLAKE POUSH | THE VISUAL AIDES: BLAKE POUSH, DEVIN JACOBSEN | THE MASTER OF BALANCE: NICOLO M. DELA MERCED. | THE EXCELLENT: JONOMAN3000 & FREEKNIGHT | THE SPELL-INSPIRING: BOLUN LIU | THE VERY HELPFUL FOLKS: DREW BROECKLEMAN, THEWICKLING, EDUARD PUCI, PEANUT, IZZY, SGTBRIAR, BOES, COMRADE WALRUS, STEVE "LAYHNET" FIDLER, DAVID ADAMS

THE UNCATEGORIZED, UNEDITED LIST OF OTHER HELPFUL FOLKS:
metler88 IBananaShake HazeZero GM_Jurek eainmonster SmilingCatSith Angel_Feather Zurei Finalplayer14 BudderPrime Lasercat77 SwordMeow KonateTheGreat Pixie1001 Regerem DMsWorkshop TheOldTubaroo yrralldlok2 est1roth PeanutJayGee Primelibrarian TheThievingMick Level9Zubat datspongecake Therval KamiBarn Longshot-Forrester ApostleO ragebarr StxAffliction Butler_Pointer 5eBrewer Nightshot HammaHHouse samassaroni Linnus42 DonaldTrumpsCombover ReadingIs4Communists Phylea IrishBandit TheDarkFiddler TormundGiantstink SpiketailDrake bleakdisciple gaylordqueen69 SimpleCrow Ausschliessi MacSage some_hippies droon99 thorn1993 Elvenoob darkflameexeter arcticvibe yus404 Zwets WhoAteTheBagel Richard_Sanders vaegrim SwEcky EthnicElvis Thurse SgtBriar thewickling Caim martin1703 MarshieMarsh VampireBagel AnUnoriginalDavid layhnet Groggen2 Zeph eronth EarthAllAlong Sketter337 Spreadsheets amadeus9 NixAvernal AeonsShadow eternamemoria Ikillzommbies Charrmeleon JapJum Jonoman3000 EdgarGomezArt jjcanvas cobaltplasma noahbradley Aeon-Lux Asahisuperdry SourShade spyders JKRoots Candra MattBarley mist XG TentaclesandTeeth eronzki999 artozi Apofiss hibbary GENZOMAN Vablo BRMC Zenwork BCPO
...and everyone on the Discord of Many Things!

If you should be here and aren't here, then contact Gen!

THE ARTISTS OF THE COMPENDIUM

Julijana Mijailovic: Cover Page, The Ashen Wolf (Both), The Blackthorn Grove, The Currency Conspiracy, The Fallen Exile, The Forbidden Graveyard (Both), The Gelatinous Convocation, The Perfect Chord, The Shadowcat (Both), Spidertouched Dagger, The Wild Huntsman, The Maledicti, The Statuesque, The Luminari, The Oozian, The Imperial, The Nocturne, The Heraldic, Harrowing Hawk, Haunted Crow, Imperial Cobra, Luminous Shard, Scribeant Swarm, Shade Widow, Symphonic Songbird, Wealth Mimic, Sword & Crown, Pact Firearm
Nicolas Espinzoa: Eyeless Watcher, Record-Hunter, Spark Seeker, Wiggly Cube, Animate Image, Bloodless Wanderer
Vincent Van Hoof: The Storm Lord, The Keeper of the Depths, The Weaver of Lies
Alejandro Arevalo: The Groveborn, The Ashenspawn, Fire Magic Tiefling "Wendy"
Ben Jan: The Accursed Archive, The Eternal Citadel
Simon Tjong: The Warrior-Saint, The Arachi
Lidija Raletic: The Gray Portrait, The Serpent Empress
William King: Fire Sigil, Screaming Page, Soulforged Cover

ISBN 978-0-6921-5484-7 genfantasypress.com

THE COVER:

A seeker of forbidden knowledge discovers an ancient tome, once thought lost to time. The light disturbs the Keeper of the Depths, which opens an unforgiving eye to gaze upon the daring soul.

Illustrated by Julijana Mijailovic

Disclaimer: Genuine is not responsible for the consequences of making a deal with the Weaver of Lies, putting a wiggly cube on your head, eating a spark seeker, or prying into secrets best left untouched by mortal minds. If you're found guilty of breaking a contract with an Alrisen, the Convocation has first dibs on your corpse after the original holder is done with it. Praise the Jiggly Ones! Oloo! Oloo!

The Compendium of Forgotten Secrets: Awakening, Genuine Fantasy Press LLC, the Genuine Flame logo, all other respective Genuine Fantasy Press product names and their respective logos are trademarks of Genuine Fantasy Press LLC. The 5E logo is used with the permission of Devin Jacobsen. See page 180 for additional licensing information. Reproduction of content copyrighted by Genuine Fantasy Press LLC is prohibited without written permission by Genuine Fantasy Press LLC.

The Compendium of Forgotten Secrets: Awakening

INTRODUCTION

Greetings, Adventurer!

You've discovered an unearthly tome of great power and unnatural energy. Within, you will find information on some of the darkest secrets that mortals have attempted to conceal across the countless ages. There are forces out there that are beyond our understanding and that defy the conventional laws of arcanery and divinity.

We call these forces **Alrisen** – entities that are powerful enough to stand alone against a deity and survive, but lacking in divinity themselves. Archfiends and elder creatures from beyond the farthest planes would fall into the category of Alrisen, as would certain celestial beings and artifacts of power. Some Alrisen are spoken of in other texts, but those here have never been revealed elsewhere. They have been forgotten, suppressed deliberately, until this very moment.

They are joined by the **Alfallen** – the races of peoples that have been created from other, natural races by the powerful eldritch influence of the Alrisen upon their bloodline.

I have compiled this Compendium of Forgotten Secrets to herald the awakening of these ancient entities, and to provide you with the tools you will require to combat or aid them in their struggles. Use it wisely, and beware what you find inside.

For the Player

Warlocks are one of the few classes where conflict is built into the very nature of the character. While clerics may get guidance from the divine, and paladins are bound to an oath, you've taken a darker road fraught with peril and danger just for the mere ability to pursue your other goals.

Talk to your Master

An excellent way to ensure that you can enjoy your warlock is to speak with your GM about how your pact was made, what the details of the service were, and how it affected your character as a person. By being upfront about what kinds of expectations you and they have for interactions regarding your patron, you can ensure that you are on the same page, and will get the opportunity to participate in your own subsection of plot – provided you and the GM are both on board. This isn't an easy thing to work out sometimes, especially in premade adventures or certain settings. Communication is key, even if you don't have any specific requests or desires for your character.

Charisma and the Warlock

It's often discussed why the explanation of the warlock class reads the same way one would expect an Intelligence-based class to read. To alleviate this discrepancy for those who want to play that kind of character, there are defined options for Intelligence and Wisdom-based warlocks listed in the Optional Rules section.

One way to consider a warlock is as an ordinary person getting a loan. This fits with other explanations of Charisma-based spellcasters; a sorcerer is born with the power inside them, and it is tied to their soul. A bard is the same: they express their soul through their magic and art. A paladin has made an oath that represents their personal determination to act in accordance with their beliefs, and that force of internal guidance is expressed magically.

So, the warlock has done the same, having negotiated the purchase of power and having brought it into their ownership. Their patron cannot take it back without using force in some way, be that through a magical contract or by other means.

This makes warlocks very different from clerics in that the deity of a cleric can simply stop sending their servant power. There is no force involved, merely a halt in the flow of divine essence. In this way, warlocks are more akin to sorcerers who have obtained their power in a way other than by birthright.

The studying and research warlocks do is not to gain new power from an outside source, but instead to learn, grow, and control the power they have already obtained or to gain key insights into the construction of a new bargain. Obviously, this paradigm may not

Hello! I'm Sylvette, and that's Xandith — Hey — and we're the ones who discovered the old Compendium of Forgotten Secrets.

Yeah, you don't want to know where we found it. Seriously, don't ask. You should probably wash your hands after this.

Anyways! We've gone through and expanded everything to the full extent of our experiences, though I suspect there's still some things that we've missed! The Alrisen are mysterious, even to their servants and scholars! I've discovered two new ones: the Blackthorn Grove and the Currency Conspiracy. The latter was a real trick to find, let me tell you.

Yeah S, a real trick when you're not the one getting eaten by mimic coins and stabbed by freaks in masks.

Whatever! So, since the page count has tripled and the old bindings were falling apart, I've rewritten the book and paid a few friends to give us some new and more accurate illustrations of the things we've seen. I've filled in what I know about each Alrisen as best I can, but it's up to you to check me on everything. It's your world, after all!

S is really smart, but sometimes the ooze gets to her and she gets weird so just don't question it.

So says the infamous "Scourge of Footstools, Devourer of Chairs!"

apply to all warlocks. Some may be like wizards, and learn to manipulate the power of their patron through study and intellectual pursuit. Others may have a relationship more like that of a cleric and their deity, or a druid and the forces of nature, relying on constant favor and understanding.

The soul, sold or held tight within, is the source of the power of the warlock. Is the price worth it?

That's for you to decide.

For the Master

The Alrisen within this book are generally open enough to be usable (or at least adaptable enough to fit) in almost every fantasy world. However, at the end of this document are a few tips on possible plot potential for each one, and how they might be used to provide your player with a unique experience that you can tailor to your own world and theme.

Lore and Style

You'll probably notice that many of these patrons have specific thematic styles and are often less general in application than those included elsewhere. On one hand, a series of very general patrons that can apply to many different warlocks is excellent for giving an overview of the class. On the other hand, by being so general, they neglect to explore all the different themes and features that a warlock can encompass. Not all fiends are about fire and brimstone, not all ethereal oddities can be explored when discussing the fey, and not all nightmarish monsters can be shown with an incomprehensible and incoherent entity. The Alrisen are new patrons that can explore new and similar themes without entering the same explicit territory.

Updates and Revisions

Each of these patrons have received large amounts of feedback and balancing advice from the excellent and experienced community members of /r/UnearthedArcana and /r/BoH5e. While some options may feel outside the norm, you'll also find design notes that shed light on the creation process.

If you notice something that seems terribly wrong and makes you want to reconsider allowing your players to use this material, feel free to send a message to gen@genuinefantasypress.com and we'll discuss it. These wouldn't even exist without feedback like your own, so it is more than welcome.

Future Endeavors

The Compendium of Forgotten Secrets: Awakening is the first product of Genuine Fantasy Press, and with your help, it won't be the last! The next planned content release is the Compendium of Sacred Mysteries: Resurrection, which will give druids and clerics a similar treatment. If you'd like to help make this possible, please purchase the Compendium of Forgotten Secrets if you haven't done so already, tell your friends about it in real life and on social media, and enjoy using this content in your games.

Things to Remember

There's a lot of content in the Compendium, and much of it relies on a strong understanding of the game mechanics. If you aren't perfectly familiar with how actions, bonus actions, and reactions work, with how spell slots function and interact, or with how resistances and immunities work, then you may want to read on those topics.

Alrisen and Subclasses

The Alrisen act as Otherworldly Patrons for the warlock class, and they also are associated with a second subclass for other classes like fighters and wizards.

New Spells

Any spell that you see that is marked with an asterisk* is exclusive to the Compendium of Forgotten Secrets: Awakening and will not be found elsewhere. All other spells are found in the System Reference Document (SRD).

New Eldritch Invocations

Remember that the level requirement for an invocation is referencing the character's warlock level, not their total class level. Many of these invocations are restricted to specific Alrisen. This is primarily to enforce the theme of each and to preserve the balance of the game, however, there may be circumstances where it could be appropriate for this restriction to be lifted or modified. Discuss this potential optional rule with your group, and be sure that you are seeking this change because of creative intent, rather than power or ability.

Using the Alrisen

Each Alrisen has a discussion on potential questions you may need to answer in order to use them. The lore regarding each one is kept intentionally vague on some topics in order to provide you with more freedom in your implementation, but you are welcome and encouraged to change any lore details regarding the Alrisen to fit your world or story. Also remember that you don't need to include all 17; consider implementing no more than four, unless you'd like them to represent a core part of your world and plot.

Using the Mechanics

The mechanical features within this book have been carefully reviewed and balanced, so avoid modifying them unless you are certain of the consequences. If, in your modifications of the Alrisen, you decide to change the elemental damage types associated with that patron, please remember that certain damage types are more valuable than others. For example, changing fire damage to force damage is a fairly powerful improvement, while changing fire to poison is relatively weak. If you have questions about mechanical balance, please reach out to Genuine.

And with a measured haste propel
Yourselves from heaven
through the world
to hell.

–Johann Wolfgang von Goethe, Faust

The Alrisen and Alfallen

The strange and otherworldly creatures that plague the realms and twist the minds of mortals come in many different guises. Most are not truly evil, but few are benevolent. Instead, one should simply think of them as forces of nature: a hurricane is not evil, but is destructive and powerful. Fire is not evil, but it can save lives or take them depending on how it is dealt with. The ocean is a wondrous thing filled with opportunity and beauty, but is also terrible, deadly, and dangerous. The Alrisen are the same: brutal, powerful, indifferent, and often alien to the minds of ordinary folk.

The Alfallen races are a mixed breed – twisted by the power of the Alrisen, these former humans, dwarves, elves and members of other races have been changed into something far different. Some are twisted because of the pacts that they have made, while others are simply born to it. While some see it as a curse, others consider it a blessing as the otherworldly powers that they can now command are often worth the price.

The Alrisen all act as warlock patrons, granting power to those who make deals with them. Other disciplines often learn to draw power from the Alrisen in a different manner, though not all are on such friendly terms. Each Alrisen has a secondary subclass associated with it, such as a martial archetype for a fighter or a monastic tradition for a monk.

Some Alrisen also are responsible for the creation of an Alfallen race associated with their power. The following table provides a list of all the Alrisen featured in this document, a brief description of their portfolio, a description of their secondary subclass, the name of their associated Pact of the Chain familiar, and the Alfallen they may be responsible for creating.

The Alrisen

Name	Description	Second Subclass	Familiar	Alfallen Race
The Accursed Archive	Enter a library filled with horrifying secrets	**Barbarian:** Path of the Accursed	Record-hunter	The Maledicti
The Ashen Wolf	Join the hungering pack	**Sorcerer:** Ashen Lineage	Emberborn	The Ashenspawn
The Blackthorn Grove	Rip out your heart and regain your will to live	**Sorcerer:** Blackthorn Lineage	Bloodless Wanderer	The Groveborn
The Currency Conspiracy	Sell your soul, and receive a coin of Gilt	**Paladin:** Oath of Avarice	Wealth Mimic	—
The Eternal Citadel	Wander, and preserve the world forever	**Fighter:** Timeless Monumental	Animate Shield	The Statuesque
The Fallen Exile	Help an outcast star	**Monk:** Way of the Black Star	Luminous Shard	The Luminari
The Forbidden Graveyard	Visit the edge of death and come back changed	**Rogue:** Graverobber	Haunted Crow	—
The Gelatinous Convocation	Cheerfully join the wonderful slimes	**Wizard:** Esoteric Plasmology	Wiggly Cube	The Oozian
The Gray Portrait	Paint your soul out	**Bard:** College of Portraiture	Animate Image	—
The Keeper of the Depths	Allow a nightmare to visit your dreams	**Wizard:** Dream Cartography	Eyeless Watcher	—
The Perfect Chord	Sing to the endless song	**Fighter:** Discordant	Symphonic Songbird	—
The Serpent Empress	Swear yourself to the Sovereign of the Empire	**Monk:** Way of the Noble Serpent	Imperial Cobra	The Imperial
The Shadowcat	Dream of the Inverse, and become nightmare	**Barbarian:** Path of the Mercurial	Dimcat	The Nocturne
The Storm Lord	Bow to the majestic storm	**Bard:** College of Harbingers	Spark Seeker	The Heraldic
The Warrior-Saint	Preserve cosmic order	**Paladin:** Oath of Judgment	Scribeant Swarm	—
The Weaver of Lies	Live a life without truth	**Rogue:** Spidertouched	Shade Widow	The Arachi
The Wild Huntsman	Hunt, kill, and feast as a lord of frozen beasts	**Ranger:** Hound of the Huntsman	Harrowing Hawk	—

THE ACCURSED ARCHIVE

THE VAULT OF DARK SECRETS

Hidden away in a place outside the ravages of time, there is a singular library, accessible to only an unfortunate few. This place is known as the Accursed Archive, and it contains the hidden mysteries of the world, carefully collected and curated over untold centuries.

Those who learn of this place are rarely the wise and well-prepared. The foolhardy and impetuous, the brave and the power-hungry are far more often those who manage to find their way to this place.

The reason for this is simple. Those poor, misguided souls are the ones the Archive seeks to use to fulfill its purpose: the spread of ruin and suffering to every sentient being in the entirety of the endless planes.

Sadly, few of them are aware of this risk. The Archive's malevolent intelligence is cunning and alien. It does not communicate by words, but by the small twists of fate that guide its pawns to discover the entrance and open the way on their own.

ENTERING THE ARCHIVE

A forlorn and power-hungry soul will often find the Archive through what they would call sheer luck or chance. A drafty window will blow down a stack of papers, causing a scholar to scramble underneath a table in search of them, finding an ancient tome of forbidden lore in the process. A door left conveniently open will tempt a would-be thief into entering a dark hallway that leads to a place darker still. A desperate scion of a noble house will speak with a madman, who rants about the images that plague his nightmares before guiding the questing fool to a small monument carved from bone and lashed together with still-living sinew.

In all of these cases, the result is the same. The scholar shall speak the words within the tome, the thief shall turn the final corner, and the noble shall chant alongside the madman. In an instant, they appear inside the Archive, staring around at the sights to behold within the great hall.

THE GREAT HALL

Whenever one enters the Archive, they will always find themselves in the great hall, within which is a unique and massive tome alongside a small bell mounted to a desk.

Beyond this, seemingly endless space is filled with dark wooden shelves, alcoves, stairways, and seating areas. There are no lamps or flames here. Those who travel within rely upon the brilliant red light of the single full moon above, which shines down through the open space and is captured and reflected in the crystals that dot the walls.

Fire is extinguished even as it sparks within the Archive, a phenomenon believed to be caused by the simple refusal of the intelligence within this place to suffer the indignity of loss.

Statues of nightmarish monstrosities and vile horrors are commonplace, along with replicas of armor and weapons wielded by the greatest tyrants from all worlds. Each is sealed within a coating of pure force, preventing them from being tampered with or damaged except when the Archive decides that the time is right for these forces to be unleashed.

Within the stacks of books, scrolls, and unbound manuscripts, the darkest secrets and greatest triumphs of magic, religion, philosophy, history, science, and every topic ever researched or discovered by mortals can be found. However, the shelves themselves are not sorted by any conventional means. Many have been driven mad attempting to catalogue the shelves, as they seem to move and twist and distort whenever they are closely inspected. One will often find completely disparate topics adjacent to one another, seemingly categorized not by subject, year written, or author but instead by something as mundane as the color of ink in which they were transcribed. Many of the books within are inherently dangerous, bearing defenses such as sharpened steel sheets instead of pages, magical glyphs of blindness and destruction, living eyes and teeth that snap at observers, or poison in place of ink.

THE INDEX INCARNATUS

In order to find a particular tome by anything other than sheer mad chance, one must consult the *Index Incarnatus* – the one singular document that contains the location of each and every scrap of lore within the Archive.

Unfortunately, this means opening the tome located within the entryway of the great hall and exposing oneself to the soul-scouring weight of the Archive's malicious intent. The process is exhausting and terrible, weighing heavily upon one's sanity. Nevertheless, some believe it is a price worth paying.

BEYOND THE ARCHIVE

In the worlds that bear the burden of the Archive's attention, there are many who have responded to this place's presence. Those who have entered and survived often go mad, rambling of the things they have seen and the truths that have been revealed to them. Blood sacrifice and ritualistic murder are common in places where the Archive's influence is heavily felt, leading to dark rumors and terrible secrets.

Orders of inquisitors and heretic-hunters often arise in response to these events, holding book-burnings and purges to help regain control over their citizens. In places where the leadership itself has been corrupted by the Archive, hellish fiends and aberrations often stalk the streets and countryside, feasting upon the unwary and the brave alike.

One of the most common symbols of the Archive is a single scroll, painted black and dripping with blood. Another, favored by scribes and fanatics who have seen within, is a quill crafted from a raven's feather.

When the Archive is accessed, places near the entryway have reported unattended papers filling with scribbles of undecipherable glyphs and runes. The asymmetry and long, sinuous shapes of these scrawlings causes instinctive distress and fear in most who view them. Those who whisper rumors in the quiet evenings may speak of dark dreams dominated by a blood-red moon. Persons formerly unable to read suddenly learning how to do so are often said to have visited the Archive, even if clear proof to the contrary is easily provided. Mysterious gatherings of carrion birds are sometimes called a "curse" in cultures that associate them with the Archive, claiming that they feast upon the bodies of the dead only as a cover for their fouler work: stealing the secrets of goodly

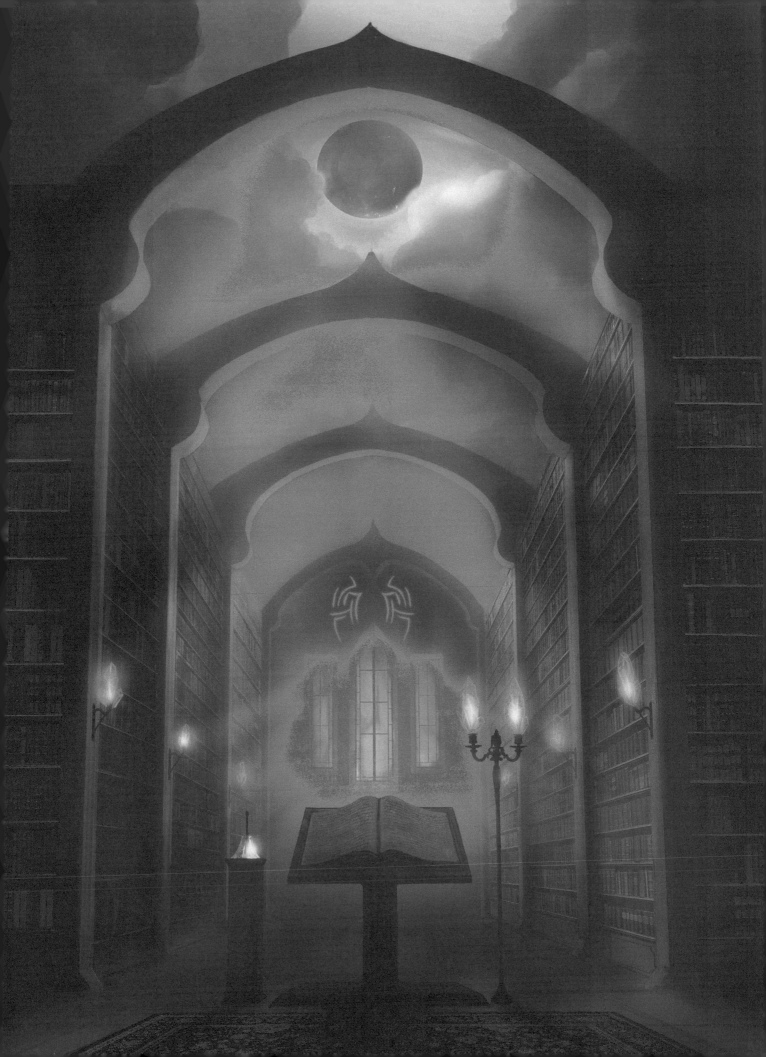

folk and inscribing them upon some tome to take away to the Archive's unearthly corridors.

Nearly all cultures that have a written language of some kind will have stories and tales of the Archive in some form or fashion. Some feature heroes who have sought the Archive in search of knowledge required to complete their quest, but far more portray the terrible consequences of this knowledge coming to light.

Families are torn apart after a genealogical lie is revealed, split down the middle and squabbling over inheritances lost and discovered. Kingdoms are thrown into chaos when the deeds of a supposedly-benevolent ruler are revealed to the world. Practitioners of the arcane arts, who sought methods to increase their power, reveal the disgusting madness that hid within them the entire time. Clerics and priests seek the truth behind the nature of the gods and fall to doubt, confusion, and ruin after their core teachings are revealed to be hypocrisy of the highest order. Warriors, brave and foolhardy, seek the locations of weapons thought lost to time and tragedy. Only too late do they realize why such things were better left undiscovered. Thieves, seeking to steal the secrets of the Archive, find themselves stumbling upon corruptive texts that enable them to twist the minds of others. When these enchantments fail, they are left to roll the dice in the devil's game. Crusaders and paladins of noble orders, desiring the downfall of the forces of evil, venture into the Archive in a desperate attempt to discover the means by which they may defeat their foes. All too often, they fall prone to the very same hubris that plagues their enemies, dragging them into the vile arts unspoken by better men.

No matter who enters, the questions are always the same: What price are they willing to pay, and will they be willing to survive the consequences?

Unlocking the Archive

If you're interested in adding the Accursed Archive to your world, you may want to consider how it has affected the literary tradition of the civilizations that have arisen.

Are scholars and sages held in high esteem, or are they viewed as meddlers who undermine the will of the gods? Is the Archive a new phenomenon, or has it always been present and active in the world? Did writing itself come from the Archive, or did the Archive manifest after the mortal races began to write? Who was the first Archivist to venture inside and learn the secrets of this place? Do angels and demons and creatures from beyond the planes have access to the Archive? What kind of relationship does it have with them? Is it viewed as a treasure by the forces of evil, or is it sealed somehow by the agents of good? What is the most reliable way for a layperson to stumble into the Archive? Can the Archive be accessed by seemingly non-magical means, or does it require study and arcane intervention?

How do the Alrisen, the gods, and the elder races view the Archive? Does the Huntsman visit in hopes of discovering a new challenge? Do the servants of the Serpent Empress rely upon the Archive when plotting their intrigues? Does religion condemn or revere those who venture within? Did the gods create the Archive? Did it manifest spontaneously? **Consider all of these when opening the Accursed Archive.**

It's just a snooty book-reading club where a bunch of freaks hold their no-whispering sessions. —X

Otherworldly Patron: The Accursed Archive

In every library there is a book that has never been read, a section that has never been seen, and a hallway that leads to nowhere – yet, you have managed to read that tome of unspoken secrets, find that shelf of unholy blasphemies, and step beyond the dead-end corridor into the Accursed Archive, where you have become bound to the nightmare-inducing writings within. Demonology, blood magic, and the summoning of things from beyond are among the most mundane of topics here, but draw the eye and call to the hand nonetheless. By some malignant intelligence that selects only the most desperate, the most ambitious, and the most willing to sacrifice, the Accursed Archive collects souls to do its ruinous work: to share the terrible truths that reside upon its endless shelves, and bring chaos and upheaval to the outside world through the disclosure of these forgotten secrets.

Expanded Spell List

The Accursed Archive lets you choose from an expanded list of spells when you learn a warlock spell. The following spells are added to the warlock spell list for you.

Accursed Archive Expanded Spells

Spell Level	Spells
1st	*detect evil and good, inflict wounds*
2nd	*accursed wish*, dark secret**
3rd	*blackened heart*, blasphemy**
4th	*black tentacles, forbidden obelisk**
5th	*dispel evil and good, legend lore*

Tainted Knowledge

At 1st level, you have feasted your eyes upon the books of the Archive, and your mind has both withered and grown. Choose two of the following: Arcana, History, Nature, or Religion. Your proficiency bonus is doubled for any ability check you make that uses a chosen skill if you are proficient in that skill, and you gain proficiency in any one skill of your choosing.

You can use an action to enter the Accursed Archive along with up to ten willing companions of your choosing that you can see. Time does not pass outside the Archive while you are within, and you cannot rest, recover hit points, or maintain concentration while inside. For more information on the Archive, see the *"Inside the Archive"* section. When you choose to depart, you and your companions return instantly to the point from which you entered.

Once you use this feature, you cannot do so again until you finish a long rest.

Written in Blood

At 6th level, you've learned to read your servants and adversaries as easily as the scrolls located within the darkest places of the Accursed Archive and can twist them to serve your cruel whims.

As an action, touch a creature within reach. The target must make a Charisma saving throw with a DC equal to your warlock spell save DC. If they fail, they are paralyzed until the

You'd do well to heed the Archivists, oaf. Just because the finer points of the eldritch arts escape you does not mean they are without power. What I'd give to see the inside and live to tell the tale... —Sylvette

end of your next turn, and their flesh peels back into the pages of a book bound underneath their skin. The words within describe who they are and what they have done, and you can read up to six different sentences from them, prioritizing details you wish to learn. While the creature is paralyzed, you have advantage on Charisma and Intelligence checks relating to the creature and it has disadvantage on Charisma and Wisdom checks.

Once you use this feature, you can't do so again until you finish a short or long rest.

VILE HERESIES

At 10th level, you uncover secrets that could shatter the balance of the heavens and hells. Choose any spell of 4th level or lower that is not a cantrip. You can cast this spell once using a warlock spell slot.

Once you do so, you cannot do so again until you finish a long rest.

Whenever you are within the Archive, you can exchange this spell for a different one, but cannot use it until you finish a long rest. Whenever you cast your chosen spell, you gain immunity to the frightened condition. This immunity lasts until you finish a short or long rest.

UNSPEAKABLE TRUTHS

At 14th level, you discover the real purpose of the Accursed Archive – the spread of information that will bring ruin to the world. As an action, you can share an unspeakable truth with all creatures that can hear you within 60 feet of you. All hostile creatures who can hear and understand your words must make a Wisdom saving throw against your warlock spell save DC. If they fail, they are driven mad and suffer confusion as though affected by the *confusion* spell for one minute. They can repeat this saving throw each time they suffer damage, ending the effect on a success.

When you do this, choose up to four creatures within 60 feet of you that you can see. These creatures are infused with dark power that distorts the fabric of reality. Choose one spell you can cast of 2nd level or lower that inflicts damage and has a casting time of one action or bonus action. Each infused creature can use their reaction to cast this spell immediately without using verbal, somatic, or material components. Charisma is their spellcasting modifier for this spell.

Once you use this feature, you cannot do so again until you finish a long rest.

ELDRITCH INVOCATIONS

THE ARCHIVIST'S JOURNAL
Prerequisite: Accursed Archive patron, Pact of the Tome feature

You gain advantage on saving throws while within the Archive. Whenever you cast a spell of 1st level or higher that deals damage, you can use your bonus action to cause one target of the spell to become vulnerable to the first instance of damage from a single type, rolled randomly on the table below. If the creature has resistance to the damage type, this resistance is ignored and vulnerability is applied instead. If the spell you cast deals that damage type, roll until you get a different result.

Once you use this bonus action, you cannot do so again until you finish a short or long rest.

JOURNAL DAMAGE TYPE

d4	Type
1	fire
2	cold
3	poison
4	necrotic

BUTCHER'S QUILL
Prerequisite: Accursed Archive patron, Pact of the Blade feature

Using your Pact of the Blade feature, you can create a weapon wrapped in raven feathers and the hide of abominations that drips and bleeds black ink. When you hit a creature with this weapon, you can cast a single 1st level spell you know with a casting time of one bonus action without expending a spell slot. Once you cast a spell in this way, you can't do so again until you finish a short or long rest.

CURSE OF CARASPHYX
Prerequisite: Accursed Archive patron

Your flesh grows corrupt in appearance but is imbued with terrible might. While you are not wearing armor or using a shield, you can choose to have your AC equal 10 + your Strength modifier + your Charisma modifier.

SCRIBE'S ADJUNCT
Prerequisite: Accursed Archive patron, Pact of the Chain feature

While you have a record-hunter as your familiar, it gains additional maximum hit points equal to your warlock level and you gain the ability to cast the *mending* cantrip.

TENEBROUS BLAST
Prerequisite: 7th level, Accursed Archive patron

When you deal damage with a cantrip or hit a creature with a weapon attack, you can use a bonus action to unleash a shadowy blast of malevolent power. Choose one target of the cantrip or attack. The chosen creature suffers disadvantage on attack rolls targeting lightly obscured creatures until the end of their next turn.

INSIDE THE ARCHIVE

While few venture into the Accursed Archive, those who do cannot help but be drawn through the great hall to gaze upon the tome in the center of the room – the *Index Incarnatus*, a singular, endless book that contains the location and description of every single scrap of forbidden lore within the Archive. Even gazing upon it for mere moments can cause discomfort, and reading from it can cause agony to both the body and the soul.

Any creature that attempts to read from the Index must make a Charisma saving throw with a DC equal to the skill check DC that would be required to gain the knowledge they seek through ordinary means. If they fail, they gain a level of exhaustion, but might still find the location of the correct tome or scroll at the discretion of the *Index*.

All levels of exhaustion gained while within the Archive are removed whenever the subject finishes a long rest.

The Silent One

Each time a person speaks or makes noise within the Archive, roll a d20. If the result is a 1, the person has attracted the attention of the Silent One: a terrifying, tentacled nightmare of unspeakable strength that exists with the sole purpose of curating and protecting the knowledge hidden here. The Silent One is blind, but has keen hearing and long tendrils that cannot be truly harmed by ordinary magic or metal, only driven back for mere moments.

Hunting Methods

Each turn this creature is hunting the party, randomly choose one target, prioritizing those who have spoken loudly or who have damaged writings within the Archive.

The target must make an appropriate saving throw or ability check with a DC equal to 10 plus the character's proficiency bonus. If they succeed, they manage to flee, quiet themselves sufficiently, or fend off the monstrosity for a moment, buying time for the rest of the party to complete their work.

If they fail, the dark tendrils of the creature corrupt the flesh of the target, inflicting one level of exhaustion. If a member of the party gains six levels of exhaustion, they are seized by the horror and dragged into the depths of the Archive to meet a dark and twisted fate.

Fighting the Silent One

If the party somehow gains the knowledge and skill required to face the Silent One in open combat, the fight will not be an easy task. The creature will make multiple attacks using its tentacles, each one inflicting a level of exhaustion to any creature struck by these eerie tendrils.

The horror may resort to hit-and-run tactics, concealing itself within the endless and shadowed alcoves of the Archive before lashing out in a vicious barrage of attacks. The Silent One may also grapple and abduct any spellcasters within the party who use spells that require verbal components, seeking to choke the life from them.

The Silent One is deliberately left without a defined statistics block in this document. It is up to you to define the form of the Silent One and the statistics it will use, though in all cases it should be all but impossible to fight with conventional means.

A Nightmarish Visage

While no two accounts of the Silent One are the same, all describe it as large, powerful, and extremely dangerous.

Some claim it looks similar to a hound, blind and eyeless, with massive teeth and an eerie walk that conceals its speed. They say tendrils spiral from its back, laying around the hallways waiting to ensnare someone walking without sufficient caution.

Others claim it looks like a bat, with large wings and ears that twitch atop a mass of tentacles. Those who have seen this incarnation claim it swoops down from the highest bookshelves, crashing into unfortunate souls before pinning them beneath its unholy mass and devouring them alive.

Few see it as a serpent, silently flickering a tongue-like tendril that enables it to seek out those who are quiet enough to hide from it. A rare number call it a spider, sitting within a web of limbs and tentacles, waiting for a fly to stumble upon it. Those who have fallen to madness after seeing the beast multiple times claim all of these answers are wrong, and put forth an even more disturbing hypothesis: There is not merely a single Silent One, but many. Each that greets the next unfortunate soul is one of the previous victims of the horrors, transformed into their worst nightmare by the unspeakable powers that dwell within the darkest depths of the Archive.

Few believe these tales, of course, but those who have attempted to resurrect individuals who've fallen to the beast have failed, even when using the most powerful of magic.

Leaving the Archive

The party can depart from the Archive by returning to the great hall and striking the small bell located beside the *Index* as an action. Each person striking the bell instantly departs and returns to the location from which they entered the Archive, with no time having passed from the moment they left.

Traits of the Archivist

When creating a warlock or after spending time researching in the Archive, consider adding one or more of the following traits to your character.

d20	Trait
1	You always hold books as far away from you as possible.
2	You're uncomfortable in open spaces.
3	You compulsively hush other people.
4	You're convinced your shadow is alive and plotting against you. You might be correct.
5	You can't stand to see others handle books in your presence and take them away immediately.
6	You curse quietly when you think others aren't listening.
7	You constantly chant a single phrase under your breath in a language you don't understand.
8	You avoid looking people in the eye.
9	Whenever you hear a secret, you write it down.
10	You keep a record of the events of each day and store it within a tome you allow no others to see.
11	An eye has grown on the back of one of your hands. You can't see from it, but something can.
12	Your skin becomes pale like parchment.
13	Thick black veins run through your arms and legs. Occasionally, they twitch.
14	Blood placed on your skin appears to form runic sigils. You're not certain what they mean.
15	Your tears are black like ink and stain heavily.
16	Your tongue becomes black and eerily long.
17	Your irises become red with black veins running through them. Sometimes others can see the veins form words.
18	Your posture degrades and your back stoops heavily.
19	Your hands are always stained with ink.
20	Scars you can't explain appear and vanish at random.

Primal Path: Path of the Accursed

There is a place beyond time, filled with malignant intelligence and ruinous intent. This is the Accursed Archive – the singular repository of all knowledge known to mortal men, populated with the darkest of secrets and the foulest of heresies. You managed to find a tome of these blighted mysteries and stepped through the door to nowhere that led to the Archive at some point in your past, yet your mind cracked under the weight of the knowledge contained within and the horrible vistas of forgotten power that stood just within your feeble mortal grasp. Now you have finally realized that the true source of your furious rage is both defiance and acceptance of the madness that lies within the Accursed Archive.

The Lurking Fear

At 3rd level, you have yet to come to terms with what you have witnessed within the Archive, and in your bouts of rage you ramble about these twisted things even as your tongue fights to stop. You gain resistance to all damage inflicted by frightened creatures while you are raging.

Whenever you are raging, each creature that starts its turn within 10 feet of you must succeed on a Wisdom saving throw (DC equal to 8 + your proficiency bonus + your Charisma modifier) or be frightened of you until the end of your next turn. Once a creature fails this saving throw, it can't be frightened by this feature again for one minute.

Additionally, you can use your Charisma modifier in place of your Intelligence modifier when making skill checks and saving throws.

I struck Sebastian today. He claimed he couldn't see it, but I knew he was lying. That horrible thing had slithered its tendrils into his mind, and it was using him like a puppet, twisting his words against me. He said I was mad!

MAD!

What an inane thought devised by a moron of the highest order. It's not madness to cower, hidden in the shining light when one knows what lies in the darkness beyond.

That thing that was hidden behind the last door of that strange library knows. It knows I know. It followed me out, and it's here, sometimes. It's watching me write this, I'm sure of it. Well, the tables are about to turn. I've hired a few specialists to accompany me on a journey to the Temple of Dienero in Westbrook, where the priests there can hopefully banish the horrible nightmare that plagues me. I still can't believe I lashed out in anger like that. I hope the wriggling tendrils haven't already squirmed into the minds of my new companions. Maybe they'll be able to see them… His blood is still on my hands. I wonder if he will survive…

From Beyond

Starting at 6th level, your words seem to cut at the minds of those who listen even more horribly than before. You can cast *dark secret*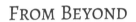 once, and you recover this use whenever you enter a rage. Charisma is your spellcasting ability for this spell.

The Thing on the Doorstep

At 10th level, your hallucinations slowly enter reality, as the dark tendrils of the Silent One move at the corners of your vision. Whenever you enter a rage, you can choose to unleash the horrors that dwell within your mind upon the world. Choose a number of creatures within 30 feet of you equal to or less than your Charisma modifier. Each one is pulled to an open space within 5 feet of you, or the nearest available space, by massive tendrils that spawn from the air around you. Until the end of your turn, when the tendrils disappear, you cannot suffer disadvantage from any source on any check made to grapple one of these creatures.

What the Moon Brings

At 14th level, you finally accept the things you learned within the Archive and realize that the ruinous secrets it unleashes upon the world are merely the statements of a truth that mankind has long dreaded to learn. The Silent Ones are not villains, but are guardians, destined to safeguard the universe from those who would exploit the foul heresies of the Accursed Archive, and so you begin your preparations to join their ranks.

Whenever you reduce a creature to 0 hit points, you can choose to allow a Silent One to lash out from within your skin, ensnaring another unwary soul and twisting their flesh from its good purpose. Choose a creature within 30 feet of you. The target must make a Strength (Athletics) or Dexterity (Acrobatics) check contested by your own Strength (Athletics) check. If the target fails, the tendril snares them and drags them into the closest open space near you, and the creature gains one level of exhaustion. A creature cannot be affected by this feature more than once per turn.

Discovering the Archive

The Accursed Archive is intended to represent the dark arts as something once discovered and deliberately sealed away in order to keep the world safe from the harm such knowledge would cause. This section discusses other possible interpretations of the Archive, what themes it explores and how it does so, and how you can change and adapt the Archive to suit your world, game, or character.

Adjusting the Archive

The Accursed Archive should fit in its current state in most worlds and games, but it does present a few dilemmas that may warrant it being changed and modified, or even excluded entirely in some circumstances. Not all Alrisen are appropriate for all worlds and games, so if you're wanting to play one of these subclasses, make sure that it will be allowed.

The first and most obvious source of difficulty would arise if there isn't a written language in the world. If there is no written language, then the Archive could contain a series of murals and other visual artworks that conveys its dark secrets. Alternatively, you could include magical devices that orate stories and knowledge, whispering silently into the minds of those that look upon the paintings.

Divine Darkness

The second problem that the Archive can pose is one of divine importance: How are the gods responsible for the domain of knowledge related to the Archive? Were they the ones who created it? Are they aware of its existence? How would they react to a new Archivist? Evil deities may seek to gain entrance to the Archive, while good deities could desire its destruction or captivity. This may coincide with the burning of books and other texts in order to keep the secrets within the Archive from escaping into the greater world, or it could come from formal schooling and celestial guardians who keep the Archive from being easily accessed. Be sure to avoid preventing the party from entering the Archive, even if you do create safeguards and barriers, as the Archivist is intended to be someone who has gained the knowledge of how to surpass these limitations by virtue of their direct and deliberate connection with the Archive.

Where beyond the World

The third problem is one of location: Where is the Archive going to actually be? In most circumstances, it's appropriate to situate the Archive on a demiplane or other extra-dimensional space that could be feasibly visited via the magical means described within the features of the Archivist. However, if that's not the case, then the Archive should be located at a defined place that can be visited in person, and the features related to visiting the Archive are adjusted to indicate that the party is either instantly traveling to that location or are making a sort of instantaneous spiritual journey or vision quest that leads them to the knowledge they seek.

Themes of the Accursed Archive

The Accursed Archive is built on the idea of forbidden knowledge, with secondary themes of dark magic, blood sacrifice, darkness, horror, and eldritch power. It's possible to change the nature of the Archive to suit your world by directly changing some of these secondary themes.

For example, it's possible to change the Archive into a holy sanctuary filled with knowledge only fit for the gods to know. The Silent One would become a divine guardian tasked with protecting the knowledge from interfering mortals. The Unspeakable Truths feature could represent blessing one's allies with the power of a celestial figure or teaching them the language of the gods themselves. The Path of the Accursed could become the Path of the Fervent, speaking phrases of holy wrath, summoning scrolls of angelic script to bind and drag your enemies, and sapping the fortitude of your foes with the force of your zealous might.

Holy Power or Foul Arcana

Re-flavoring features and subclasses is relatively easy and can provide interesting and distinctive character concepts, so don't be afraid to give it a try. Here's an example of a replacement to the Path of the Accursed "What the Moon Brings" feature.

Burdens of Knowledge

At 14th level, your furious defense of the Archive has imbued you with glorious might. Whenever you reduce a creature to 0 hit points, you can choose to ensnare a creature with chains of holy light and drag it to you. Choose a creature within 30 feet of you. The target must make a Strength (Athletics) or Dexterity (Acrobatics) check contested by your own Strength (Athletics) check. If the target fails, the chain snares them and drags them into the closest open space near you, and the creature gains one level of exhaustion. A creature cannot be affected by this feature more than once per turn.

As you can see, the mechanical outcome is identical, but the flavor is completely different and provides a distinctive visual, which is essential for a compelling feature.

Interactions of the Archive

One final thing to consider when implementing the Accursed Archive in your world is understanding how it will interact with the warlocks who make pacts with it. Consider if you plan to have it be frequently present, occasionally present, or rarely present, especially when determining how powerful and important it can be. An Archive that holds all the knowledge of the multiverse can be very interesting, but if the story is focusing on uncovering knowledge then it may provide a very easy solution to many problems unless complications are presented. For example, the Silent One could be particularly watchful and difficult to fool. Other parties could be interested in the Archive, causing it to be difficult to openly discuss or utilize. Interactions with the

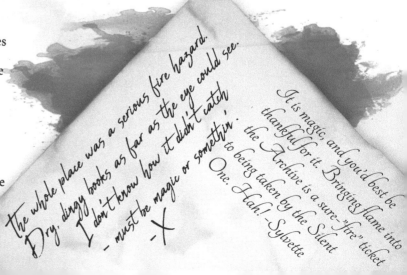

The whole place was a serious fire hazard. Dry, dingy books as far as the eye could see. I don't know how it didn't catch - must be magic or somethin'. -X

It is magic, and you'd best be thankful for it. Bringing flame into the Archive is a sure "fire" ticket to being taken by the Silent One. Hah! -Sylvette

Archive could be particularly straining upon the mind, causing madness, hallucinations, and insanity.

The Archive is a dark place filled with terrible things. Let it shine as a beacon of that infinite horror.

Your players will thank you for it!

Stories of the Accursed

In cultures exposed to the Accursed Archive, it is commonly represented as a harrowing tale of the perils of progress and the consequence of delving too deeply into things that should be left buried. Some cultures that are skeptical of learning, literature especially, point to legends of the Archive as their reasoning for their close-mindedness.

A popular tale depicts a priest who questions their deity, asking "If the hosts of the heavens are so mighty, why have they yet to defeat the wretched fiends of the hells?" The answer given was unsatisfactory, so the priest began to research. Seeking out ever more esoteric bits of lore, the priest eventually stumbled upon a tome containing true demonology not written of in the texts of their faith.

The tome revealed the path to the Archive one fateful night, and the priest entered, eager to learn how the fiends might be destroyed. Silently the priest researched, night after night, until the madness stored within began to eat at their mind in earnest. They devised a plan and an experiment. They would summon forth a fiend from the blackest pit and thus force an angelic avenger to descend and do battle with the fiend. By witnessing the battle, the priest would finally understand the real reason that the foul hordes still existed.

An Unfortunate End

Plan concocted, the priest set into motion a series of events that would live in infamy. The fiend was summoned, and it brought with it scores of lesser fiends that quickly escaped into the land, causing chaos and destruction. An angel arrived, and slew the fiend, but the damage was already done. The fiends began to multiply and spread, to the horror of the priest, who had lived to realize what they had done. In sorrow, the priest begged the angel to kill them, but the celestial avenger refused.

Instead, the former priest was cast out and blinded, so that they could never read another word of the dark arts, and was tasked with the destruction of any forbidden lore that they could still find in their wretched state. Whether truth or myth, luddites and individuals who find the arcane arts distasteful will reference the parable of the priest and curse the Archive in the same breath.

Mysteries and Plots

The cruel secrets that lurk within the Accursed Archive go beyond simple literature, however. Some claim that inside this terrible place there are artifacts and objects of power waiting to be set free upon the world once more.

The phylactery of an ancient lich is said to be hidden within a hollowed-out book, the clever arcanist turning the Silent One into its own personal guardian.

The true names of the most powerful fiends are located within, though they are so deep and so well-guarded by magical defenses that none have been able to reach them. The only hint that they even exist is located within the *Index Incarnatus*, for it cannot lie about the contents of the Archive.

The corpse of an archangel is supposedly hidden somewhere within. There's no telling if it's true, or how much a powerful fiend would be willing to pay for it.

Books of Forbidden Lore

There are countless tomes and scrolls within the Archive. If you need a quick one, generate it using the following table. Roll on the first, second, and third columns to create a piece of foul and unholy literature.

d8	First	Second	Third
1	The Scroll	of Esoteric	Hatreds
3	The Book	of Unknown	Terror
4	The Tome	of Spiteful	Demons
5	The Notebook	of Demonic	Incursions
6	The Compendium	of Lost	Mysteries
7	The Sketchbook	of Forgotten	Secrets
8	The Tablet	Dark	Defilement
			Blasphemy

Relics of the Archive

The Accursed Archive is a repository of knowledge, but also has held countless magical objects over the years. Archivists are accomplished in the physical crafting of devices and weapons to suit their needs. Some are capable of binding fiends and abominations to armor, while others have created tools of great cruelty and cunning. Here are a few of the many objects associated with the Archive and who have entered it:

The Bloodstained Quill
wondrous item, legendary

Whenever this quill is dipped in the blood of a living creature, it can be used to write one or more words upon that creature's skin as an action. Those words become true and the target acts as though affected by the *geas* spell. The target can be written upon multiple times, creating a series of soul-binding instructions that each act as a unique instance of the *geas* spell. If the creature is targeted with a *remove curse* spell, only one of the writings is removed each time.

Celestial's Spiteful Armor
magical armor (any), very rare (requires attunement)

While a creature is wearing and attuned to this dark and corrupted armor, they gain resistance to magical damage from spells and have advantage on saving throws against spells cast by non-evil creatures. A non-evil creature wearing this armor cannot cast spells.

Ink Razor
magical weapon (dagger), very rare (requires attunement)

This magical dagger appears to be an inkwell, but when opened, it transforms into a blade of hardened black liquid. Whenever you hit a creature with this weapon, it suffers disadvantage on saving throws against spells until the start of your next turn.

THE ASHEN WOLF
THE HUNGERING FLAME

Within every fire, there is an insatiable and gluttonous greed. A simple and pure predatory urge to consume, feast, and burn until nothing is left. Wood, flesh, and metal alike bow before the furious supremacy of the flame.

The Ashen Wolf is a physical manifestation of this terrible hunger. Some call it a fiend from the blackest pit, others call it an elemental creature. Enlightened sages call it an Alrisen, placing it among the greatest of beings below the gods themselves. Nevertheless, it is living, it is hungry, and it burns for the thrill of the hunt.

THE VOICE OF THE FIRE

Those who have laid eyes upon the Wolf and lived describe it as a being of unquestionable presence. It is a massive lupine creature with eyes like the fires of a burning home, fur that smolders in the dark, a cloak of smoky ash, teeth of sharpened steel that gleam in the light, and a deep voice that carries like the whisper of a struck match in a quiet forest.

While the Wolf is ever-hungry, it seeks more than mere meat. It hungers for conflict, companionship, and the freedom to roam and burn. Often surrounded by emberborn, small wolf-like fire elementals, it hunts the forests of the world for ancient beasts, cunning prey, and lost wanderers.

A DANGEROUS BARGAIN

The Ashen Wolf is known to the mortal races from the stories told of those who have gone to entreat this beast, begging for aid, power, or control over their own destiny. The Wolf is known to grant these requests, but the price for this boon is cruel and terrible by all accounts.

The Wolf delights in the suffering of mortals it does not consider within its pack, and thus payment often comes in the form of a curse that plagues the supplicant forevermore. Those that survive often regret their decision, in the end.

SIGN OF THE BURNING HARVEST

Cultures that lie within the untamed lands beyond the civilized world are often more familiar with the Ashen Wolf than those who dwell within the cities, though even their knowledge is often rife with superstition. The Wolf seems to enjoy the sacrifices made in its name and responds favorably to those who perform the proper rituals, sending its emberborn servants to hunt the beasts that plague its supplicants or to purge outcasts and criminals from their land. If the fields burn and the granaries are destroyed in the process, then that is the price of the hungering flame.

The Wolf is often symbolized with a flag coated in ash with prominent markings of fangs or claw-prints drawn in red or orange paint. In some cultures, magically-heated metal is twisted into unusual shapes and pressed into trees to mark the domain of the Wolf's servants.

UNLEASH THE ASHEN WOLF

When including the Ashen Wolf in your world, decide where it dwells. Does it move around or is it fairly static? Who serves it, and how do they interact with the servants of other Alrisen and the creatures of the hellish and heavenly hierarchies? Is it tied to the elemental forces? What does it want to accomplish? Who defies the Wolf? Is it regarded as a force of evil or a protector of the natural world?

Otherworldly Patron: The Ashen Wolf

You've made a pact with a primal spirit of fire and the hunt – a scourge of the forests and fields, and a harbinger of ill fate. This creature is wise and cunning, making deals with those who have the potential to bring ruin and change. Some consider the beast to be native to the Plane of Elemental Fire; others call it a fiend from the darkest hells. Whatever its origin, the ember-eyed wolf often extracts payment in the form of wishes gone awry: a demand for power becomes a battle to retain one's humanity, while a request for a peaceful resolution often has a price that brings constant regret.

Expanded Spell List

The Ashen Wolf lets you choose from an expanded list of spells when you learn a warlock spell. The following spells are added to the warlock spell list for you.

Ashen Wolf Expanded Spells

Spell Level	Spells
1st	hunter's pace*, inflict wounds
2nd	flame blade, pass without trace
3rd	funeral pyre*, haste
4th	ashen pack*, wall of fire
5th	cloudkill, hungering hate*

Breath of Smoke

Starting at 1st level, you can use your action to exhale blistering embers in a 15-foot cone. Each creature in that area must make a Constitution saving throw against your warlock spell save DC. Creature that fail take fire damage equal to your warlock level + your Charisma modifier and are blinded until the end of their next turn.

If you activate this feature again before finishing a short or long rest, you gain one level of exhaustion.

Additionally, you can breathe and see normally in smoke or ash-filled air.

Feast for the Fire

Beginning at 6th level, you have gained the ability to mark a target for sacrifice to the Ashen Wolf. As a bonus action, choose one creature you can see within 60 feet of you. For one minute, the target is cursed by the Ashen Wolf. The curse ends early if the target dies. Until the curse ends, the target loses any resistance to fire damage, and opportunity attacks against the target are made with advantage.

Once you use this feature, you can't do so again until you finish a short or long rest.

At 10th level, the curse grows in strength as your connection with your patron deepens. The target also loses any immunity to fire damage.

Endless Pursuit

At 10th level, your patron grants you a portion of its primal stamina. You gain resistance to fire damage.

Whenever you finish a short rest, you can choose to reduce your level of exhaustion by one.

You can do this once, and this use recovers whenever you finish a long rest.

Beast of the Burning End

At 14th level, you unlock the power to incarnate in the form of your patron. As an action, you wrap yourself in the guise of a massive flaming lupine creature. For 1 minute, or until you exit this incarnation as a bonus action, you gain the following benefits.

- Your size becomes Medium or Large (your choice).
- You ignore all levels of exhaustion.
- Your speed increases by 20 feet.
- You have advantage on melee attack rolls against a creature if at least one of your allies is within 5 feet of the creature and the ally isn't incapacitated.
- You are immune to fire damage.

When you use this feature, two hell hounds burst forth from your burning flesh into spaces within 5 feet of you. They obey any verbal commands that you issue to them (no action required by you). If you don't issue any commands to them or are incapacitated, they defend themselves and you from hostile creatures, but otherwise take no actions. They act on your initiative count, have twice as many hit points as a normal hell hound, and are considered elementals instead of their normal type.

When you exit this incarnation, the hell hounds instantly turn to ash. Your body immediately attempts to reabsorb the ash as it swirls back to you from up to 300 feet away. If a hell hound has died or the ash cannot return to you due to distance, you gain one level of exhaustion per missing hound.

Once you use this feature, you can't do so again until you finish a long rest.

Eldritch Invocations

Chronicle of the Flame
Prerequisite: Ashen Wolf patron, Pact of the Tome feature

You can perform a ritual for the Wolf during a short or long rest. When you do so, choose either Dexterity or Strength saving throws. When you make a saving throw of this type, you can use your reaction to gain advantage on that saving throw and cast a cantrip with a casting time of one action.

Once you use this invocation, you cannot do so again until you finish a short or long rest.

Essence of Ash
Prerequisite: Ashen Wolf patron, Pact of the Chain feature

If you have an emberborn as your familiar, it gains additional hit points equal to your warlock level plus twice your Charisma modifier.

When you reach 11th level, the emberborn can grow in size to become a Medium creature, at your discretion. While it is Medium, its bite attack deals 2d6 piercing damage and 2d6 fire damage, and the emberborn's speed increases to 50 feet. Creatures hit by the bite attack must succeed on a DC 13 Strength saving throw or be knocked prone. At 16th level, the Medium emberborn's bite attack deals 3d6 piercing damage and 3d6 fire damage, and the Strength saving throw DC equals your warlock spell save DC.

Hellfire Infusion
Prerequisite: Ashen Wolf patron

Whenever you cast a cantrip that deals damage or make a weapon attack, you can use your bonus action to empower it with elemental fire. The cantrip or attack deals fire

damage instead of its normal damage type. When you do so, enemies within 5 feet of you take necrotic damage equal to your Charisma modifier as black ash bursts from your body.

Hide of Cinders

Prerequisite: Ashen Wolf patron, Pact of the Blade feature

You can summon a coating of embers and ash to cover your skin, protecting you from harm. You can choose to have your AC equal 10 + your Dexterity modifier + your Charisma modifier. If a creatures hits you with a melee attack while this armor is active, you can use your reaction to deal fire damage to the creature equal to your Charisma modifier.

Hunger of the Wolf

Prerequisite: Ashen Wolf patron

On your turn, when you score a critical hit with an attack roll or reduce a creature to 0 hit points, you can cast any cantrip that targets an enemy creature as a bonus action.

Once you use this invocation, you can't do so again until you finish a short or long rest.

Scorched Blade

Prerequisite: Ashen Wolf patron, Pact of the Blade feature

You can create a wickedly barbed one-handed or versatile melee weapon made from embers and molten steel using your Pact of the Blade feature. You can choose to have this weapon deal fire damage. You can use your Charisma modifier for attack and damage rolls made with this weapon.

Whenever a creature within your reach takes damage directly due to hitting you with an attack, such as from the effect of the *fire shield* spell, you can use your reaction to make an opportunity attack against your attacker using this weapon. If the spell or feature that would deal damage to the attacker requires a reaction, such as the Hide of Cinders invocation, you can make the opportunity attack as part of the same reaction.

Once you do so, you can't do so again until you finish a short or long rest.

Through Fire and Flame

Prerequisite: 13th level, Ashen Wolf patron

Whenever you would take fire damage or are exposed to damaging flame, you can use your reaction to absorb the elemental fire as an offering to the Ashen Wolf. The damage is negated, and instead you gain temporary hit points equal to the amount of damage you would have taken before resistances and immunities.

The amount of temporary hit points received at one time cannot exceed three times your Charisma modifier.

You can use this invocation twice. You regain all uses of this invocation when you finish a short or long rest.

The Festival of the Wolf

In some cultures and locations, the Ashen Wolf is celebrated either before or after a successful hunt. Some believe that by praising and honoring the beast, its servants can be kept from preying upon the inhabitants of the region. Others think that the rites performed are to summon the beast, inviting it to carry off rivals and undesirables.

Regardless of the intention, the rituals performed often carry a common theme. Offerings of food and metal, especially raw meat and rusted steel, are cast into a pyre located on the edge of the city or settlement. Once the fire has risen sufficiently and the meat is fully burned, a sacrificial animal is brought before the pyre, faced toward the wilderness, and coated in tar and oil. The celebrants then fan the flames of the pyre toward the beast until the embers on the wind cause the creature's coating to ignite. The rope securing the creature is cut, and it runs off into the wild, burning brightly. Huntsmen and soldiers will chase the beast into the night, seeking to wound it but not to kill it, as killing it may offend the Wolf. Instead, it is pursued until it escapes, where it is believed to be eaten whole by the Ashen Wolf.

Once the animal has fled into the wilderness to be consumed by the flame, the supplicants feast on raw meats prepared in a special ritual in an attempt to claim themselves as members of the Ashen Wolf's favored pack. Those who are stricken by illness from this practice are said to be imposters and are subject to much scorn and disrespect until an offering of meat and metal is presented and burned upon the ground where the pyre was made using only the remaining embers from the fire.

If the pyre has grown cold and cannot be restarted, then only an offering of one's own blood is considered sufficient. Those that reach this desperate stage and fail to make the appropriate offering are often never seen again.

Traits of the Ashen

Warlocks who have made a pact with the Ashen Wolf are often known simply as ashen. Consider adding one or more of these traits when creating a warlock or after performing an action that would please the Wolf.

d20	Trait
1	You tend to pace in circles before sitting.
2	You eat your meat raw or badly burned.
3	You habitually start fires using damp or wet wood.
4	You have a strange hostility to cats.
5	Your voice is scratchy, yet oddly deep.
6	You prefer to sleep on the ground rather than a bed.
7	You talk to fire, and sometimes, it answers.
8	You compulsively scratch your fingers on wood.
9	You never knock before entering.
10	You always sit closest to the fire.
11	A thin layer of ash constantly flakes off your skin.
12	Your eyes glow like hot coals.
13	Your fingernails become dark and claw-like.
14	Your teeth become eerily large and sharp.
15	Your legs become jointed like those of a wolf.
16	Your breath often comes out as a cloud of smoke.
17	Your hair becomes thick and coarse.
18	Food you eat always tastes like ash.
19	Sparks appear when your skin is rubbed.
20	Smoke slowly swirls around your head and limbs.

SORCEROUS ORIGIN: ASHEN LINEAGE

Somewhere in your bloodline, one of your ancestors made a pact with a powerful spirit of flame and predation known as the Ashen Wolf. This elemental creature is neither fiend nor fey, but something primal and otherworldly. It is honored with ritualistic immolation and sacrifices of meat and metal. While the Wolf may have no hold over you, it may be interested in your affairs nevertheless, and your very existence could draw the ire of the Wolf's eternal foe: the frost-bound Wild Huntsman. With smoke and cinders pouring from your hands with each spell you cast and a layer of ash gradually creeping over your body, you are the incarnation of a smoldering ember thrown upon a dry forest.

Let your power burn forth like wildfire.

ORIGIN SPELLS

When you choose this sorcerous origin, you gain access to the following spells, which do not count against your spells known but can only be cast once you reach the required sorcerer level.

ASHEN LINEAGE ORIGIN SPELLS

Level	Spell Level	Spells
1st	1st	*burning hands*
3rd	2nd	*heat metal*
5th	3rd	*fireball*
7th	4th	*locate creature*
9th	5th	*commune with nature*
11th	6th	*circle of death*

BORN OF EMBER

At 1st level, a thin layer of ash and charred wood begins to coat your skin as you fight, engulfing you, yet allowing you to blaze back to life with a vengeance. Whenever you are below your hit point maximum, charred claws and fangs erupt from your hands and mouth. While you have these claws, you can use your bonus action to make a melee spell attack that deals fire damage equal to 1d8 + your Charisma modifier. At 11th level, the damage increases to 2d8 + your Charisma modifier.

The first time after a long rest when you are below half your hit point maximum, the ash that coats your body infuses your soul, granting you gain resistance to fire damage. This lasts until you finish a long rest. At 14th level, you gain immunity instead of resistance.

Additionally, you can speak, read, and write Primordial, the language of elementals, and you learn the *produce flame* cantrip.

BURNING FURY

Starting at 6th level, the fire within you begins to call directly to the Ashen Wolf, and it grants you strength, either in honor of your ancestor or in a twisted form of revenge. When you reduce a creature to 0 hit points with an attack granted by your Born of Ember class feature, the burning fury empowering your attack surges through the creature, turning its vital organs to ash and granting you temporary hit points equal to twice your Charisma modifier.

Additionally, you can spend 1 sorcery point during your turn when you are below half your hit point maximum to cause the ash upon your skin to harden. Until the start of your next turn, your AC is 17. This has no effect if your AC is equal to or greater than 17.

CINDERWRAITH

At 14th level, your spark has grown to a flame, burning black with dark power. Any time you would inflict fire damage, you can choose to inflict necrotic damage instead, and vice versa.

Additionally, your ashen form allows you to move with unnatural ease, disintegrating and reforming with each step you take. You ignore difficult terrain, and you can move through any space at least 6 inches wide without squeezing.

THE WOLF'S BARGAIN

At 18th level, your strength has grown to surpass that of your ancestor, and your power over the ancient and primal magics of flame and ash is without peer.

As an action, you can spend 5 sorcery points to launch yourself skyward in a pillar of fire and smoke before crashing down at a location that you can see within 60 feet of your point of origin, unleashing a hellish blast of fire and cursed power at a creature within 5 feet of you. The target must make a Wisdom saving throw against your sorcerer spell save DC. The target takes 6d10 fire damage on a failed save, or half as much damage on a successful one.

If the target is slain by this attack, it is consumed instantly by flame, and the ashes coalesce into a hell hound. Hell hounds summoned by this feature are elementals instead of fiends. The hell hound obeys your orders without question and acts during your turn. You can't have more than two hell hounds at a time from this feature. Creation of a third hell hound destroys the oldest one still alive. Each hell hound remains in your service until slain or until the third dawn after it was summoned, at which point it disintegrates.

Once you use this feature, you can't do so again until you finish a long rest.

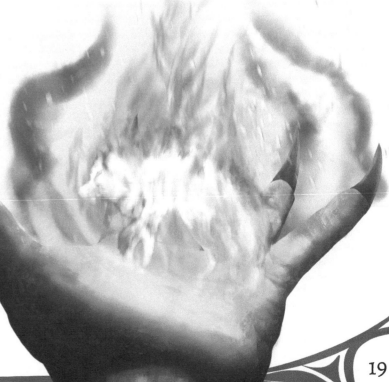

IGNITE THE ASHEN WOLF

The Ashen Wolf is a creature of elemental fire, but it can become so much more. This section focuses on providing you ideas about how to make the Ashen Wolf a powerful, deep, and interesting character in your campaign by offering optional modifications, examples of individuals who would be willing to make pacts with the Wolf, artifacts that are relevant to this powerful creature, locations that could be used when dealing with this beast, and possible behaviors it may have when interacting with the party and with other mortal characters.

BURN TO PERFECTION

The Ashen Wolf is presented as gender-neutral, so an effective way to shape how the party may see it is to assign a gender to this elemental force. A male Ashen Wolf could be presented as a singular force, filled with pride and dominant cruelty, and could be used to provide an adversarial relationship to the party without changing a single personality trait. A female Ashen Wolf could be used to display a cruelty born of hunger and malice as well, but the expectation between a vicious she-wolf and a howling male can be different enough in the minds of your players to provide a simple yet distinctive opportunity to customize the Wolf to suit your roleplaying abilities and personal tastes.

FURY IN THE FLAME

A second parameter to decide when including the Ashen Wolf in your game is the level of power that it possesses, especially in relation to other elemental and celestial forces. Is the Ashen Wolf relatively weak or incredibly powerful? A weaker Ashen Wolf would possess a small territory and would be more akin to an elemental that is awaiting a time to awaken to its full power and potential. A stronger Ashen Wolf could be a god in its own right, the true essence of fire upon the Material Plane, or one of the ancient primordials that has taken form as an apex predator. When making the Ashen Wolf more powerful, it may be entertaining to tie it to the divine powers in some way, as the estranged pet of a fire god or a demon that has been summoned to the earth.

THE NATURE OF THE BEAST

A third thing to decide is the actual nature of the Ashen Wolf. Is it an elemental, a fiend, a dark angel, a twisted fey, or some other strange and exotic entity that cannot be classified so easily? How do other beings in this category view the Ashen Wolf, and how do they respond to the activities of its warlocks? Are they hostile to the Wolf, seeking to destroy it, or do they see it as a begrudging ally in their fight against other forces? Does it have allies, or is it alone? What enemies does it have, and what forces do they array against the Wolf and those associated with it? Why are they hostile, and what goals do they have? All of these questions are essential to creating a complete picture of the inevitable conflict.

BEYOND THE WOLF

The Ashen Wolf is a relatively simple concept and has a singular core theme: fire. The secondary themes associated with the Ashen Wolf are hunting, smoke, hunger, cruelty, wishes gone awry, dark bargains, loyalty, wolves, and hatred. In order to adjust the Ashen Wolf to fit your game, consider

changing one or more of these secondary themes to better complete your personal vision of the Ashen Wolf. For example, changing the Ashen Wolf from a cruel and hate-filled monster to a kind and benevolent spirit has a strong impact on how the world would interact with it, especially your players. A benevolent Ashen Wolf could focus on the positive or neutral aspects of fire, such as warmth, cleansing, purity, cauterization, valiant passion, and radiant power. A warlock devoted to a benevolent Ashen Wolf would learn to exhale sweet incense into the eyes of their foes, mark their enemies for purification, continue on in the face of overwhelming obstacles, and call upon their patron's pack-mates for assistance in the most deadly of conflicts. Instances of necrotic damage inflicted by a benevolent Ashen Wolf warlock or sorcerer could possibly be replaced by radiant damage, symbolizing the purity of the power flowing through their spellcasting.

Another option is to replace the lupine aspects of the Ashen Wolf with more human ones, changing it from a fearsome beast to a loathsome pyromancer of incredible power and renown. If you decide to take this path, consider changing the lair of this individual to suit their more humanoid status, and implement buildings or other man-made constructions in your design.

DARKER DEALS

The Ashen Wolf is known for making bargains without a positive outcome for those that come to call, inflicting terrible curses that gradually twist the form of the recipient into an ashenspawn – one of the many Alfallen races of individuals who have been touched by the magic of the Alrisen. This is not the only price that the Wolf will ask, but it is by far the most common as it delights in the suffering, pain, and gradual acceptance of the changed soul, though that acceptance rarely survives an encounter with former friends and family.

Individuals willing to call upon the Ashen Wolf usually have very little to lose and everything to gain. Outcasts, orphans, and those left for dead are often among the ranks of its warlocks, though mercenaries, assassins, and other individuals who care more for violence and wealth by any means than a comfortable life are also drawn to the twisted power of the Wolf. Not all who go to it are this dark in tone, however. Nobility and champions of great fame are also known to call upon the Wolf, provided the right motivation, sacrificing whatever they hold dear into the fires of an offering pyre in an attempt to gain its favor. Those who succeed have entertained it with their obeisance, though they are rarely fortunate enough to escape entirely unscathed. Most of these individuals have eyes that shine gold or red in the firelight, marking their nature as pact-makers to the Wolf.

A WARLOCK'S TALE

Xandith, a mercenary and formerly human champion of the Ashen Wolf, illustrates clearly how its cursed blessings often work. Though granted powers over ash and flame, his body was still vulnerable to their scalding touch. Whenever he

fell in combat due to his own weakness or foolhardy sense of invulnerability, that scalding ash would spread further, covering more of his body with each successive failure. Eventually, it consumed his form completely, irreversibly transforming into a full ashenspawn. His humanity stripped from him, he began to hunger for precious metals and fine wood, which filled his veins with glowing steel and replaced his teeth with scorched mahogany covered in gold. Many others follow similar paths, gradually being consumed by the fire within them until they are no longer what they once were.

THE WOLF'S LAIR

The Ashen Wolf commonly dwells in places where fire is prevalent or easy to spread, enjoying forests in dry climes or volcanic regions. The area around its lair would be affected similarly to the space occupied by a red dragon or powerful fire elemental, becoming filled with deadly flame, hazy ash, and blistering heat at all hours of the day and night. It prefers natural environments and will take up residence in caves or woodland groves. It tends to avoid rivers and streams when possible, though when it does interact with them, they will usually dry to the bed within a mile of the Wolf's crossing. As an Alrisen, it has the capacity to teleport and burn across the sky as a flaming comet, but it usually prefers to walk like a natural beast when possible.

UNFORTUNATE INVITATION

The Ashen Wolf is typically seen as cruel and capricious, eager to make a deal but only because it knows it holds all the cards. Mortals that are insolent or rude occasionally entertain it but they are often run down and devoured just the same. Those who show the proper respect will have cordial relations with the Wolf, though few who stand within its presence are able to meet its furious and soul searing gaze. Those who grovel and cower before the Wolf are viewed as prey, and it will devour them as though they were the sacrifices deliberately brought before it. The Wolf will demand displays of fearlessness, bravery, and animalistic cunning from those it wishes to have as servants. Sometimes, it's simply looking for entertainment, but other times, it requires a problem solved. From the weak, it will simply demand payment, often with a curse attached. To seal a pact with a mortal, the Wolf will breathe ash and flame upon them until they are burned nearly to death, stopping only at the last moment to see if they are strong enough to survive and be welcomed into its pack.

ITEMS OF POWER

The Ashen Wolf is rarely one for objects, fashioning whatever it may require from wood and metal the moment it is required, but there are many famed blacksmiths and craftsmen who have sworn pacts with the Ashen Wolf or have descended from those who did. Among these objects are the Arcfire Chain, the Scorched Sigil, the Stone of Braxi, and the Armor of Inferno, detailed below:

ARCFIRE CHAIN

weapon (whip), rare (requires attunement)

This whip appears to nothing more than a thick chain covered in gruesome spikes. You can use this whip to cast *hellfire lash** at will, without using a spell slot. Charisma is your spellcasting ability for this spell.

ARMOR OF INFERNO

armor (heavy), very rare (requires attunement)

This armor is covered with ceremonial insignia associated with the Ashen Wolf, and smoke constantly billows from the markings. While wearing this armor, you gain resistance to fire damage. Whenever you take damage while wearing this armor, you can use your reaction to unleash a burst of flame, dealing 2d10 fire damage to all creatures and unattended objects within 5 feet of you.

SCORCHED SIGIL

wondrous item, common

This twisted and bent piece of blackened metal is shaped into a foreboding sigil and is constantly warm to the touch. These sigils are frequently used by Ashenspawn to mark their territory and to brand their greatest warriors and adversaries alike. Whenever it is pressed into a tree, it ignites and adheres fully, becoming permanently affixed. If applied to living flesh, it burns into the skin, dealing 1d10 fire damage and permanently branding the creature as it fuses with their body. The sigil can only be removed from the creature's body by deliberately cutting it out, a process that deals 10 slashing damage to the creature and takes one minute.

STONE OF BRAXI

wondrous item, rare (requires attunement by a warlock with the Pact of the Blade feature)

This blood red ruby has been carved into a finger-sized spike and glows with an otherworldly light. To attune to the ruby, the holder must pierce their dominant hand and force the ruby into their flesh until only the smooth, glittering surface is visible at the base of their palm. While attuned to the ruby, your pact weapon is empowered. Once per turn, you can create your pact weapon without using an action, and your pact weapon gains a +1 bonus to attack rolls and damage rolls. Additionally, you can choose to have it deal fire damage instead of its normal damage type.

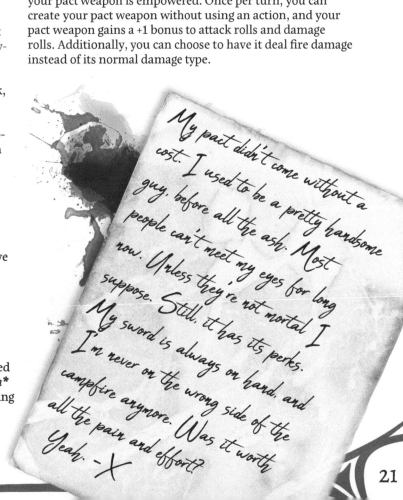

My pact didn't come without a cost. I used to be a pretty handsome guy, before all the ash. Most people can't meet my eyes for long now. Unless they're not mortal I suppose. Still, it has its perks. My sword is always on hand, and I'm never on the wrong side of the campfire anymore. Was it worth all the pain and effort? Yeah. -X

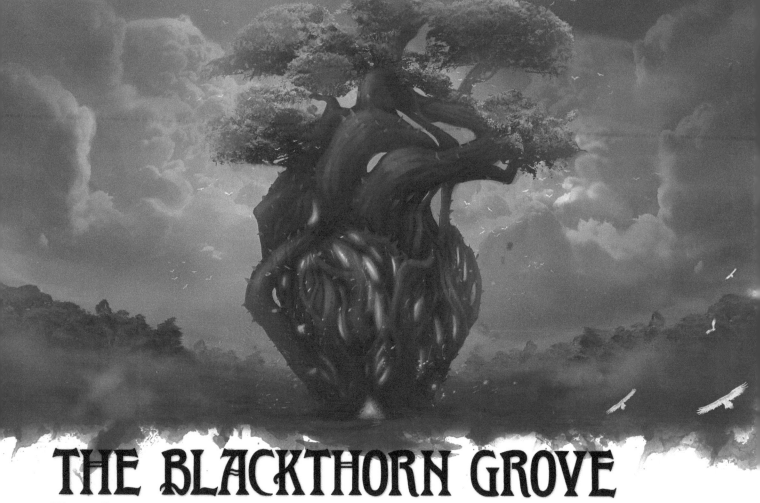

THE BLACKTHORN GROVE

THE JOURNEY OF THE LOST

Nature possesses a beauty that is only rivaled by the works of the finest minds of mortals, yet it is not a beauty born from will and determination, but from single-minded apathy to everything but oneself. Those who wander, departing from society due to misery or tragedy, who enter the untouched wildlands to find themselves will end up somewhere dark and perilous. The Blackthorn Grove is their destination, whether they know it or not.

THE MAZE OF BLOOD

Lost and stranded, yet unafraid and uncaring of the outcome, the wandering souls will find themselves within a maze of bloody brambles and roses blacker than ink. Those who are weakened by their journey often fall here and are feasted upon by the vines that burrow into their corpses. The vines move with deliberate motions, causing dead jaws to open before snapping shut and broken teeth to grind in a symphony of suffering. The ones who close their hearts to the cruelty inflicted upon the dead find themselves called forward, deeper into the maze. They will face obstacles that are insurmountable without sacrifice, their clothing and armor torn to shreds by the thorns of the black roses as they watch the plants feast upon their crimson bounty.

THE FIELDS OF ACEDIA

The few who manage to enter the Maze of Blood and survive to find the exit are greeted by broad fields of flowers, endless in variety and color. Small copses of trees bearing fruits unseen by those in the outside world dot the landscape, and a stream runs through the center filled with pure water. In short, it would seem to be a paradise by comparison to those who suffered such a harrowing journey. However, this place is far more dangerous than the Maze, for it does not harvest the body, but the mind. Those who enter this place and feast upon the fruits and drink of the water find that the wounds they suffered within the Maze of Blood shall not heal. Instead, they continue to slowly drip that precious crimson ichor upon the roots of the flowers and trees, the blood loss numbing the pain of the journey. Those who partake do not care, however, as their minds are filled with the pleasures of their meal. In the center of the field, the Blackthorn Grove awaits.

THE HEART OF REBIRTH

The wanderers who care not for the false temptations of the Fields while seeking the true purpose of this otherworldly place inevitably find themselves standing before the entrance to the Blackthorn Grove. Within, they are consumed by the disdain they feel for both themselves and the world, and shall use the thorns as claws to tear their own hearts from their chests, offering them as tribute to the single flower within. In response, it shall burrow into the gap where their heart once was, filling them with purpose – to grow, to fight, to live, and to see the world with eyes unclouded by hate. Reborn, they revel in the emotions abandoned within the Maze and Fields, now seeking the joy of life. However, the blackthorn heart rooted in their chest thirsts for blood, and they will be instinctively drawn to violent conflict and suffer a heightened lust for power. It is the nature of a grove to seek to spread and grow, after all, and only the most powerful can provide fertile soil for the seed of the Blackthorn Grove.

OTHERWORLDLY PATRON: THE BLACKTHORN GROVE

You've torn out your heart as an offering to the Blackthorn Grove after braving the Maze of Blood and resisting the temptations of the Fields of Acedia. In place of your heart, a pulsing, beating, writhing mass of thorns has grown and made you whole. The lifeblood of the world itself runs through your veins, granting you power and passion alike to fulfill your purpose, whatever that may be. The trials and suffering of your past beckon you to make amends or take your revenge, but the feeling of grass under your feet and the sunlight upon your face is enough to help you understand the worth of life. Wander alone no longer, for even in death the Grove shall grant you a home.

EXPANDED SPELL LIST

The Blackthorn Grove lets you choose from an expanded list of spells when you learn a warlock spell. The following spells are added to the warlock spell list for you.

BLACKTHORN GROVE EXPANDED SPELLS

Spell Level	Spells
1st	entangle, hunter's pace*
2nd	heartripper*, replenish*
3rd	plant growth, skewering vines*
4th	bloodthorn*, cage of briars*
5th	overwhelming emotion*, tree stride

BLACKTHORN HEART

At 1st level, you have torn out your heart and replaced it with something otherworldly, granting you the will to survive. You ignore nonmagical difficult terrain. Whenever you fail a death saving throw, your Blackthorn heart bursts from your chest and lashes out with life-stealing briars toward the nearest hostile creature. Make a melee spell attack against an enemy within 15 feet of you. On a hit, the creature takes magical piercing damage equal to your warlock level, and you regain hit points equal to the damage dealt.

After you recover hit points using this feature, you cannot make this attack again until you finish a short or long rest.

APATHY IS DEATH

At 6th level, you can use your reaction to surge with purpose and haste whenever you make an Intelligence, Wisdom, or Charisma saving throw. You gain advantage on the saving throw, can move up to half your speed, and can make a single weapon attack before the result of the roll is revealed.

Once you use this feature, you can't do so again until you finish a short or long rest.

ARBOREAL GUARDIAN

At 10th level, your purpose is not merely to exist, but to safeguard life. Whenever a creature within 5 feet of you would take damage, you can choose to redirect half of the damage to you by shielding them with vines from your Blackthorn heart. Only the original target suffers any additional effects of the damage. If this damage reduces you to 0 hit points, you gain advantage on the first attack made by your Blackthorn Heart feature.

SEEDS OF DESTRUCTION

At 14th level, you realize the reason you have been blessed with this power and purpose: to spread the Blackthorn Grove. As an action, or whenever you are reduced to 0 hit points and you fail to recover hit points using your Blackthorn Heart feature, you can choose to have the beginnings of a new Maze of Blood appear around you. The area within a 30-foot radius of you becomes difficult terrain as blood-hungry vines emerge from the assembled briars to drink their fill. A creature within the radius at the start of its turn must make a Constitution saving throw against your warlock spell save DC. A target takes 4d6 magical slashing damage on a failed save, or half as much damage on a successful one. Allies make this saving throw with advantage. If summoned as an action, it lasts until the start of your next turn. If summoned when you are at 0 hit points, it lasts until you recover 1 hit point, or becomes permanent if you die.

The Maze can be summoned once as an action, and this use recovers whenever you finish a long rest. The Maze can also be summoned once when you are at 0 hit points, and this use recovers whenever you finish a long rest.

ELDRITCH INVOCATIONS

AWAKENED BLADE
Prerequisite: Blackthorn Grove patron. Pact of the Blade feature

You can choose to create a weapon from polished black wood and wicked spines using your Pact of the Blade feature. While you maintain concentration on a spell cast using a warlock spell slot while wielding this weapon, dense foliage covers your skin, causing your AC to equal 17 if it would normally be lower.

BOOK OF THE BLACKTHORN
Prerequisite: Blackthorn Grove patron, Pact of the Tome

During a short or long rest, you can choose to create an effigy from plant material, weaving and shaping it into a heart. Over the course of one minute, you can choose to replace the heart of a dead creature with this effigy, causing it to rise as a zombie with 1 hit point. The zombie will unerringly seek a path towards a destination you name at the time of this ritual. It will ignore any creatures it encounters and will not pause or stop unless it is destroyed. Once the zombie reaches its destination, it will fall to the ground and a sapling will sprout from the corpse. If you create a new effigy, the previous one ceases to function, and the zombie crumbles to the ground, a lifeless corpse once more.

NIGHTSHADE'S EMBRACE
Prerequisite: 7th level, Blackthorn Grove patron

Whenever you deal damage with a cantrip or weapon attack, you can use your bonus action to attempt to overwhelm one target with a deadly poison. The next time the target takes bludgeoning, piercing, or slashing damage before the start of your next turn, they must they must succeed on a Constitution saving throw against your warlock spell save DC or become poisoned until the end of your next turn. While they are poisoned, they are also blinded.

UNITED SURVIVAL
Prerequisite: Blackthorn Grove patron, Pact of the Chain

If you have a bloodless wanderer as your familiar, it gains additional hit points equal to your warlock level.

As an action, you can touch a creature and transfer some of your life force to it. Sacrifice a number of hit points up to your warlock level. The target regains a number of hit points equal to the amount you sacrificed.

Traits of the Thornhearted

Warlocks who draw power from the Blackthorn Grove are called thornhearted and are often secretive about their origins, instead preferring to converse about more pressing matters. Their secrecy is often born of necessity, as most have enemies that would love to see them dead. Consider adding one or more of these traits when creating a warlock or after drawing heavily from the power of the Grove.

d20	Trait
1	You smile and laugh without reservation.
2	You sleep on bare earth when outdoors.
3	You weep openly whenever you feel despair.
4	You eat raw meat whenever you get the chance.
5	You move constantly, even when still.
6	You refuse to surrender without a fight.
7	You dislike cities and urban areas.
8	People often wonder about the nature of your powers.
9	You make inspiring speeches with surprising frequency.
10	You break into song on beautiful days.
11	Your flesh seems to ripple under your skin.
12	Your irises become blood red with green streaks.
13	You seem to fit in perfectly to natural environments.
14	Your facial features become accentuated by small plant-like growths that cover your cheekbones or brow.
15	Your limbs become long and branch-like.
16	Your teeth look like wicked thorns.
17	Your hair becomes long strands of grass and leaves.
18	Wooden horns emerge from your forehead.
19	Your fingernails become sharp and barbed.
20	Whenever you cast a spell, your Blackthorn heart pulses with crimson energy.

Sorcerous Origin: Blackthorn Lineage

Somewhere in your lineage, an ancestor entered and made a pact with the Blackthorn Grove, replacing their heart with one crafted from the essence of the Grove itself. Working with plants has always come naturally to you, but one day your magical power awakened. In defense of your life or in pursuit of your heart's deepest desires, the strange arcana of the Blackthorn Grove sprouted within your veins, giving you power to use as you see fit.

Origin Spells

When you choose this sorcerous origin, you gain access to the following spells, which do not count against your spells known but can only be cast once you reach the required sorcerer level.

Blackthorn Lineage Origin Spells

Level	Spell Level	Spells
1st	1st	entangle
3rd	2nd	replenish*
5th	3rd	plant growth
7th	4th	hallucinatory terrain
9th	5th	commune with nature
11th	6th	transport via plants

Blood of the Dark Forest

When you select this origin at 1st level, your spirit aligns to the power of the Grove, calling to the cycles of regrowth. You learn the *druidcraft* cantrip. When your Spellcasting feature lets you learn or replace a sorcerer cantrip or a sorcerer spell of 1st level or higher, you can choose the new spell from the druid spell list or the sorcerer spell list. You must otherwise obey all the restrictions for selecting the spell, and it becomes a sorcerer spell for you.

Sleeper in the Field

Also at 1st level, whenever you cast a spell using a spell slot of 1st level or higher, you can choose a creature that you can see within 30 feet of you. Roll 1d10 for each level of the spell slot you expended. If the total is equal to or greater than the creature's remaining hit point total, it falls asleep as though affected by the *sleep* spell.

Glade Reaper

At 6th level, your connection to the Grove imbues you with a thirst for blood and the power to claim it. When you cast a spell on the druid spell list that deals damage by expending a spell slot, you can spend sorcery points equal to half the spell's level to gain temporary hit points equal to half the damage dealt to one creature damaged by the spell.

Watcher in the Maze

At 14th level, you attune yourself to the Maze of Blood. You ignore difficult terrain. You can ignore magical and nonmagical effects that would cause plants to hinder or damage you, such as from the effect of the *entangle* spell. Whenever you use your Sleeper in the Field feature and the target's hit points are greater than the number rolled, you can use your bonus action to deal magical piercing damage equal to half the number rolled to the target.

Heart of the Wilderness

At 18th level, while you maintain concentration on a spell, you can have blackthorn vines swarm around you in a 30-foot radius, acting as difficult terrain for hostile creatures.

THE HEART OF THORNS

The Blackthorn Grove represents a dark journey that one embarks upon voluntarily and one that would always end in tragedy if not for the eldritch power contained within. However, the Grove does not always need to be defined in this way. This section is dedicated to provoking the questions you'll need to answer in order to make the Blackthorn Grove your own, provides information on individuals who would have made pacts with the Grove, and describes practices surrounding the Grove and its keepers.

OPENING THE HEART

One of the first things to consider when including the Blackthorn Grove in your world is its location. Is the Grove located on the Material Plane? Does it move around in any way, or is it static? Is it located in a demiplane of some kind, made especially for it? Does it reside among the courts of the fey, or is it a beacon of natural disorder somewhere in the outer planes?

Once you've decided upon a location for the Grove, consider how someone would manage to visit it. Are they shown the path by other beings, or would they be able to find it themselves? Is it guarded by otherworldly forces or by mortals? Are there other obstacles that one would face on the journey to the Grove, and how would an ordinary person in a dark state of mind manage to overcome these obstacles in order to reach the Grove? Is it even possible, or can only trained warriors and mages reach the Blackthorn Grove?

Once you've placed obstacles in the way, decide what the return journey looks like. Do they leave the same way they entered, or is there another route? What lands lie in that direction, and why would a person now filled with personal purpose decide to visit them? Would they go home instead? What would they do when they arrived? If you can answer these questions, you'll have a good idea about how the Grove can fit with your character or world.

A FRAGMENT OF NATURE

When implementing the Grove in your world, it would be useful to decide how powerful it is in relation to the other forces that preside over the landscape. Is it a living embodiment of all natural things, or is it merely a parasitic organism clawing forth from the dirt in a desperate bid to grow and survive?

Honestly I have a lot of respect for these folks; you can't argue with that kind of commitment. I don't think it's for me though. My heart is already on fire. —X

If the Grove is powerful, consider emphasizing the knowledge others in the world may have about it and connecting it to deities or other higher powers. Is it the heart of an ancient fey or the soul of a woodland spirit? How was it created, and where did it come from? What magic could be used to make something like this, and why was it employed? What kind of price would one have to pay to create such a powerful and bloodthirsty force, and why would they have been willing to do so? Answering these questions will help determine how powerful the Grove is in your cosmology, and what the end result of its desire to spread will be.

THORNS AND LEAVES

Another option to consider when including the Grove in your world is changing the nature of the entity from an unfeeling plant to a sentient being. What does this creature look like? Is it humanoid, bestial, or something more outlandish? How does it speak, and what does its voice sound like? How does it behave? Is it calm and benevolent, brash and wild, or quiet and scheming? Why would it be willing to accept the heart of a mortal creature, and why would it offer a new one in return? What does it do with the hearts it collects? Does it eat them, store them, or place them into new bodies, to be reborn anew? Why would it do this, and how would other forces and individuals of power respond to this creature's behavior?

A BRINGER OF DEATH

One of the stories told of the Blackthorn Grove is of a dwarf, surprisingly enough. Broken and battered after seeing her clan slaughtered before her very eyes, Fjola staggered into the wilderness with the wretched look of a broken woman. For days she wandered, living out the horrors of her past, night after night, screaming in anguish and torment.

Uncaring where her wanderings took her, she stumbled into the Maze of Blood. The dead spoke to her, cracking their jaws in the grasp of the vines, but she ignored them, for she knew they were not her kin. The bloody thorns tore at her flesh and ruined her once-fine robes, but she pressed on, unwilling to lie down and die.

She stumbled into the Fields of Acedia, but the beauty of the place had no hold upon her, for her heart was cold and empty. She continued, eyes blank and face slack, till she stood before the massive trees that lie at the center of the Blackthorn Grove, uncaring that they pulsed silently like a beating heart. She entered the space within, and witnessed with unseeing eyes the bloody light that shone from within bark of the trees.

There she felt the final urge, the dark compulsion that is inescapable, and reached for the thorns. Unfeeling as they cut at her flesh and ruined her hands, she fashioned a gauntlet from the razor-sharp vines and plunged this terrible tool into her chest, shattering bone as the living vines dove in and extracted her heart.

Supported only by the foul foliage, she raised her arm, and her still-beating heart spoke aloud, swearing vengeance upon those that had wronged her. The Grove responded, barbed vines coiling in her chest, crafting a new heart as it consumed her old one. With new purpose she grinned as she brought herself to her feet, her teeth now sharpened thorns and her eyes glowing red – Fjola the Bloodstained had been reborn.

Within a week, the orcish raiders were slain. Within a month, their tribe was found massacred. Within a year, not a single one was left within the dwarven lands. All were found twisted and broken, with nothing but a vacant cavity where their hearts once beat.

SOURCE OF THE APATHY

Individuals who journey to the Blackthorn Grove are drawn there instinctively, but in order to hear that subtle calling within their soul, they must first be emptied of both emotion and hope. When creating an individual touched by the Grove, decide how they succumbed to this, or roll on the table below.

d6	Source
1	You were born uncaring and unfeeling, though you concealed this fact for the entirety of your childhood.
2	You were mistreated and harmed by one or more people who were close to you, and you lost the ability to trust or care about your future.
3	You were cursed by a malignant entity, such as a witch or genie, and lost the ability to enjoy the pleasures of life.
4	You failed at a task of monumental importance, such as protecting a loved one when they needed you most.
5	You lost everything to misfortune and suffered incredible adversity you could not overcome.
6	You were a warrior, and are the sole survivor of a horrible battle that claimed the lives of your comrades. The loss broke your spirit.

JOURNEY TO THE GROVE

A lone wanderer traveling to the Blackthorn Grove may face many perilous obstacles on their grim trek. Consult the following table for potential hazards on the journey, and consider how your character would overcome them.

d10	Hazard
1	The exterior of the Grove is guarded by an ancient and powerful monster, such as a dragon, giant, demon, or celestial. It may pose riddles or attempt to dissuade a wanderer by force if they are detected.
2	Bandits plague the area around the Grove, seeking to strip apathetic travelers of their few remaining possessions.
3	A coven of hags lurks near the Grove, disguised as beautiful women. They try to tempt travelers from their path so they can boil them for stew.
4	The Grove is deliberately concealed by a curse or spell designed to confuse the senses and baffle the mind.
5	The Grove is considered to be the sacred heart of an eternal forest by a circle of druids who refuse to allow travelers near it under any circumstances.
6	The Grove is located in the middle of a harsh desert and is an oasis of sorts with a deadly price.
7	The Grove is located at the peak of a mountain and can only be reached by one willing to die. Despite the cold, it is warm and verdant within.
8	The Grove is located at the heart of a dormant volcano, and the only entrance is through the caldera.
9	The Grove is located in a royal conservatory and is carefully guarded by the local monarchy to prevent a rebellion using this power.
10	The Grove is not even a real place, but is instead a spiritual journey that plays out in one's dreams. The exchanged heart, however, remains even after waking.

AWAKENED MOTIVES

Once a person has made a pact with the Blackthorn Grove and exchanged their heart, they are inspired with new purpose and vigor. Some may simply desire to achieve goals they thought impossible, while others are inspired by their renewed passion for life. Choose a new goal for the character, or roll on the table below.

d8	Source
1	You want revenge for the injustice done to you and will not allow anything to stand in your way.
2	The people who are responsible for your suffering must not be allowed to hurt anyone else, and you're the one to make sure of that.
3	Society is damaged, hurtful, and irresponsible. You're going to be the one to make things right.
4	There are forces in the world beyond the knowledge of mortals, and they must be opposed.
5	The Blackthorn Grove relies upon new hearts to grow in power. You're going to make sure it gets them, one way or another.
6	You've listened to nature itself, and it cries out for you to protect it from the assault of civilization.
7	Your new heart demands to be taken to new lands, far from the Grove, and you crave the adventure.
8	You want to explore the full extent of your new power and change the world to suit your whims.

REPUTATION OF THE BLACKTHORN

The Blackthorn Grove is known for being a place of both death and renewal, and it is often referenced in myths and legends. One of the more popular myths calls it the dark heart of a fallen god, bursting forth from the ground in an attempt to recover its worshipers and regain its power.

Individuals who have journeyed from the Grove rarely return to it, instead establishing new sanctuaries within the wilderness and devoting them to the forces beyond civilization. They are viewed with both suspicion and joy, depending on how those that have come before them have acted. In cultures where known thornhearted have returned to wreak havoc and exact bloody revenge upon those who have wronged them, most are branded criminals upon sight for fear of the retaliation they will bring.

However, in some places, they are seen as harbingers of justice and avengers of the wronged, seeking to destroy only the cruel and merciless. In these places, they are known for forming bands of vigilantes to topple tyrants, slay powerful beasts, and bring order to the chaos of life.

A Cycle of Death

When a thornhearted kills someone who has wronged them with using the unnatural magic of the Blackthorn Grove, they will often extract the heart from their foe and offer it to the Grove in a sacrificial ritual, planting the heart in the earth so that it may grow into a new Maze of Blood.

Maturation takes years, however, and rarely succeeds. When it does, the plant appears as a small rosebush and is rarely noticed, attracting attention only by botanists curious why the crimson petals are streaked with black. If the plant is ignored, it will wither and die within the year without adverse effect.

If the plant is deliberately fed the fresh blood of a sentient creature, then it will slowly mature, the petals completely blackening and the thorns growing longer, sharper, and more insistent. If there is enough space for it to grow, it will spread linearly, encircling the landscape until its ends meet. Once the ring has formed, a thick, unnatural fog flows into the center, gradually choking the life from all the plants and animals caught within. Those that try to flee become food for the increasingly aggressive vines of this new Maze of Blood.

Over time, the landscape within will change from a barren, open waste into the lush Fields of Acedia, full of fruited trees and delicate flowers that ensnare travelers in a peaceful haze. Once the conversion is complete, a new Blackthorn Grove will burst forth from the soil, a verdant replica of the original heart that gave it life and a chilling reminder of the cost that was paid in blood.

Blades of the Blackthorn Grove

Numerous scholars, druids, and sages of all stripes have attempted to study the Blackthorn Grove and to create weapons, armor, and artifacts from the innately magical foliage within. Over time, the collected eldritch energies led to the creation of several magical objects, three of which are known as the infamous Blades of the Blackthorn.

The Regretful Thorn
weapon (dagger), very rare (requires attunement)

This dagger is crafted from dozens of blackened thorns surrounded by crimson fog floating together in the shape of a blade. The handle is covered in these same thorns, and they pierce the hand of whomever dares hold this grim weapon.

You gain a +2 bonus to attack rolls and damage rolls. On a hit, you can choose to unleash the thorns within the blade. The target takes 3d10 piercing damage, and you take piercing damage equal to half the damage dealt.

The Spiteful Skewer
weapon (pike), very rare (requires attunement)

This slender barbed pike appears to be made from countless vines wrapped and shaped into a singular core and is capped at each end with thin, needle-like leaves.

You gain a +2 bonus to attack rolls and damage rolls. As a bonus action, you can transform this weapon into a longbow or a pike by speaking the command word. As part of an attack, if the bow is drawn without an arrow nocked, one of the vines will harden into a blackened arrow. On a hit in either form, you can use your bonus action to skewer the target. The target must succeed on a DC 15 Constitution saving throw or take 1d12 piercing damage and become restrained by dark vines until the start of their next turn. A creature within 5 feet of the restrained target can remove these vines using an action. While you have a creature skewered, you can't attack with this weapon. You can use a bonus action to cause the vines to retract, freeing the creature.

The Blood Thief
weapon (greatsword), very rare (requires attunement)

The iron of this massive greatsword is uniquely shaped, as though it were forged by intent rather than heat and pressure, and the hilt is crafted out of dark wood from the heart of the Blackthorn Grove. This blade hungers for the iron contained within blood. On a hit, the target takes an extra 2d6 necrotic damage as the blade extracts the precious metal, slowly adding length and breadth to the ever-growing blade.

As an action, you can impale a corpse with this blade to extract the blood that remains. You gain 10 temporary hit points that last 1 hour. Once a corpse has been drained by this weapon, it can't be used again in this manner.

Armor of the Heartless Knight
armor (plate), legendary (requires attunement)

This armor appears to be made from thick brambles carefully shaped into an armored carapace. The helm that accompanies it is sleek, form-fitting, and must be worn to unlock the full potential of the armor. While wearing this armor, you gain temporary hit points equal to your character level at the start of each of your turns. If you would be reduced to 0 hit points, you can use your reaction be to reduced to 1 hit point instead and gain temporary hit points equal to your hit point maximum. Once this property is used, it can't be used again until you have slain a humanoid in cold blood.

The Blackthorn Guardian

If all three Blades of the Blackthorn are gathered, a ritual can be performed to combine the blades into the Final Revenge. To perform this ritual, you must be attuned to and wearing the Armor of the Heartless Knight and spend one day in unbroken meditation with the three blades. Once this ritual has been completed, the only way to separate the Blades of the Blackthorn is to stab the Final Revenge into the heart of the Blackthorn Grove. Some suspect that this may be one of the only ways to truly harm the eldritch plant, but no living mortal knows for certain.

The Final Revenge
weapon (longsword), legendary (requires attunement)

This longsword has a blade comprised of fragments of iron and blackened thorns floating in a red mist. The handle is made of twisting vines that dig into the flesh of whomever wields this weapon, harming and healing simultaneously.

You gain a +3 bonus to attack rolls and damage rolls. While you are attuned to this weapon and holding it, you have proficiency with it, and you take necrotic damage equal to your character level at the end of each of your turns as it drains your blood.

On a hit, deadly thorns and sharp metal barbs dig into the target's flesh dealing piercing damage equal to your character level instead of its normal damage. If you score a critical hit, this damage is doubled. If a creature is slain by this attack, you can choose to have the thorns impaling them explode outward. All creatures other than you and unattended objects within 10 feet of the target take 4d10 piercing damage, and you regain hit points equal to your character level.

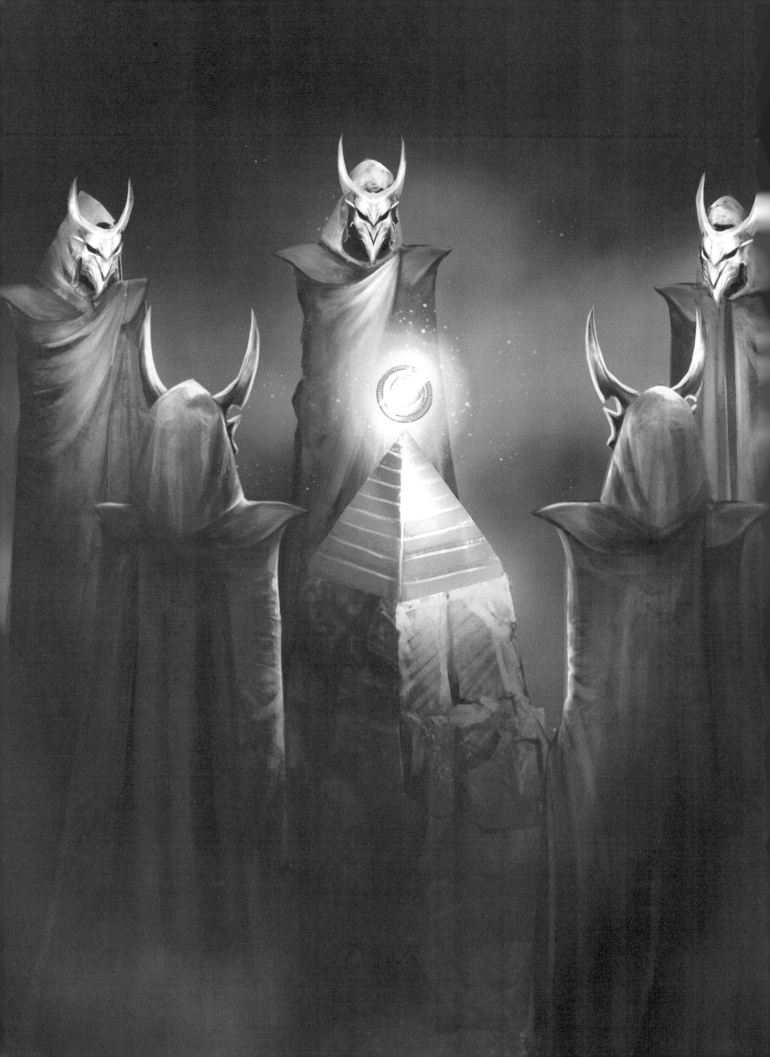

THE CURRENCY CONSPIRACY

THE FINAL TRANSACTORS

In all but the most barbaric places, there is currency. A coin, a bill, a gem, a shard of glass, a shell, a letter of credit – the form matters little, but the power that these simple objects possess matters greatly.

The Currency Conspiracy is the name often assigned to the hidden actors who work to spread these currencies far and wide throughout all corners of the endless planes, until the final coin rests within the last open hand. Upon that day, they shall awaken to consume the world.

THE WEIGHT OF A LIFE

The eldest and most influential among the conspirators are referenced in hushed whispers as the Cabal, and it is their duty to imbue the currencies of the worlds with fragments of the greatest souls stolen, bargained for, taken, and recovered by the Conspiracy. First, they weigh the value of the soul, seeking to judge its level of Gilt. Those who touched the lives of others in powerful ways and shaped the course of history possess much of this power, while those who did nothing of significance are viewed as worthless. Once the judgment is complete, the soul is torn apart and reforged into creatures known as "karensee" or wealth mimics in the common tongue.

A FORGOTTEN AGREEMENT

Those who have power and influence are often those most approached by the Conspiracy, both for their ability to further its inscrutable ends and for the potential end value of their soul. However, the famed and wealthy are not the only ones inducted into the ranks of the Conspiracy. Those with talent and skill, unseen by society, are also viewed as valuable. Monsters and loathsome creatures are often inducted into the ranks of the conspiracy, though they are typically considered nothing more than mere collectors and agents.

Regardless, the conspiracy approaches in small but remarkable ways: a lucky coin, a discovered gemstone, a few small trinkets that seem to keep turning up again. Once taken, the whispers of the Cabal's endless schemes reach the ears of the subject, and they are brought before this shrouded council for an audience, carried through space and time in an instant. When one arrives, a contract written in blood and arcane ink is presented. One's soul in exchange for wealth, power, and purpose. Those who sign are inducted, instructed, and returned to their point of departure. Upon leaving the council, all conscious memories of the events that transpired are wiped from the inductee, leaving only the faintest inkling of the deal they made.

Those who refuse the contract have their memories purged of the event and are returned unharmed to find a bag of currency lying on the ground before them. Most don't question the missing moments, instead praising their good fortune as they count their newly acquired wealth. Some, however, feel that something is not right and instead begin to question the situation. These are the ones that the Conspiracy seeks to silence, as they tarnish its name.

THE REACH OF THE COINMAKERS

Those inducted into the Conspiracy are given a single coin of pure Gilt, representing their own soul. It is by this coin that conspirators know and forget one another, for to all but those inducted, the coin is naught but another ordinary denomination.

When a conspirator claims the soul of a mortal, through death or thrift, the Conspiracy may fragment the Gilt collected into more karensee. A dragon's hoard may be the accumulation of the victims it has slain, the champions it has vanquished, and the beasts that have sworn loyalty to it. It may not truly know the true nature of this coinage, instead merely remarking upon its luck and fortune. A king conquering a new land may find his coffers filled to bursting, the creatures within waiting patiently for their time to rise. Upon that dark and terrible day, the karensee will awaken and feast upon the living in a grand ritual that will send the power of countless souls to the Cabal, making them greater than the gods themselves.

REVEAL THE CONSPIRACY

When including the Currency Conspiracy in your world, consider what methods the Cabal uses to spread their devious minions across the planes. What is their end goal? Why do they wish to consume sentient life? Are the karensee aware of their purpose? Can they conceal their true nature fully, or are there some who have discovered the truth?

GILT: THE CURRENCY OF SOUL

Mortal life accumulates Gilt simply by existing, though not all are possessed of great quantities. Gilt is a metaphysical measure of the amount of impact that a person or entity has had upon the world. Those with more Gilt have been more impactful, while those with less are often merely cogs in the great cosmic machine, fulfilling roles simply because they were born to them. Heroes and villains, champions and cruel tyrants alike all possess Gilt in great quantities. When Gilt is made to manifest physically by the magic of the Conspiracy, it appears as golden coins that shimmer and sparkle with unseen light, and they are far more burdensome than one might expect from such small objects.

A BINDING OATH

One of the easiest ways for a conspirator to gain Gilt from another creature is to have that being swear an oath of fealty. The creature must speak sincerely, yet does not need to be aware of the full extent of their actions. The oath must contain a declaration of loyalty and a statement of intention to serve. When it is completed, the Gilt from that person flows to the one who is the beneficiary of the oath.

Members of the Currency Conspiracy who have been initiated in the secrets of Gilt can wield this power and release it into the universe to manipulate magical energies. Once the Gilt has been released, it naturally flows back to the person who swore the oath.

Those who have had their Gilt harvested from them by lethal means do not recover their Gilt in the afterlife. Instead, it flows about in the inter-planar spaces, waiting to accumulate around a new mortal soul. Gilt always re-enters circulation, and eventually, even the lowliest soul may bear the Gilt of dead gods from ages past.

Otherworldly Patron: The Currency Conspiracy

Hushed whispers fill your mind, informing you that your memories are your own. You don't quite understand what that means, but it seems that the Cabal may have a grand plan that requires your action and needs you to be aware of the reality behind your deeds. Perhaps you were knowledgeable and unscrupulous, willing to bargain away the life of another, or perhaps more powerful entities, intervened on your behalf and restored your memory. Nevertheless, now you know the truth behind the Currency Conspiracy. Along with this knowledge comes the ability to manifest the unusual power of Gilt and to wield a measure of control over the karensee. Will you use it to further the dark goals of the Conspiracy, or will you bite the hand that feeds and turn against the dark masterminds of the Cabal?

The choice is yours, but the price must be paid in blood.

Expanded Spell List

The Currency Conspiracy lets you choose from an expanded list of spells when you learn a warlock spell. The following spells are added to the warlock spell list for you.

Currency Conspiracy Expanded Spells

Spell Level	Spells
1st	command, identify
2nd	arcane lock, knock
3rd	clairvoyance, glyph of warding
4th	skin of flint*, unspoken agreement*
5th	dominate person, teleportation circle

Weight of Gilt

When you choose this patron at 1st level, you gain a single coin that acts as a manifestation of your soul, known as a Gilded Coin. You can summon the coin to your hand or dismiss this coin as a bonus action regardless of its location. Other creatures see this coin as 1 gp or other appropriate currency of equivalent value. You are always aware of who is in possession of your Gilded Coin.

As an action, you can choose to convert all currency you have in your possession into an equivalent value in any other denomination or currency. For example, you can convert gold coins into an equivalent value of silver or copper pieces, or change them into other currencies you've seen before. Additionally, you can choose to conceal currency you possess in a pocket dimension, which you can access using a bonus action. If you die, the currency reappears on your corpse.

Also, whenever you reduce a Small or larger creature to 0 hit points using a cantrip or a spell cast using a warlock spell slot or when a creature swears a binding oath of loyalty to you, you can choose to capture a fraction of their soul, granting you an amount of Gilt equal to the creature's hit point maximum. Once you've acquired Gilt from a creature, you can't acquire more from that creature until their Gilt has been spent in full. Whenever you cast a spell using a warlock spell slot that has a material component worth more than 1 gp, you can choose to pay an equal amount of Gilt in place of the material components. The material components appear and exist for the duration of the spell if not consumed by the spell.

Gilded Shadow

At 6th level, you can choose to spend an amount of Gilt equal to your warlock level as a bonus action to conceal your movements for 1 hour. When you take the Hide action, you become invisible and inaudible to creatures until the start of your next turn so long as they are more than 10 feet away from you. This can allow you to Hide even when you lack cover or concealment.

Once you use this feature, you can't do so again until you finish a short or long rest.

Grand Design

At 10th level, your connection to wealth allows you to manipulate events in your favor in subtle yet surprising ways. Whenever a creature is touching your Gilded Coin, you gain a measure of control over them. As a bonus action while you can see this creature, you can manipulate them in a subtle way that can't be detected. The target must make a Wisdom saving throw against your warlock spell save DC. If they fail, the target uses its reaction to move up to its speed then takes the Use an Object action, performing an activity of your choice. The action can't cause direct harm to them or anyone that they are aware of, but can have unforeseen consequences. Once you target a creature with this feature, you can't target them again for the next 24 hours.

Conspirator's Veil

At 14th level, your connection to the Conspiracy enables you to erase the memories of others at a whim. As an action, choose any number of creatures that you can see within 60 feet of you, and expend an amount of Gilt less than or equal to three times your warlock level. Each target must succeed on a Wisdom saving throw against your warlock spell save DC or have their memories erased, forgetting about actions you've taken and events that directly involved you for the previous number of minutes equal to the amount of Gilt spent.

Once you use this feature, you can't do so again until you finish a long rest.

Eldritch Invocations

Broker's Blade
Prerequisite: Currency Conspiracy patron, Pact of the Blade

You can choose to create a weapon from pure golden metal covered in precious gemstones using your Pact of the Blade feature. While you are wielding this weapon, you can choose to make an exchanging strike in place of a weapon attack. Make a Charisma (Persuasion) check contested by the target's Wisdom (Insight) check. If you succeed, you trade the pact weapon in your hand for one object the target is currently holding, passing your blade to them and taking the item in one smooth motion. Creatures that are immune to the charmed condition are immune to this feature.

Contract Killer
Prerequisite: Currency Conspiracy patron, Pact of the Tome

During a short or long rest, you can summon a contract detailing any agreement filled with your exact stipulations and requests. Any creature that signs the contract is bound by an obligation to fulfill the terms of the agreement for as long as the contract exists or until the terms are completed. If you break the agreement, you lose Gilt equal to three times your

character level. If the amount lost is higher than your current total, you suffer force damage equal to twice the difference. If a creature other than you breaks the agreement, you can choose to spend an amount of Gilt equal to or less than five times your warlock level, dealing force damage equal to the amount spent to all offending parties. Once you either break the contract or inflict damage using this feature, the contract is destroyed and can no longer be enforced. You can have a maximum number of contracts in existence at one time equal to your Charisma modifier.

EMERGENCY FUND
Prerequisite: 7th level, Currency Conspiracy patron

If all of your warlock spell slots have been expended, you can use your bonus action to spend Gilt equal to four times your warlock level to regain one warlock spell slot.

Once you use this invocation, you can't do so again until you finish a long rest.

OPEN EYES
Prerequisite: 7th level, Currency Conspiracy patron

Whenever you make a weapon attack or cast a cantrip that deals damage, you can use your bonus action to spend an amount of Gilt equal to or less than your warlock level to overwhelm the mind of your target with the truth of the Conspiracy. The target must make a Charisma saving throw against your warlock spell save DC. If they fail, they take psychic damage equal to half the amount of Gilt spent and can't take reactions until the start of your next turn.

PERFECT APPRAISAL
Prerequisite: Currency Conspiracy patron

You can correctly judge the value of any object, compared to any currency, and can tell the price that any person would be willing and able to pay for an object in your possession simply by looking at the person or thinking about a person you know well. You are also aware of the current net worth and liquid assets of any person you have met and greeted formally.

TWO OF A KIND
Prerequisite: Currency Conspiracy patron, Pact of the Chain

If you have a wealth mimic as your familiar, it gains additional hit points equal to your warlock level.

While you have a wealth mimic as your familiar and you are attuned to an object, you can have your familiar become a perfect duplicate of the object during a short or long rest. It loses its normal statistics and gains any magical features of the object until it chooses to leave that form. It cannot duplicate features that rely on charges or limited uses.

TRAITS OF THE CONSPIRATOR

Warlocks who have been initiated into the Currency Conspiracy are secretive about where their power comes from, merely evading the question and calling to a higher authority. Consider adding one or more of these traits when creating a warlock or after collecting a large sum of Gilt.

d20	Trait
1	You incessantly count your money time and time again.
2	You keep detailed records of transactions you've witnessed.
3	You greet everyone with a large smile and a handshake.
4	You always insist on the finest food and drink.
5	You haggle, even when it is rude or inappropriate.
6	You refuse to do something without first making a deal.
7	You can't seem to buy things for the full price.
8	People instinctively wonder what you're selling.
9	You always fully inspect things before buying them.
10	You habitually rush others into making decisions.
11	Your skin takes on a faint golden hue.
12	Your eyes become a richer, brighter shade.
13	You seem to fade into the background when you're not talking.
14	Your facial features become larger and more exaggerated.
15	Your stature becomes greatly exaggerated.
16	Your footsteps echo with the jingle of coins.
17	Your hair becomes soft and luxurious.
18	Jewels you hold always seem to sparkle more brightly.
19	Coins in your hand appear more numerous than they are.
20	Whenever you cast a spell with a verbal component, a "Cha-Ching!" sound briefly replaces your heartbeat.

Ugh, I've seen these lunatics weave webs larger than the Weaver itself. Killing an entire world by giving everyone money just seems like a joke at first, but once the coin started eating its way out of my pocket, I knew there was trouble. You know how hard it is to find good pants that won't burn up after a day? AND to add insult to injury, I had to kill the coin, so now I can't buy new pants. These folks are the worst, and that's a fact. —X

Sacred Oath: Oath of Avarice

Wealth is the availability of goods and services, and thus is a representation of both power and opportunity. A wealthy benefactor can save a civilization, while a wealthy tyrant can turn the world on its head. You've sworn to let nothing stand between you and the accumulation of wealth, as any whim that takes you can be accomplished with the prudent use of overwhelming financial might. You may have attracted the attention of the Currency Conspiracy, for if your greed blinds you to the truth of their work, then they will gladly take you into their ranks.

Tenets of Avarice

The tenets of the Oath of Avarice are often sworn only to oneself, born of greed, desire, and greater goals.

Take and Keep: The more you have, the more you can do. Take what you need and give nothing back without greater gain.

Spend and Deliver: Everything has a price. Seek wealth so that you can pay it in coin, rather than your own blood.

Blood and Soul: There are currencies intangible that must be obtained or protected, for wealth is worthless otherwise.

Wealth and Unity: All the money in the world does nothing if you cannot spend it. Join with others and invest in their efforts, so that you may reap the rewards.

Oath Spells

You gain oath spells at the paladin levels listed.

Oath of Avarice Spells

Paladin Level	Spells
3rd	alarm, charm person
5th	knock, sinister threat*
9th	blackened heart*, detect interference*
13th	invitation*, unspoken agreement*
17th	nemesis*, overwhelming emotion*

Channel Divinity

When you take this oath at 3rd level, you gain the following two Channel Divinity options.

Golden Suit. As an action, you can use your Channel Divinity to coat yourself in shining gold for 1 hour. You gain temporary hit points equal to twice your paladin level for the duration. Whenever a creature hits you with a melee attack while you have these hit points, gold sprays off your armor, causing the creature to suffer disadvantage on their next attack before the start of their next turn.

Hired Help. As an action, you can use your Channel Divinity to summon a simple magical construct for one hour. This construct has the statistics of a commoner, though it is a construct instead of its normal type. It cannot attack, cast spells, or activate magic items. If it dies or the duration expires, it fades into mist.

Aura of Investment

Starting at 7th level, you are surrounded by a 10-foot aura of mutual benefit. Whenever you or a friendly creature gain temporary hit points while within the aura, all other friendly creatures within the aura (including you) gain an equal amount of temporary hit points that last for the same duration. This effect cannot cause a creature to gain more than twice your Charisma modifier in temporary hit points at once.

At 18th level, the range of this aura increases to 30 feet.

Rate of Exchange

Starting at 15th level, once per turn when you hit a creature with an unarmed strike, you can attempt to steal an object or weapon from the target. The target must succeed on a Strength saving throw against your paladin spell save DC or lose the chosen item. If you lack a free hand to steal the item, the attempt automatically fails.

Hidden Agenda

At 20th level, you reveal your true desires to the world and call upon the debts that you are owed. You are empowered as the life force of dozens of debtors is drawn into you. For 1 minute, you gain the following benefits.

- You gain 20 temporary hit points at the start of each of your turns that last for the duration of this feature.
- Whenever you steal a weapon using your Rate of Exchange feature, you can immediately make a weapon attack using it. This does not require an action.
- When you hit a creature with a melee weapon attack, you can choose to unleash a blast of golden light. The target must make a Wisdom saving throw against your paladin spell save DC. If they fail, they are blinded until the end of your next turn.

Once you use this feature, you can't do so again until you finish a long rest.

UNCOVERING THE CURRENCY CONSPIRACY

The Conspiracy is one of the more unique Alrisen because it isn't a location or even a single entity. Instead, it's a collection of individuals who may or may not even know of their involvement with this dark and secretive organization.

When adding the Currency Conspiracy to your universe, consider how far-reaching the implications could be. It's one of the Alrisen that can be fun to include even when none of your players are associated with it, especially if you reveal that fact later in the campaign. Therefore, it's essential that you tie it into your world in a coherent and logical way, particularly because of how generally complex and outlandish it can be.

The first thing to do is determine if the Conspiracy is a widespread group as shown here, or if there's a single individual responsible for the whole thing. The Cabal stands in as a group that you could reasonably assign members to, or you could simply have one mastermind running it all.

The second thing to determine is the stage the Conspiracy has reached. Are there multiple conspirators that have reached positions of power, or is the plan still just beginning? How much of the world's currency has been replaced with karensee? Has anyone discovered the truth, and is the Conspiracy aware of their interest? How long until the karensee will awaken, if they will at all? What is the goal of the mastermind or Cabal after that final day dawns? Do they seek ultimate power for its own sake, or do they intend to use it to some unspeakable end? How does this goal affect their choices in their dealings with the mortal world? Does the Currency Conspiracy have allies who are aware of its true nature? Are there deities or fiends that have associated themselves with the Conspiracy? If you can answer some or all of these questions, you'll have a firm grasp on how you can begin to use the Conspiracy in your campaign.

FORGERY AND FALSEHOOD

If you're less interested in exploring a broad conspiracy and are more interested in looking at wealth as a singular end, it's very easy to reflavor the Currency Conspiracy as a singular entity that seeks or offers wealth in exchange for souls. Many fiends would be appropriate patrons to offer powers such as these, granting control over the hearts and minds of others in exchange for souls sworn to its service.

This can lead to many classic plot elements, such as a person selling their soul and then seeking to claim enough Gilt from other people in order to repurchase their soul. It could be used to tell the tale of a warlock who discovered that killing could lead directly to eldritch power and only knew that the spiritual energy of others was tied to the process. Alternatively, in a lighthearted and comedic game, someone could simply gain magic by being incredibly wealthy and buying it from many different sources, and these powers represent the end results of those transactions.

KNOWLEDGE OF THE CONSPIRACY

The Currency Conspiracy really shines the more implausible you decide to make it. All of the money in the world literally being living beings bent on the consumption and destruction of the mortal races in order to channel the power of an entire world into a shadowy cabal of hidden masterminds who wipe the memories of those who interact with them would sound like something a madman would ramble about, but in this case, it's completely true.

Confronting your players with this fact, and then expecting them to take it seriously could be a bit of a challenge. However, there's a few secret tricks you can use to make sure that this actually comes across correctly. The first and foremost is to provide them with tangible, unmistakable proof, and there's one really easy way to do it: use the karensee. Have your players' coinage wake up and try to kill them, either intentionally triggered by the Conspiracy or as a side effect of other magical energies that adventurers are commonly exposed to. Don't reveal the truth of what happened until later, and constantly mention subtle fragments of the Conspiracy through unreliable sources of information. Either the party will fully ignore every sign until they finally put it all together at the right moment, or they'll immediately jump to the conclusion but have a difficult time acting on that hunch.

The Conspiracy is relatively easy to keep hidden, simply because very few of the members are even consciously aware of their membership. Instead, they're pawns strung along by their own subconscious urges to seek wealth and indulge in their greed. Warlocks who have sworn pacts with the Conspiracy are among the few who retain their awareness of their obligations and goals, and the Conspiracy carefully chooses who it is willing to induct.

EVIDENCE OF THE CONSPIRACY

While the Currency Conspiracy manages to keep itself well hidden from mortal eyes, enough that there are few cultural references to it, there are certain items and artifacts that cannot be explained any other way. The following objects are among those strange devices.

CLOCKWORK HEART
wondrous item, very rare (requires attunement)

This object looks like a human heart crafted from mechanical components. When it is placed within a living person over the course of a long rest using a surgical technique that can only be performed with the assistance of magical healing, it begins to beat at a steady and deliberate pace. Whenever the bearer of the heart would be exposed to magic that would alter their memories or modify time in a way that would affect them, they can choose to become immune to the effect.

GILT MONITOR
wondrous item, rare

As an action, while holding this fist-sized contraption of cogs and antennae, you can point it at a creature you can see within 60 feet of you. Swirling dust in the shape of numbers will appear above this object that indicate the target's hit point maximum.

BLADE OF THE SALESMAN
weapon (dagger), legendary

This dagger looks surprisingly ordinary, like a belt knife someone had carried so long they'd forgotten about it. Once per turn when you hit a creature within this magical dagger, the target immediately drops its most valuable and expensive possession to the ground in an open space within 5 feet of itself using its reaction. It will not cause the target to remove armor, and if the target has already used their reaction then they will not drop another object.

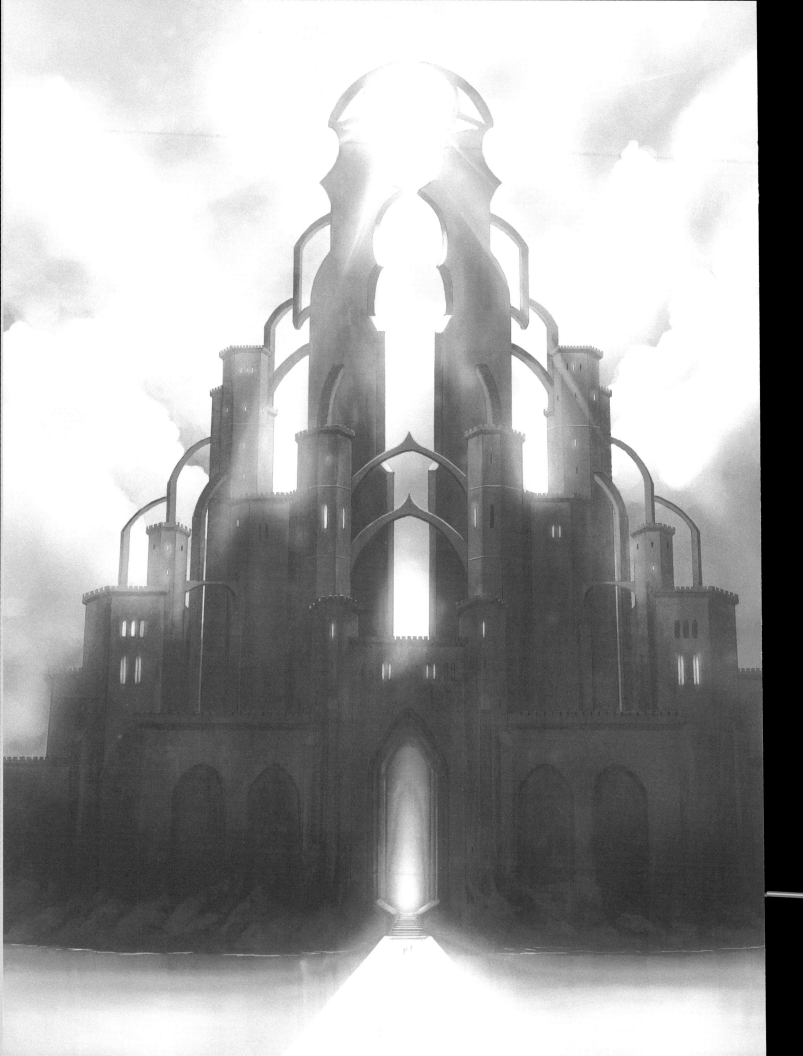

THE ETERNAL CITADEL

THE BASTION OF FATE

Outside of time yet wandering the endless planes, there is a singular fortress that acts as a monument to the power of preservation. The Eternal Citadel may have been constructed, but the builders of this place remain a mystery, as the final stone was set at the beginning of time itself. This massive construction, traveling from world to world in a seemingly random pattern, is sentient. Moving with inscrutable purpose, it collects the lost and forlorn and deposits them elsewhere in the multiverse, upon a new continent or plane, potentially far in the future or in a time once lost to history.

HARBINGER OF THE BEGINNING

The Eternal Citadel appears as a massive fortress surrounded by a moat of liquid starlight. Tall towers jut above the battlements, and in the center, a massive pair of spires rise and curve toward one another. Between them, a radiant sphere of light shines into the ever-present clouds above, illuminating them in the pure light of preservation.

Travelers who view the Citadel are often overwhelmed by a compulsion to travel to the edge of the moat, where a bridge of light begins to appear under their feet. They are drawn to walk across it, only to come to their senses once they arrive inside. The bridge disappears and the gate seals behind them, keeping them safe inside while the Citadel decides their fate.

THE SENSATION OF TIMELESSNESS

Those who find themselves trapped within the Citadel are safe and unharmed, free to wander among the empty city within. It is rare for more than one person to be within the Citadel at a time. Left in solitude and silence with only their own shadow for company, those so isolated lose any feeling of hunger or thirst. Trapped in a place without the procession of day into night to mark the passage of time, they are forced to wait.

One might think years have passed, or only a few days, before they find themselves feeling what some have called a "timeless" sensation.

AT THE RIGHT MOMENT

The lost wanderer will suddenly find themselves standing upon a new world with few memories of their experience in the Citadel. Thrust into a foreign land with foreign cultures, they are often noticed for their strange manner of dress and unusual behavior. While they are granted the ability to speak the native tongue of the place they where they have been abandoned, their unfamiliarity with local customs causes these wanderers to appear remarkably ignorant yet curiously informed of foreign ways. With their strange powers over the forces of preservation, these rare people are often hailed as saviors and protectors. As such, it is unusual for them to arrive in a place of peace, or a time without great and ruinous evil.

PRESERVATION WITHOUT REGARD

The Eternal Citadel is a force of protection and stasis, seeking to keep the world exactly as it is. However, once a new change has occurred and has become finalized, it will immediately shift course and seek to maintain the new status quo. One of the few things that it does not oppose in any way is the construction of architecture and the creation of permanent things that are designed to last for eternity. The subtle consciousness within the Citadel welcomes the creation of more eternal bastions, though few are ever so grand or so imposing, and none match it in power.

DEFENDERS AND GUARDIANS

Those who have sworn themselves to the Eternal Citadel are not known for welcoming change and are often highly conflicted in their quests. They seek to end the forces of ruination, constantly working against unholy powers of destruction and decay. Warlocks, statuesque, and soldiers who endeavor to emulate and call upon the power of the Citadel are known for their patience and determination at seeking their goals. They are not always gentle about their activities, however. Many are known as grand architects, builders, and warriors, creating fortresses in mere days and dealing death to the ruinous powers from behind their new fortifications.

PURPOSE IN POWER

This single-minded pursuit of preservation often leads to conflict between mortals and those who have fully embraced the intent of the Citadel. Champions of the Citadel will seek to build monuments that will safeguard against invading hordes, granting incredible military might to those that they side with. Yet, if those they support become cruel and destructive thanks to their new and glorious fortresses, they shall depart for the opposing ranks in order to preserve those who are now defenseless. Often, warlocks and servants of the Citadel are responsible for the creation the lost fortresses that dot the landscapes of countless worlds. These silent bastions are filled with monsters and raiders as the people who once stood guard were not as enduring as the constructions they once defended.

PURIFIER OF SOULS

The Eternal Citadel does possess a single offensive power that is rarely matched, which it reserves for truly ruinous wretches. A beam of spiritual light pours forth from the eternal orb of glorious radiance that rests between the central spires, striking down the unrepentant. Those that survive are stricken blind by the terrible light, their bodies scorched as much as their souls. Those who die are forever removed from time, cursed to suffer eternally for their sins against the natural order in the purity of the lightless void.

SUMMON THE ETERNAL CITADEL

The Eternal Citadel moves between all worlds, so it's easy to include in yours. First, decide if it has appeared in your world before, or if this is the first time. Who else has it taken? Where did they end up? What does the Citadel want? Do the gods care about the actions of the Citadel? Is there an organization or entity dedicated to destroying it, and is it possible for them to succeed? What forces of ruin are present in the world, and why would the Citadel think to intervene?

Otherworldly Patron: The Eternal Citadel

You've made a pact with the Eternal Citadel, a massive yet empty bastion that seems to wander between worlds, collecting travelers and releasing them once they agree to serve. The Eternal Citadel communicates through the silent transfer of emotions and feelings – an instinctual sense to follow a course of action, no matter how enigmatic it may seem. An unknown number of people have sworn their allegiance to the Citadel, and few ever meet, but they all serve the same end, known or otherwise: preservation against the forces that seek destruction.

Expanded Spell List

The Eternal Citadel lets you choose from an expanded list of spells when you learn a warlock spell. The following spells are added to the warlock spell list for you.

Eternal Citadel Expanded Spells

Spell Level	Spells
1st	defy ruin*, sanctuary
2nd	arcane lock, warding bond
3rd	glyph of warding, tiny hut
4th	resilient sphere, stoneskin
5th	passwall, wall of stone

Righteous Guardian

At 1st level, you gain the ability to shield yourself and others from harm. Whenever you or an ally within 30 feet takes damage, you can use your reaction to create a mystical barrier of energy. The amount of damage taken is reduced by half your warlock level + your Charisma modifier (minimum 1) after applying resistances or vulnerabilities.

You can use this feature a number of times equal to your Charisma modifier (minimum of once), and you regain all expended uses of it when you finish a long rest.

Force of Preservation

At 6th level, you gain the ability to fortify yourself further. Whenever you take damage, you can use your reaction to become immune to the damage from that effect or attack, and you gain temporary hit points equal to half your warlock level.

Once you use this feature, you can't use it again until you finish a short or long rest.

Builder of Walls

At 10th level, your connection with the Eternal Citadel deepens, enabling you to call upon it for defense. You learn two spells with the word "wall" in their name that are of 5th level or lower, they count as warlock spells for you, and they do not count against your total spells known. You can't choose wall of force as one of these spells.

You can cast one of these two spells once without expending a spell slot. Once you do so, you can't do so again until you finish a long rest.

Bound to the Aeons

At 14th level, your oath to the Eternal Citadel becomes irrevocable. You no longer age and cannot be magically aged. You also do not require food or water.

Additionally, you can call down an onslaught of timeless power from the central spire of the Citadel to burn away the souls of your foes. During your turn, you can use an action to choose a location that you can see within 200 feet of you. An infinitely tall 10-foot-radius cylinder expands in that space, illuminating it with bright otherworldly light. At the start of your next turn, a beam of golden energy shoots down from the sky, and creatures within the area must make a Charisma saving throw against your warlock spell save DC. If they fail, they take 7d6 radiant damage, 7d6 force damage, and are blinded until the start of your next turn. If they succeed, they take half as much damage and are not blinded. This beam passes through obstacles without damaging them.

Once you use this feature, you can't do so again until you finish a long rest.

Eldritch Invocations

Alliance Upheld
Prerequisite: 7th level, Eternal Citadel patron

Whenever you use your Righteous Guardian feature on an ally who has at least 1 hit point, they regain hit points equal to your Charisma modifier.

Steadfast Companion
Prerequisite: Eternal Citadel patron, Pact of the Chain feature

If you have an animate shield as your familiar, it gains additional hit points equal to you warlock level. While you have this familiar, you can cast the *mending* and *light* cantrips.

Hammer of Dawn
Prerequisite: Eternal Citadel patron, Pact of the Blade feature

You can create any weapon that inflicts bludgeoning damage from worked stone infused with golden metal using your Pact of the Blade feature. At creation, you can choose to have this weapon deal force damage instead of bludgeoning damage. You can use your Charisma modifier on attack and damage rolls made with this weapon. A target hit by this weapon cannot make opportunity attacks targeting creatures other than you until the start of your next turn.

Invested Defense
Prerequisite: Eternal Citadel patron, Pact of the Blade feature

You gain proficiency in shields. While you are wielding your pact weapon, you are considered to have a shield equipped.

Preserved Document
Prerequisite: Eternal Citadel patron, Pact of the Tome feature

You are instantly aware of any attempt by the other parties to break the terms of any contract or written agreement signed by you. If the contract is broken, you become aware of it.

Servants of the Citadel
Prerequisite: Eternal Citadel patron

When you deal damage to a creature with a cantrip or weapon attack, you can use your bonus action to fortify an ally that you can see within 60 feet of you. The target gains temporary hit points equal to your Charisma modifier that last 1 minute.

INSIDE THE CITADEL

Though the Eternal Citadel often lacks inhabitants, it is far from empty. The bridge of golden light leads to a large courtyard around which the central spires stand. Outside this lies a diamond-shaped street filled with empty storefronts, taverns, and residences. Staircases within the spires lead to beautiful homes built like balconies and to galleries of art and cultural achievement from eras past and future. A bottomless pit located in the heart of the central courtyard, directly below the orb of radiant light, and a passage that lies within the one destroyed building within the Citadel are the only places that resist exploration, and none who have entered have ever returned. The only thing that stands out is a strange sigil carved into the stone at both locations, indicating that there is a power of ruin within the world with the ability to mark the living rock of the Citadel itself. This is the Citadel's eternal foe.

TRAITS OF THE TIMELESS

Warlocks who have made a pact with the Eternal Citadel are often known as timeless, and are known for their strangeness and unusual habits, given many are stolen from other worlds. Consider adding one or more of these traits when creating a warlock or after performing one of your duties as a servant of the Citadel.

d20	Trait
1	You tend to assess doorways before walking through them.
2	You often forget which language is being spoken.
3	You occasionally awaken confused about where you are.
4	You strongly dislike being alone or confined.
5	You are hesitant to destroy any objects.
6	You are anxious when outdoors.
7	You talk to structures and expect an answer.
8	You often stroke stone as though it were a pet.
9	You sketch architectural designs in your sleep.
10	Your skin appears to be made of marble, in the right light.
11	Your skin is always cool to the touch.
12	Your eyes glow with a soft, golden light.
13	Your flesh chips and cracks rather than being cut in the normal way.
14	Your facial structure is oddly statuesque.
15	Clothing or armor you wear for long periods of time becomes increasingly thick and durable.
16	Your skin tone slowly adapts to appear identical to any stone that you are touching while you are asleep.
17	Your hair remains in a single shape, no matter how hard you try to change it.
18	The scent of stone and metal seems to follow you.
19	When you cast a spell, a soft halo of light appears over you.
20	Walls seem to reach out to caress you when you lean against them.

MARTIAL ARCHETYPE: TIMELESS MONUMENTAL

Wandering between worlds, a massive fortress known as the Eternal Citadel collects forlorn travelers, hermits, and sole survivors to work in its service. Trapping these lost souls within its walls until they agree to follow the strange instincts brought on by the emotions and feelings the Citadel silently sends, this mysterious bastion works to preserve and protect all things, destroying only that which would bring ruin and desolation to the world. You are one of the few who have wandered inside at some point in your life, seeking shelter or knowledge, and now the influence of this place becomes clearly felt, granting you power and longevity to fight the forces of destruction for all eternity.

STATUESQUE PHYSIQUE

At 3rd level, your body begins to gradually become more refined, made perfect and whole in preparation for your work. Any physical deformities that you may have are fixed and your body is made whole again. Lost limbs reform, blemishes vanish, and your visage becomes timeless and clean. You gain advantage on Charisma (Persuasion) and Charisma (Performance) checks. If you take no damage for seven consecutive days, this process of purification and renewal occurs again at sunset.

GAZE OF ETERNITY

Also at 3rd level, your defensive prowess allows you to halt the progress of your foes. Hostile creatures cannot move through your space. If a hostile creature is within 10 feet of you, the weight of countless ages bears down upon them. If they attempt to move to another space that is further than 10 feet from you, they must first make a Wisdom saving throw with a DC equal to 8 + your proficiency bonus + your Charisma modifier. If they fail, they lose the ability to move farther away from you for the remainder of their turn unless they inflict damage upon you after failing their saving throw.

WITNESS TO RUIN

At 7th level, your transformation continues as you become further attuned to the Citadel. You no longer need to eat, drink, breathe, or sleep. In order to gain the benefits of a short or long rest, you must still spend the downtime performing only light activity.

Your eyes see the small cracks and wear upon everything around you, allowing you to mark the passage of time with perfect accuracy. You can unerringly identify the true age of any person or object that you can clearly see, and you can choose to know the time that the person will die of old age based on their current health, diet, and lifespan, down to the day.

RADIANCE OF THE SPIRE

At 10th level, your body and soul are bathed in the glorious light of the Citadel, granting you immortality. You no longer age and cannot be magically aged.

Whenever you are reduced to 0 hit points, you are automatically stabilized. Once this occurs, you can't gain this benefit again until you finish a short or long rest.

TITAN'S VIRTUE

At 15th level, you learn to call upon the triumphant power of the lost ages to contain the ruinous corruption wrought by mortality. Whenever you hit a creature that is within 10 feet of you with a weapon attack, it can't choose to move to a location farther than 10 feet away from you during its next turn. If you move to a location farther than 10 feet away from it, then this restriction is lifted.

PRICE OF PRESERVATION

At 18th level, you truly comprehend the nature of the Eternal Citadel, causing otherworldly power pour through you.

When an ally within 15 feet of you takes damage from an attack, you can use your reaction to intercede on their behalf, teleporting in a flash of light to an unoccupied space within 5 feet of their attacker. The attack hits you instead, regardless if the attack would have missed you had you been the initial target. Immediately after the attack resolves, the ally can use their reaction to make a weapon attack against their original attacker.

MANEUVERS

Presented here are maneuvers unique to the Timeless Monumental, allowing them to call on the power of the Citadel's endless intent. These maneuvers are designed for use with Fighting Maneuvers, a replacement for Fighting Styles published by Vorpal Dice Press. If you are not using this supplement, then ignore this section.

AEGIS STRIKE
Prerequisite: Timeless Monumental archetype

When you take the Attack action on your turn, and hit a creature with a weapon attack, you can choose to have your attack deal no damage. Instead, the target is wreathed in a punishing barrier of energy. The first time the target makes an attack before the start of your next turn, it takes radiant damage equal to 2d6 + your Charisma modifier.

FORTIFICATION
Prerequisite: Timeless Monumental archetype

When you take the Attack action on your turn, you can forgo one of your attacks in order to summon a wall of magical stone in an open space within 10 feet of you. The wall has AC equal to your AC, has hit points equal to your fighter level, and is up to 5 feet long, 5 feet tall, and 1 foot thick. At the start of your next turn, the wall instantly crumbles into dust before vanishing.

RETURNING TO THE CITADEL

The Eternal Citadel is typically something that one sees only once in their lifetime, carrying them away to a new world before departing forever.

Those who are left upon strange shores are often left without guidance, simply cast out without regard to when or if they will ever see home again. The Citadel is apathetic to their emotional struggles, as it does not care about the feelings of mortals. It is a cold and distant thing, shining with a warm light of immortality even as it rips wanderers from their homelands and the worlds they once knew.

Those who complete great tasks and monuments are often left alone, simply protecting what they have created and the peace and stability of the land. Those who fail, or worse, turn aside from their assigned task face a different fate.

THE DISPLEASURE OF THE SILENT

The Citadel does not speak, but communicates instead in pure sensations of desire and belief. The subtle consciousness of the place is not bound by the mortal constraint of time, but it does know that the minds of others are vulnerable to its passing.

Warlocks who turn against the pact and shatter the deal are often the first to be granted what some call the Citadel's darkest curse: false immortality.

Tales are told of individuals who grow old, feeble, and weak. Their minds suffer under the weight of eons, trapping them in a state of helpless confusion. Their bodies become thin and skeletal no matter how much they eat, and their breathing becomes slow and painful. Yet, no matter how agonized or miserable they are, they cannot die. The Citadel will not allow it. They must be preserved, for they have been marked by that shining and terrible fortress.

TRIUMPHANT IN PURSUIT

Not all tales of the Citadel are so steeped in suffering. Most are joyous ones: riveting legends of saviors and champions, heroic struggles, and valiant last stands against the forces of ruin.

Some who survive and act in the Citadel's eternal name are allowed to return within it, guiding new companions to join them in service to its cause. It is welcoming to individuals of all but the foulest disposition, and when they are accompanied by a champion of the Citadel, it does not press its purpose so forcefully upon them.

ONWARD AGAIN

When the heroes arrive at a new world filled with conflict and destruction, the Citadel will depart once more. Those who have entered a second time are blessed with true immortality, never aging or growing weak and infirm. Many find themselves restored and preserved, the Citadel's magic maintaining their minds even as their bodies are healed.

What? A pact with a building? Really? Seriously? Who comes up with this garbage? I swear, this world is a joke. —X

Rebuilding the Citadel

The Eternal Citadel has two primary themes that make it unique among the Alrisen: preservation and construction. This gives you quite a bit of opportunity to tie it into your world and creates many enemies for its champions to battle.

The first thing to do when including the Citadel is to decide if it's still actually just a building. Is the Citadel a fortress, as it is presented here, or a person who lives within the fortress? Is there even a fortress at all? Would this person be a guardian or sentinel or an architect of incredible skill? Where would they live, what would they look like, and how would they behave?

Once you've decided what the Citadel actually is, consider what impact it will have had on the world. Have its champions constructed countless monuments and cities? Are those fortresses still inhabited by civilized societies, or have they been overtaken by monsters and brigands? Are some lost to time, having become known as mere myth and legend?

Wanderers of Worlds

Once you've determined what the Citadel has created, consider how it could be related to the divine powers of your world. Are they in favor of its actions? Is it directly associated with one of the gods of light, creation, or travel? Is it opposed to the gods, seeking to maintain their creations without allowing them to change and grow as they should? Have its champions disrupted a natural cycle of destruction and creation, or are they saviors against the forces of ancient powers? Have there even been any champions in the past? If there weren't any, how would the world react to this new force meddling with its affairs? Once you've considered these questions, you can really start to tie the Citadel into your world and bring it to life.

Adjusting the Citadel

The Eternal Citadel has additional themes of light, radiance, time, peace, souls, and compulsion. If you're interested in changing the Citadel without modifying the mechanics associated with it, you can easily change one or more of these themes to suit your tastes. For example, by replacing its themes of light and peace with ones of darkness and war, you can easily create a horrifying fortress of black magic. Statues of petrified heroes would stand before the gates, screaming silently for all eternity. Thunderclouds would boom overhead, and the galleries within the spires would be filled with scenes of torture and war, executions and massacres. Champions from the citadel would be undying conquerers, seeking to rule and construct civilizations that would dominate and control all others. An empire ruled by a powerful warlock who would never die of age nor change for the better would present an excellent foe for a party of benevolent adventurers and would present a very different take on the Citadel.

A Gray Light

Alternatively, you could shift the focus to something more ambiguous, such as preservation without thought for the consequences. Maintaining a status quo that is unjust and unfair is certainly preservation, even at the cost of the people it may seek to preserve. However, breaking the system would cause chaos, harm, and confusion, which would not be beneficial either. These champions would be the old guard, only allowing incremental improvements to the existing structure. The choice is yours and that of your players.

I wonder who created the Citadel? Was it even made, or did it simply manifest? It's supposed to last forever, so perhaps some strange civilization in the far future created it and sent it back to make sure they would be able to easily colonize new worlds when they began to emerge? Well, speculation is pointless. I probably wouldn't live long enough to see that, and I'm an elf! — Sylvette

Constructing a Fortress

The timeless champions of the Eternal Citadel are known for constructing imposing structures in fractions of the time it would take ordinary masons, and out-pacing even practitioners of the arcane arts. Consider this: a warlock of the Citadel who could cast *wall of stone* could reasonably expect to do so at least sixteen times within one day, assuming they did nothing else. Each casting produces 1000 square feet of solid stone that they can easily manipulate for their uses, and it becomes permanent almost instantly.

Within one week, they could cast the spell over 112 times, leading to over 112,000 square feet of stone. Within a month, it becomes more than 448,000 square feet of stone. Within a year, you could produce a fortress comprised of over 5,376,000 square feet of permanent stone. By contrast, the largest buildings in the real world have around 4,000,000 square feet of usable space. One single warlock of the Eternal Citadel could construct that building in a year. This provides an easy explanation for why a massive dungeon exists in the middle of nowhere without anyone knowing how it was made or who built it. One warlock, long departed, was responsible.

Additionally, they gain access to the spell *defy ruin*, which enables you to easily preserve and fortify an object against damage, including the strains of bearing a heavy load. Not only could you make a fortress that is larger than our world's largest building, you could make it last forever and look pretty much however you wanted it to. A single warlock could build a staircase to the moon in just over a century, assuming they were sufficiently powerful.

That's the beauty of the Citadel.

Artifacts of the Eternal

While the timeless are mostly known for their architecture, some become smiths or enchanters of magical items. These are among their most notable creations:

Mason's Hammer

wondrous item, very rare (requires attunement)

As an action, you can strike the ground with the simple hammer to cast *wall of stone* without expending a spell slot. Once you do so, the hammer can't be used again in this way until the next dawn.

Eternal Armor

armor (any), very rare (requires attunement)

This magical armor appears to be crafted from fine golden material and shimmers with a glittering light. While you are wearing this armor, you do not age, you suffer no penalties from advanced age, and you cannot be magically aged. Additionally, you gain resistance to necrotic damage and to damage from critical hits.

THE FALLEN EXILE

THE FORLORN STAR

The void between worlds is filled with countless stars born when time began and the multiverse was still young. They are nigh-immortal, burning bright for uncountable ages within the pure blackness that separates them. All things that exist with such fire and light and primal power cannot stay complacent for long, however.

Over the millennia, these stars gained sentience and knowledge, watching and speaking with one another of the countless worlds they watch, glaring balefully or benevolently at the lives of the mortals below, witnessing them appear and disappear in what seems to be mere moments. The Fallen Exile was one of these stars, though it is counted among their number no longer.

THE LONELY WANDERER

The Fallen Exile was a star of golden radiance, but one without a world to claim as its own. It was a lonely thing, without even a constellation of companions. It longed to experience something other than its bleak sector of space and the dim, almost faded light of its distant neighbors.

So the star began to move, mustering its power to burn a path across the cosmos. This was met with much disapproval by the other stars, but the Exile was careful and remained in the far corners of the multiverse in its travels, only experiencing worlds that had not yet been bathed in starlight. Mortals who traveled in the distant reaches of space occasionally reached out to the Exile, and it spoke with them gladly, eager for any semblance of companionship, fleeting as it may have been.

Years passed between each conversation the star had during that ageless period, but it was famed for the wisdom and guidance it offered. Things were peaceful for the Exile, but it was not content. It desired more, for the barren worlds deprived of light held little mystery after close inspection, and the infrequent passage of mortal life was only entertaining so long as they brought new stories and knowledge to share.

THE SEEKER

The Exile's wanderings took it ever closer to the center of the multiverse, where radiant light and everdark void danced and spun like the threads of a weaver's loom. There it sought wisdom at the core of the universe, which had existed from the first moment. The core spoke to the Exile in a conversation that lasted countless years, foretelling a great and passionate love that the Exile would discover and guiding it on its path through the cosmos. The Exile, overcome with an emotion it had never felt, rushed away before the core could deliver the final part of its prophecy: the love it found would mean the end of the Exile, and perhaps, the end of the stars themselves.

THE PASSIONATE SPARK

Unaware of the inevitable price, the Exile flew through the void, leaving a trail of blistering fire behind as it raced through the cosmos on a path toward the world the core mentioned in its prophecy. It became timid, however, as it neared the mighty star that oversaw the world, and thus hung in the sky just far enough away that it could clearly see the world below.

As it waited, brimming with anticipation, it flashed and spun gently in place, eager to see its prophesied love. Ages passed as it waited, filled with confidence that the core's words were true. The other stars nearby grew curious and asked after the Exile's purpose. When it replied, they marked it off as harmless insanity or a simple game that it would eventually tire of. However, it did not tire, nor did it rest, until one moment, when it heard a sound it had never heard before.

THE CURIOUS FLAME

The sound the Exile heard was a song, bright and brilliant and filled with life. Its majesty floated through the void of space unhindered by the distance, filling the Exile with passion and adoration. Overwhelming compulsion to see the source of the sound and hear it more clearly drove the Exile to move ever-closer to the world. This drew the attention of the star that stood watch, and it expressed its intent to jealously guard such an interesting world, though it seemed unable to hear the glorious sound. The Exile was undeterred. Using the eldritch magics learned in its travels across the infinite multiverse, it grew smaller and cooler, hiding behind the planet's moon so the other star would not see it. It only emerged at night, always seeking the source of the sound that echoed forth each dawn. The Exile became frustrated and pained, so eager, but so terrified of the wrath of the greater star. Upon the hundredth such dawn, the Exile could stand the solitude no longer and flew across the sky looking everywhere to try to find the source of that great beauty. At long last, the Exile found what it had sought for countless ages. A beautiful mortal arose each morning to sing, captive in a prison made by a vile villain. The song was defiant, filled with life and hope and glorious righteousness, and the Exile was so moved upon seeing this injustice that it burned away the bars and walls of the prison in a furious display of magical power.

THE FALL OF THE EXILE

Once free, the two spoke for what seemed like an eternity, and upon their confession of mutual love and adoration, the sky was filled with a frenzied radiance unlike any seen before or since. This had angered the great star that watched over the world. It called the cosmic council of stars, powerful entities tasked with maintaining order in the universe. They passed judgment on the events that had transpired below, and the Exile was found to have acted in disharmony with what was righteous and pure. In a display of terrible fury, the mortal was destroyed by the wrath of the stars, rendered less than ash and erased from the face of the world. The Exile was stripped of its power and trapped in its current, weakened form, cursed to only wander its paramour's grave for eternity. The great star hangs vigilant in the night sky, keeping watch for the Exile as it constantly tries to flee from its persecutor's gaze. The void that was created when the Fallen Exile embarked on its cursed journey now grows larger as the hatred and rage within this cast-down star burns brighter. Now, the Fallen Exile's seeks the return of its lost love and to exact revenge against the stars themselves. It will allow nothing to stand in its way.

Otherworldly Patron: The Fallen Exile

Stars beyond measure populate the void beyond the world while celestial spheres circle above. You have met with one of their number, cast down by the many cold and unfeeling suns above for the sin of falling in love with a mortal. As punishment, the spiteful and envious stars shined their pale fury upon the paramour, destroying them utterly. The Exile now wanders the world it has been cast upon, appearing as a shimmer of light. Its goal is known only to those whom it trusts, and it grants power to them as it is powerless itself, stripped of interaction with the mortal world for its hubris. It endlessly searches, seeking either a soul of great kindness to help it find the knowledge and power to resurrect its fallen paramour or one unscrupulous enough to wage war upon the very stars themselves. The light shines, but that fire can be cold and merciless, like the wrath of a love destroyed.

Expanded Spell List

The Fallen Exile lets you choose from an expanded list of spells when you learn a warlock spell. The following spells are added to the warlock spell list for you.

Fallen Exile Expanded Spells

Spell Level	Spells
1st	color spray, faerie fire
2nd	continual flame, see invisibility
3rd	blink, daylight
4th	divination, greater invisibility
5th	dispel evil and good, falling star*

Cosmic Conduit

At 1st level, the Exile's duality of betrayal and compassion infuses your spellcasting, enabling you to reach into the world in the same way that it does. Whenever you cast a spell using a warlock spell slot, you can choose to cast the spell as though you were located in the space of an enemy or ally that you can see within 60 feet. When you cast from the space of an enemy, they take 1d6 radiant damage. When you cast from the space of an ally, they gain 1d6 temporary hit points.

Stardust Crusader

At 6th level, the Exile grants you a portion of the power it stole from the other stars as it fell, allowing access to their spirits. Choose two of the following Dawn Constellations.

The Chariot: When you take the Attack action, you can take the Dash action as a bonus action.

Death: You gain proficiency in death saving throws.

The Emperor: Fire, cold and lightning damage you deal ignores resistance.

The Fool: Whenever you cast a spell that does not deal damage, you can take the Disengage action as a bonus action.

The Hanged Man: You gain advantage on ability checks and saving throws to see through illusions.

The Lovers: You have advantage on saving throws against the charmed condition.

The Magician: Your spells of 1st level and higher ignore half and three-quarters cover so long as there is nothing between the sky and the target.

The Sun: You can cast feather fall at will without expending a spell slot, and you gain immunity to falling damage.

Temperance: You gain advantage on Wisdom (Insight) checks made to discern the motives of creatures.

The Tower: Damage you deal to unattended objects is tripled.

The World: You learn one cantrip on the wizard spell list and it counts as a warlock cantrip for you. You can replace this cantrip with a different one from the wizard spell list whenever you finish a long rest.

Under the Night Sky

At 10th level, you wrest power from the Exile's true foes with ease. Whenever you finish a long rest, you can exchange your chosen Constellations for different ones. Additionally, you gain resistance to radiant damage.

Astrological Savant

At 14th level, you have finally usurped the celestial spheres. You can choose two of the following Dusk Constellations and can exchange them using your Under the Night Sky feature.

The Devil: You have advantage on Persuasion checks.

The Empress: When you finish a short or long rest, you gain temporary hit points equal to half your warlock level.

The Hierophant: You can cast water walk at will targeting only yourself without expending a spell slot. You also gain resistance to fire and acid damage.

Justice: Whenever you cast a spell using a spell slot, you regain hit points equal to the level of the spell slot expended.

The Moon: You can cast enlarge/reduce without expending a spell slot. Once you do so, you can't do so again until you finish a short or long rest.

The Priestess: While this Constellation is selected, your hit point maximum increases by your warlock level.

The Star: As a bonus action, you can choose to end the charmed or frightened condition on yourself. Once you do so, you can't do so again until you finish a short or long rest..

Strength: You count as one size larger when determining carrying capacity, lifting, grappling, and shoving.

The Wheel of Fortune: As a bonus action, you can create items worth 25 gp or less. They persist until you use this ability again.

Eldritch Invocations

Astrological Chart
Prerequisite: Fallen Exile Patron, Pact of the Tome feature

When a creature targets you with an attack, you can use your reaction to unleash a wave of sparkling light around yourself in a 10-foot radius. All invisible creatures and objects in the area are highlighted by glowing motes of stardust. Hostile creatures in the area must succeed on a Wisdom saving throw against your warlock spell save DC or become blinded until the start of your next turn.

Once you use this ability, you cannot do so again until you finish a short or long rest.

Additionally, you can't become lost when you have an unobstructed view of the night sky, and you gain advantage on ability checks made to navigate at night.

SPECK OF SUNLIGHT
Prerequisite: Fallen Exile Patron, Pact of the Chain feature

If you have a luminous shard as your familiar, it gains additional hit points equal to your warlock level, and it can teleport up to 30 feet using a bonus action.

STOLEN HEART
Prerequisite: Fallen Exile Patron, Pact of the Blade feature

You can create a two-handed weapon made of smooth black metal impaling a gleaming gemstone using your Pact of the Blade feature. When you attack with this weapon, you can use your Charisma modifier, instead of Strength or Dexterity, for the attack and damage rolls. While wielding this weapon, you can choose to cast cantrips through your Cosmic Conduit feature, though the additional radiant damage or temporary hit points do not apply and you can't do so with cantrips that require a weapon attack.

THE EXILE'S DEMAND
Prerequisite: Fallen Exile Patron, 20th level

You can cast *wish* once without expending a spell slot. Once you do so, you can't do so again until the sun rises at dawn after seven days have passed.

AN ELVISH LEGEND OF THE EXILE

Once, there was a nameless star that hung above the world, shining among all its brothers and sisters. All of them spoke to one another and watched the universe, as they had since the beginning of time and in the countless eons since.

They performed their celestial dances with precision and inscrutability, circling and shifting without a single thought for the worlds that orbited them.

However, this star was not like the others. It looked upon the world we walk and saw that there was life. Intrigued, it crept every so slowly toward our world, watching our fleeting lives pass in mere moments to the timeless and cosmic being.

With great hope and sadness it watched as countless creatures rose and fell before it, and it became numb to the violent lives of lesser things, until one fateful moment.

A mortal, singing a song of all the things that make life so bittersweet caught the attention of this nameless star, and so with an effort of will it shifted ever closer and sought to hear.

The song had pulled it from the endless cycle of apathy that had grown within the heart of the star, and it began to care about the life of the mortal. It shined brightly in the nights and competed with the sun during the day. Its well wishes blessed the mortal with happiness and health.

Yet, all of this required the star to move from where it was intended to be in the celestial balance. The other stars were disrupted and cried out, spiteful and envious of the emotion a nameless one among their number could feel.

Their rage was made manifest, and the stars struck the place where the mortal lived with the hate of one thousand suns, utterly destroying the mortal. They then took their former sibling

and cast them down from the heavens, to wander and beg for champions to bring it justice and peace.

So remember, children, do not follow the dancing lights that come wandering in the night. Those are the servants of the Exile, and the road they walk will only end in sorrow, either for themselves or for the world.

TRAITS OF THE EXILED

Warlocks who have taken the purpose of the Fallen Exile to heart are known as the exiled, as they often forsake societal norms and boundaries in their quest. Consider adding one or more of these traits when creating a warlock or after serving the goal of the Fallen Exile.

d20	Trait
1	You are often content to watch the interactions of others rather than participate directly.
2	You never seem to blink.
3	You sometimes sleepwalk and awaken under the starlit sky.
4	You have a strange affinity for dark places.
5	You are touchy and quick to anger.
6	You tend to find decay especially disgusting.
7	You frequently curse at the sky under your breath.
8	You find it difficult to maintain loving relationships.
9	You are the first to extinguish a torch in the darkness.
10	You appear youthful and pure in starlight.
11	Your skin is always oddly smooth.
12	Your eyes appear to contain a field of stars.
13	You glow faintly when light is cast upon you.
14	Your heart seems to shine gently inside your chest.
15	Clothing or armor you wear for long periods of time adopts symbols representing constellations.
16	Your blood slowly becomes motes of light when exposed to air.
17	Your hair becomes white, like the color of a star.
18	A scent of clean night air seems to follow you.
19	When you cast a spell, a nimbus of light forms around you.
20	Sparks and ribbons of light trail from your fingertips whenever you gesture.

Uh, I don't know what to say here. Brutal stuff. —X

Monastic Tradition: Way of the Black Star

The night sky has offered peace and solace in times of turmoil, exposing the insignificance of those who walk upon the earth, yet you do not call out for peace. Your meditations have taken you to the void where the Fallen Exile once shined, filling your spirit with a blackened and sorrowful power. This may have come to pass by the intervention of the Exile, spiritual enlightenment you have sought yourself, or the teachings of a master who has traveled this dark path. Regardless of your original intention, your ki has been corrupted by this unnatural void within the cosmic order, granting you the ability to draw it forth to form a deadly weapon of light and eerie blackness. Fueling your techniques with the anguish of your foes, you strive ever closer to understanding the secrets within the eternal black star that lies at the center of the cosmos.

Void Blade

At 3rd level, you learn to pull the corruption in your ki forth to create a weapon from light and shadow. This monk weapon inflicts 1d8 slashing damage and has the light, finesse, and thrown (30/60) properties. You can choose to manifest this weapon whenever you would attack with it, and it vanishes when it leaves your grasp or after being thrown. You can choose the appearance of this weapon whenever you summon it, but it always appears to be constructed of pure blackness clad in streamers of light.

Moonlight Techniques

Also at 3rd level, your meditations unlock the powers hidden within your void blade, and you can channel your ki to activate them. You can spend 1 ki point to cast *black lotus assault**, *duskwalk**, *falling spider's spite**, or *masterful focus** without providing material components.

Acolyte of the Lost Sun

At 6th level, your ki begins to manifest around your body as tiny motes of shadow that seek to preserve life even as it is taken. Whenever you cast a spell by spending ki points, you can use your bonus action to enter a defensive stance until the start of your next turn. The first time you take damage while in this stance, you can reduce that damage by three times the number of ki points you spent to cast the spell.

Starlight Techniques

Also at 6th level, the darkness within your void blade deepens, granting you further power. Your void blade's damage is now considered magical for the purpose of overcoming resistance and immunity to nonmagical attacks and damage. Additionally, you can spend 2 ki points to cast *tormented flurry**, *shadow armor**, *dark secret**, or *heartripper** without providing material components. Finally, you can spend 2 ki points to cast the spells granted by your Moonlight Techniques feature as if they were cast using a 2nd-level spell slot.

Open Soul

At 11th level, your ki has become completely consumed by the space between the stars, leaving you with a soul laid bare to the secrets of the universe and open to consume the ki of others. Whenever you reduce a creature to 0 hit points using a monk weapon or unarmed strike, you gain advantage on your next attack roll, ability check, or saving throw.

Sunless Techniques

Also at 11th level, your devotion to the darkness beyond the sky allows you to call forth even greater power. You can spend 3 ki points to cast *creeping dark**, *fox's fangs**, *shadow refuge**, or *shadow toxin** without providing material components. Finally, you can spend 3 ki points to cast the spells granted by your other Path of the Black Star features as if they were cast using a 3rd-level spell slot.

Otherworldly Knowledge

At 17th level, your spiritual journey has led you to gaze into the black heart of the stars themselves, where all light is eventually consumed, and it has gazed into you, granting you the collective wisdom of the universe. As an action, you can open your mind to this for 10 minutes. During this time, you gain proficiency in all skills and tools, and you can use your Wisdom modifier, instead of another ability modifier, for any skill check.

Once you use this feature, you can't do so again until you finish a short or long rest.

Eclipse Techniques

Also at 17th level, you complete your explorations of your void blade and have finally seen the truth beyond the dark within. You can spend 4 ki points to cast *assassin's promise**, *crimson cloak**, *flashing blades**, or *unseen claw** without providing material components. Finally, you can spend 4 ki points to cast the spells granted by your other Path of the Black Star features as if they were cast using a 4th-level spell slot.

You can never tell if they're about to brood or about to punch you, so that gives them an edge. -X

I sincerely hope no horrible nightmares come out of that giant hole in the sky. Of course, with our luck, there's one already on its way. Guess we'll have to go collect the seven whatsits of whoever to build a magical sealing rune that'll be powered by love and friendship or... something. Still, I guess that's what all of you are for! Well, I hope we're friends. You seem nice, anyways. -Sylvette

The Star of Sorrow

Unlike other Alrisen, the Exile is neither heartless nor inherently of a nature beyond the understanding of mortals. It feels, it grieves, and it plots with a burning and passionate rage. The stars acted without regard for the emotion of the Exile and behaved unjustly. Now, forever chased by the sun, the Exile seeks champions that can help it to find peace or revenge. Once a warlock sworn to the Exile becomes powerful enough, they will have the strength to snuff out the sun itself. However, if they do, it may be the last act they perform.

Light in the Darkness

The Fallen Exile has a story, and this tale may be either too heavy or too unfitting for your game. If you'd like to change the Exile to be more neutral and less dark, consider having it be simply a wandering star that seeks excitement or adventure. You could choose to reduce its relative power to that of a mere wisp that follows the party, occasionally offering insight, but never interfering directly. Sunlight is normally harmful to the Exile, but in a brighter world, the Exile could simply be a child of the sun, exploring or guarding the domain of their parent. It could be an angel of pure starlight, fallen from the heavens and seeking a way back.

Exile Of Mortality

If you're looking to further dissociate the Exile from its celestial origins, consider representing it as a skilled astrologer or astronomer who has discovered the secrets of the cosmos. Their observation of the worlds beyond could have led them to learn truths that mortals are not meant to know, leading to them being outcast from normal society by a priesthood or other organization that desired the machinations of the higher powers to be left unseen.

Incorporating the Exile

If you choose to implement the Exile as it is presented here, consider filling in the open parts of its story. Who was the paramour of the Exile? What did they look like? How did they behave, and why did they attract the attention of this cosmic being? Were all of the other stars as malevolent as depicted, or were there some among the many that disagreed with what was done? Are they responsible for the powers that the Exile can grant to its followers? What is going on with the void left in the night sky where the Exile should have been? Is its absence allowing something horrible to enter the universe? Might there be a cult of shadowy figures dedicated to ensuring that the void grows large enough to consume the universe? If so, what are their methods, and what will they do? The Exile normally seeks to kill all of the other stars, but is that goal set in stone? Could it learn to love again, and if it did, would it give up its mad quest? Would it continue on, motivated by a false sense of justice, or would it seek reconciliation with the others of its kind?

Cultures and Starscapes

When you are introducing the Exile to your world, decide how long it has been around. Was this event relatively recent, or was the Exile cast down centuries or even millennia ago? What has it seen, what has it tried to do in the past, and how has this impacted your world? Has the Exile already won? Is the sun collapsing into a black hole, its transformation only held at bay by the slowly fading magic left in the world?

In any case, at least a few people will have interacted with the Exile, and possibly countless thousands over the ages. Some places may revere the Exile and seek to honor it and worship it, not realizing that its presence heralds their eventual doom. They could see it as harmless and consider it only a symbol of forbidden love and lost opportunities, but they may know the truth about the Exile's motives and be looking for a way to destroy it.

Blades of the Exile

Many individuals have followed the Exile, falling before they could finish their quest. There's a certain flair to the items that they have crafted or influenced, and these creations breathe with a spark of the celestial fires beyond the void. These are the weapons associated with its greatest champions who fell just before their victory.

Rising Dawn

weapon (shortsword), very rare (requires attunement)

This glorious sword leaves ribbons of light trailing in the wake of the blade. Some who have witnessed it say that the ribbons of light appear to reveal a painting of a sunrise. This weapon deals radiant damage instead of piercing damage. Once per turn, when you attack with this weapon while prone, you can rise to your feet and gain advantage on the attack.

Falling Dusk

weapon (shortsword), very rare (requires attunement)

This shrouded blade is cast in a black hue and appears to have stars dimly shining from within. Some say that an image of a sunset can be seen in the dark shadows that follow the blade's edge. This weapon deals necrotic damage instead of piercing damage. Once per turn, when you attack with this weapon while jumping or falling, you gain advantage on the attack, and if you hit, the target is knocked prone. While attuned to this weapon, you don't provoke opportunity attacks while jumping or falling.

Moonlit Midnight

weapon (greatsword), legendary (special attunement)

While attuned to both Rising Dawn and Falling Dusk, you can merge them together into Moonlit Midnight or separate them as a bonus action. You maintain attunement to both shortswords in the merged form, and this counts as attunement to Moonlit Midnight. A rare sight to behold, bystanders have reported that a twinkling image of a full moon in a night sky can be observed trailing behind the blade as the interplay of light and dark spill off into the air. This weapon has the finesse property. This weapon has the abilities of both Rising Dawn and Falling Dusk. Whenever you gain advantage from this weapon's features, you gain temporary hit points equal to half your character level.

> The duality of mortality is such a fickle thing, for every last mortal seems to seek a path to power, yet so many desire to lose themselves in pursuit of the goals of another. How interesting...

THE FORBIDDEN GRAVEYARD
THE PLACE BEFORE DEATH

People die. Flesh decays. Bodies waste away. Yet sometimes, spirits remain bound to the mortal realm and do not enter the afterlife. There exists a place to contain the souls of the undeparted that lack a strong enough physical connection to manifest as ghosts and phantoms. This place is known as the Forbidden Graveyard, yet it is neither sealed against entry nor a place constructed by mortals for the burial of the dead.

ON DEATH'S DOORSTEP

The Forbidden Graveyard is a nexus of sorts, holding all of the souls who have yet to fully pass on. Those strong of spirit and inner vitality may be able to glimpse the gates and grounds as they lay dying, but rarer still are those able to control themselves with purpose once inside. Those who can wander among the false mausoleums, speaking with other spirits and learning their stories and secrets.

THE GATE OF SOULS

Those who continue to linger upon the brink of death will find themselves drawn to the center of the Graveyard, where they will encounter a gate of silver bars. Souls passing to the afterlife flow through it without disturbing the solemn quiet of this sanctuary. Those who can act here, however, are able to stop themselves, grasping the silver bars even as their ethereal flesh burns from the contact. If they manage to close the gate before being pulled beyond, then they have turned their back on death, seeking instead to return to life of. Those who make it to this pivotal moment are marked by the experience and

can call forth ancient powers and unnatural energies from beyond the final threshold where immortals dare not tread.

TRAVERSE THE CARRION FIELDS

The Forbidden Graveyard is most known among those who scavenge the remains of large battlefields littered with hundreds or even thousands of corpses. Those who close the Gate of Souls manage to lift their broken bodies from the bloodstained earth, clutching tightly the goals that drew them back from the beyond. Stories hail them as heroes and champions who have conquered even death, but they are also viewed with suspicion and hatred by those who have lost their loved ones in the same fight. In cultures that venerate the dead and departed, those who have been clearly touched by the Graveyard may be viewed as messengers of the ancestors or kept alive by holy purpose alone. In these cultures, they often take to wearing a small silver amulet shaped like the Gate of Souls to symbolize their determination and will to continue on after their intended time.

WALK BEYOND THE GRAVE

The Forbidden Graveyard is a spiritual phenomenon, so it's easy to include in your world. Consider how rarely people visit and remember the Graveyard. Is this commonplace or nearly unheard of? What traditions are present in your world that focus on this location? Do people try to go there intentionally? What means might someone use to force such a visit? What are the consequences, and what are the intentions of those who return?

Otherworldly Patron: The Forbidden Graveyard

You've stepped into the Forbidden Graveyard, a sanctuary found on the boundary between life and death, where the rare few whose minds are attuned to this place come to wander as their bodies heal or slip away into the cold clutches of the night. Those who embrace the experience and seal shut the Gate of Souls within find themselves gifted with an understanding of both the living and the dead. Unknown to all but those like you, the Gate requires repayment for this mercy, and only the souls of others will do. Choose wisely, for all who cross your path are marked for collection by the Graveyard. It is up to you to safeguard them from that dark plane or to send them there to take your place in the cold embrace of death.

Expanded Spell List

The Forbidden Graveyard lets you choose from an expanded list of spells when you learn a warlock spell. The above spells are added to the warlock spell list for you.

Forbidden Graveyard Expanded Spells

Spell Level	Spells
1st	inflict wounds, mend flesh*
2nd	see invisibility, suffer*
3rd	phantom steed, sending
4th	dark empowerment*, phantasmal killer
5th	hallow, legend lore

Rejection of the Crypt

At 1st level, your refusal to travel through the Gate of Souls has left a mark upon you that cannot be denied. You can add your Charisma modifier to death saving throws, and you gain immunity to effects that would reduce your hit point maximum. While you are at 0 hit points, you can still move, but you can't take actions, reactions, or bonus actions.

Ghoulish Constitution

Starting at 6th level, your flesh is filled with the icy chill of the grave. You can choose to allow attacks against you to hit. Whenever you are hit with a melee attack, you can use your reaction to steal life's precious warmth from your attacker. When you do so, you gain resistance to the damage dealt, and the attacker takes cold damage equal to your warlock level. If the attacker is reduced to 0 hit points by this damage, you gain temporary hit points equal to your warlock level. If you already have temporary hit points, increase those temporary hit points by this amount instead.

You can use this feature twice, and you regain all expended uses when you finish a short or long rest.

Keeper of Souls

Starting at 10th level, your gain a measure of control over the spirits that dwell in the Graveyard. Whenever a hostile undead within 60 feet of you is reduced to 0 hit points, you gain temporary hit points equal to your warlock level. Also, you gain resistance to necrotic damage and immunity to effects that would kill you instantly without dealing damage.

Fear the Reaper

At 14th level, you are as implacable as the specter of death itself. You no longer age and cannot be magically aged. You gain immunity to the charmed and frightened conditions. As an action, you can mark a creature you can see within 30 feet of you with a terrible curse. When the creature takes damage, you can use your reaction to delay that damage and store it within a pool. At the end of each minute after the curse was cast, the target takes twice as much necrotic damage as is stored in the pool and the pool is emptied. This curse lasts for one hour or until the target dies.

Eldritch Invocations

Ledger of the Deceased
Prerequisite: Forbidden Graveyard patron, Pact of the Tome feature

Whenever a creature that you can see within 120 feet of you dies or you touch a corpse, you can choose to have their name be magically inscribed in your Book of Shadows. That creature's corpse is always considered to be present and whole within your Book. If your Book of Shadows is destroyed, all the names within are lost.

Creature of Carrion
Prerequisite: Forbidden Graveyard patron, Pact of the Chain feature

If you have a haunted crow as your familiar, it gains additional hit points equal to your warlock level. While you have this familiar, it recovers a single use of its Shriek action whenever either of you reduces a creature to 0 hit points, and the saving throw DC of this action equals your warlock spell save DC.

Eyes of the Lost
Prerequisite: Forbidden Graveyard patron

As an action, you can choose to perceive through the senses of an undead creature within 120 feet of you until the start of your next turn. During this time, you are deaf and blind with regard to your own senses.

Grim Guardian
Prerequisite: 7th level, Forbidden Graveyard patron

While asleep, you gain resistance to all damage, and you automatically awaken when a hostile creature is within 15 feet of you. If you awaken in this way, you gain advantage on your first initiative roll within 1 minute.

Scythe of the Lifetaker
Prerequisite: Forbidden Graveyard patron, Pact of the Blade feature

You can create a two-handed weapon of polished bone and golden metal using your Pact of the Blade feature. This weapon deals radiant damage instead of its normal damage type. When you attack with this weapon, you can use your Charisma modifier, instead of Strength or Dexterity, for the attack and damage rolls. On a hit, you can cast *healing word* as a bonus action using a warlock spell slot.

Soul-Burning Incantation
Prerequisite: Forbidden Graveyard patron

Whenever you cast a cantrip that deals damage or make a

weapon attack, you can use your bonus action to empower it with cruel energy. Each target hit gains disadvantage on ability checks until the start of their next turn. If an empowered attack reduces a target to 0 hit points or is used to attack a corpse, the target can't be raised as undead or resurrected by an effect or spell cast using a spell slot lower than 6th level.

FROM THE JOURNAL OF THE GRAVEBOUND, ALVIRA RUX

Truly, there is power here. All around me, the currents of fate itself writhe at my fingertips, begging me to tear them asunder. I cast the blood upon the corpse and command it to rise. The power pours from me, giving life to the dead.

I must be cautious so the villagers don't figure out that their former friend has returned to them in such a state. The last necromancer was foolish and drew the ire of many. I will not make the same mistake.

I will learn the strengths and weaknesses of those I call forth and commit them to memory, as failure to remember can lead to frustration and defeat.

I will consult with the higher spirits and the powers that guide this world and determine how I will proceed with these dark minions at my command.

I will ally with those who understand this power and accept it, as those who would cast it aside may have their reasons, foolish as they may be.

I will think with haste and command my servants with swiftness and clarity, that they may act with speed and sureness beyond even the cunning of their former souls.

These are the tenets of a true necromancer, and thus they shall be my own.

TRAITS OF THE GRAVEBOUND

Warlocks who have walked the line between life and death and endured the trials of this mysterious place are known as gravebound, as their fate is tied to the inevitable passage of the soul into the beyond. Consider adding one or more of these traits when creating a warlock or after gaining knowledge of the Graveyard's forbidden arts.

d20	Trait
1	You avoid walking over graves and corpses whenever possible.
2	You occasionally forget to breathe.
3	You sometimes sleepwalk and awaken on bare earth.
4	You have a strange affinity for carrion birds.
5	You are overly eager to discuss death and decay.
6	You snap your fingers when you're anxious.
7	You talk to corpses and expect a response.
8	You tend to twitch in an unnatural manner.
9	Your shadow sometimes whispers in the voices of the dead.
10	You appear skeletal and decayed in moonlight.
11	Your skin is always cool to the touch.
12	Your eyes are like those of a dead man.
13	Your flesh doesn't normally bleed when cut.
14	Your heart beats only a few times per minute.
15	Clothing or armor you wear for long periods of time loses its color, becoming either pale white or dark black.
16	Your blood slowly becomes dust when exposed to air.
17	Your hair becomes pale and grows at an unusually high rate.
18	A scent of freshly turned earth seems to follow you.
19	When you cast a spell, spectral forms can be seen hovering around you.
20	Corpses twitch and shift while in your presence.

Xandith told me a story about one of these warlocks that he had met before I traveled with him. She had obtained a book supposedly written by the Weaver of Lies, and its pages would constantly rewrite themselves, speaking of hidden mysteries that would appeal to the reader's desires. They were all lies, of course, but this warlock was clever. She constructed a massive undead machine from every corpse within an ancient crypt. The device would use the undead to read the book and record what appeared, then mark it off from the possible truths. She was seeking a way to bring back the dead without the use of rare material components or dangerous and malignant practices. It was quite a noble effort, but of course the draw of eldritch energy was interfering with the party's attempt to break a curse that afflicted a group of their allies, so Xandith and his companions slew her, destroyed the machine, and hurled the book into the ocean. Such a waste.

—Sylvette

Roguish Archetype: Graverobber

You've nearly died. Sometime recently, or earlier in your life, you've fallen to the brink of death and felt your heartbeat stop. In that moment, far from hope, your spirit wandered the border of life and death, where it entered the Forbidden Graveyard. Amidst the sepulchers and crypts of this haunted dimension, you bore witness to the secrets of life and death, speaking with the fallen whose gaze chilled your very soul. Somehow, you returned from that fallen plane, but it has stained you. Your spirit is filled with both the eerie power of darkness and the flowing force of life, granting you the ability to touch the souls of others directly. You might still be living, but your every step is one of a dead man walking.

Spirit Mending

Starting at 3rd level, your unnatural luck and affinity for the energies of life allow you to bring people back from the brink of death. When an ally within 5 feet of you is below half their hit point maximum, you can use your action to pour healing energy into them. The target recovers hit points equal to your rogue level + your Charisma modifier. If the target has been reduced to 0 hit points, they recover half as many hit points instead. Once a creature has been healed by this feature, it can't be targeted again until it finishes a long rest.

Soul Thief

At 3rd level, you learn to steal the life essence of your enemies, and your connection to the grave grants you incredible power. Whenever you or an undead you control kills a creature with an Intelligence score of 6 or greater, you can choose to harvest a fraction of your victim's soul, binding it into a small object you keep about your person, such as a gemstone, doll, or weapon. Each object can contain only one such soul at a time.

As a bonus action, you can choose to unleash one of these enslaved spirits to do your bidding, freeing it from the item. If the spirit was bound to a weapon, you summon a ghostly version of the weapon and use it to make a melee weapon attack with a 15-foot reach. This attack deals force damage. After the attack is made, the ethereal weapon vanishes.

If the spirit was bound to any other item, its release opens a small, shadowy rift to the Graveyard through the Ethereal Plane. You can teleport to a location that you can see within 10 + 5 times your Charisma modifier (minimum 10) feet of you.

Whenever you finish a long rest, your powerful soul calls to the Graveyard, bringing forth a number of spirits for you to bind equal to your Charisma modifier (minimum 1). The maximum number of spirits you can have bound at once is equal to twice your Charisma modifier (minimum 2).

You can choose to release a spirit without effect at any time to make space for a new one.

Whisper to the Fallen

Starting at 9th level, your voice gains an unearthly quality, allowing you to commune with the departed. You can cast *speak with dead* at will without expending a spell slot, but you can only target a soul that you have bound to an item. You ignore the requirement that the corpse must still have a mouth when you cast the spell using this feature.

Spirits summoned from the Graveyard are mindless and rarely have anything interesting to say.

Hangman's Dance

At 13th level, your control over the spirits of the dead enables you to bend them more fully to your whims. You gain the ability to cast *animate dead* without expending a spell slot by unleashing one of your bound souls instead.

You can use this feature twice in this way, and you regain all expended uses of it when you finish long rest.

Also, you can use your bonus action to cause all friendly undead within 60 feet of you to surge with otherworldly power. Each undead can use its reaction to move up to 30 feet without provoking opportunity attacks and ignoring difficult terrain.

No Rest for the Wicked

At 17th level, your darkly stained soul fully reconnects with your body, allowing you to bridge the gap between the Graveyard and the other planes with ease. Whenever you roll initiative, you can choose one hostile creature that you can see within 60 feet of you. That creature is marked by the Gate of Souls as a beacon for the energies of the fallen who lurk within the Graveyard. Once per turn when you deal damage to that creature, you can choose to bind a single soul from the Graveyard to an item in your possession. This mark lasts for one minute.

There's nothing wrong with looting the corpses of your enemies. Anyone who tells you there's no honor in it is just waiting for a chance to snag the good stuff. They'll wait until you come across something neat then call dibs because they "honorably" left the loot untouched earlier. Plus, the enemy would have taken your stuff if you died. Or eaten it. That's just the cycle of life, right? –X

Dig Open the Grave

The Forbidden Graveyard is a place on the razor edge between life and death. There is little here to distinguish those who walk on the mortal plane from those who are in the process of moving beyond mortality, and thus there is little that can be done for these poor souls. Those who travel here while lying at the edge of death are both blessed and cursed with the chance to choose their path. There is a certain peace in letting go and following the path beyond, but for those who choose otherwise, the consequences of their decision can be dire.

The Gate of Souls

The silver-wrought gate that lies within the center of the Forbidden Graveyard is the precipice from which the souls of the fallen enter the afterlife. Not all pass through the graveyard, and not everyone has the opportunity to attempt to close the gate. Only those of strong will and determination to live have the chance to determine their fate, and in doing so, they doom themselves to a new path of suffering and despair.

The Curse of the Gate

There is a cruel reasoning behind the Forbidden Graveyard, and a reason that it has earned such a dark reputation. Anyone who speaks even a single word to a person who has sealed the Gate of Souls is marked for collection by the Graveyard. These individuals are cursed, and are fated to die before their time. It is a subtle, insidious thing. Those who are friends or allies to the Gravebound will often live out their normal lifespans so long as they are protected deliberately by their grim companion, but those who are unaware of their nature or actively hostile will find themselves sliding into the embrace of death ever so slightly faster than they should have.

Grim Fate

These subtle changes to the lifespans of those around them lead most Gravebound to live apart from normal society, seeking to avoid interacting with people to prevent spreading their curse. Some are ambivalent to the curse, saying that anyone who dies before their time is simply unlucky, and that fate is not as fixed as the curse would seem to claim. Others disbelieve, thinking that they have managed to avoid the eerie effects of this dark mark. The misfortune is not immediately obvious, after all. A beloved family member dying a few years before one might expect, slipping away into the night, is not so odd as to represent a supernatural phenomenon. Even still, what could have been done to prevent it? Little.

Death after Death

When a Gravebound truly dies, their soul is trapped forever within the Graveyard. There is little hope for these souls, as they remain here, trapped among all those who have died thanks to the curse that was laid upon them. Those with friends may find companionship and comfort, but few are without enemies. The screaming torments of the damned souls trapped in this purgatorial plane will pursue the dead Gravebound endlessly, chasing them to the farthest corners and deepest reaches of the Graveyard. In these ancient mausoleums, they will hide and plot and scheme, speaking with others of their kind. Those who have come before them enforce an oath: none shall interfere with the choices of new souls that come wandering into this dark place. The reason is simple: if a new Gravebound awakens to their power and lives a life beyond what they were destined, that new Gravebound may discover a way to destroy the Graveyard forever, either freeing the souls within or banishing them to peaceful oblivion.

Dark Purpose

The Graveyard's origins are unclear in contemporary study. Some claim that it was a purgatory created by the gods to test heroic champions and to safeguard them from the clutches of evil deities and fiends while still giving them a way to defy the cruel tides of fate. Others think that there is something more sinister about this place, calling it a trap for the unwary souls who have wandered there. They hypothesize that there is a malignant force that lurks within the Graveyard, feasting upon the souls of the fallen in small enough numbers that the Gravebound who are trapped there do not realize that they have become prey. Many consider it a punishment established by the higher powers for those who would deny their faith, casting them as heathens and heretics for their defiance of the deities that rule the world.

A Dying Mind's Gift

A rare few scholars would simply define it as a natural phenomenon that cannot be explained with a normal understanding of the metaphysical world. They would claim instead that the Graveyard is not an external place, but an internal one, locked within the psyche of each mortal mind. Whenever someone is on the very brink of death, time seems to slow to a crawl, and their mind passes into a dreamlike realm representing their experiences in life and shaped by their cultural beliefs about the nature of death. It is within this sanctum that they can choose to defy the wounds to their bodies and call upon the power locked within their soul, forcing it to cast aside death.

A False Death

If those researchers are correct, then the Graveyard is little more than an idea associated with the awakening of an internal power present within all mortals. Gravebound who die simply think that they have died, and are actually permanently trapped within this strange state, experiencing the sensation of death only when they are resurrected by divine magic. Their supernatural resilience comes from their ability to call on this power, but their weakness is that they cannot decide to willingly stop. The ancient secrets they uncover in the Graveyard are constructs created by their minds as representations of how to use this internal eldritch power, and the spirits of their friends and foes are really only memories come to life within a mind on the brink of death.

An Averted Demise

The deities of the heavens have little say over the events within the Graveyard, but when they insist on interfering, they will send clerics and champions to turn aside wayward souls. To do this, they consume a special poison that will take them quickly to the gateway. Some cannot persevere, and pass through the Gate, while others fall prey to the temptations of power and seek to close those silver gates themselves. Rarely are the divines pleased by this outcome, but those mortals are now beyond their grasp, having seized their own destiny in hand.

I've got a friend who would love to put all of these folks back in the grave where they belong. Defying death is only supposed to happen when it's allowed by the gods, to hear him tell it. Explains why he was so happy to put that necromancer in the ground, but it doesn't explain why I'm still alive. Guess my time isn't come quite yet. I wonder if my deal with the Wolf has something to do with it. —X

Seal Shut the Gate

The Forbidden Graveyard is universally applicable in almost every world, so when including it in your game, there are several things that you should strongly consider. First, you'll need to decide what the Graveyard actually is and how it works in your world. Decide if it exists as it is presented here, or if you'd like to incorporate your own twist on the concept. Is it actually a planar location, or is it located in the mind of each individual? Is it even a place, or is it actually an entity? Is it a god of death prone to making deals or a personification of the true metaphysical concept of Death? If it is a sentient entity rather than a mere construct or force, what is it like? Does it have a gender or other distinguishing referential traits? Does it appear as a skeleton, or is it more abstract? What does it desire? What does it hate? What does it fear? Whom has it made deals with in the past, and how have those gone? Does it have a collection of fallen souls that it torments for entertainment, or is it a benevolent force that offers a second chance for heroes who die before they should?

A Graveyard Unlike Any Other

Once you've answered some of the above questions and decided on the form your Graveyard will take, there are more things you should think about to better define it within your world. Does it appear to everyone, or only to a select few? Who or what created it? Is it associated with a deity of death, or is it something less divine? Is there a fiend or fey creature who is involved, and if so, what do they desire from the souls who pass through? If it appears to everyone, how do some individuals manage to interact with the Gate of Souls while others are incapable of doing so? What are the other fallen Gravebound like, and what schemes have they concocted? What are their friends and companions doing while they are here? Could the party interact with these individuals at some point during their adventures?

Expanding the Graveyard

One of the more common concepts that arises when dealing with death and undeath is the idea of vampirisim, revenants, and other creatures that are sentient but simultaneously dead. The Graveyard's mechanical and thematic features can function as effective stand-ins for many of these ideas. For example, the features gifted to a warlock could easily be reflavored as the cursed power of a revenant, forcing enemies to die without the ability to heal, rising countless times after falling, chilling the flesh of the living, stealing the life of other undead, and standing as a monstrous creature that cannot be defied by the weak of will.

Similarly, the roguish archetype could be reflavored to represent the unearthly power of a vampiric curse that has been suppressed or restricted. Mending the flesh of allies by infusing them with cursed blood provides a clean visual, as does transforming into swarms of bats and wielding weapons of shadow. Listening to the blood of those you have slain while summoning undead minions and servants is suitable for many fantastical imaginings of the vampiric curse, and being able to steal night-endless amounts of blood from a single creature is certainly appropriate to the idea of a cloaked stalker of the night. Changing the visual appearance of a feature while allowing the mechanical effects to remain the same is one of the best ways to expand your character concept.

Inexplicable Oddities

There are many objects associated with death and the endless pursuits of inflicting or avoiding it. Those who scavenge the corpses of the fallen have found these strange artifacts of unknown origin, often crediting the Graveyard.

Auspicious Eye

wondrous item, rare

This glass eye actively looks around, seeking to observe everything in its sight. While holding it and adjacent to a humanoid corpse, you can use your action to insert into the mouth of the deceased if they have one. An illusory light will appear above the corpse and display what the creature saw for the minute prior to their death. Once it has been used, it can't be used again until after the stroke of midnight.

Digger's Shovel

wondrous item, uncommon

This ordinary shovel is rusted and poorly maintained. As an action, you can strike the ground with it to create a 5-foot by 10-foot rectangular hole that is 10 feet deep. If a creature occupies this space, it must make a DC 12 Dexterity saving throw. If it fails, it falls to the bottom of the hole. If it succeeds, it moves to the nearest unoccupied space adjacent to the hole. As an action, you can touch the edge of the hole with the shovel to instantly fill the hole if no living creatures are within. Once the shovel has created a hole, it can't do so again until the next dawn.

Graveseekers

wondrous item, uncommon

These eyeglasses shine with a faint blue sheen in the dark, concealing the eyes of the person wearing them. While wearing them, you can clearly see the exact location of any corpse or undead creature within 30 feet of you.

Unlucky Dice

wondrous item, uncommon

A pair of six-sided dice that have skulls instead of regular pips. As an action, you can roll these dice. When you do, roll 2d6. If the total is odd, you take necrotic damage equal to the result. If the total is even, you gain temporary hit points equal to the result that last 1 hour.

THE GELATINOUS CONVOCATION
THE SLIME BEYOND

Every life has value in the eyes of the oozes. However, that value is often best expressed after one has died. The Gelatinous Convocation is a nigh-infinite number of colorful, sentient slime cubes that float through space collecting the memories of the dead by absorbing their bodies. The Convocation is the origin of all slimes – those that are mindless have simply yet to consume a sufficient amount of memories. However, they are not sorrowful in their task: the Convocation is an entity of joy and happiness, ever-growing and ever-contented.

THE WIGGLING ONES

The Gelatinous Convocation will descend to a world from the sky and gently rest upon the ground, offering a single member as an emissary. All but the core of the cube will fragment into countless slimes and oozes of every variety that lose their connection to the Convocation for a time. These newly born oozes will spread out across the land, seeking dead things to consume and dark dungeons to dwell within. Some are captured and used as guardians, while others wander cheerfully across the landscape.

THE JOYFUL COLLECTORS

Each slime within the Convocation is part of the greater whole, and all have the same innate desire: to learn more about the universe and the lives of all who exist. Most have a strong affection for the memories of vertebrates, as bone is something the Convocation has never truly possessed. Humans and other enlightened creatures offer an exciting meal because their memories are flavored not only with the countless emotions of life but also the deep intellectual thoughts that are so foreign to a mindless creature. Yet, among all the emotions that a slime will consume and experience, only happiness and revelry will remain. It is simply their nature.

THE ICHOROUS AWAKENED

People who have interacted with the creatures touched by the Convocation always describe them in the same way: unnerving. A smiling face atop a pillar of sentient ooze that laughs at everything said and smiles when talking about learning from a corpse tends to generate fear and concern, though most of them truly are as kind-hearted as they seem on the outside. Those who've sworn themselves to the Convocation are often cheerful and upstanding individuals who find happiness in both fantastic adventure as well as mundane life. Citizens of cultures that view the Convocation in a favorable light often encourage their warlocks and sentient slimes to participate in investigations of murder, to answer final questions that the mourning family may have at a funeral, and to act as those who dispose of refuse. The endless joy of these people is infectious, but for those of poor demeanor, it can be taken as sadistic glee or smugness.

WEIRD RITUALS

The Gelatinous Convocation is known for performing countless acts of seemingly random behavior, all acting towards some inscrutable purpose. Witnesses claim to have seen them suck all of the sand from a desert into themselves before flying off, revealing a lost city below. They will then return days later, replacing the sand where it once was, though this time the earthen substance is entirely purple and smelling faintly of lime.

In other instances, they descend into the ocean, becoming almost entirely transparent within the waves. This is harmless to the wildlife nearby, who steer clear of the overwhelming mental presence of the slimes, but is disturbing nevertheless. They will emit powerful sensations of contentment that ebb and flow with the tides, reveling in the curious memories of the tiny lives of the dead fish and krill that float into their embrace.

STUDIED BY SCHOLARS

Sentient slime is a strange substance that few truly understand. Those who dedicate themselves to this pursuit are often considered mad by their colleagues for bothering to research something as mundane as a mindless ichor that drifts about, but when the skeptics are presented with the truth of the Convocation, then their arguments quickly fall apart. Some claim that the slimes, in their unusual shared mind and constant collecting, are seeking to become the most intelligent and learned creatures in the cosmos. Others would argue that this is merely a side effect of their insatiable curiosity, brought about by their consumption of countless corpses over the millennia. Regardless, the slimes are happy, no matter how brilliant they seem to become.

AURA OF CHEER

One of the most remarkable things about the Convocation and the Oozian is that they never seem to be unhappy. Just got stabbed? Happy. Fighting a horde of demons? Happy. Lost a friend in battle? Happy (though slightly less happy than before, admittedly). To them and their servants, suffering is temporary. Death means returning to the embrace of the Convocation, and solitude is an opportunity to gather unique combinations of memories and emotions that no other slime will experience.

There's something pure about them, though they are not all benevolent in their cheer. Torturing an enemy with acid? Happy. Burning down a village? Happy. Inciting rebellion in a peaceful kingdom? Happy. Not all experiences are good ones, as the Convocation would willingly admit. Still, they tend to be pleasant and polite, at the very least, though it is likely because so many more people within the universe are decent folk, and it has colored the swirling green and purple of the Convocation with a heart of gold.

CHANT WITH THE CONVOCATION

The Gelatinous Convocation floats serenely through space and time, so including them in your world is as easy as deciding when and where they have arrived. Are they responsible for all slimes, or just some of them? Does the Convocation have a firm goal, or are they more fluid in their motives? Who has been touched by the Convocation? What phenomena are they responsible for? Where will they go once they decide to leave?

Otherworldly Patron: The Gelatinous Convocation

You've made a pact with the cheerful wandering cubes of sentient ooze that wiggle and wobble their way across the multiverse. They visit worlds beyond measure with the singular goal of spreading their offspring within the deepest dungeons to collect and absorb the memories of the fallen. As they happily bounce between the planes, they occasionally encounter a soul they view as truly amusing. With a mere wave of their pseudopods, they granted you a measure of their strange power over slimes and oozes. Now, their joy is yours.

Expanded Spell List

The Gelatinous Convocation lets you choose from an expanded list of spells when you learn a warlock spell. The following spells are added to the warlock spell list for you.

Gelatinous Convocation Expanded Spells

Spell Level	Spells
1st	grease, hideous laughter
2nd	acid arrow, enlarge/reduce
3rd	meld into stone, water walk
4th	stone shape, slime sphere*
5th	summon slime*, wall of ooze*

Recovered Memories

At 1st level, you learn to dissolve the bodies of the dead and learn from their lives. As an action while standing adjacent to a corpse, you can produce an iridescent acid that consumes the corpse over the course of 1 minute.

Once the process has finished, you can reabsorb the acid to access the creature's memories. You gain information about the creature's last 48 hours alive and the most important memories from their final year of life.

Once you use this feature, you can't use it again until you finish a long rest.

Cheerful Friend

At 1st level, you gain the ability to speak with oozes and communicate simple concepts, even if they can't speak a language. You are not subject to acid damage that would be caused by a non-hostile ooze touching you, and you gain resistance to acid damage.

Side Splitting

At 6th level, your body becomes somewhat... slimy. Whenever you suffer damage, you can use your reaction to divide into a Medium swarm of Tiny oozes. Your hit points remain the same, and you function as a single unified swarm that occupies the same space as a Medium creature. While in this state, you can't take actions other than the Dash action, your movement speed is halved, you gain resistance to bludgeoning, piercing, and slashing damage, you gain immunity to acid and poison damage, you don't provoke opportunity attacks, and you can move through any space as narrow as 1 inch without squeezing. You can return to your normal form at will without using an action, provided there is room to do so.

Once you use this feature, you can't use it again until you finish a long rest. Starting at 10th level, you can use this feature at will as an action. Using this feature as a reaction is still limited to once per long rest.

Acidic Body

At 10th level, your form is infused with caustic power. You gain immunity to acid damage. Whenever a creature starts its turn in a grapple with you, you can choose to have it take 2d8 acid damage.

Consuming Joy

Starting at 14th level, your understanding of the happiness that pervades the Gelatinous Convocation grants you immunity to the charmed condition. You also gain the ability to cast the *polymorph* spell, but the target can only be turned into an ooze. You can cast this spell using a warlock spell slot or without expending a spell slot. When you cast it without expending a spell slot, you can't do so again until you finish a long rest.

Eldritch Invocations

Catalogue of Experiences
Prerequisite: Gelatinous Convocation patron, Pact of the Tome feature

Whenever you use your Recovered Memories feature to absorb the knowledge of a creature, you can store the experience in your Book of Shadows, and make it come to life upon the pages of the book. You can copy and transfer any memories within your Book to another creature by touching them with the Book as an action.

Caustic Blast
Prerequisite: 7th level, Gelatinous Convocation patron

Whenever you cast a cantrip that deals damage or make a weapon attack, you can use a bonus action to infuse it with acidic energy. The cantrip or attack deals acid damage instead of the normal type, can target objects, and inflicts twice as much damage to unattended objects and structures. If a creature damaged by this acid is using a nonmagical shield, they must make a Dexterity saving throw against your warlock spell save DC. If they fail, their shield is destroyed.

Convocation's Child
Prerequisite: Gelatinous Convocation patron, Pact of the Chain feature

While you have a wiggly cube as your familiar, it gains additional maximum hit points equal to your warlock level. When you reach 6th level, you can choose to have your wiggly cube grow to become a Medium creature, and at 14th level, you can choose to have your wiggly cube become a Large creature. You can change the size of the cube as a bonus action. Whenever it is Medium, it's Engulf damage improves to 2d8 initial damage and to 4d8 at the start of the cube's turn. When it is Large, the damage improves to 3d8 initial damage and to 5d8 at the start of the cube's turn.

Jiggly Defense
Prerequisite: 11th level, Gelatinous Convocation patron, Pact of the Blade feature

When you would take damage, you can use your reaction to gain resistance to bludgeoning, piercing, and slashing damage from nonmagical attacks until the end of the current turn.

SLICK HANDS
Prerequisite: 7th level, Gelatinous Convocation patron

Your arms extend in rope-like coils of ooze. When you make a melee attack on your turn, your reach for that attack is 5 feet greater than normal. Also, you have advantage on checks made to maintain a grapple and on Sleight of Hand checks.

SLIME SLAYER
Prerequisite: Gelatinous Convocation patron, Pact of the Blade feature

You can create a weapon made from colorful ooze using your Pact of the Blade feature. You can choose to have this weapon inflict acid damage. Whenever you hit an enemy with this weapon, you can use a bonus action to attempt to grapple the target. When you do, you can make a Charisma (Athletics) check instead of a Strength (Athletics) check. You can maintain this grapple using Charisma (Athletics) checks.

UNUSUAL FORM
Prerequisite: 13th level, Gelatinous Convocation patron

Whenever you would be subject to a critical hit, roll a d6. If the result is a 5 or 6, the attack is not a critical hit. Additionally, you gain resistance to poison damage.

TRAITS OF THE CONVOKER

The Convocation touches more than just the soul. Consider adding one or more of these traits when creating a warlock or after contributing to the Convocation's memories.

d20	Trait
1	You tend to lick your hands clean.
2	You would rather pour water on your head than drink.
3	You sometimes talk in your sleep, replaying the memories you have taken from the dead.
4	You have a strange fondness for gelatin.
5	You are overly-eager to discuss death and the consumption of memories.
6	You roll your stomach when dancing.
7	You weep uncontrollably at odd times.
8	You tend to wiggle in an unnatural manner.
9	You sometimes confuse people for corpses you've consumed.
10	You appear wet and sticky.
11	Your skin is always slimy.
12	Your eyes are acid green with purple flecks.
13	Cuts on your skin move like mouths.
14	Your heart feels like it wanders around in your chest.
15	Your blood slowly becomes slime when exposed to air.
16	Clothing or armor you wear for long periods of time is scoured clean, becoming shiny or fresh.
17	Your hair is perpetually spiked with gel.
18	A scent of lime or other fruit seems to follow you.
19	When you cast a spell, your veins flare with color.
20	You track footprints of slime wherever you go while outdoors. You can suppress this when you notice it.

CHANT OF CONSUMPTION

Oloo! Oloo! Cubed Ones, take this body!
Oloo! Oloo! Find the eternal joy!
Oloo! Oloo! Seek the freedom from sorrow!
Oloo! Oloo!
 Take this discarded vessel!
Oloo! Oloo!
 Unite this broken shell!
Oloo! Oloo!
 Let us know! Let us see! Grant us this enlightenment!
Oloo! Oloo!
 -Funerary practices of the servants of the Convocation,
 9th Era

Weird. Very weird. They make for very nice hosts though. The Weaver and the Keeper are deceptive folk, but I've never been able to understand what the Convocation wants.

Also, slime and ash do not mix well together. It's messy. It also stains carpets. Badly.

I mean, when I was around them they got rid of a perfectly good desert and replaced it with an entire kingdom of slime-folk. In my eyes, it's a travesty, but at least they enjoy themselves. -X

Yes, Xandith, but the Oozians fed you chairs and gave you somewhere nice to sleep, didn't they? That's nicer than anyone else we've met. I think we should stay here. They're so happy all the time and it's quite refreshing, really. I'm staying, anyways. You can go off and fight things and make doe-eyes at Pyre. -Sylvette

Arcane Tradition: Esoteric Plasmology

It is common for one to ask a disciple of this tradition: "Are you a wizard that casts ooze-related spells, or an ooze that is a wizard?"

The truth is, both are correct.

Esoteric plasmology has long ties to the Gelatinous Convocation, which wanders between worlds spreading happy, cheerful slimes to all corners of the multiverse. Though direct interaction with the Convocation is uncommon for practitioners of this tradition, many are apprenticed to more powerful ooze wizards for a time as they learn to control their newfound power. While the slime core that awakens within a practitioner seems to grant a surprising amount of control over one's form, careful study and research is required to coax the more powerful magics from this arcane phenomenon. As such, ooze wizards traditionally adventure in order to expand their knowledge of the physical world, enjoying a life of leisure and hardship alike in their quests for purpose and power.

Primordial Form

When you choose this tradition at 2nd level, a slime core develops within your body, allowing you to assume the primordial form of the first acolytes of the Convocation. As an action, you can enter a primordial form, filling yourself with the giddy glee of an ooze and changing your appearance to appear as a slime-like caricature of your normal form. You gain advantage on Charisma checks and gain resistance to acid damage, but you suffer disadvantage on Wisdom checks. You can exit this form as an action, though doing so requires a successful Wisdom saving throw against your spell save DC.

Simply Slippery

Also at 2nd level, your newfound malleability and magical aptitude grants you several benefits. You can use an action to begin to emit bright light in a 10-foot radius, and dim light in a 20-foot radius.

Whenever you would suffer damage from falling, you can use your reaction to reduce the damage taken by four times your wizard level.

Finally, you can squeeze through spaces at least 5 inches wide, even if you would not normally fit.

Weird Magic

At 6th level, the mystical motions you perform when casting spells become fluid and warped, causing slime to drip from your fingertips with every gesture. Whenever you cast a spell, you can choose an unoccupied space within 10 feet of you. The coiling ooze from your hands assembles in this space, forming a 5-foot cube of colorful slime. This slime is immobile, provides half cover, has an AC of 6, and has hit points equal to your wizard level. The slime remains until you dismiss it (no action required) or it is destroyed.

As a bonus action, you can cause one of these slimes to extend a pseudopod to grab a creature within 5 feet of it. The target must make a Strength saving throw against your wizard spell save DC. If they fail, they are grappled by the cube. The DC to escape from the grapple is equal to your spell save DC.

Caustic Viscosity

At 10th level, the magic you wield becomes further infused with ooze. Whenever you cast a spell with a duration of "Instantaneous" that affects an area, you can use a bonus action to summon a mass of slime in the area. The ground within the area becomes difficult terrain for one minute, or until another spell is cast targeting the area that inflicts fire, cold, or necrotic damage. Creatures that end their turn within the area suffer 1d6 acid damage. You ignore the effects of this slime.

Cheerful Recollection

At 14th level, your mastery of the arts of esoteric plasmology has granted you a connection with the Gelatinous Convocation, allowing you to tap into their understanding of the world through the creatures they have gracefully consumed. Whenever you are in your primordial form, you can add your proficiency bonus to any skill or ability check you make.

Additionally, you learn to cast *speak with dead* as a ritual.

Be wary of being around slime too long. It is contagious, and you will become a gelatinous airhead like S did. I'm glad Pyre is actually sensible. -X

p.s. I'm really dumb and I like to eat chairs more than real food because I'm a dummy.

Exxey, I made your girlfriend out of wood and some magic as a whim when building that ship. Figurehead, they said? Yeah, you got a figurehead with a FIGURE didn't you! Hah! If you want to call me an airhead, then you're just outta luck; I'm the one writing the big sketchy notes in this thing and you're just sitting there letting me imitate your handwriting because we both know you'd burn the paper. Respect the slime, or pay the fine! -Sylvette!

WITNESS THE WIGGLY ONES

The Gelatinous Convocation have an interesting disconnect from the other Alrisen that you can use to your advantage. They are brilliant, but compared to the dark schemes of the Keeper and the Weaver, they are relatively obscure in their motives and actions. In most cases, they are not actively malevolent, and almost all are simply content to observe, consume, and spread. Think of the Convocation as a particularly friendly kind of migratory moss: it acts in accordance with an innate desire but often lacks any higher ambition, despite its advanced intellect.

WOBBLING JIGGLIES

Slimes and oozes are the core components of the Convocation, as one might expect, but there are many different things that you can do to make your slimes interesting. Consider how a slime may adapt to the environment that it grows within and what kind of effect consuming the entities that live there would have. A slime that consumes nothing but fiends and evil creatures would likely be hostile and malevolent itself, while one that grew from consuming the corpses of benevolent humanoids would probably tend to be nice itself.

Thankfully, intellect on the scale of the Convocation tends to lead to enlightened self-interest, so it rarely attacks others without extremely good cause. The one thing that the Convocation and its children seem to lack is the capacity for despair. They are always cheerful, even in the darkest of circumstances, and that provides a special sense of contentment and positivity to those around them.

When acting as the Convocation, remember that they are comprised of countless minds all acting in perfect unison. Imagine a crowd of thousands of people all yelling a single word at the same time, smiling as they do so. That overwhelming volume and perfect unity is what it's like to be the subject of the Convocation's attention.

FRIENDLY OR FEARSOME?

Not all worlds are suitable for such a happy Convocation. While slime is the obvious primary theme of the Convocation, it has secondary themes of cheerfulness, death, memories, unity, and growth. If you are interested in changing one or more of these themes, you can easily turn this joyous group into a nightmarish horror. Imagine if the Convocation was not the origin of all slime, but was instead simply the result of a fiendish creature's dark experiments and greed for the souls of the dead. The Convocation could act as harvesters and collectors of secrets and spirits, devouring everything in its path. It could be sorrowful, filled with bitter regret and pity for those that die to it, or it could be equally cheerful and simply sociopathic, glad to be away from the fiend and free to consume and spread as it feels that it should.

PROTECTORS AND COLLECTORS

The Convocation is known for being open to deals and trades with the sentient races, though the price is often paid in the corpses of other sentients. Thankfully, the Convocation does not advocate violent means of gaining these dead in most cases, and instead will simply ask for the recovery of memories that should have been collected by it in the first place. Once the task is complete, the Gelatinous ones will attune the new warlock to their eldritch energies, granting them power over the slime now within them.

One of the Convocation's most remarkable feats is the ability to bring the dead back to life as Oozians. When a civilization is on the brink of cataclysmic destruction, a representative of the Convocation will arrive and present a simple yet heavy offer to the inhabitants: swear their minds and futures to the Convocation, join with it, and be preserved within a massive cube of crystalline ooze. The crystal is then placed in a hidden location within the now-fallen civilization, and when it is found, the inhabitants shall be freed.

In one instance of this, a cursed king who stole power from other eldritch beings threatened an island nation with cataclysmic destruction, burying their entire island in sand. The inhabitants, fearful of the king's power and helpless to stop him, forged a pact with the Convocation. More than a century later, a band of wandering heroes stumbled across a single tower emerging from the sand. When they entered, they discovered the ruined civilization, and with the help of the Convocation, they freed the souls trapped within. Reborn as oozians, the new slime-folk waged war on the king, empowered by the might of the Convocation.

FLUBBERY FLOBBERIES

Surprisingly, the Convocation has an unusual tendency to create magical items. Admittedly, most of these are made of solidified slime, but their power is undeniable. The secrets of slime-smithing are difficult to learn and even harder to initially discover, as each weapon or armor comes with a curious quirk.

ADHESIVE ARMOR

armor (any), rare (requires attunement)

While wearing this green, ichorous armor, you gain advantage on any checks you make to initiate or maintain a grapple. Additionally, you can move along vertical surfaces on your turn without falling during your movement. You take no damage from falls of 30 feet or less.

JELLY HELM

wondrous item, rare (requires attunement)

Vibrations in the air around you are amplified by the supple slime covering your head. You gain blindsight out to a range of 20 feet.

SLIPPERY SKEWER

weapon (dagger), very rare (requires attunement)

This dagger appears to be crafted out of an unknown gemstone, but it is actually hardened slime. While attuned to it, you gain advantage on any check you make to escape a grapple, and you can take the Disengage action as a bonus action. When you hit with this weapon, the target is coated in slime until the end of its next turn. A creature coated in slime gains disadvantage on Strength and Dexterity checks and falls prone if it ends its movement on a surface. Creatures who don't touch surfaces to move are immune to these effects.

WOBBLING CESTUSES

wondrous item, very rare (requires attunement)

While wearing these gauntlets, your unarmed strikes can deal acid damage instead of their normal damage type. Whenever you take the Dodge action and a creature misses you with a melee attack, you can use your reaction to make a single unarmed strike against the attacker. On a hit, the target can't take reactions until the end of its next turn.

THE GRAY PORTRAIT

THE FINAL MASTERWORK

Some may refer to blood as the currency of the soul, stating that life itself and all of its joys can be found within and arguing that death is merely a loss and decay of that blood. Others, however, argue that this precious currency is not blood, but paint, ink, graphite, and canvas. These individuals have unlocked the secrets of the Gray Portrait, for they have asked, "If art is my life, then can my art contain my life, and can my art contain my soul?"

AN EXPRESSION OF INTROSPECTION

The Gray Portrait is not a singular entity or object. Instead, it is a technique, a motif, a desire, and an insatiable hunger that must be pursued without pause or question. The Portrait is a manifestation of the unquenched fire within the mortal soul, and it appears as one would choose to display that which they know best: the self. The Gray Portraits are paintings and statues, masks and masonry, metalworks and construction of arcane complexity. The bargain one creates with a Gray Portrait is no deal with a tormenting devil, unless one considers what lies within the mirror to be a fiend.

ART FOR THE SOUL

The process for creating a Gray Portrait often begins with a mad sort of narcissism and a desire for one's own perfection. This devotion to artistic endeavors and constant challenge to grow and improve forces an artist to strive toward seemingly impossible heights of talent and skill, mastering their chosen art form in a fraction of the time it would take an ordinary person. At the same time, they suffer the price for their talents: food sits uneaten, pleas from friends are ignored, cries for attention go unanswered, and even one's competitors view them with distress and concern.

Nevertheless, they continue undeterred.

THE FINAL STROKE

When the artist has been completely consumed by their work, left only as a fraction of the person they once were, they may finally feel ready to pursue their masterwork: a portrait, not as they are, but of what they wish to become. They pour their soul into this piece, driven to continue without rest. Reds and crimsons are painted with their blood, marble is broken from the block with their bare hands, and metal is forged without regard to burns and exhaustion.

After countless hours of unceasing work, the finishing stroke is painted, the last curve is smoothed, and the metal is finally quenched. The artist falls nearly comatose in the process as their soul slips away and merges with the Gray Portrait.

The artist's body is consumed when the transference is complete, but a new one is soon created, identical to the form depicted in the Gray Portrait. The artist steps forth from the medium, eyes flashing with pride and delight. Looking over their masterpiece, the artist notices an oddity: the withered husk they left behind is now within the art. A chilling realization overcomes them as they realize their soul is trapped within the portrait. Looking at their masterpiece again, they now see only an expression of their flaws, their hunger, and their cruelest desires. It lacks any hint of perfection, and instead it speaks and demands satisfaction.

CONDUIT OF AMBITION

The Portrait is more than a simple painting, sculpture, or mask. It is a conduit to the eldritch power wielded by fantastic beings. There is a certain elegance in this, as the font is not some external source offering power to an unwary mortal, but the result of a mortal creating a patron to grant them power. Therefore, the Gray Portrait bears certain properties that differentiate it from all other Alrisen. It is a newly created entity of power and spite, envy and lust, hunger and jealousy. It is the defiance of the higher powers of the world and an expression of one's mad quest to obtain satisfaction of a desire that can never be satiated. That is the one thing that the heavens often forget – the hells do not make darkness. They reveal it, nurture it, and allow it to grow. The power to defy a god does not come from eldritch rite and unholy ritual. It comes from eternal, insatiable ambition.

A NEW MASTER

The Portrait is not entirely bound to the artist in every fashion, however, for it is still a separate object and distinct expression and manifestation of the soul. The new body that the Portrait creates for the mind that painted it is especially vulnerable to the desires of the soul bound within that canvas, and therefore will often act erratically or destructively when the desires of that foul entity are not met. Some have described individuals who have created Portraits as mad, as many obey the dark demands that surge forth from their Portraits without a moment's thought. They are constantly driven onward by the destructive passions that lurk deep within their former selves. This spiritual corruption seeps into the soul within the Portrait as the desires are fulfilled, leading to their eventual descent into darker practices.

ELDRITCH ARTS

The strange power that led to the creation of a Portrait is one of eldritch origin, stretching back to the beginning of time. It was once said that you could capture the soul of another person in art, and the speaker was halfway correct. You can capture your own soul, and in doing so, you leave yourself open to the eldritch powers of the universe. This is often expressed in fantastical magic that appears as though painted, with bolts of burning light flaring across a canvas of reality or runes of pure silver inscribed into the masonry. Illusion is the forte of the painter and the sculptor, making visions appear from naught but wood and ink and stone. Thus, illusion is the power of the Portrait, making one appear beautiful and strong, when in reality that strength is merely concealed disdain for the laws of the natural order. Death is alien to the Portrait-maker, for a body crafted from art is not a body at all, but a shell that houses the few discarded remnants of a soul that should have long since departed.

PAINT A NEW PORTRAIT

The Gray Portrait is a very personal creation, so this phenomenon may be unique to one person, or a widespread practice. What have others experienced in the past, and what mark have their desires left upon the world? Are they known as depraved monsters, or are they seen as masters who have sacrificed everything for glory, power, and success?

OTHERWORLDLY PATRON: THE GRAY PORTRAIT

Your dedication to art and beauty has led you to discover the art of creating a Gray Portrait: an artifact that your soul and body are bound to that channels the ambitions you have always held but never revealed. The portrait reflects your inner self and the dark desires you hold, and suffers the damage you would take, the diseases you would contract, and the cruelty you may inflict. It grants you the power to use your art to perform feats of incredible magic, and to paint beauty and ugliness alike upon the fabric of reality. This freedom often has hideous consequences, as you are forever tormented by the demands of that horrible self that lurks within your painted mirror. You are not yourself. You are a copy, a false perfection created by a master, and your master's demands must be met. The Portrait requires it.

EXPANDED SPELL LIST

The Gray Portrait lets you choose from an expanded list of spells when you learn a warlock spell. The following spells are added to the warlock spell list for you.

GRAY PORTRAIT EXPANDED SPELLS

Spell Level	Spells
1st	color spray, sanctuary
2nd	calm emotions, enhance ability
3rd	glyph of warding, sending
4th	death ward, stone shape
5th	mislead, seeming

BOUND TO THE PORTRAIT

At 1st level, you create and magically bind yourself to your Gray Portrait. The Gray Portrait is a Small or Medium object that weighs at least 15 pounds, has AC 15, hit points equal to four times your warlock level, resistance to all damage, and uses your statistics for saving throws. It can be repaired at a rate of 1 hit point per minute. You can choose to see through the Portrait's eyes at any time and are always aware of its current state. If your portrait is destroyed, you tirelessly construct another during your next long rest, and you gain no benefit from that long rest.

If a spell has the sole effect of restoring you to life, such as *revivify*, the caster can cast the spell on the portrait as though it were your whole corpse without using material components, causing you to step forth from your portrait. However, if your portrait is destroyed and you are dead, you can't be revived without the use of the *wish* spell.

You can use your action to cure yourself of any effect that is causing you to be poisoned, diseased, cursed, blinded, or deafened, sending the affliction to appear on your portrait. You can't do this if it is destroyed.

HUNGER WITHIN

At 6th level, your portrait's desires begin to catch up to you, and only cruelty or creation will sate it. Whenever a creature succeeds on a saving throw against a spell you cast using a warlock spell slot, you can use your bonus action to tear an unseen fraction of their life from them. When you do, you learn the target's ability scores. For 1 minute, you gain

advantage on ability checks and saving throws associated with their highest ability score, and they gain disadvantage on their first saving throw associated with that score.

Once you use this feature, you can't do so again until you finish a short or long rest.

THE PAINTED WORLD

At 10th level, your distinction between reality and the false world of art grows ever thinner. As a bonus action, you can touch an artwork that is Large or larger, creating a portal to a demiplane. The demiplane can be up to 100 feet in every dimension, depending on the level of detail present in the artwork. Any object, creature, or effect can pass through into the art demiplane freely as though the art was an open doorway to another room. The demiplane duplicates the subject of the artwork, containing all objects and locations depicted therein. Everything within the artwork is static, including painted creatures, instantly disintegrates to dust if removed, and has no value. While within, everything from the real world changes in appearance to match the style of the art. A creature trying to detect that something within the art demiplane is real has disadvantage on checks made to do so, and creatures standing still within the art demiplane have advantage on Stealth checks. While you are in an art demiplane, you have advantage on checks made to identify objects, people, and concepts represented within.

If you leave the demiplane or if the painting is an animate image and it changes appearance or moves, every creature and object that entered from the real world is immediately ejected and the demiplane vanishes.

THE CANVAS OF REALITY

At 14th level, you learn to change the fabric of the universe to suit the cruel desires of your portrait. Whenever you cast a spell using a warlock spell slot, you can choose a 20-foot cube you can see within 60 feet of you. You can reshape unattended nonmagical objects within that space into different nonmagical objects. The new objects must be of the same size category as the previous objects or smaller and must be of equal or lesser value (measured in gold pieces) and can be of any material or quality so long as it meets the other requirements. For example, you could turn a pile of crates into a collection of chairs, a tree into a mound of ash, a diamond into a fine ruby, or a fortress wall into a pile of sand.

ELDRITCH INVOCATIONS

CURSED PORTFOLIO
Prerequisites: Gray Portrait patron, Pact of the Tome feature

When you cast a spell that creates an illusion, you can use your bonus action to become invisible until the start of your next turn, leaving an illusion of yourself standing in your place.

You can do this a number of times equal to your Charisma modifier, and these uses recover when you finish a long rest.

FRAME OF REFERENCE
Prerequisites: 11th level, Gray Portrait patron

While you are within an art demiplane, you can use your bonus action to teleport to any location within the demiplane that you can see. You can also use your action to create an art demiplane in a different piece of real art you can see and teleport to a location within that demiplane. The new piece of real art must be within 60 feet of the original piece.

Living Art

Prerequisites: Gray Portrait patron, Pact of the Chain feature

When you have an animate image as your familiar, it gains additional hit points equal to your warlock level. You can use your action to change the size of your animate image to any size category of your choosing.

Magnum Opus

Prerequisites: 18th level, Gray Portrait patron

You can cast *mirage arcane* and *symbol* without expending a spell slot. You can cast one of these spells once. After you do so, you can't do so again until you finish a long rest.

Papercut

Prerequisites: Gray Portrait patron, Pact of the Blade feature

You can create a finesse weapon of pale parchment covered in bloody scratches using your Pact of the Blade feature. While you are wielding this weapon, you can cast *minor illusion* as a bonus action. When you cast this illusion in a creature's space, the creature takes 1d4 magical slashing damage. You learn this cantrip if you do not already know it.

Signature Work

Prerequisites: 16th level, Gray Portrait patron

You can cast *programmed illusion* without expending a spell slot. When you cast this spell, you can choose a cantrip that you know. The illusion can cast this cantrip once per minute as part of its programming. It uses your warlock spellcasting ability for attack rolls and saving throw DC, and treats your character level as its own.

If you grant a cantrip to an illusion and the illusion would suffer damage if it were real, it is immediately dispelled.

Once you cast this spell using this invocation, you can't do so again until you finish a long rest.

Thou Art Immortal

Prerequisites: 10th level, Gray Portrait patron

You no longer age and cannot be magically aged. You gain resistance to necrotic damage and immunity to effects that would reduce the value of your maximum hit points, such as a vampire's life draining attack.

A True and Honest Critique of Ser Isendale's Mirror

Truly, this statue is a sham, the artist a buffoon, and the decorations are simply appalling to anyone with a sense of taste or true artistic talent. The eerie thing seems to follow you around the room, and not in the way of a skilled sculptor's work. Nay, when I deigned to inspect it, the accursed thing seemed to bite at me with its little teeth. Surely a trick of the light played upon me by my disgust for the abomination, but nevertheless. Spare your eyes, good people. Much like the artist himself, there is nothing of saintly virtue here!

...The last publishing of Ser Vergaio, before his unfortunate and untimely accident...

Traits of the Artist

Binding one's life to an artwork is not something done without consequence and takes a toll upon the mind and body alike. Consider adding one or more of these traits when creating a warlock or after acting without care for the consequences.

d20	Trait
1	You suffer bouts of paranoia.
2	You insist on having only the finest food and drink.
3	You sometimes talk in your sleep, laughing at the misfortune you have seen during the day.
4	You are extremely critical of other artists.
5	You are a shameless self-promoter, even when doing so would be inappropriate.
6	You move in a way that appears exceptionally imprecise, but is still surprisingly fluid.
7	You laugh uncontrollably at odd times.
8	You tend to look down on those of lower social or economic standing.
9	You oftentimes ignore social standards regarding dress and fashion.
10	Your appearance becomes debauched, refined, youthful, or charming, and always stays that way.
11	Your skin becomes like plastic, smooth and free from marks or imperfections.
12	Your eyes are deep and captivating.
13	Your hands are always freshly manicured.
14	Your heartbeat can't be heard, only felt.
15	Clothing or armor you wear for long periods of time assumes the appearance of what you were wearing in your Gray Portrait.
16	Your blood slowly becomes paint when exposed to air.
17	Your hair is always how it was in your Portrait.
18	A scent of paint, cut stone, wood, or clay seems to follow you everywhere.
19	When you cast a spell, a shadowy duplicate of yourself seems to stand beside you.
20	Your eyes visibly sparkle when you look upon the object of your desires.

How deeply curious I have become. A mortal so devoted to the creation of art that they allow that art to consume them. I wonder what dreams such a mortal might have? Would they be beautiful? I should visit them. Perhaps this one will make a welcome addition to my collection...

Bardic College: College of Portraiture

Bards of the College of Portraiture are artisans first and foremost. Through your intensive study of anatomy and artistry, you've begun to unlock the secrets of instilling your soul into your creations. The creation of a Gray Portrait is a perversion of this technique, linking one's whole essence and intrinsic talent to a single piece of art. Artisans like you view that heretical practice as shortsighted and limited. True artistic mastery lies in the ability to imbue each masterpiece with a fragment of one's soul, binding each creation to the artist in an elegant and harmonious union. Your skill and talent in the manipulation of your life essence allows you to create and animate works of art in your own image. Narcissism is common among the practitioners of this College, though it can hardly be faulted. If everyone could portray themselves so beautifully, surely they would.

Master Artisan

When you join the College of Portraiture at 3rd level, you gain the ability to create incredible works of art at a manic pace. You gain proficiency in any tools required to paint or create statuary, and you can add your proficiency bonus twice to all checks made with these tools.

You no longer require sleep, but must still perform light activity, such as reading, painting, or keeping watch, to gain the benefits of a rest.

During a rest, you can summon the materials and tools to create Small or Medium portraits or statues, and you can complete one such work each hour. You can also expend one use of your Bardic Inspiration per rest to grant yourself an artistic bonus. Roll a Bardic Inspiration die and add the result to your ability check to determine the quality of the your work. To finish a piece made with this feature, you must imbue it with a fragment of your soul, making it permanent and impossible to dispel. You can sell or give away imbued art, but you gain 1 level of exhaustion when someone else takes ownership of a piece.

Living Exhibition

Also at 3rd level, you gain the ability to breathe life and purpose into artwork made in your image.

When you create a painting or statue that is a portrait of yourself and is equal to or smaller than your size, you can imbue it with a fragment of your soul and bring it to life by expending a spell slot of 1st level or higher.

The masterpiece becomes an animate portrait-soldier. Each portrait-soldier has hit points equal to twice your bard level + three times the level of the expended spell slot, has an AC equal to 12 + the level of the expended spell slot, and is equipped with a nonmagical version of a simple or martial weapon in which you have proficiency. If the weapon requires ammunition, the soldier appears with 30 pieces of ammunition in a quiver.

Portrait-soldiers share your statistics and act on your initiative, but automatically fail Wisdom and Intelligence ability checks and saving throws. Portrait-soldiers can't speak, operate magical items, or cast spells and lack sufficient autonomy to attack without your magical direction. A creature that is charmed or frightened by you is also charmed or frightened by all of your portrait-soldiers.

When you take the Attack action, you can expend a spell slot of 1st level or higher to infuse a malevolent spark into your portrait-soldiers. A number of portrait-soldiers up to the level of the expended spell slot can take the Attack action until the end of your turn.

You can animate a number of portrait-soldiers equal to Charisma modifier (minimum 1). Every 24 hours, you must expend a spell slot for each in order to maintain the soul link that animates them, adjusting their hit point maximum and AC if necessary, or they crumble to dust.

Legion's Defense

Starting at 6th level, your control over your portrait-soldiers improves. Whenever a creature would provoke an opportunity attack from a portrait-soldier, you can use your reaction to enable the soldier to make the attack.

Also, whenever two or more of your portrait-soldiers make a saving throw against the same effect and one succeeds, the others also succeed automatically.

Personal Unity

Starting at 14th level, the soul link with your portrait-soldiers becomes more efficient, enabling you to unlock the latent power within them. You can now animate a number of portrait-soldiers equal to twice your Charisma modifier (minimum 2).

Whenever you cast a spell, you can use one of your portrait-soldiers as the point of origin or as a vessel to deliver the spell. Whenever a portrait-solider would take damage, you can use your reaction to channel your life energy into it. The target gains temporary hit points equal to the number of hit points you sacrifice (up to your bard level).

Whenever you would take damage, you can use your reaction to sacrifice the life of one of your portrait-soldiers before the damage is applied. You gain temporary hit points equal to the portrait-soldier's remaining hit points, and the portrait-soldier is destroyed.

Does the world really need more bards? I met a bard once who claimed that his instrument was something called an "air guitar" and he apparently played it with his lips and fingers without actually touching anything. It was annoying and he looked like an idiot. I can't imagine how terrible it would be if that guy made a few dozen copies of himself that were running around and screeching everywhere. —X

Painting the Portrait

Out of all the Alrisen presented here, the portrait is probably the most different from any other. It lacks external motivations, a true form, and even the ability to act independently from the maker. This makes it incredibly easy to implement in almost every world, simply because it doesn't require anything at all. Even the most impoverished tribes of indigenous people have created art in some form or fashion, so a character bound to the Portrait could just as easily be from humble origins as royal ones. A mask made from simple wood and cunningly entwined fibers is still a mask that could act as a Portrait, just as much as a statue of glorious marble.

Changing the Portrait

If you are interested in introducing additional elements of complexity into your depiction of the Portrait, consider giving it more specific and unusual motivations. A person whose inner dark desires are strange and compelling and brought about by the external influence of another entity could easily be driven by motives that are as odd as any Alrisen.

The warlock could be a worshiper of a god of art and beauty, discovering a method for honoring that deity through their work and creations. They could be an apprentice to a master arcanist who discovered the secrets of immortality and used the warlock as a test subject before committing to the act themselves.

The warlock could be indebted to another artist who bound them to a Portrait against their will by unknown means until they pay off their debt. Whatever the origin, try to find some way to tie the character into the world and give them life and purpose. Seeing new lands and slaying nightmarish monsters could be the inspiration for the greatest artwork ever, a masterful composition that would span an entire museum depicting the life of the artist.

Varying Art Forms

The Portrait can come in an infinite number of possible appearances. The only limitations are on size, so you can easily shape the Portrait to fit your character's artistic concept. If you need some inspiration, check the table below.

d8	Portrait Appearance
1	The Portrait is a large mask carved from stone.
2	The Portrait is classical, made from paint on canvas framed in mahogany.
3	The Portrait is odd and impressionistic, stylized to suit a different era. It is framed with silver metal.
4	The Portrait is a statue of you with your arms outstretched, embracing the viewer.
5	The Portrait is a statue forged from gold, depicting you atop a mountain of wealth.
6	The Portrait depicts you practicing the arcane arts.
7	The Portrait is eerily blank, and the image appears only in the light of a full moon.
8	The Portrait is actually an intricate puzzle, with each piece representing a part of yourself.

Artifacts of the Arcane Artists

Art can be more than paintings and sculpture. It can be weapons and armor, swords and shields, even simple tools refined to incredible skill. Those who craft Portraits rarely stop creating art and will often find new and innovative ways to express their desires upon the world. These are some of the objects that renowned Portrait-makers have crafted and scattered across the endless planes.

Bloodstained Brush

weapon (dagger), legendary (requires attunement)

With a blade crafted from hundreds of fine filaments, this dagger is reminiscent of a paintbrush. When you deal damage, you can impart a splash of that damage type's color into the dagger, giving it a unique property that lasts until you finish a long rest. Each property only affects attacks made with this dagger. The dagger can contain multiple colors at the same time.

- **Acid: Green** - Damage dealt can't be healed until the target finishes a short or long rest.
- **Cold: Blue** - On a hit, the target's movement speed is reduced by 5 feet for 1 minute. This does not stack.
- **Fire: Red** - The dagger's base damage increases from 1d4 to 1d8.
- **Lightning: Yellow** - While wielding the dagger, your movement speeds increase by 10 feet.
- **Necrotic: Black** - Attacks made with advantage deal an extra 2d4 necrotic damage.
- **Psychic: Purple** - While wielding the dagger, you gain immunity to the charmed and frightened conditions.
- **Radiant: White** - Damage dealt ignores resistance and immunity.

Infinite Inkwell

wondrous item, legendary (requires attunement)

This inkwell is strangely heavy and seems to pull at the light around it. You can use it to cast *creation* at will as a 9th level spell without expending a spell slot. You can't cast the spell again until the duration of the previous cast has elapsed.

Ordinary Brush

wondrous item, common

This looks like an ordinary paintbrush. You can use it to cast the cantrip *fresh paint* at will.

Sigil Scribe

wondrous item, uncommon

This object appears to be a very cleverly made chisel with fine edges that seem to cut through stone easier than they should. A pair of bars on either side prevent it from going more than one inch into the surface. You can use this chisel as normal, or you can choose to inscribe a sigil. When touched, a sigil repeats the words and sounds made by the artist during its creation.

Sketchy Quill

wondrous item, uncommon

As an action, you can speak a command word to activate this quill. It will sketch whatever you describe, producing an endless supply of ink to do so. It is quick and fairly skilled, but can't compare to a practiced artist.

THE KEEPER OF THE DEPTHS

COLLECTOR OF SECRETS

There are ancient things that dwell within the darkness of the ocean, watching those who live upon the surface of the world with curiosity and envy. Among them, there is a creature known as the Keeper of the Depths – a hulking tentacled crustacean of great wisdom and greater madness that stares into the night sky with greed, for the light of the sun is painful to its sensitive eyes. Thus, it waits for a time when thunderstorms and squalls drench the shores and cloud the skies to emerge, ever hungry for the secrets once thought lost.

AN ACCUMULATION OF AGES

The Keeper is a jealous lord, ever vigilant for another prize. Ships carrying artifacts and treasures often draw its attention, as it will invade the dreams of the captain and crew to drive them into its clutches. The beast shall call forth a storm and rise from its home, grasping the ship and dragging it down into the deep to add to its collection. Its lair is littered with countless shipwrecks and ruins of civilizations long lost to time, and it decorates itself with the weapons of those sent to slay it and the treasures they sought to protect. The Keeper uses magic to preserve the objects that cannot bear the terrible pressure of the ocean depths and places the pieces of its collection that are still living in suspended animation, keeping them alive and aware of their surroundings even as they are trapped and unable to act, blinded by the dark. The horror of this is beyond description, driving even stalwart souls mad.

HARVESTER OF DREAMS

Those who survive but are not worthy of collection are marked by the Keeper, who entraps them in servitude by forcing them to relive death after terrible death in their dreams, only relenting when they agree to serve. It will erase the memories of the torments they have suffered, sealing them behind an accursed black mark hidden upon one's soul. Nevertheless, it will continue to seek out these unfortunate chosen in their sleeping hours, taking knowledge from their minds in exchange for information relating to the goals it wishes them to pursue.

THAT WHICH LURKS BENEATH

All who interact with the Keeper of the Depths directly and live to tell the tale report that it is calculating and merciless, wise and regal in a twisted sense. Some communities along the coastline make offerings to it in an attempt to appease the appetites of its insatiable greed. Sacrifices of maidens and priests during moonlit nights are entertaining to this cruel nightmare, yet those who seek to bargain with it on equal terms often grant it this offering in an attempt to curry favor. Typically, they are rewarded with little more than scraps and teasing hints of secrets once forgotten, but those who succeed are granted power over both the ocean and the minds of mortals. Few among its entourage know the true motive of their master, however...

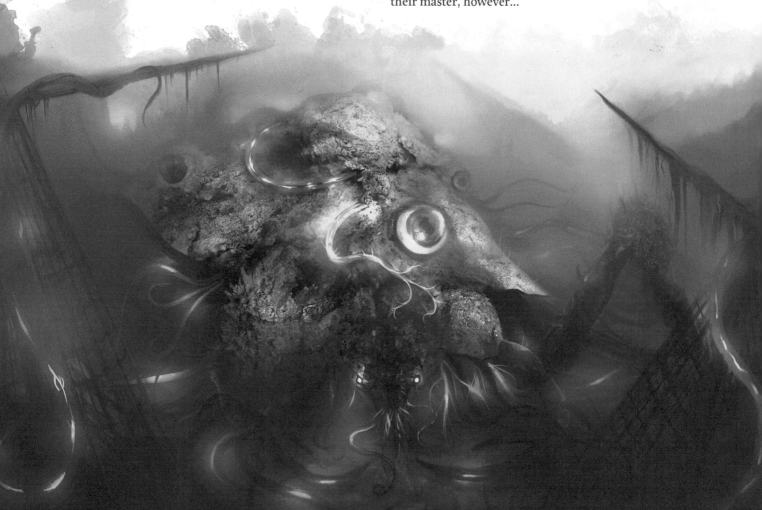

OTHERWORLDLY PATRON: THE KEEPER OF THE DEPTHS

You've made a pact with an ancient oceanic entity known as the Keeper of the Depths. As life teems within the seas, so do the secrets of the forgotten ages – sunken cities, ships lost at sea, and treasures unimaginable gone to the darkest currents that churn with horrible tentacles and creatures from nightmare. The Keeper watches over all this hidden knowledge, and harvests ever more in its endless pursuit of the unspoken secrets of the universe. In the deepest crevices where sunlight has never been seen, all oceans are one to the Keeper of the Depths, and its desire is insatiable.

EXPANDED SPELL LIST

The Keeper of the Depths lets you choose from an expanded list of spells when you learn a warlock spell. The following spells are added to the warlock spell list for you.

KEEPER OF THE DEPTHS EXPANDED SPELLS

Spell Level	Spells
1st	identify, sleep
2nd	locate object, zone of truth
3rd	crushing tide*, luring light*
4th	control water, sleepwalking*
5th	forgotten pain*, legend lore

SECRETS OF THE LOST

Starting at 1st level, your patron visits you in your dreams, stealing fragments of your experiences in exchange for hidden knowledge. Whenever you finish a long rest, you gain proficiency in two skills, languages, or tools of your choice. You remain proficient in these until you finish another long rest, at which point you can choose new ones to replace them.

Additionally, you gain a swimming speed equal to your walking speed.

SAILOR'S NIGHTMARE

At 6th level, you learn to curse your enemies, using the weight of ethereal water to drag them into the sea's embrace. As a bonus action, you can curse a creature that you can see within 60 feet of you for 1 minute. While the creature is afflicted by this curse, it cannot jump or fly, and it treats all terrain as difficult terrain. If the creature is flying or swimming, it automatically descends 60 feet at the start of each of its turns.

Once you use this feature, you can't do so again until you finish a short or long rest.

MADNESS OF THE DEEP

At 10th level, the Keeper's gaze looms over you. Whenever you take damage, you can use your reaction to unleash a wave of black ink to cloud the air in a 10-foot radius of your current location for one minute, heavily obscuring the area. Hostile creatures that end their turn within the area must make a Wisdom saving throw against your warlock spell save DC. If they fail, they are frightened until the start of your next turn and must attempt to escape the cloud.

Once you use this feature, you can't do so again until you finish a short or long rest.

HUNGER FOR KNOWLEDGE

Starting at 14th level, you can summon the terrible maw of the Keeper to appear before you as an action. A massive beak surrounded by tentacles appears and attempts to grab a target of your choice within 30 feet. When a creature is targeted, it must make a Strength saving throw against your warlock spell save DC to shake off the grasp of the horror. If the target fails, it is dragged into the beak and bitten, taking 6d10 piercing damage and 6d10 psychic damage. If this is enough to reduce the target to 0 hit points, you can choose to have them be swallowed whole by the mouth, consuming them. Either way, the maw then immediately disappears.

Once you summon this maw, you can't do so again until you finish a long rest.

If the maw consumes a creature using this feature, your patron visits you in your dreams during your next long rest and grants you a boon in return for the sacrifice. Choose any spell of 5th level or lower from the warlock or wizard spell lists. You can cast this spell twice using a warlock spell slot, after which it is lost. The spell is also lost if you sacrifice a new creature and select a new spell using this feature.

ELDRITCH INVOCATIONS

AWESTRUCK AWAKENING
Prerequisite: Keeper of the Depths patron

Whenever you finish a long rest, your mind overflows with the terrible secrets of your patron. You can speak to one allied creature over the course of 10 minutes, filling its mind with what you've learned. That creature can add your proficiency bonus to one skill or tool of your choice that it is not already proficient in until its next long rest.

BOOK OF STOLEN SECRETS
Prerequisite: Keeper of the Depths patron, Pact of the Tome feature

Whenever you are in conversation, you can take your Book of Shadows in hand and ask a creature one question. The creature must make a Wisdom saving throw against your warlock spell save DC if it is unwilling to answer. If it fails or if it decides to respond truthfully, the most accurate answer the creature could possibly give is immediately written in the book.

Once you do this, you can't do so again until you finish a short or long rest.

CLASH OF WILLS
Prerequisite: Keeper of the Depths patron

Whenever you deal damage to an enemy creature with a cantrip or weapon attack, you can use your bonus action to disrupt their magic. The target must make a Wisdom saving throw against your warlock spell save DC. If they fail, their concentration saving throws are made with disadvantage until the end of your next turn and if the target is not maintaining concentration on a spell, it takes 1d4 psychic damage.

DARKEST SECRETS
Prerequisite: 4th level, Keeper of the Depths patron

Whenever you choose your proficiencies for your Secrets of the Lost feature, you can forfeit both gained proficiencies. When you do, you can have your proficiency bonus be doubled for any ability check on a single skill or tool you are

proficient with. This lasts until you finish a long rest.

DEEPEST SYMPATHIES
Prerequisite: Keeper of the Depths patron, Pact of the Chain feature

If you have an eyeless watcher as a familiar, it gains additional hit points equal to your warlock level. Whenever your eyeless watcher takes the Help action, it can use a bonus action to become invisible until the start of its next turn.

NET OF THE TRUTH-HARVESTER
Prerequisite: Keeper of the Depths patron, Pact of the Blade feature

You can create a net made of coiled seaweed and living flesh using your Pact of the Blade feature, in addition to your normal Pact of the Blade weapon. It has a range of 15/30, AC 15, and hit points equal to 5 + your warlock level. The Strength DC to break free is equal to your warlock spell save DC. Creatures entangled in this net suffer 1d8 lightning damage whenever they knowingly lie.

TRAITS OF THE DWELLER

The Keeper takes more than just restful sleep; it steals humanity and one's own sense of self as well. Consider adding one or more of these traits when creating a warlock or after serving the goals of the Keeper of the Depths.

d20	Trait
1	You often inquire about the dreams of others.
2	You insist on going to bed early every night.
3	You sometimes talk in your sleep, whispering terrible secrets about things unknown to you.
4	You are extremely interested in the secrets of other people, especially those no one else knows.
5	You always listen with complete focus when being taught something.
6	You move in a way that is somehow... *wrong*.
7	You speak to bodies of water and expect a response.
8	You tend to blabber on and on.
9	You sometimes ask personal questions instead of offering greetings.
10	You appear oddly wet at all times, even when dry.
11	Your skin becomes rubbery and cold.
12	Your pupils are oddly shaped, like those of an octopus.
13	Your fingernails have disappeared.
14	Your heartbeat can't be felt, only heard.
15	Clothing or armor you wear for long periods of time assumes the appearance of coral or seaweed.
16	Your blood slowly becomes saltwater when exposed to air and smells like dead fish.
17	Your hair is always wet and discolored.
18	A scent of ocean air seems to follow you.
19	When you cast a spell, dark tentacles seem to reach up from under your skin before disappearing.
20	Chitinous barbs sprout from you skin and seem to easily collect scraps of clothing and plants.

DREAMS OF THE DEEP

The Keeper's reach is more than a mere invasion. Even elves and other races who do not sleep in the traditional sense are vulnerable to the influence of the Keeper of the Depths. Its long and wretched tentacles crawl into the minds of those it takes interest in, but they are only aware of this when they block out the sensations of the world around them. An elf in a trance is vulnerable to this insidious creeping, and the Keeper knows this. Thus, it will visit them in the darkest corners of their mind, crawling about like a crab, picking apart their memories with claws of pure eldritch arcana.

Once the Keeper discovers something interesting, it will begin to dig, burrowing into the consciousness of the unfortunate victim. Tentacles of unearthly energy pour forth from its dream self into the surrounding ego, changing and twisting existing memories as it extracts what it desires.

Those who have experienced it describe it as being like suffering an injury and finding out that one's bones are actually endless teeth stacked one atop another, merged into the shape that they should be but completely wrong nevertheless. Such is the horror that the Keeper inflicts, and yet some still go to it in supplication, for there is power in the twisting marks it makes upon ones soul.

THE DREAMSCAPE

Individuals who learn the art of lucid dreaming and are gifted with arcane talents often discover the method for creating a personal world within the dream, known among them as the dreamscape. This place is often fantastical and strange, filled with the unconscious thoughts and hidden desires of the dreamer who created it.

Individuals who study this process and map their dreamscapes while seeking to make them precise and exacting are known as dream cartographers. Their magic takes on strange properties because of this practice, and flashes of their dreamscape appear upon the world with each spell they cast.

The Keeper of the Depths takes special interest in these individuals. Those who draw its attention report of dark tentacles invading the edges of their dreamscapes, while others simply never wake again. Many practitioners speculate that the Keeper drags the lost ones away to its own dreamscape, but none have learned the truth. If one sought to venture to the dreams of the Keeper to discover if that were the case, then it would surely respond in kind.

Always assume it's involved in some way. Those tentacles reach farther than you'd expect. It took us into a dream once. I hope we've left. —X

Arcane Tradition: Dream Cartography

The sleeping mind stares out into an endless vista, stitching together the thoughts and actions of the day into dreams. Yet, in a world of magic, especially to a practitioner of the arcane arts, dreams hold far greater revelations. By mapping one's own mental landscape, new insights into reality can be found and harnessed. Many of these wizards often draw the attentions of the Keeper of the Depths, who may greet them by offering bargains both simple and terrible. Few have the liberty of continuing their pursuits without attracting its attention, as the ripples of magic across the dreamscape are particularly attractive to this ancient nightmare. You've chosen to begin to map your own dreams by pursuing this tradition, seeking insight into the lands beyond the veil of sleep.

Dreamscape Spellbook

When you choose this tradition at 2nd level, you develop a peculiar memorization technique. You gain darkvision out to 60 feet. Whenever you are in darkness, you can access your dreamscape spellbook, which is a mental construct that you've created to aid in your understanding of the spells you learn. When you are inscribing a spell into your physical spellbook during a long rest, you can choose to also inscribe the spell into your dreamscape spellbook without cost. You can copy down spells from your dreamscape spellbook into a physical spellbook in half the time it would normally take you to copy a spell.

Upon the Veil of Night

Also at 2nd level, you learn to use your spellcasting to call forth fragments of your dreamworld into reality. Whenever you cast a spell of 1st level or higher using a spell slot, you can use your bonus action to create an effect based on the school of the spell you cast. You can use this feature a number of times equal to your Intelligence modifier (minimum 1), and you regain all expended uses when you finish a long rest.

- **Abjuration:** You dream of a wall, infinite in majesty. Choose an unoccupied space that is up to 10 feet high, 10 feet wide, and one foot thick. A dreamscape wall appears in the location that lasts until the end of your next turn. The wall has hit points equal to your Intelligence modifier plus your wizard level (minimum 1), and AC 10.

- **Conjuration:** You dream of a portal to faraway lands. Choose an unoccupied space within 5 feet of you. A portal appears in this space that lasts until the start of your next turn. Whenever you or another creature enters the portal, they teleport to an unoccupied point of your choosing within 20 feet of the portal, determined by you when they enter.

- **Divination:** You dream of a star, shining above the world. A radiant light appears at a location of your choosing within 30 feet of you. This light counts as natural sunlight and casts bright light in a 50-foot radius and dim light in an additional 50-foot radius. The light lasts for 1 minute or until you dismiss it as a bonus action.

- **Enchantment:** You dream of a beautiful landscape. One creature of your choosing within 30 feet of you must make a Wisdom saving throw against your wizard spell save DC. If they fail, they are charmed during their next turn and will move directly towards you by the safest open route.

- **Evocation:** You dream of a great cataclysm. Choose one creature targeted by your spell or a creature within 30 feet of you. That creature must make a Strength saving throw against your wizard spell save DC or be knocked prone.

- **Illusion:** You dream of a maze of mirrors and mist. You become heavily obscured until the start of your next turn, but you can see clearly from inside the fog.

- **Necromancy:** You dream of an open grave. Choose a creature within 30 feet of you. The target must make a Wisdom saving throw against your wizard spell save DC. If they fail, the next time they take damage from a weapon attack, they also take extra necrotic damage equal to your wizard level.

- **Transmutation:** You dream of a world, strange yet familiar. Choose a number of 5-foot cubes within 30 feet of you equal to the level of the spell cast. These cubes become difficult terrain for 1 minute.

Descent into the Depths

Starting at 6th level, you learn to drag others with you into your dreams. Whenever you cast a spell of 1st level or higher while you have access to your dreamscape spellbook you can use your bonus action to enter a harmless dreamscape until the end of your next turn, reappearing at a location of your choosing within 30 feet of the point of your departure. You can touch a creature when you enter, bringing them with you. Neither of you can use actions or take damage while in this dreamscape. If you cannot reappear at the point you chose, you are shunted to the nearest open location and take 10 force damage.

In the Place Beyond

At 10th level, your dreams come to you even in your waking moments. You can now access your dreamscape spellbook while you are in either dim light or darkness.

Additionally, you can choose to cast spells as though you were located at any point that you can see within 15 feet of your current location, provided that location is within dim light or darkness.

The End of Sleep

At 14th level, you have encountered the dreams of a powerful entity and have learned the secrets of the universe from its ancient mind. This could be the Keeper of the Depths or another eldritch being that defies comprehension. Regardless of its nature, it offers you power over your dreams in exchange for the sacrifice of blood.

When you cast a spell of 6th level or higher using a spell slot, you can choose to recover all expended uses of your Upon the Veil of Night feature. When you do this, target one humanoid creature within 60 feet of you that you can see. If there are no other targets available, you must target yourself. The target must make a Wisdom saving throw against your wizard spell save DC. If they fail, they take 8d10 psychic damage as the eldritch entity feasts upon their mind. If they are slain by this damage, their body is consumed and they vanish into the dreamscape, leaving only magical items behind.

Once you use this feature, you can't do so again until you finish a long rest.

My companions have told me stories of the Keeper, and the strange and horrible tortures that it inflicts upon those it captures. Yet, when I hear its fervent worshipers speak of a benevolent entity that tells them tales of wonder, I begin to doubt. Perhaps that is the greatest terror of this thing: the inability to trust one's own mind. — Sylvette

The Nightmare of the Deep

The Keeper of the Depths has lived for untold millennia, constantly scheming and planning. It whispers quiet thoughts into the minds of mortals across every world and makes its home in the depths of countless oceans across the cosmos.

There are a number of steps that you can perform in order to make the Keeper suitable for your world. This nightmarish being makes for an excellent antagonist to your party, even when no warlock or wizard is associated with it, and can provide you with a variety of interesting encounters.

Comprehension of the Unknown

When you are adding the Keeper to your world, there are several questions that you will need to address. First, you'll need to decide what form the Keeper takes. Is it a massive crustacean-like monstrosity as depicted here, or is it something more familiar and describable? Is it large or small? Can it take the form of a mortal, or is it beyond such trappings? If it can, what does that form look like?

Second, you'll want to consider where it lives. The Keeper rarely emerges from its lair, so deciding where it dwells is very important if you ever intend to have the party encounter it there. What ocean does it live under? What happened to the area that drew it to this location in particular? Is it simply the deepest part of the ocean, or is this place filled with the ruins of lost ships and sunken ruins?

Dominion of the Seas

The Keeper is often known for having minions and slaves that serve it blindly, eager to please their tyrant. The eyeless watchers, which act as scouts and servitors both in the deep and in the world above, are very intelligent and privy to many of the secrets of the Keeper. There are countless other races and creatures that live in the ocean, however, so the Keeper could have other servants. Are the mer known as its heralds and harbingers, or do they oppose this dark monstrosity? Are the savage undersea races subservient to the Keeper, or do they fight against its minions?

A second thing to consider is how sailors and coastal peoples interact with the Keeper. Some may tell tales of the creature, as it emerges on stormy nights to wreak havoc upon fishing ships and treasure barges. Others could make sacrifices to the Keeper in order to try to avoid drawing its ire. Those who live in areas that are frequently wracked by storms and foul weather far from other civilized lands are especially vulnerable to the influence of the Keeper, and it takes special delight in invading their dreams.

The Changing

Those who succumb to the Keeper's whispers find themselves changed in slow, gradual steps. First, their hair slowly falls out, leaving their bodies waxy and rubbery. Second, their eyes begin to grow large and bulbous, and they become sensitive to light. Through their dreams, the Keeper whispers madness, gradually driving them insane and calling them to the sea.

Once the first two stages are complete, the real horror begins. Chitinous growths begin to form on the afflicted, building up in patchy scabs and ridged joints. Their limbs may become boneless, seeming more akin to writhing tentacles than true hands or feet. Some may sprout additional eyes on unusual places upon their body or could have their teeth replaced by the mandibles of a crab. All will grow gills and small fins with which to swim, but other changes appear seemingly at random.

Individuals with teeth like that of a shark, octopus tentacles instead of legs, and eyes on all sides of their bloated bodies are not uncommon, though their mindless stares show that they have become little more than puppets for the Keeper's dark desires. Others have eyes on stalks, chitinous armor around their bodies, and claws instead of hands. Eerie tentacles reach from under their armor, grasping at any who come too close.

The Uprising

People who have been changed by the Keeper do their best to conceal their affliction as long as they can, driven by shame and the foul compulsions of the eldritch horror. It will force them to gather artifacts and gemstones, baubles and trinkets to hurl into the sea in ritual sacrifice. Most will form cabals in secret, praying and chanting to their ruler. Those whom the Keeper blesses are often the most depraved of their ranks, taking those who have embraced the change and turning them into darker abominations who can't withstand the light of day. Most of these groups gradually take control of their towns, forcing outsiders to leave and causing locals who make trouble for them to vanish into the night. Some wield magical powers granted by the Keeper, which they use to lure unsuspecting victims to their watery graves.

Consider one or more of the following goals for a cult of the Keeper, or make one of your own:

d8	Cult Activity
1	The cult poisons the local fish in order to starve the town, reducing morale and weakening the populace.
2	The cult invades the dreams of prominent citizens to drive them increasingly mad.
3	The cult performs human sacrifices in order to curry favor with the Keeper.
4	The cult introduces slavery to the town and transforms the slaves into wretched abominations.
5	The cult is preparing the rites required to summon a storm to destroy the town.
6	The cult invites nobility to join them, offering power and knowledge in exchange for loyalty.
7	The cult attempts to barter with a kraken.
8	The cult destroys ships, cutting off trade.

Minions of the Keeper

The changing affects creatures in many different ways, each more horrible and grotesque than the last. Creating a creature that has been touched by the influence of the Keeper is relatively easy. First, give the creature a swimming speed equal to its walking speed and the ability to breathe water. If the creature is weaker, consider giving it sensitivity to sunlight to highlight the vulnerability it has gained. Then, roll on the following table to determine how the Keeper's influence has manifested.

d10	Result of Corruptive Influence
1	The creature has thick chitin covering its skin. Increase its AC by 1 and its hit points by 20.
2	The creature has tentacles growing from its back. It can use these to attempt to grapple a creature as a bonus action, and its reach increases by 5 feet.
3	The creature has an eerily appealing voice that conceals its foul nature. Its Charisma score increases to 16. As an action, it can begin to sing. Hostile creatures within 30 feet that can hear the siren song must make a DC 14 Wisdom saving throw. If they fail, they are charmed by the singer until the end of their next turn.
4	The creature has large, shark-like teeth. Its Strength score increases by 4, and it gains a bite attack that deals 1d12 piercing damage. It can add its Strength modifier to attack and damage rolls for this natural weapon.
5	The creature has studied the arcane arts. Its Intelligence score increases to 18, and it can cast spells as though it were a wizard of a level equal to its CR.
6	The creature is nearly insensate with bloodlust. It gains immunity to the frightened and charmed conditions, and it gains temporary hit points equal to the damage it deals.
7	The creature is unnaturally horrifying. Whenever a creature starts its turn within 30 feet of the nightmarish monster, it must make a DC 15 Wisdom saving throw. If it fails, it is frightened until the end of its next turn.
8	The creature is truly blessed by the Keeper, and has fully embraced the eldritch power offered to it. Its Charisma score increases to 20, and it gains 30 additional hit points. It can cast spells as though it were a warlock of a level equal to twice its CR with the Keeper as its patron.
9	The creature is gains two of the above features.
10	The creature gains three of the above features. In addition, it can use an action to summon up to three other creatures that have been touched by the influence of the Keeper that have a combined CR equal to or less than that of the summoner. Once it uses this action, it can't do so again until it finishes a long rest.

Changing the Keeper

The Keeper has primary themes of oceans, dreams, and forbidden knowledge, but it also has some secondary themes that are possible to adjust to suit your world. It could easily be an ancient kraken or other powerful sea-dwelling creature, or it could be the servant of a dark deity of the seas.

If your world is entirely desert or lacks an ocean of sufficient size, it could be an ancient creature that lurks beneath the sands, dwelling within the ruins of a lost civilization. The features associated with it could be shifted to focus on sand instead of water. Simply allow the warlock to ignore difficult terrain created by shifting sands and give immunity to adverse effects produced by desert conditions instead of allowing them to swim. *Crushing tide* and *control water* could be changed to manipulate sand in an identical way, replacing their control over the ocean with control over the desert landscape.

Madness from Below

Insanity is something that can be difficult to effectively and convincingly roleplay, especially in a way that is not comedic or improper. One thing to remember when dealing with insanity induced by exposure to the influence of the Keeper is that it is being actively caused and nurtured by an outside source. Hearing whispers in one's mind at all times that tell of forbidden things and darker, more awful paths one could choose to take would surely be a heavy burden to bear.

The Keeper is always scheming, looking for a way to further its mysterious goals. It is the type to play the long game, perhaps more than any other Alrisen. It doesn't care about time, because it has seen the rise and fall of countless civilizations. Even when it may seem like the Keeper's plans have been defeated, it could be simply building the adventurers into a weapon that it can turn against its enemies.

If you are aware of this, the knowledge can easily lead to paranoia and fear. Remember to be courteous when interacting with your party members, no matter how crazed your character becomes. It'll be much more enjoyable and memorable for everyone if you do.

Objects of the Keeper

The Keeper has collected thousands of magical artifacts over the millennia. Here are two of them you may encounter.

Bloodstained Stone
wondrous item, very rare (requires attunement)

This stone is carved with eldritch runes and is permanently stained with blood. While you carry it, your attacks are considered magical and you gain a +1 bonus to attack and damage rolls made with weapons.

Eerie Conch
wondrous item, very rare

This conch shell feels heavier than it should. You can use your action to blow into it, unleashing a horrifying sound. Each hostile creature within 120 feet of you must make a DC 16 Wisdom saving throw. If they fail they are frightened of you for 1 minute. A creature can repeat this save at the end of each of their turns, ending the effect on a success.

Once the conch is blown, it can't be used again until after the next sunset.

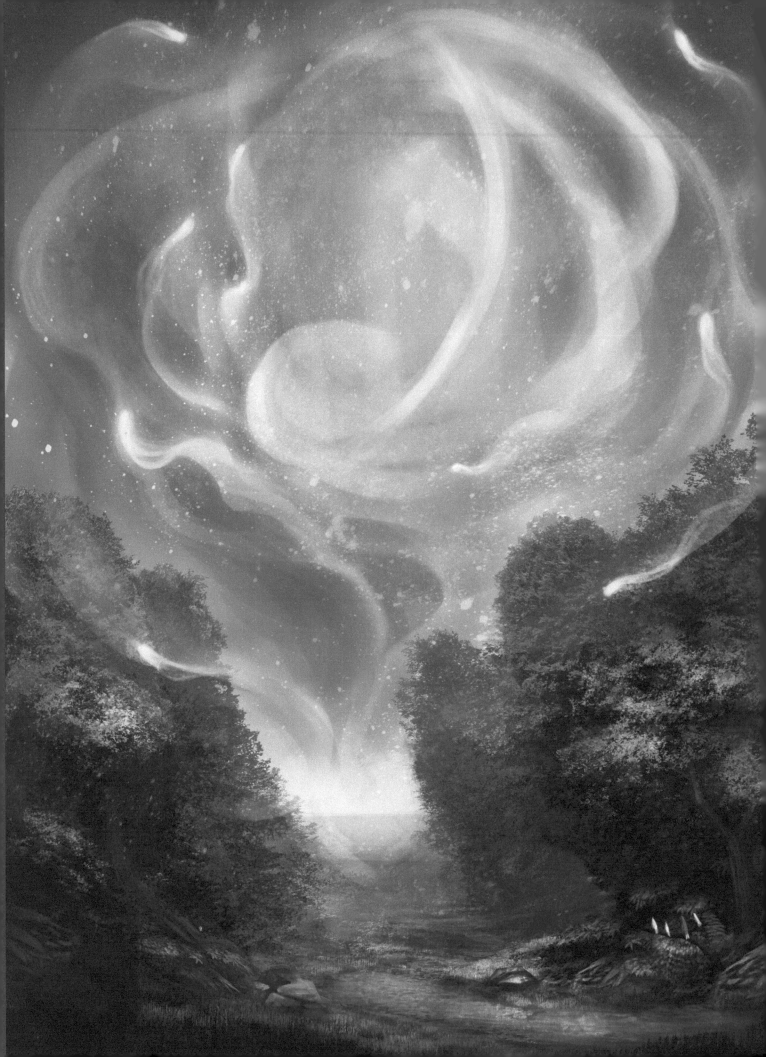

THE PERFECT CHORD

THE SOUND OF CREATION

When the world was created, there was a sound. A single, overwhelming noise that defined the event, echoing out into the empty space beyond and scattering itself to the far corners of creation, falling into every fragment of physical material and granting it that continuing pulse, that never-ending beat of life and vibrancy. The Perfect Chord emerged in the silence that followed, a swirling manifestation of light and sound that seeks to encompass the music of the multiverse.

THE WORLD'S HEARTBEAT

The Chord is often described by those who hear and see it as the singular instance of perfection that constantly becomes more perfect. It is life and change, order and discord, unification and destruction all wrapped into one singular mote of light. The world distorts in its presence, becoming filled with a wash of color and overwhelming sound; sometimes the roar of an avalanche of singers and instruments crashing down upon the stage in a furious triumph, and in other cases a soft lullaby, gently dancing along the ear with all the subtlety of a quiet morning as the sun rises over the mountains. Such is the nature of the Chord.

THE COLLECTOR OF THE PULSE

Those who have studied the Chord extensively, or have been touched by its power themselves, claim that there is a purpose to the great dynamism that dwells within this indescribable harmony. The Chord seeks to incorporate all of the sounds that came after the time of creation into itself, and in doing so, achieve true perfection. Once that happens, it is said that the Chord will enact the Great Rest, where all of the sound in the multiverse will stop for one singular moment, gathering itself to remake the world anew in a grand exposition that will redefine reality as it was once known. This could be mere conjecture, however, for the songs of those who have embraced the Chord also speak of an eternal quest to gather these sounds, as every moment brings about a sound that has never been heard before nor will be heard again.

SING! SING! SING TO THE SONG!

Cultures that revere the Chord are common, though most view it as a natural phenomenon rather than an entity. Its appearance in a location is cause for celebration and is an omen of good fortune, causing joy and enlightened behavior even after it vanishes. Those who are touched by the Chord are viewed as the greatest of singers and instrumentalists, causing bards from all over the world to frequently seek out the Chord in a quest to gain its favor. The best way to do this is to produce a sound none have heard before, though it is not always a foolproof method.

CREATE PERFECTION

The Chord is not mindless in its actions, though it is a thing of elemental harmony. It will deliberately act in ways that will create new sounds, simply because of the small actions it takes. Appearing before a musician who has just begun their career and plays an off-key note that is so hideous it could never be replicated, only to inspire that musician to continue to grow and practice, is an act of self-motivated benevolence by this elemental force.

PURSUE THE FUTURE

The Chord is a manifestation of history that constantly desires more for itself. The songs of ancient civilizations thought lost to time will live forever within the Chord, as will the battle-cries of dead tyrants and the cheering of the crowds as their oppressors were slain. All sounds are valuable to the Perfect Chord, and so it collects them without regard to the morality of the act. The screaming of a child and the laughter of a saint are both worthy of being joined with the light and sound.

SWIRLING CHROMATICISM

The sounds of the Chord can hardly be described with words, but it is beautiful nevertheless. The strangest part of this phenomenon is the endless lights that swirl and dance within it, manifesting as visual representations of the endless sound. When the Chord is pleased, it will appears as a light purple color. When it is angered, a dark red hue mixed with black will begin to shift into view. Deep bass notes and shrill screams will tear into the ears and minds of those around it when it senses opposition to its goals, and any who attempt to capture or chain the Perfect Chord will feel its unbridled fury.

MADDENING SOUND

If the Perfect Chord touches a living creature, every fraction of their being thrums and dances with the sheer power of the overwhelming sound. This is not something most mortals are strong enough to withstand. Those who are blessed by deities or have made bargains with other Alrisen are able to call upon that influence to purify themselves of this power, but others are vulnerable to it. Those who can accept the rhythm within themselves become warlocks to the Chord, while those who are unpracticed in the eldritch arts but still manage to emerge with their minds intact often become warriors called discordants. Both are valuable to the Chord, for their actions are the most likely to create sounds that have never been heard, or to bring about a pause worthy of recognition.

Obnoxiously loud and gaudy. You'd think that a "Perfect Chord" would be something that you'd want to hear. Turns out its incredibly unpleasant for other warlocks. I let it out of a cage and what's the first thing it does? Goes through me, nearly deafens me, makes me feel like I'm going to explode, and then runs off into the sky. Not even a word of gratitude. Still, the lights were pretty. In a "tear my remaining eye out" kind of way, but pretty. -X

OTHERWORLDLY PATRON: THE PERFECT CHORD

You have heard the most sublime sound in the world, and it has changed you forever. You've taken the resonance into your beating heart and it has brought meaning and inspiration to your days. The Perfect Chord resounds through the quiet places of the world as a clear and harmonious note that spirals with infinite complexity, gaining sentience and life with every sound it collects. It has no motive but to include every sound in the universe within itself, and it inspires others with an endless desire to find new forms of radiant music to call forth and collect.

EXPANDED SPELL LIST

The Perfect Chord lets you choose from an expanded list of spells when you learn a warlock spell. The following spells are added to the warlock spell list for you.

PERFECT CHORD EXPANDED SPELLS

Spell Level	Spells
1st	shrill whistle*, thunderwave
2nd	knock, silence
3rd	beacon of hope, resonance*
4th	compulsion, shattersong*
5th	animate objects, awaken

SEEKER OF THE SOUND

At 1st level, your heartbeat is tuned to the Perfect Chord. You gain proficiency in the Performance skill and with all musical instruments. You can use a musical instrument as a spellcasting focus for your warlock spells, and can play it in place of using a verbal spellcasting component.

When you cast a spell that has only a verbal and somatic component, you can choose to cast it as though it only had a verbal component.

When you cast a spell of 1st level or higher that only has a verbal component, including those modified by this feature, you gain temporary hit points equal to your Charisma modifier that last for one minute.

INSTRUMENT OF THE CHORD

At 6th level, your practice teaches you to turn others into your instruments. Using your bonus action, you can curse or harmonize with one creature within 60 feet of you. Each time you cast a spell using a warlock spell slot, you can cause that creature to vibrate in harmony with your spell. If the creature is friendly, its movement speed is doubled until the end of its next turn. If it is hostile, it must make a Constitution saving throw against your warlock spell save DC. If it fails, it is knocked prone. This curse lasts for 1 minute or until the creature enters an area of magical silence.

Once you use this feature, you can't do so again until you finish a short or long rest.

VOICE OF THE MAESTRO

At 10th level, your spirit copies the sounds it hears with perfect clarity. You gain resistance to thunder damage. Whenever you cast a spell that makes noise or the illusion of noise, you can cause it to produce any sound you wish.

Additionally, you can perfectly mimic the speech and other vocalizations of creatures you have heard, but not spellcasting. Creatures must succeed an Insight check against your warlock spell save DC to determine the sound is a mimicry, and they make this check with disadvantage.

THE GRAND FINALE

Starting at 14th level, you can use your action to call upon a single note of the Perfect Chord. Choose one of the following effects. Once you use this feature, you can't do so again until you finish a long rest.

- **Celebration:** Each friendly creature within 1 mile of you gains advantage on Charisma checks for 8 hours. During this time, these creatures can use their actions to magically conjure an instrument of their choosing, and they gain proficiency with that instrument for the duration. They can also use their action to summon delicious food or beverages sufficient to satisfy their needs for one day. They can only use each action once. Finally, they can cast any cantrips that you know that are from the schools of illusion or enchantment. After 8 hours, all of the conjured objects vanish and all ongoing effects created or enabled by this feature end.

- **Defiance:** You unleash a painful sound. Creatures of your choosing within 120 feet of you can choose to use their reaction to drop what they are holding and cover their ears. If they don't do so, they take 8d10 thunder damage and are deafened for one hour. If they do, they take half as much damage and are not deafened.

- **Discord:** Each hostile creature within 60 feet of you that can hear you must make a Charisma saving throw against your warlock spell save DC. If they fail, they are frightened of you and of all creatures friendly to you for one minute. A creature can repeat their saving throw at the end of each of its turns, ending the effect on a success.

- **Exaltation:** Each creature within 60 feet of you that can hear you can use their reaction to cheer. You immediately gain temporary hit points equal to ten times the number of creatures that cheer. These temporary hit points last for 10 minutes.

- **Unity:** Each friendly creature within 60 feet of you that can hear you can use their reaction to immediately move up to 30 feet and make one weapon attack.

ELDRITCH INVOCATIONS

ALLEGRO VIVACE
Prerequisite: 9th level, Perfect Chord patron

You can cast *greater restoration* using a warlock spell slot. Once you cast this spell, you cannot do so again until you finish a long rest.

CHEERFUL DUET
Prerequisite: Perfect Chord patron, Pact of the Chain feature

If you have a symphonic songbird as your familiar, it gains additional maximum hit points equal to your warlock level. You can choose to cast spells that require only verbal components as though you were in your familiar's space.

COMPOSITIONS OF THE MASTERS
Prerequisite: Perfect Chord patron, Pact of the Tome feature

You can ignore the effects of the *silence* spell and of magical effects that would produce a similar area of magical silence,

enabling you to speak and cast spells normally. You also become immune to the deafened condition.

Singing Slayer
Prerequisite: Perfect Chord patron, Pact of the Blade feature

You can create a weapon of swirling light that emanates musical tones using your Pact of the Blade feature. It counts as a musical instrument. Whenever you cast a cantrip as an action using a verbal component, one friendly creature within 30 feet of you that can hear you can use their reaction to harmonize with you. You gain advantage on your next weapon attack during your next turn and the other creature gains advantage on its next attack roll during its next turn.

Wicked Waltz
Prerequisite: 18th level, Perfect Chord patron

You can cast *irresistible dance* once without using a spell slot. You cannot do so again until you finish a long rest.

Record of the Incident at Estelle Sharp's Performance of "The Calling of the Rainbow's Soul"

At 7:43 in the "Jovial Spirit" opera house, Ms. Sharp began to sing to a full house of nobles after being greeted with much polite applause. At 7:45, during the opening lines of the chorus, a strange phenomenon began to manifest around Ms. Sharp. Statements taken afterwards from eyewitnesses claimed a sort of "glowing mark" had manifested itself above the stage. One of the nobility who possessed magical aptitude but could not be found for comment had apparently feared foul play of some kind and cast a dweomer that would repel any sorceries present. Their attempt was unsuccessful. Several reported that the quality of her singing had grown steadily as the light remained above the stage, and claimed that such magical enhancements were "unprofessional" and "unwarranted" Soon after, the light disappeared, and the performance resumed without any further disruption. Ms. Sharp declined to comment further on the incident, claiming it to be "merely a sign of inspiration."

Alrisen and Distance

The Perfect Chord is a prime example of an Alrisen patron that can be either kept close to the party or far away, nearly unseen and always sought. Distance in this instance is something that you'll need to consider when controlling one of the Alrisen, and is a good way to set the tone for a game.

Close Patrons

If the Alrisen patron is present frequently, then the players will often assume that it is essential to the grander plot of the world. This gives you the opportunity to use it as a quest-giver, guide, or guardian of other non-player characters. This allows you to present them with more personality and humanity, but it does detract from the idea of the patron as something alien, otherworldly, and extremely powerful. When having a close patron, consider having it be limited in some way, so that the party is presented with full and effective challenges. Alrisen are presented here as nearly godlike in power, but you could easily reduce them to simply being particularly strong examples of other elemental or supernatural beings.

Distant Patrons

If the Alrisen patron appears infrequently, it is much easier to present them as alien and powerful. Making their appearance rare will give you more opportunities to show them at pivotal moments or as cruel, inhuman, or otherwise deadly and dangerous. Be certain that the party avoids engaging in open conflict with an Alrisen, unless you are prepared.

Traits of the Vocalist

Warlocks who have been touched by the Chord often manifest unique physical or mental traits thanks to the influence of this curious Alrisen. These warlocks are known to scholars as Vocalists, as most devote themselves to musicality through their voice. However, not all are singers: many master an instrument, while others are passionate about unique forms of musical art. Some are famed for their use of illusion magic to create powerful displays of sound and light, singing the verbal components of their spells in order to summon symphonies of instruments to accompany the eldritch arts that they invoke. Consider adding one or more of these traits when creating a warlock or after seeking a new sound to add to the Perfect Chord's eternal symphony.

d20	Trait
1	You often inquire about people's music preferences.
2	You insist on others joining you when you sing.
3	You sometimes hum in your sleep.
4	You are extremely interested in new environments.
5	You always listen with complete focus when hearing a piece of music for the first time.
6	You move in a way that is perfectly in rhythm.
7	You speak to instruments and expect a response.
8	You have a tendency to snap in time.
9	You sometimes ask people to repeat or speak certain words so that you can memorize their voices.
10	You do not walk. You march. Everywhere.
11	Your skin has odd parallel lines tracing it, like those of sheet music.
12	Your eyes are shaped like those of a bird.
13	Your fingers are oddly supple and delicate.
14	Your heartbeat is always in rhythm with your words.
15	Clothing or armor you wear for long periods of time becomes colorful or somber to suit your mood.
16	Your speech comes in defined patterns, such as haiku, rhyming couplets, or particular timing.
17	Your hair is always perfectly kept.
18	The scent of spring air always surrounds you.
19	When you cast a spell, a pulsing light appears from your chest in time with your heartbeat.
20	Your vocal range surpasses human hearing.

Martial Archetype: Discordant

In battle, blades clash and ring, shields break and snap, warriors yell and scream, and beneath it all, the sound of violence reigns supreme. One sound, however, stands out above the rest in your memory: the eternal song of the Perfect Chord, a manifestation of light and sound that bore witness to your conflict, collecting the cries of the wounded and the yells of the victors before vanishing once more. Inspired by this melody, you have dedicated your martial focus to the creation of dissonance, adjusting the vibrations of the universe to inflict a discordant cacophony of destructive power upon your adversaries. With weapons singing a tale of triumph and despair, you stand valiant before the chaos of everlasting war.

Ring the Blade

When you choose this archetype at 3rd level, you learn to make your blades sing with destructive energy. While you are wielding a melee weapon, you can use a bonus action to make it ring with sonorous power for one minute. If the weapon leaves your hand, it stops ringing.

While a weapon is ringing, it inflicts thunder damage instead of the normal type. Whenever a creature other than you starts its turn within 5 feet if you while your weapon is ringing, it takes thunder damage equal to your highest ability score modifier.

As an action while holding a ringing weapon, you can unleash this energy, generating sharpened edges of pure sound to lash out in all directions around you and causing the weapon to stop ringing. When you do this, each creature other than you within 15 feet of you takes thunder damage equal to the damage dice of the weapon plus your highest ability score modifier.

You can unleash the energy within a ringing weapon twice, and you regain these uses when you finish a short or long rest.

Starting at 7th level, unleashing this energy inflicts twice as much damage, and it inflicts three times as much damage at 15th level.

Hear the Silence

Also at 3rd level, you learn to stop noise around you by disrupting your own heartbeat. As a bonus action, you can cast *silence* centered on yourself. When cast in this way, it requires no verbal, somatic, or material components, lasts until the start of your next turn, and affects a 5-foot-radius sphere centered on you.

Defy Harmony

At 7th level, you move against the beat of the universe, like nails upon life's chalkboard. You gain proficiency in the Intimidation skill. When you wield a weapon that is ringing, your attacks with that weapon ignore disadvantage caused by your target being heavily obscured.

Shatter Syncronicity

At 10th level, you learn to further manipulate sound and silence. Friendly creatures within 15 feet of you gain resistance to thunder damage. When a hostile creature takes thunder damage as a result of starting its turn within 5 feet of you

while your weapon is ringing, it becomes disrupted by eldritch vibrations that interfere with spellcasting. If it tries to cast a spell with a verbal component before the start of your next turn, it takes 2d10 thunder damage immediately after casting the spell. If this would cause it to make a concentration saving throw, it makes this saving throw with disadvantage.

Strike Unhindered

At 15th level, while your weapon is ringing, you can use a bonus action to take the Dash action. When you do, you automatically break free from any creature grappling you. After you use this bonus action, any creature or object other than you within 5 feet of you at any time during your turn takes thunder damage equal to your highest ability score modifier at the end of your turn.

As Perfect Imperfection

At 18th level, your path has taken you to the final measure, as you at last become the metronome of the Chord. Your heartbeat is as unstoppable as it is unpredictable, and your pulse thunders in your ears. Whenever you are below half your maximum hit points, you can unleash the energy within a ringing weapon without expending your use of the feature.

Whenever you are reduced to 0 hit points, you can choose to be reduced to 1 hit point instead. Once you do so, you can't do so again until you finish a long rest.

Maneuvers

Presented here are maneuvers unique to the Discordant, highlighting their defiance of harmony. These maneuvers are designed for use with Fighting Maneuvers, a replacement for Fighting Styles published by Vorpal Dice Press. If you are not using this supplement, then ignore this section.

Crashing Symbol
Prerequisite: Discordant archetype

When you are hit by an attack, you can use your reaction to unleash a burst of sound. If the attacker is within 10 feet of you and can hear, they suffer disadvantage on their next attack against you before the start of their next turn.

Sonic Blade
Prerequisite: Discordant archetype

When you take the Attack action on your turn and make an attack with your ringing weapon, you can choose to hone the disruptive sound. If this attack hits a creature that is concentrating on a spell, it has disadvantage on the saving throw to maintain concentration.

Hear the Chord

The Perfect Chord is one of the more neutral or benevolent Alrisen. The end result of its actions is believed to be the creation of a new universe, but the time frame for doing so is measured in millennia rather than lifetimes. Therefore, it simply goes about its task, never wavering or ceasing unless interfered with by an outside force.

Form of Music

When you are implementing the Chord in your world, there are a number of different things you should consider. First, decide what the Chord actually is. Is it a mass of light and sound, as presented here, or is it something different? The Perfect Chord could actually be a masterful composer who has designed a symphony perfectly crafted to pluck at the cosmic strings of magical power, or an elemental of air that has discovered a love for music. It could be a deity or other divine entity that has dominion over sound, song, and dance. It could be a fey creature that sings an enchanting spell over the minds of mortals. It could even be a band or talented musician that the warlock has befriended and whose masterful music they call upon to rewrite reality.

Seeking the Chord

A second thing to consider when implementing the Chord in your world are the goals of this entity. The Chord presented here is constantly seeking new sounds and collecting from around the cosmos, and it is aware of every sound simultaneously. It simply arrives and listens with full intent in order to claim the sound for itself. If you desire, you could change it from a peaceful gatherer into a wicked thief that steals the voices from innocent people in order to build a collection to last the ages. If you've decided to present it as a masterful composer or other powerful mortal, what does this person want? Do they seek fame, fortune, or understanding of universal secrets? How would one study these things, and what adversaries would they encounter while seeking them? You could easily create an entire campaign dedicated to exploring the rise to fame and glory of a radical band of hardcore musicians inspired by the one true musical note, fighting for supremacy in a high-fantasy world. Alternatively, they could be the only ones who are actually interested in music in a world that has fallen to despondency and suffering.

A World of Music

Imagine a world where everything is tied to musicality. Swords are replaced with tuning forks, shields with cymbals, and parties of adventurers with rag-tag bands whose only possessions are their outfits and their instruments.

Horrible fiends pour forth from the ground, wielding guitars made from the bones of the damned. They ride around on strange machines that belch fire and brimstone, spinning wheels that burn with black ash. They unleash a new kind of music upon the material plane, one of dark growling and screaming instruments. Your band stands alone before the horde, performing a concert while flinging spells and explosive ammunition from the stage. The leader of the fiends challenges your lead vocalist to a duel and they accept. In the center of the battlefield, surrounded by corpses, the pair sing a song of war and death that makes the ground tremble and the earth quake. The fiend is banished in a column of fire and the watching crowd roars, calling you heroes!

Instruments of the Chord

There are hundreds of unique and exotic instruments that populate the lands, creating revelry and inspiring all who hear them played. The skill of the musician is far more important than what they use to express it, but some instruments have the capacity to display that skill far better than others. Some instruments have attracted the attention of the Perfect Chord, which has given them strange and impossible powers. Certain collectors would pay unimaginable sums to possess such an object, and they are fought over by musicians and instrument-makers alike for their rarity, quality, and value.

Boar's Head Drum
wondrous item, very rare (requires attunement)

This drum has a boar's visage stitched into the head, and is covered in ritualistic symbols of hunting and blood-sport. While you are playing it, you can use your action to inspire up to 10 creatures that you can see that can hear you. Each creature gains advantage on their next attack roll within 1 minute.

Cheerful Bells
wondrous item, very rare (requires attunement by a bard)

This series of seven bells are each made from a different metal, with the smallest being adamantine and the largest being copper. As an action, you can ring one of the bells and expend a use of your Bardic Inspiration. When you do, you can grant your Bardic Inspiration die to two creatures instead of one.

Cwrth of Traitor's Reprise
wondrous item, very rare (requires attunement)

This stringed instrument was made from the bones of a dead warrior after a vicious betrayal. As an action while you are playing it, you can choose one creature that you can see that can hear you. The target must make a DC 15 Wisdom saving throw. If they fail, they must use their action during their next turn to move to a space within 5 feet of the nearest creature and make a melee attack targeting that creature.

Fleet Fiddle
wondrous item, very rare (requires attunement)

The stem of this gold-plated fiddle is stylized to look like a bird's wing. As an action while playing it, you can cast *haste* or *fly*. Charisma is your spellcasting modifier for these spells when they are cast in this way.

Grim Taglharpe
wondrous item, very rare (requires attunement)

This lyre does not have a traditional stem, but instead is open around the strings, and is covered in runic etchings. As an action while you are playing it, you can force one creature that can hear it to experience extreme doubt. The target suffers disadvantage on their next attack roll, saving throw, or ability check.

Lightning Guitar
wondrous item, very rare (requires attunement)

This guitar appears to be made from metal and makes an unusually synthetic sound. You can use it as an arcane focus, a holy symbol, or a greataxe. When you cast a spell that deals lightning or thunder damage, this instrument is empowered, and inflicts an additional 2d10 thunder damage the next time it hits a creature when used as a greataxe.

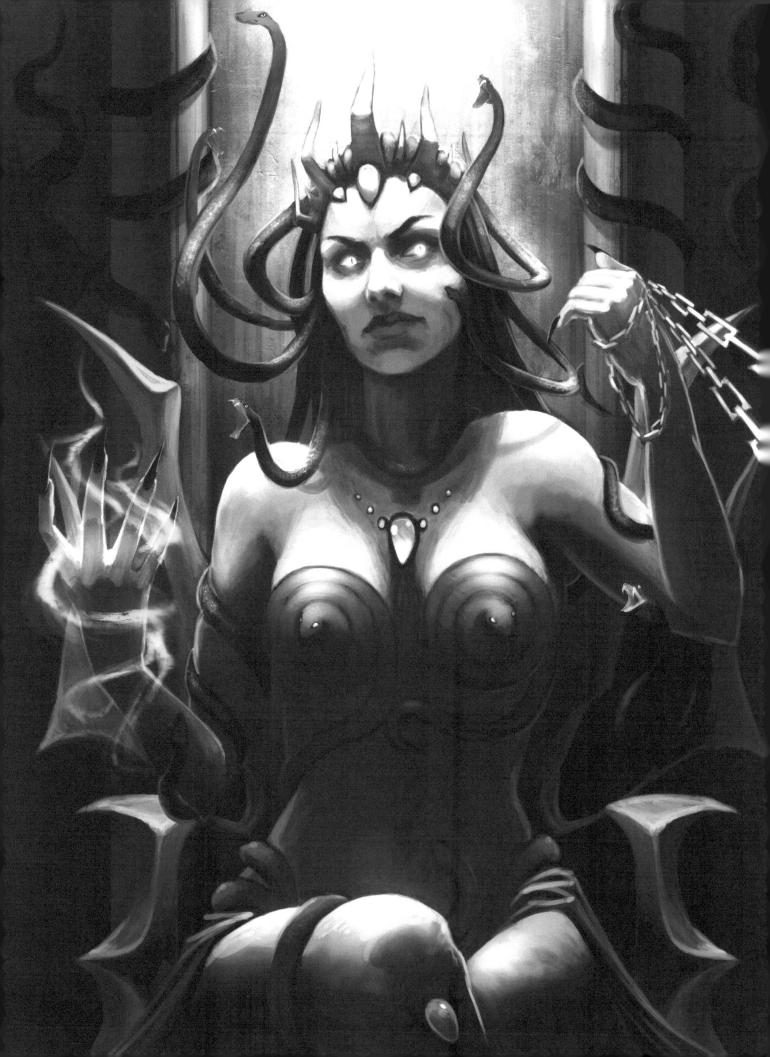

THE SERPENT EMPRESS
HER IMPERIAL MAJESTY

Slavery. Subjugation. Suffering.

These are the words whispered in silent places across the planes, spoken with dismay and suspicion by tongues filled with cowardice and spite.

Supremacy. Sovereignty. Superiority.

These are the words spoken by loyal subjects and servants, strong in mind and body, sworn to serve and slay in the name of the Serpent Empress, Mistress of Misery, Ruler of the Reviled, Queen of Scales: the monarch of the Endless Empire.

MISTRESS OF MISERY

The Serpent Empress is a cataclysm of beauty and terror, if one believes the accounts of those who claim to have seen her without having their eyes torn from their head. Pale shimmering skin lightly dusted with subtle scales gives way to eyes of golden emerald, slitted like a serpent in the brightest daylight and glowing with unearthly power. A crown of gold and turquoise sits atop her head, rising from between the serpents that rest upon her scalp. The strange snakes rise from beneath her skin, coiling and slithering down her neck before rising around her high cheekbones, whispering in her ears of punishments she has inflicted and desires she has acted upon. Sapphire gemstones adorn her stately attire, scandalously placed to draw the eye, that offense might be taken and that same eye removed for impudence. She sits upon a throne of gold and stone shaped from victims of her petrifying gaze. The Empress speaks in a soft and sibilant voice, like the whisper of poison upon the sharpened blade. Handmaidens kneel adjacent to her throne, attending to her every whim, and serpents cover the floors and walls of her throne room, watching with unblinking eyes.

FALLEN GODDESS

Some claim that the Serpent Empress was once a deity of generosity cast down from a greater pantheon. Her envy and spite twisted her form into a mockery of her former beauty. Weakened, she sought a new path to power, and discovered that belief is what creates gods. Now she intends to build an empire of devoted worshipers, as each one who sees her as a goddess increases her power. Generosity is now greed, kindness is now hate, and purity is now corruption. The Empress shall reclaim her throne and rule for all eternity.

RULER OF THE REVILED

The Endless Empire spans across many worlds within the universe, and has footholds upon a great number of planes. Whenever a new one catches the attention of the Empress, a series of spies and assassins infiltrate the societies of the world, scouting out the political systems and seeking artifacts that may be useful in the world's subjugation. If left undiscovered, they will sow the seeds of chaos and rebellion among the nobility and common folk alike. Over time, the world will gradually fall under the control of the Endless Empire and be so converted to their culture that when the Empress herself arrives to survey her new domain, the citizens of the world will bow and chant the oath of allegiance with smiles upon their faces.

QUEEN OF SCALES

Not all worlds are as vulnerable to the strife brought on by the Imperial saboteurs, forming alliances and creating systems to detect the scaled shapeshifters in their midst. These worlds are invaded using planar portals that carry legions of the Empire's finest soldiers to subjugate the landscape and the people within. Towers containing arcane sanctuaries are constructed in mere days, touching the sky and filling the air with a subtle toxin that weakens the resolve of the defending forces.

THE IMPERIUM OF THE SNAKE

The Endless Empire spreads in a dark and twisted way, insidious and cruel. Once the masters of that domain surrender to the will of the Empress, the curse falls upon the land. Whenever a child is born within that territory, they are born as an imperial, rather than as true-blooded to their original race. These children are inherently influenced by the demands of the Empress, calling upon her magic to turn against those who would defy her demands. Not all are entirely consumed by her will, however, and may turn away from the cruelty and carnage that they would inflict in her name. These are the individuals that struggle, learning to conceal their true motivations under her yoke.

VIZIERS, MISERABLES, AND SLAVES

The Endless Empire is built upon the backs of slaves, individuals conquered in wars upon foreign lands and broken beneath the lash of the whip. They construct massive monuments to the glory of the Empress, building pyramids and temples in her name. Their children are imperials, raised by others in their stead. The slaves' blood falls upon the stone altars in sacrifice to the Empress. Their hearts are broken, filled with suffering and hatred. Rebellion is common, for the viziers that rule over each former kingdom or city-state do not spare the lash nor conceal the rod. The viziers eagerly allow rebellion to brew within their cities so that they may crush it with brutal force, taking control with malicious decrees that cause misery to all under their banner. This is how they maintain their hordes of slaves on worlds that have been completely conquered, for only those who have raised arms against the Empress are taken for labor. The rest, known as miserables, are left to live in squalor beneath the brutal yoke of the Empire. Famine among the miserables is common, as they are viewed as worthless. Nobility of the old world are forced to be servants to their new imperial masters, and are often the first to speak of rebellion. None have ever succeeded in the long term, but their struggles entertain the Empress.

INTRODUCE THE EMPRESS

The Serpent Empress plans to rule all of creation, so she may have an interest in your world. Is she well-established, or has her insurrection just begun? Are her infiltrators successful, or is the invasion of the world inevitable? Has it already started? Who will fight, and who will bow? How could she be stopped?

Otherworldly Patron: The Serpent Empress

Situated within her palace of gold and turquoise, the Serpent Empress sleeps in serene silence, guiding her slaves to serve in her secret business. Envious and vain, the Empress personifies greed and avarice in the hearts of man. Jealousy, spite, and simple pride have driven her servants to her side. She whispers in a sibilant voice, speaking of wealth and power promised but so rarely delivered. The sins she offers are subtle at first, but grow in style and salaciousness with every slow cycle of the hourglass. You've assigned yourself to her service and sworn fealty to the Serpent Empress in exchange for a sliver of her supreme strength.

Expanded Spell List

The Serpent Empress lets you choose from an expanded list of spells when you learn a warlock spell. The following spells are added to the warlock spell list for you.

Serpent Empress Expanded Spells

Spell Level	Spells
1st	command, ray of sickness
2nd	protection from poison, silence
3rd	feign death, venom blast*
4th	compulsion, serpentine ward*
5th	cloudkill, constriction*

Blessing of the Empress

At 1st level, you receive the favor of your patron. You gain advantage on saving throws against poison and effects that inflict the poisoned condition. You can speak to snakes, serpents, and other reptiles as though you were under the effects of the *speak with animals* spell.

Whenever you cast a spell that has a verbal component, you can suppress the senses of those around you. Choose one creature that can hear you within 30 feet of you. Your spellcasting is silent to that creature, and it has disadvantage on its next Wisdom, Intelligence, or Charisma check within 1 minute.

Hair of Snakes

At 6th level, you can cause a swarm of serpents to grow from your head as a bonus action, and they remain until you dismiss them. While they are out, you can see through the eyes of these serpents. As long as the serpents can see, you have advantage on Perception checks, gain darkvision out to 30 feet, and gain immunity to the blinded condition.

While you are within 10 feet of a creature, you can use your action to have your serpents whisper a sinful secret to the creature. The target must make a Wisdom saving throw against your warlock spell save DC. If it fails, it is charmed by you until the end of your next turn or until it takes damage.

Toxic Blood

At 10th level, your veins run with venom. You gain resistance to poison damage and immunity to the poisoned condition. Additionally, you can have poison damage you deal treat poison immunity as poison resistance. You can have creatures immune to the poisoned condition lose their immunity against your attacks and effects, but they gain advantage on saving throws to resist the poisoned condition.

Gaze of the Goddess

At 14th level, your patron looks from your eyes and exerts her supreme power through you. As an action, choose one creature within 30 feet of you that you can see. The target is paralyzed for one minute. If the target takes damage, the effect ends. If the target is immune to paralysis, it takes 3d10 psychic damage and is knocked prone.

Once you use this feature, you can't do so again until you finish a long rest.

Eldritch Invocations

Cold Blooded
Prerequisite: 7th level, Serpent Empress patron

You can cast *polymorph* once without expending a spell slot, but only to turn the target into a snake or other reptile. Once you do this, you can't do so again until you finish a long rest.

Commanding Presence
Prerequisite: 12th level, Serpent Empress patron

Whenever you cast a spell with a range of Self using a warlock spell slot, choose one creature within 15 feet of you. The target must make a Wisdom saving throw against your warlock spell save DC. If they fail, they are charmed by you until the end of your next turn.

Handmaiden's Guardian
Prerequisite: Serpent Empress patron, Pact of the Chain feature

When you have an imperial cobra as your familiar, it gains additional hit points equal to your warlock level. While your familiar is within 10 feet of you, it can use its reaction to make an attack whenever you take damage.

Majestic Scales
Prerequisite: 6th level, Serpent Empress patron

When you aren't wearing armor or a shield, you can choose to have your AC equal 10 + your Charisma modifier + your Dexterity modifier. While you do so, your hair serpents can deliver melee spell attacks with a reach of 10 feet. If the melee spell attack hits, the serpents will bite the target, dealing poison damage equal to your Charisma modifier.

Ophidian Fang
Prerequisite: Serpent Empress patron, Pact of the Blade feature

You can create a golden weapon from the fang of a giant serpent that deals piercing or slashing damage using your Pact of the Blade feature. You can choose to have this weapon deal poison damage. When you hit a target with this weapon, you can use your bonus action to take the Disengage action. Once do you so, you can't do so again until you inflict the poisoned condition on an enemy or you finish a short or long rest. Critical hits with this weapon poison the target until the end of your next turn.

Scroll of Imperial Authority
Prerequisite: Serpent Empress patron, Pact of the Tome feature

Whenever you can see a creature charmed by you, you can use your bonus action to cause it to speak any phrase you wish. The creature thinks that it chose to say those words of its own volition, though they may not believe them to be true.

Venomous Blast
Prerequisite: 4th level, Serpent Empress patron

Whenever you cast a cantrip that deals damage or make a weapon attack, you can use a bonus action to cause venom to surge forth from your veins. The damage type of the attack or cantrip changes to poison. If the target takes damage, they must make a Constitution saving throw against your warlock spell save DC or be poisoned until the end of your next turn.

Traits of the Imperial Courtier

Individuals who have sworn themselves to the Serpent Empress and have gained power from their pacts with this deadly tyrant are known as Imperial Courtiers among those who swear allegiance to this ruler. They hold a special place in the hierarchy, expected to follow the instructions and decrees of the local governance while still maintaining a degree of autonomy. They often have their own branded groups of servants and slaves who assist them in their work while being untouchable by other imperials. Consider adding one or more of these traits when creating a warlock or after serving the schemes of the Empress.

d20	Trait
1	You speak with sibilant syllables.
2	You insist on eating your food raw.
3	You sometimes hiss in your sleep.
4	You enjoy watching others squirm.
5	You consider other authorities to be beneath you.
6	You move in a way that is oddly serpentine.
7	You frequently wear snakes upon your body.
8	You have a tendency to not blink.
9	You rise and posture boldly when threatened.
10	You enjoy lounging in the sunlight.
11	Your skin has patterned marks of deep color.
12	Your irises are shaped like those of a snake.
13	Your blood is dark green or black.
14	Your skin is always cool to the touch.
15	Clothing or armor you wear for long periods of time becomes scaled or patterned.
16	Your teeth become fanged and sharp.
17	Your tongue becomes long and forked.
18	Your shadow seems to be that of a snake.
19	When you cast a spell, your eyes glow with an eerie golden radiance and shimmering scales momentarily cover your skin.
20	Your tongue becomes serpentine and often flicks out, tasting for scents.

The Hierarchy of the Empire

The following chart will assist you in understanding the broad hierarchy of the Endless Empire and in structuring your personal relationships with other imperial servants.

Rank	Individuals
1	The Serpent Empress
2	The Handmaidens of the Empress: her most trusted servants, having been bred for hundreds of generations for their loyalty and cunning.
3	Imperial Courtiers: these individuals are commonly warlocks, and they operate slightly outside the ordinary hierarchy in most cases.
4	World Governors: these individuals rule over entire worlds within the Endless Empire.
5	Legion Commanders: these soldiers control the entire military might of the Empire on their world.
6	Grand Viziers: these rulers control continents, and are responsible for the lesser viziers within.
7	Infiltrators: these secretive assassins follow the will of the Empress, and while they are technically beneath those above them, they are rarely available to follow those orders.
8	Legion Generals: these soldiers serve the Legion Commander for their world.
9	Viziers: these individuals are responsible for governing ordinary city-states or kingdoms.
10	Ur-Generals: these soldiers serve the Legion Generals, but are subservient to the local Vizier.
11	Imperial Servants: these individuals are at the beck and call of the Ur-Generals, but primarily serve their respective Viziers.
12	Colonels: these soldiers serve beneath the Ur-Generals, but often call upon Imperial Servants for assistance with their logistical needs.
13	Majors: each Colonel will have several Majors, who control individual segments of their forces.
14	Captains: each Captain is responsible for a century of ordinary soldiers, usually 100-strong.
15	Saboteurs: each captain will have several saboteurs that act as scouts and spies for their forces.
16	Soldiers: 100 soldiers make up a century.
17	Citizens: imperials who are neither soldiers nor magically inclined fall into this category.
18	Servants: these are former nobility to the old world.
19	Miserables: the former citizenry of the old world.
20	Slaves: former soldiers conquered by the Empire, or rebels against the rule of the Empress.

Monastic Tradition: Way of the Noble Serpent

By lineage or accident of fate, spiritual enlightenment or inner turmoil, you've taken your first steps down the path of a servant of the Serpent Empress, a ruler from beyond the planes whose power rivals the gods themselves. Residing in her palace of gold and turquoise, her imperial majesty sleeps in solitude for countless ages, traveling slowly between the planes. When her palace arrives upon a new world and she awakens, her reign of cruelty commences. Your style of martial arts has been taught to you by one of her handmaidens or was discovered in scrolls containing these forbidden techniques that were left behind when the Empress departed from your world ages ago for unknown reasons.

Constricting Vice

At 3rd level, you learn to ensnare your foes, crushing the life from them as punishment for their transgressions. You can choose to use your Dexterity modifier instead of your Strength modifier when you make a Strength (Athletics) check. Once per turn when you hit a creature with one of the attacks granted by your Flurry of Blows feature, you can choose to attempt to grapple the target. While you are grappling a creature, you can spend 1 ki point as a bonus action to constrict them, dealing bludgeoning damage equal to your Martial Arts die + your Dexterity modifier. The target is also restrained until the start of your next turn or until the grapple ends.

Ophidian Stance

At 6th level, you learn to adapt your body to the movements of the more advanced techniques of this style. You can move at full speed while you are prone, and you gain the benefits of the Disengage action while you are prone. You can stand up from prone without spending additional movement. When you are the target of an attack, you can use your reaction and spend 1 ki point to stand up from prone or drop prone before the attack roll is made.

Eyes of the Empress

At 11th level, your reptilian ki infuses your eyes, sharpening your vision and causing your pupils to become snake-like slits. You gain darkvision out to 60 feet, and your darkvision is not impeded by magical darkness. As an action, you can attempt to transfix a target that can see you, overpowering their senses with your mental influence. The target must make a Wisdom saving throw against your Ki save DC. If it fails, it is charmed until the start of your next turn. You can use this feature on a creature who failed its saving throw as a bonus action on your next turn. A creature who succeeds on its saving throw is immune to the effect to this feature for 1 minute.

Basilisk Venom

Starting at 17th level, your fingers drip with a deadly toxin whose effects mimic the fearsome power of the Empress. Whenever a creature is grappled by you and is struck by your Stunning Strike feature, you can spend 2 additional ki points to paralyze the target until the end of its next turn. If you critically hit a creature, you can spend 3 ki points to petrify it. The target must make a Wisdom saving throw against your Ki save DC. If it fails, it is petrified as though it had failed three saves against a *flesh to stone* spell. If you maintain concentration on this effect for 1 minute, the creature is permanently turned to stone, and the petrification can only be reversed by a *remove curse* or *dispel magic* spell cast at 6th level or higher.

Quite tactical fighters, but I don't understand how someone who follows a snake like her could be "noble". Still, I'd hate for one to get their hands on me. It would probably hurt. –X

The Role of an Infiltrator

The word "traitor" lies within the name of this caste, and such is their role. They are tasked with sowing dissent and subverting the common morality of those they fight. Pushing an enemy to the brink of horrible choice is common for these imperials, for it is what they were born to do.

Most are followers of the Way of the Noble Serpent, trained to fight without weapons or armor so they can get closer to their targets. A few cunning assassinations will often lead to the downfall of a society, as infighting and struggles over power will happen to even the most hierarchical of cultures. When presented with an unseen external foe, most will not even realize that they are in danger until it is far too late.

The Role of an Imperial Courtier

While infiltrators are tasked with specific goals in mind, the Imperial Courtiers are given more broad directions on most occasions. They are instructed to spread the influence of the Endless Empire to any lands beyond its reach, to quell rebellion and insurrection within them, and to seek out new sources of power and wealth that will benefit the Empress. Most act according to the wishes of the World Governors, though they are technically above them in the hierarchy, or serve as aides to the Legion Commanders.

Rebellion amongst the Courtiers

There have been whispers, however, of a rebellion that has been brewing for centuries among those close to the Empress. Her magic is gifted to her Courtiers and cannot be taken back. Those who manage to hide their true intentions from this foul tyrant for the entirety of their lives may have the capacity to bring about her downfall, though they are currently weak and few in number. Perhaps with the aid of others, who have yet to know the cruelty of the Empire, the Serpent Empress can be made to pay for the obscene and vile things that she has done across the countless worlds and endless millennia.

ENTER THE IMPERIAL COURT

The Serpent Empress is a ruler of snakes, first and foremost, but her dominion is actually a secondary theme that can easily be adjusted to suit your game. First, consider the Empress. Is she truly as she has been represented here, or is she an Emperor, or even an entity that cannot be defined by such gendered terms? Does she rule over lands, or is she a hidden monarch who conceals her forces in the underbelly of society? Does she rule openly, with an iron fist, or is she patient, calm, and cunning? Why does she seek dominion? Does she intend to prevent a greater danger, or is she merely acting to supplement her own power and wealth? Is she kind and benevolent, or as cruel as a snake toying with a mouse? Is she actually a goddess or is she wicked fiend who has made her home among the mortal races? How do divine powers react to the invasion of their world? What dark gods have agreed to serve the Empress, and what do they get from this bargain? How do the forces of freedom respond? Do they even know, or are they helpless before the darkness to come?

SADISTIC AND SCHEMING

The Empress's sibilant voice whispers in the darkness of so many worlds that one may be simply surprised at how subtle her servants can be. When scheming with the imperial infiltrators, consider how deeply they have slipped into society. Are they already embedded into the networks of spies and assassins that comprise the guilds of thieves and rebels, or are they acting independently of any other organizations that already exist in the world? If they are among these organizations, how have they twisted them to their own ends, and what new methods have they introduced to bring about the downfall of their enemies? Do any among the organization know of their true nature? What were these individuals promised in exchange for their continued loyalty to the cause of the Serpent Empress, and will they follow through to the end, or will they hesitate before the final blow?

SPREADING THE EMPIRE

The countless soldiers of the Endless Empire are known for arriving without warning, traveling through massive portal gates crafted for the exclusive purpose of their invasion. These artifacts are difficult to construct, requiring many rare materials and secret techniques known only to the upper echelons of the researchers, scholars, sorcerers, and wizards that serve the Empress. Those who designed them in the first place have long since been slain by the Empress to preserve her secrets. Those who create them now simply follow an ancient blueprint laid down centuries ago.

THE INVASION

Once a portal has been created, the legions of the Empress will pour forth onto the landscape like a plague, cutting down any resistance and demanding the immediate surrender of the civilizations of the world. The portal is usually placed deep within the most populated lands, making it difficult to resist the incursion. Their wizards and sorcerers will construct towers that emit a foul poison. Imperials are immune to this toxin, and it is subtle enough that only the weakest mortals will die. Heroic individuals are also immune to this toxin, but ordinary folk are stricken by it, becoming despondent and sapped of strength, vitality, and the will to resist.

THE CONQUERING

Once the leadership of a new world has been captured or subverted, the Imperial Palace will descend from the sky. Miles wide, the Palace will crush a populated area, sending out soldiers to collect slaves that they will use as blood sacrifices to the Empress. When she awakens fully from her slumber and a glass of crimson has been poured for her to enjoy, she will summon the former leaders from the many nations of her new dominion. There, they will be made to bow and grovel, begging for the mercy of a merciless tyrant. Those who are sufficiently entertaining are collared and bound by the Imperial Chain, which will permanently break their will and render them little more than mindless slaves. The rest are slain and eaten by the Empress's handmaidens, who devour the corpses whole as is befitting a serpent. Once this ritual is complete, the curse descends on the lands, and it becomes part of the Endless Empire forevermore.

IMPERIAL ARTIFACTS

The Serpent Empress has conquered hundreds of worlds and collected treasures from each. Her enchanters have created thousands of magical artifacts, though most revolve around warfare or subterfuge. These objects are among the possessions of the Empress and her minions.

CROWN OF THE EMPRESS
wondrous item, legendary (requires attunement)

This crown is golden, spiked, and inlaid with turquoise. While wearing it, you gain advantage on all saving throws and ability checks. As an action, you can cast *dominate person* on any imperial without using a spell slot or maintaining concentration on the spell. Charisma is your spellcasting ability for this spell.

LESSER IMPERIAL CHAIN
wondrous item, very rare (requires attunement)

This 50-foot chain is made of gold and attaches easily to any collar. A creature imprisoned with this chain obeys your telepathic commands without question or ability to resist as long as you hold the chain. Another creature can attempt to forcibly remove the chain as an action by making a DC 20 Strength check. If they succeed, the chain is snapped from the collar and the creature is freed from its influence.

MISERABLE STATUETTE
wondrous item, very rare (requires attunement)

This small statue depicts a blank humanoid figure. As an action while holding it, you can touch a humanoid creature within reach. The target must make a DC 15 Wisdom saving throw. If they fail, they are forcefully sucked into the statuette and imprisoned, causing the face of the humanoid figure to change to match the captive. The target is immune to damage and effects while inside the statuette. You can expel the target from the statuette as an action. If you die or are no longer attuned to the statuette, the creature is instantly freed.

SLAVE COLLAR
wondrous item, common

This golden serpentine collar can't be removed without a DC 18 Strength check. Failing this check inflicts a level of exhaustion on the wearer as it strangles them. You can place it on a restrained or incapacitated creature as an action. While worn, the wearer has disadvantage on attack rolls.

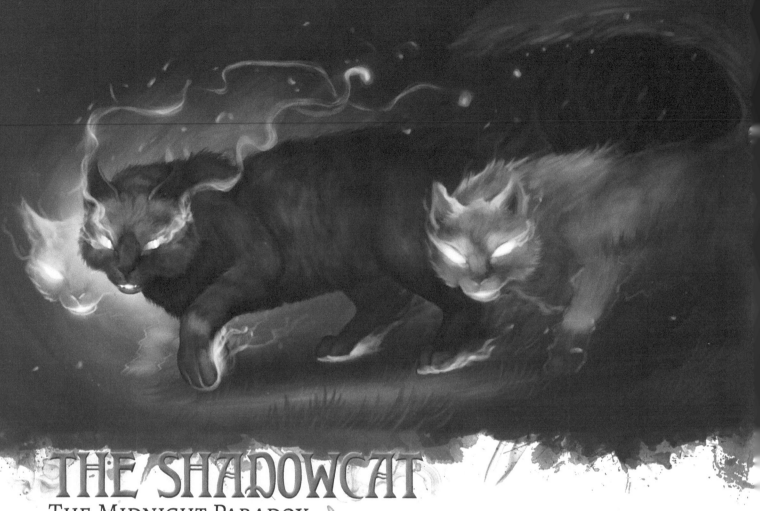

THE SHADOWCAT
THE MIDNIGHT PARADOX

Sleep is an affliction that plagues the mortal races, leaving them vulnerable to the terrors that lie within their own minds. Yet, it is something sought and desired, for without it, death is inevitable.

There is a creature that feeds upon the horrors that arise after the fall of dusk and the closing of eyes, and the lesser reflections of this creature act as servants to its will. Some call this entity the Shadowcat, and its realm is the ever-present plane known as the Inverse. Just as the stroke of midnight is both today and tomorrow, the Shadowcat is both the nightmare and the awakening dawn.

STALKER OF DREAMS

In ancient days, when mortals closed their eyes to rest, the cruelest among them was visited by a nightmare and trapped in horrors indescribable. When they finally awoke, they cried out to the universe and begged for something, anything, to answer in their defense. Thus, the Shadowcat appeared and offered a bargain: it would feast upon the nightmares spawned by mortal minds, and in return, it would never go hungry. The Shadowcat will step forth from its private realm, the Inverse, and recline upon a sleeping mortal's form, paralyzing them with coils of shadow. It will then opens its mouth and draws forth the nightmares from the mind of the victim, feasting upon them to sustain itself.

THE FIRST NIGHTMARE

The Inverse is a realm not filled with shadow, but instead filled with terrible, purifying light. All that is black within becomes pale and translucent instead, while overhead a sun that looks like an eye to the void itself rains shadows down upon the landscape. There are no people within the Inverse except those granted passage by the Shadowcat, yet it appears as an exact duplication of the plane one entered from, as it lies over all other planes like the reflection of a one-way mirror.

It is here, in this silent place, that the first nightmare was spawned: The Shadowcat itself. It was alone at first, yet as more appeared, its pride and vanity could not be sated with mere existence. It began to hunt, to kill, and to consume the other nightmares, breathing them forth anew as lesser reflections of itself. Dimcats arise from the nightmares that plague innocent children, gloomcats from those that haunt adults, and inkcats from the tormented cries of madmen who have come to know more than a mortal mind can bear.

A FEAST WITHOUT END

In places where the Shadowcat has prowled, nightmares behave differently, for they are fearful of being found vulnerable to the lesser reflections of the Shadowcat. Instead of living within the minds of those they torment, they seek to free themselves and escape, taking forms beyond the comprehension of mortal minds in an attempt to weaken the barriers between the Inverse and the material plane. Thus, the Shadowcat sends its reflections and those who have agreed to serve it, forcing the nightmares back into the minds of their originators so that they can be consumed and transformed.

Those that manage to survive the efforts of the reflections and servants are truly devious, for they will call forth more of their brethren from the Inverse by sacrificing innocents in front of those who care for them, causing nightmares to boil out of the minds of the watching victims.

OTHERWORLDLY PATRON: THE SHADOWCAT

Your patron is an otherworldly incarnation of fate that strides between planes; a living omen of ill luck and good fortune alike. Drawn to the dreams of mortals, its lesser reflections perch upon the chests of the unwary in their sleep, stealing breath and fragments of life from their victims as they feed upon the nightmares this brings. When they've had their fill, they return to their master, who sends them back again to hunt down the creatures that have escaped from the nightmares of those tormented by darker fates. You've drawn the attention of this creature, for good or ill, and have made your pact in the deepest shadows of the dark. Now, shadows boil around your hands, both inky black and snow white, tainted and blessed by the touch of the Inverse. You've been there, seen the sun of endless emptiness and the void of pure light that shines from beyond the stars, and you have felt the gaze of the nightmares that stare upon you with jealousy, feeling their hate. They know that while you can depart unharmed, their nights are numbered. You've stolen their luck, and now you'll use that power for your own ends.

EXPANDED SPELL LIST

The Shadowcat lets you choose from an expanded list of spells when you learn a warlock spell. The following spells are added to the warlock spell list for you.

SHADOWCAT EXPANDED SPELLS

Spell Level	Spells
1st	duskwalk*, feather fall
2nd	shadow armor*, silence
3rd	creeping dark*, nondetection
4th	greater invisibility, unseen claw*
5th	creation, shadow world*

DREAM STALKER

Starting at 1st level, your patron's magic allows you to be everywhere and nowhere at once. As an action, you can fade partway into the Inverse, gaining advantage on Stealth checks for 1 hour. When you roll initiative while in this state, you can choose to teleport up to 60 feet to a location within 10 feet of a creature you can see. If you deal damage to the creature with an attack during the first round of combat, you can use your bonus action to steal their breath and spirit. The target takes psychic damage equal to your warlock level and cannot speak or make sound until the start of your next turn.

Once you use this feature, you can't do so again until you finish a short or long rest.

STOLEN LUCK

At 6th level, you can curse an enemy that you can see within 60 feet of you with terrible misfortune as a bonus action. Whenever the target makes an attack roll or ability check, you can use your reaction to roll a d6 after seeing the result. If the result is a 6, the result of their d20 roll is replaced with a 1. This curse lasts for one minute, and ends early if either you or the target are reduced to 0 hit points.

Once you use this feature, you can't do so again until you finish a short or long rest.

UMBRAL LEAP

Starting at 10th level, whenever you are subject to an effect that requires you to make a Dexterity saving throw, you can use your reaction to instantly dissolve into a dark mist to avoid the initial effect. You reappear in an unoccupied space of your choosing within 30 feet of your initial location.

Once you use this feature, you can't do so again until you finish a short or long rest.

DARK APPARITION

At 14th level, the Shadowcat's hunger for nightmares grants you the power to create them. You can no longer be surprised. Your Dream Stalker feature no longer has a limit to the number of times it can be used. Whenever you use your Dream Stalker feature's bonus action, all hostile creatures within 10 feet of you must make a Wisdom saving throw against your warlock spell save DC. If they fail, they are frightened of you until the end of your next turn.

ELDRITCH INVOCATIONS

CODEX OF THE BLACK DAWN
Prerequisite: Shadowcat Patron, Pact of the Tome feature

You can summon forth nightmarish fire from the Inverse to deepen the darkness of an area. By performing a 10-minute ritual, you can create a cold, black shadowflame around an object you are touching. The object consumes light within a 30-foot radius, turning bright light to dim light and dim light to nonmagical darkness. A shadowflame remains until you dispel it as an action, it enters the radius of another shadowflame, or it comes into contact with real fire.

DUSKBORNE COMPANION
Prerequisite: Shadowcat Patron, Pact of the Chain feature

When you have a dimcat as your familiar, it gains additional hit points equal to your warlock level. Whenever you cast a spell using a warlock spell slot while you have a dimcat as your familiar, you can choose to teleport up to 30 feet to a location you can see within 5 feet of your familiar.

EVERBURNING GAZE
Prerequisite: 16th level, Shadowcat patron

Your Stolen Luck curse draws your patron's eye. The target's d20 roll is changed to a 1 if the result of your d6 roll is a 5 or 6.

FANG OF THE PROWLER
Prerequisite: Shadowcat Patron, Pact of the Blade feature

When you create a melee weapon with the finesse property using your Pact of the Blade feature, you can make it from polished silver flowing with blue-black smoke. While wielding this weapon, you gain advantage on initiative rolls. During the first round of combat, attacks with this weapon deal extra psychic damage equal to your Charisma modifier plus half your warlock level.

WRETCHED FORTUNE
Prerequisite: 6th level, Shadowcat Patron

Your Stolen Luck curse darkens. If the result of your d6 roll is a 1 or 2, choose a creature you can see within 30 feet of you. That creature gains disadvantage on their next attack roll.

Traits of the Shadestrider

Servants of the Shadowcat are often known as shadestriders. Consider adding one or more of these traits when creating a warlock or after serving the First Nightmare's goals.

d20	Trait
1	You feel most comfortable in the dark.
2	You prefer to be nocturnal in your habits.
3	You sometimes hiss when startled.
4	You enjoy watching others sleep.
5	You view everyone as beneath you.
6	You move in a way that is oddly catlike.
7	When you speak, you often purr your words.
8	You tend to grin widely and inappropriately.
9	You curl your back and bare your teeth when you are threatened.
10	You enjoy lounging in the moonlight.
11	Your skin has wisps of shadow coming from it.
12	Your irises and eyes are shaped like those of a cat.
13	Your blood is thick and dark like ink.
14	Your skin fades to an obsidian shade in shadow.
15	Clothing or armor you wear for long periods of time becomes dark and tattered.
16	Your teeth become fanged and sharp.
17	Your ears become pointed and catlike.
18	Your shadow seems to pace beside you, even against the light. The effect is disconcerting to others.
19	When you cast a spell, your eyes glow with a blue light and shadows pour from your hands.
20	Small retractable claws sprout from your fingers in place of your fingernails.

Barbarian Path: Path of the Mercurial

Your rage is not rage at all. Instead, you are filled with a malicious spite that runs wild within your veins, bringing a cruel smile to your face and causing the shadows around you to writhe and twist in sympathy. Many who walk this path find themselves in contact with the Shadowcat: an unusual creature that wanders the planes devouring nightmares, twisting fate, and causing mischief for some inscrutable end. As you learn to walk the planes like it does, that cruel joy within your heart grows ever stronger, granting you powers unseen by mortal men. You are the stalking panther, the hunting lion, and the sly grin that appears even as your form fades away. Become nightmare.

Cheshire Grin

When you choose this path at 3rd level, your rage forces a terrible smile upon your face. When you use your Reckless Attack feature while raging, shadows begin to writhe around your form until the start of your next turn. If you take damage from an attack during this time, you can use your reaction to move up to 10 feet without provoking opportunity attacks and you become invisible to your attacker until the start of your next turn.

Whenever your rage ends, you can choose to inflict that same malicious grin upon another creature. Choose a creature within 30 feet that can see you. The target must make a Wisdom saving throw (DC equal to 8 + your proficiency bonus + your Charisma modifier). If they fail, they can't speak or cast spells for 1 minute, and they lose concentration on active spells as their face contorts and twists into a cruel smile. At the end of each of its turns, the target can make another Wisdom saving throw. On a success, the effect ends.

Down the Rabbit Hole

At 6th level, you learn to journey through terrible shadow, though it fills you with a wicked madness. When you enter your rage, you can teleport up to 30 feet to an unoccupied location you can see, and while raging, you can do so again whenever you reduce a creature to 0 hit points.

Looming Shadow

Starting at 10th level, your unique perspective grants you control over the scope and scale of things. You can cast *enlarge/reduce* at will, even while raging. You can maintain concentration on this spell while you are raging, and entering your rage does not cause you to lose concentration. Charisma is your spellcasting ability for this spell.

All that Remains

Starting at 14th level, when you use your reaction to activate your Cheshire Grin feature, you can choose to have your wicked smile hang in midair, fully visible. You still gain the benefits of invisibility against your attacker, but now each creature within 15 feet of you who can see your grin, including your attacker, must make a Wisdom saving throw against your Cheshire Grin save DC. If a creature fails, they are enraged by your taunting grin and must attack you with a weapon or spell attack before the end of their next turn or take psychic damage equal to your barbarian level. If their first attack misses, they take half as much damage. Creatures immune to the charmed condition are unaffected.

Awaken the Nightmare

The Shadowcat is a creature of unseen influence that defies the normal laws of magic, space, and time. It is a paradoxical creature, because it can be true and false all at once. It is both the first nightmare and the hunter of nightmares. These nightmares are unseen by all but those who experience them, but also real and physical things that can be fought and slain and offered as tribute to the Shadowcat. It will grant protection from them, but it will also lure them in closer by using its servants as bait, deliberately influencing their minds to be especially vulnerable to the terrors of the dark. Those so tormented will seek to avoid sleep, but desire it still.

The Inverse

The domain of the Shadowcat is a plane known as the Inverse, and it rests gently over every single other plane and demiplane within the cosmos. Only those with the blessing of the Shadowcat can go there, and few are actually aware that it even exists. It is not a place of joy or wonder, but a place of harsh truths and broken laws. The sky is filled with a sun of blackness, shining down on a landscape where shadow is light and light is shadow. There, the Shadowcat appears as a pale white guardian bleeding red smoke from its crimson eyes, and its wicked reflections appear to be bloody ghosts. Nightmares are blue in this place, yet come in such a variety of forms and shapes that they can scarcely be described. A living wall of bones and flesh and rotting maggots writhing over the landscape is chased by a jester wearing the faces of the audience, gushing blood from empty eyes and laughing as it dances. Innumerable eyes stare down from hidden corners, watching and mocking, whispering of hypocrisy, treachery, and deeds best left forgotten. False children wander about clutching knives, looking for parents to torment by performing horrible acts upon their helpless guardians. It is not a place of hope. It is a place of terror.

Guardian of Children

The Shadowcat is a clever and wise creature that is well aware of the nature of things. Without mortals, there would be no more nightmares. Without children, there would be no more mortals. Therefore, in order to continue its war, the Shadowcat must protect children from nightmares. Fate is kind to children, and so in protecting them, the Shadowcat is always on the right side of the deities of light and goodness, though its domain is not aligned to theirs. It will send reflections to save them from their nightmares while allowing its influence to seep into their minds. Nightmares will come and will be all the darker and more powerful because of their long-awaited delay, giving the Shadowcat a feast with each fall of the sun.

Shed Light on the Shadowcat

When including the Shadowcat in your world, decide how you would like it to behave and what you'd like it to do. It is presented here as a guardian and a predator, a friend and a trickster that can't be entirely trusted. An easy way to help establish the Shadowcat in your mind and make it more personified rather than indescribably eldritch is to give it a gender or name, as these may provide you with inspiration as to how it may sound or behave. Is it mischievous and kind or malicious and cunning? What does it want from those who swear to it? What does it take? Can this be reclaimed by the warlock, or is it gone forever? Does it offer safety from nightmares? Could it be persuaded to stop tormenting those who offer it loyalty, and what would be needed for that?

Beyond the Dark

The Shadowcat has three primary themes: shadow, fear, and dreams. So long as you maintain these three, you can effectively do as you will with it. It could appear as a fiend that holds sway over darkness, a fey creature that dances in the moonlight, or an elemental of pure shadow that invades the dreams of others. It could be a thief who learned to steal the joy from mortals and became legendary for cunning and mastery of the darkest arts. It could simply be a dark deity of cruelty and suffering, offering bargains in exchange for time stolen from others.

Tools of the Dream Thief

The Shadowcat is revered in some cultures as an icon of thieves and assassins. This set of equipment was created to honor the Shadowcat, though it has since been lost.

Claws of the Stalker
wondrous item, very rare (requires attunement)

These gloves are equipped with retractable diamond claws at the fingertips. While wearing them, your unarmed strikes are considered weapons with the finesse property that deal 1d6 slashing damage, and you gain a climb speed equal to your walking speed.

Mask of Catseye
wondrous item, very rare (requires attunement)

This mask conceals the entirety of the face and hair behind a catlike visage. While worn, you gain darkvision out to 300 feet. If you touch a creature that is unconscious, it is paralyzed until you stop touching it. As an action, you can activate the mask to see through walls and obstacles within a 30-foot radius until the end of your current turn.

Armor of Ink
wondrous item, very rare (requires attunement)

This armor is concealed within a necklace of silver claws. When you roll initiative or as a bonus action, you can choose to have it cover your body so long as you are not wearing other armor. You can choose to integrate other equipment into this armor, such as a helm, gauntlets, or weapons, causing them to appear in your hands when the armor is deployed. While it is deployed, your AC equals 15 + your Dexterity modifier, your jumping height and distance each triple, and you have advantage on Stealth and Athletics checks. Whenever you take damage from a melee attack, you can use your reaction to unleash a pulse of shadow that pushes your attacker 10 feet directly away from you.

Curious. This one does not touch the dreamscape like a simple wanderer, but instead consumes and devours it entirely. I desire one. I will have it...

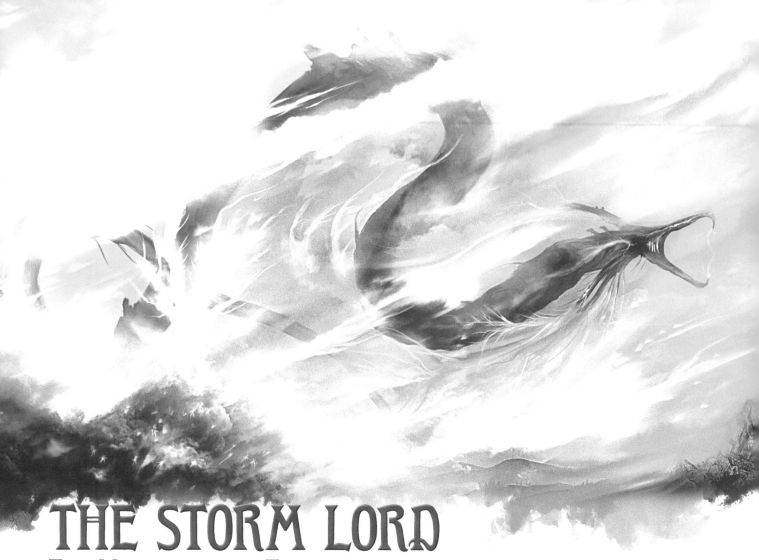

THE STORM LORD
THE MASTER OF THE TEMPEST

There are rainfalls and tempests and typhoons, but there is only one true storm. It rages eternally across all lands and through all planes bringing destruction equally to each.

The Storm Lord is the herald of this terrifying event, carrying the winds of the world along as it flies over the landscape, a calm ruler who moves with peaceful wisdom and merciless judgment as it seeks the souls of heroes.

HARBINGER OF THE END

The Storm Lord frequently appears as a massive serpentine eel-like creature with white clouds concealing the majority of its form. Its eyes glow with golden light like the sun bursting through clouds. The presence of the Lord causes even kings and rules to drop to their knees in supplication and awe of the sheer overwhelming majesty of this eternal being.

The swirling tempest that follows the Storm Lord is filled with the remnants of the souls of heroes and champions who have fought and died in both glorious combat and in the natural disasters that follow in its wake.

THE LIVING WHIRLWIND

Those driven by anger and anguish are most drawn to the Storm Lord, taken in by thoughts of rebellion against the current order of things. Outcasts and priests of fallen religions, deserters and traitors, and even those simply dissatisfied with their station in life often visit the high places of the world to stand before the dangerous winds and crashing lighting, crying out to the sky for answers.

Those who truly accept their insignificance hear the voice of the Storm Lord booming in the thunder and the chanting of the fallen heroic souls in the pounding of the rain.

KINGMAKER AND KINGBREAKER

The chanting of the fallen and the instructions of the Storm Lord resound in the mind of the supplicant as they make their offer to the maelstrom – personal suffering, sworn fealty, a task to perform, a payment, or the offering of another champion's soul to the Storm Lord's collection.

Shadowy cabals of the Storm Lord's followers will gather in the open plains, upon mountain peaks, on empty islands, and near previously dormant volcanoes seeking to summon their master to wreak havoc on the corrupt and ruined civilizations of the world. Broken spirits and shattered lives are synonymous with this majestic ruler, and it acts with spite and disdain towards those who do not show proper respect.

HAIL THE LORD OF STORMS

The Storm Lord flies between the endless worlds, so it's easy to include in your own. Consider how your civilizations would interact with the Storm Lord. Would they brace to weather its wrath or pay homage and attempt to persuade it to go elsewhere? Have its servants fostered rebellion among any of your kingdoms, drawing the attention of their lord?

Otherworldly Patron: The Storm Lord

You've made a pact with an ancient power known as the Storm Lord. Massive and timeless, this godlike entity sails the winds of the void through the darkest places between the skies of countless worlds. It is the spirit that consumes the purified souls of heroes as it welcomes them into its kingdom. Its long tendrils of lightning cover the sky, heralding the violent tempest that follows. This entity finds silent amusement at seeing mortals in peril, and it tends to draw cults of shadowy beings to worship at its altars, performing dark rituals in the name of the Lord of Winds. You have stood before the Storm Lord, unbowed and unbroken, to make a pact that will shake the very fabric of reality. Sparks will leap from your fingertips and fog will rise from your breath as you strike down your enemies with the devastating and majestic power of the Master of the Unfallen Kingdom.

Expanded Spell List

The Storm Lord lets you choose from an expanded list of spells when you learn a warlock spell. The following spells are added to the warlock spell list for you.

Storm Lord Expanded Spells

Spell Level	Spells
1st	fog cloud, thunderwave
2nd	gust of wind, skystrike*
3rd	call lightning, wind wall
4th	ice storm, windblade*
5th	storm's eye*, unstoppable ascent*

Majesty of the Cloud Ruler

At 1st level, you gain the ability to manifest a fraction of the awe-inspiring glory of the Storm Lord. As an action, choose any number of creatures in a 15-foot radius of you. The targets must make a Charisma saving throw against your warlock spell save DC. If they fail, they fall prone and remain prone on their next turn unless they use all of their movement to stand.

Once you use this feature, you can't do so again until you finish a short or long rest.

Breath of the Gale

At 6th level, you passively manifest a small tempest around yourself. You gain advantage on saving throws against dangerous gases, clouds, forceful winds, and other similar effects. Your vision is not obscured by fog, mist, smoke, rain, clouds, or other airborne particles.

Additionally, whenever you take the Dash action, nonmagical ranged attacks that target you are made with disadvantage until the start of your next turn.

Rider of Lightning

Starting at 10th level, when you deal lightning or thunder damage using a spell of 1st level or higher or cast a spell that is on your patron's extended spell list, you can use your bonus action to teleport to an unoccupied space adjacent to a target of the spell or to an unoccupied space within the spell's area of effect.

Slayer of the King

At 14th level, you discover the unspoken secrets of the heroes who sought the downfall of the Storm Lord. As an action, you cleave the air with a blade of purest wind in a line 300 feet long, 300 feet high, and 5 feet wide. Each creature in the line must make a Dexterity saving throw against your warlock spell save DC. A creature takes force damage equal to three times your warlock level on a failed save or half as much damage on a successful one. Unattended objects automatically fail this saving throw.

Once you use this feature, you can't do so again until you finish a long rest.

Eldritch Invocations

Arc Lightning
Prerequisite: 11th level, Storm Lord Patron

When you cast a cantrip that deals damage or make a weapon attack, you can use a bonus action to cast *lightning bolt* using a warlock spell slot at a target of your cantrip or weapon attack.

Dance of the Storm
Prerequisite: 15th level, Storm Lord Patron

You can cast *fly* on yourself at will without expending a spell slot or material components.

Essence of the Sky
Prerequisite: Storm Lord Patron, Pact of the Chain feature

If you have a spark seeker as your familiar, it gains additional hit points equal to your warlock level. While you have a spark seeker as your familiar, you can cast spells that deal lightning or thunder damage as though your familiar was the point of origin for the spell when determining the range and available targets.

Flaywind Blade
Prerequisite: Storm Lord Patron, Pact of the Blade feature

When you create a weapon with your Pact of the Blade feature, you can infuse it with silver mist and form it from storm-scarred steel. When you attack with this weapon, you can use your Charisma modifier, instead of Strength or Dexterity, for the attack and damage rolls. When a ranged attack misses you while you are wielding this weapon, you can use your reaction to move up to 15 feet without provoking opportunity attacks, and you can move through spaces occupied by hostile creatures without spending additional movement.

Grimoire of the Endless Rain
Prerequisite: Pact of the Tome feature, Storm Lord Patron

Whenever you finish a long rest, you can perform a percussive ritual over the course of 10 minutes to change the weather. When you finish, an unnatural storm with a 1-mile radius rolls in and follows you, gently raining and occasionally flashing with lightning. When you reduce a creature to 0 hit points while outside, you can use your reaction to call down a bolt of lightning to strike the downed creature. You gain resistance to lightning and thunder damage for 1 minute, and each creature that you choose within a 10-foot radius of the strike must make a Constitution saving throw against your warlock spell save DC. If they fail, they take thunder damage equal to your warlock level and are deafened for 1 minute. Once you summon lightning this way, you can't do so again until you finish a short or long rest.

Windswept Defense
Prerequisite: 3rd level, Storm Lord Patron

Whenever a hostile creature damages you with an attack or spell, you can take the Dash action as a bonus action once before the end of your next turn.

Traits of the Herald

Those who serve the Storm Lord through pacts and promises are known as heralds, as they stand before other mortals and speak of the coming chaos and salvation that will arrive as their master does. Consider adding one or more of these traits when creating a warlock or after sending the soul of a hero to the Storm Lord.

d20	Trait
1	You feel uncomfortable in heavy clothing and would rather stand unprotected from the elements.
2	You prefer to be outdoors whenever possible and try to sleep where you can see the sky.
3	You whistle quietly at odd times and recite bits of lost lore you may not yet understand.
4	You enjoy even the most extreme weather, laughing as thunder booms and lightning cracks.
5	You view most people as beneath you.
6	You move in a way that is strangely light and fluid.
7	You frequently wear dark robes or clothing that conceals your form.
8	You tend to grin widely when watching the suffering of others.
9	You do not ask, you *declare*.
10	You prefer music that is percussive, sharp, and frightening to others.
11	Your skin has wisps of fog coming from it that flash brightly when lightning crackles nearby.
12	Your eyes change color to match the sky above you.
13	Your blood is watery, as though it were rained upon.
14	Your skin crackles with sparks when rubbed.
15	Clothing or armor you wear for long periods of time becomes scarred as though struck by lightning.
16	Your body is covered in symbolic tattoos or scars.
17	Your hair constantly swirls, even in still air.
18	Your face is cruel and alien to behold.
19	When you cast a spell, your eyes glow with a blue light and mist pours from your hands.
20	Thunder echoes your speech while you are outside during a storm.

Bardic College: College of Harbingers

Bards of the College of Harbingers are disciples of the Storm Lord, an otherworldly entity that sails between the skies of countless worlds, consuming the souls of fallen heroes. To enter the ranks of these champions, it is typical for an applicant to anchor themselves to a high place during a storm and then throw themselves from the edge. Struck and battered against the mountain or tower, the winds and rain crash and cut at their skin for three days and nights, until finally the Lord shows its favor, strengthening body and soul. Studying the stories of the fallen champions this great beast claims, you learn to call upon the Lord's power to strike down your enemies and to free you from mortal concerns. The skies will tremble before your performance and your prowess shall become legend.

Rite of Passage

At 3rd level, you perform the harrowing spiritual journey required to gain the Storm Lord's favor, allowing the souls of ancient heroes to instruct you in combat and lore. You gain proficiency in martial weapons and in the History skill.

Black Sky Song

Also at 3rd level, you learn the hymn that calls a fraction of the attention of your Lord to your plane. As a bonus action, you can expend a use of your Bardic Inspiration to sing a grim song of pain and triumph. Hostile creatures within 10 feet of you must make a Charisma saving throw against your bard spell save DC. If they fail, they are afflicted with a feeling of horrible insignificance. The first time they are hit by an attack before the start of your next turn, they are knocked prone and take lightning damage equal to the number rolled on your Bardic Inspiration die.

Thunderstruck

Starting at 6th level, you are wreathed in graceful winds that accentuate your movements and strike down your enemies. You gain resistance to thunder and lightning damage. You are permanently under the effects of the *feather fall* spell, and your jumping height increases by a number of feet equal to twice your bard level. During your turn, you can choose to make a single jump that does not provoke opportunity attacks if the destination is within 10 feet of a hostile creature. Whenever you descend more than 10 feet during your turn, the first weapon attack you make before the end of your turn deals an extra 1d10 thunder damage and pushes the target 5 feet away from you.

The Unfallen Kingdom

At 14th level, your soul has ascended to touch the paradise that lies within the eye of the Storm Lord. You gain immunity to the frightened condition. When you are reduced to 0 hit points but not killed outright, you can drop to 1 hit point instead and gain advantage on all attack rolls, ability checks, and saving throws until the end of your next turn. At the start of your next turn, allied creatures within 30 feet of you can use their reaction to join you with a defiant war cry. If they do, they also gain these advantages until the end of their next turn.

You can't use this feature again until you finish a long rest.

In the Kingdom of the Lord

The Storm Lord is a beautiful bringer of devastation and climactic change. The world when it arrives is very different than what remains after it has departed. Its coming is rarely a surprise to those gifted with prophecy, though it is not always as destructive as it could be. On occasion, the storms are simply endless rains that may drown the unwary and the ill-prepared. To those in distant lands, the Lord heralds the end of droughts and the beginning of a new era. In the silence after the Lord passes in all of its fury, those who remain begin to recover. The living heraldic Alfallen that they find in place of those who they thought dead are grim reminders of the eldritch nature of the Lord of Storms, and an ever-present notice that war is inevitable and that blood will fall like rain.

Cults of the Black Sky

Individuals who are dissatisfied with the current order are the most likely to join with a cult to the Storm Lord. These shadowy groups practice dark magics and unusual rituals designed to stir the populace of a region into a panic. Heroes from far and wide often arrive, seeking to bring about the downfall of the malevolent cultists. Once the heroes have gathered, the cult performs a dark ritual known as the *Summoning of the Black Sky*, which calls to the void between worlds, in an attempt to attract the Storm Lord's attention. If they are successful, their master arrives and brings the true storm with it, slaying the heroes and joining their souls with the remnants of others in its swirling tempest.

Rite of the Stormbringer

Within each cult to the Storm Lord there is an individual known as the Herald who is charged with speaking the will of the Lord. To be blessed with the righteous mantle of Herald, a disciple must perform the Rite of the Stormbringer, a treacherous task that few survive. If there is no other Herald to oversee the rite, the entire cult bears witness. The disciple is stripped, beaten, and dangled from a precarious perch atop the highest point in the land. For three days and three nights, the disciple sways and swings on the whims of the winds and is battered and frozen by the driving rains. If they survive, they have proven themself to be chosen by the Lord and are inducted into the ranks of the Heralds. If they die, they are hailed as a hero for their sacrifice and their soul is consumed by the Storm Lord.

Encompass the Tempest

When you decide to include the Storm Lord in your world, consider how it has affected things in the past. Has it arrived before now, or is this its first venture onto this plane? Does it travel over civilized areas, or does it remain in the wastelands far from society? The kingdom that the Lord rules over is one of fallen souls kept from their normal resting place, so many of the divine orders are likely to have strong opinions on it. Do the deities of your world accept the Storm Lord or do they defy it? Are there forces or parties equipped to combat the threat of the Storm Lord, or is it viewed as a force of nature rather than something to be fought? How would a warlock make a pact with the Storm Lord if it has yet to arrive? Did the pact lure the Lord to this world, or was the pact made in an attempt to prevent its coming? What other titles would the Storm Lord have in the cultures of your world? Is it feared as the Soul-Stealing Storm or regarded as the Eye of the Tempest?

Reversing the Whirlwind

If you'd like to change the Storm Lord to better suit your game, there are many opportunities to adjust it. The primary themes of the Storm Lord are storms and majesty, as one might expect, but it also has secondary themes of death, rebirth, souls, sound, wind, light, rain, suffering, change, and sacrifice. One of the simplest changes is to have a Storm Queen either as a replacement or complement to the Lord. There could be many such harbingers, all powerful and unique in demeanor. They could be cruel predators from the elemental planes or noble bearers of actual cities within the sky. Consider the Storm Lord's relationship to the souls of the fallen. Is it the servant of a deity of death, acting as a sort of purgatory before the final curtain? Is it a punishment for failure in great quests or a solemn heaven that spares the souls of the dead from remembering the horrors of their lives? Are the cultists of the Storm Lord an official religion whose practices are used to destroy the enemies of a kingdom, or are they feared, reviled, and outcast?

Sounds of the Storm

Cultists of the Storm Lord often express their devotion and loyalty through the use of musical instruments, which are essential to some of the more esoteric rituals of their craft. They hold percussion and woodwind instruments in high regard: the former because of the connection to thunder and rain, the latter for the attachment to the breeze.

Cimbalom of Dazd
wondrous item, very rare (requires attunement)

This musical instrument consists of a table-like structure covered by thin metal strings that are struck with small mallets to produce sound. It is decorated with symbols of storms and rain. It can be shrunk to the size of a fist or returned to full size by speaking a command word as a bonus action. When played by someone with proficiency in a string or percussion instrument, the magic within has a transformative effect. While playing the cimbalom, you cause the effects of the *control weather* spell, though you must use your action to continue playing in order to maintain concentration. While you are playing this instrument, you are immune to any disruptive effects or damage caused by the weather.

Fujara of the Eye
wondrous item, very rare

This flute-like instrument is as tall as a human and produces a windswept, meditative sound. When played by someone with proficiency in a woodwind instrument, its soothing sounds comfort the weak and bolster the strong. While playing the fujara, you can use your action to cast the *aid* spell at 5th level. Once the magic has been spent, it can't be used again until the next dawn.

Kaba Gaida of Nevihta
wondrous item, very rare (requires attunement)

This bagpipe-like instrument was made using the bones and organs of a blue dragon. When played by someone with proficiency in a woodwind instrument, it enhances their spellcasting. While playing the kaba gaida, spells you cast that deal lightning or thunder damage are cast as though using a spell slot of one level higher. Additionally, you can cast *gust of wind* at will without expending a spell slot. Charisma is your spellcasting ability for this spell.

THE WARRIOR-SAINT
THE JUDGE AND EXECUTIONER

Across the multiverse, there are countless worlds and disasters, villains and heroes, angels and demons, champions of chaos and soldiers of law. Yet, this is not a static thing. Worlds may fall into ruin or rise into splendor by the will of their inhabitants, striving to face down the darkness that plagues them.

However, there is one force in the cosmos that has accepted the responsibility of maintaining the order of the universe, acting to maintain the balance between worlds and to ensure that one does not interfere with another. This godlike being is known as the Warrior-Saint, and it stands in eternal vigil, protecting the freedom of mortal choice by fighting against any unnatural force that defies the cosmic order.

THE KEEPER OF THE COSMIC BALANCE

The Warrior-Saint commonly appears as a humanoid, both muscular and lithe, with an androgynous face that is as unyielding as it is implacable. It carries with it a mighty blade of starsteel, forged within the embers of a dying world, capped with the gemstone heart of that world's deity: a token of the Saint's first failure, and a weapon to punish those that would seek to repeat the same unjust act. Robes woven by the finest of the celestial hierarchies adorn its massive form, while its armor was wrought and inscribed within the furious fires of the burning hells. From its shoulders, ethereal arms rise to weave defensive spirals – a manifestation of the Warrior-Saint's infinite soul.

PASSION WITHOUT EMOTION

The Warrior-Saint exists as an expression of the purity of will required to maintain the balance within the universe. Whenever an entity that is too powerful for even a deity to put down arises and begins to wreak havoc, the Warrior-Saint will arrive, sword in hand, to put things to right. This has little to do with the goodness of cause or righteousness of purpose, but instead with the natural order of things. An army of angels invading the pits of hell are just as likely to be opposed by the Saint as the horde of fiends attacking the celestial planes. The Warrior-Saint's reach is not infinite, as it can only be in one place at one time, and so it will recruit servants and warriors to fight in defense of their own rightful edifices and homes, even on opposite sides of a conflict.

JUDGMENT AND RETRIBUTION

The Warrior-Saint's servants are bound by a code of conduct that is inviolate, though they are free to interpret it as they wish; such is the right of any sentient creature. However, all yield to the judgment of the Saint, for its eyes see the truth of the universe without fail, cutting through lies and deceit like spiderwebs before the scythe. Actions they perform are recorded by scribeants: small, scarab-like automatons that act as scouts and watchmen for the Warrior-Saint.

BEGIN THE FINAL TRIAL

The Warrior-Saint is present throughout the multiverse, though more often in places of great danger and discord. If the balance of a world is threatened, its servants will unquestionably appear. What terrible act has drawn the attention of the Saint to your world? How have local deities and planar forces responded to this intervention? Are they pleased, or do they refuse assistance? Are they even aware that something has happened, or might they even be complicit?

OTHERWORLDLY PATRON: THE WARRIOR-SAINT

You've made a pact with the Warrior-Saint, one of the great champions of the multiverse. This ancient being acts as an enforcer of the cosmic balance – law and chaos, good and evil. It is the agent of the forces of creation and destruction that act upon the world and is more akin to a supernatural phenomenon than a god or demon. The Warrior-Saint grants objects and boons of terrible power crafted during the creation, as well as the strength to enforce your own morality and philosophy in the eternal conflict that spans the planes. In exchange, it watches through the eyes of its servants and uses them as guardians of its treasures.

EXPANDED SPELL LIST

The Warrior-Saint lets you choose from an expanded list of spells when you learn a warlock spell. The following spells are added to the warlock spell list for you.

WARRIOR-SAINT EXPANDED SPELLS

Spell Level	Spells
1st	defiant smite*, detect evil and good
2nd	enhance ability, enlarge/reduce
3rd	irreversible smite*, protection from energy
4th	mark of objection*, stoneskin
5th	angelic rebuke*, punishing smite*

BLIND JUSTICIAR

At 1st level, your connection to the Warrior-Saint has granted you the ability to see through the imbalance of both order and chaos. Whenever you would normally make an attack roll, ability check, or saving throw with advantage, you can choose to twist the scales of reality. Roll three d12's. The die roll result equals the sum of the two highest d12 rolls. You cannot critically hit when you do this.

TREASURES OF PAST AGES

At 6th level, your Pact object or familiar is granted power from the Warrior-Saint. You gain one of the following benefits depending on your Pact Boon feature. This feature may be used twice, and you regain all expended uses when you finish a short or long rest.

- **Pact of the Blade:** You gain proficiency in medium armor and shields. Whenever you are targeted with a spell while wielding your Pact weapon, you can use your reaction to make a Charisma saving throw against the caster's spell save DC. If you succeed, the caster must choose a different valid target or lose the spell. This does not protect you from spells that target an area, like *fireball*.
- **Pact of the Chain:** At the start of your turn or at the start of your familiar's turn, you can use your reaction to magically teleport, switching places with your familiar or moving one of you to a location within 5 feet of the other.
- **Pact of the Tome:** If you are the target of an attack, you can use your reaction to cast a spell or cantrip with a range of "self" before the result of the attack is revealed. If you would no longer be a valid target for the attack, the attack is wasted.

HANDS OF THE SAINT

Starting at 10th level, two ethereal arms of the Warrior-Saint manifest from your back at your whim. These hands can perform somatic components for spells, but cannot wield weapons, equip shields, or grapple creatures. Additionally, you can use your Blind Justiciar feature when making a Strength saving throw if you do not have disadvantage, causing the Saint's ethereal hands to aid your efforts. Once you do this, you can't do so again until after the start of your next turn.

GUARDIAN OF BALANCE

At 14th level, your patron accepts you as a disciple of the eternal law, and gifts you a treasure of its own creation. You gain one of the following benefits depending on your Pact Boon feature:

- **Pact of the Blade:** Whenever you cast a cantrip while wielding your Pact weapon, you can make a single attack with it as a bonus action. Additionally, you gain proficiency in heavy armor.
- **Pact of the Chain:** Your familiar takes half as much damage from all sources. You can use your bonus action to enable your familiar to make an attack using its reaction, and if you also use your action, it can make two additional attacks as part of the same reaction.
- **Pact of the Tome:** When you finish a long rest, choose 3 spells of 3rd level or lower that you know. You can cast them as 3rd level spells without expending a spell slot. Once you cast three times using this feature, you can't do so again until you finish a long rest.

ELDRITCH INVOCATIONS

ALL ELSE EQUAL
Prerequisites: 7th level, Warrior-Saint Patron

Whenever you cast a spell with the word "smite" in the name, you can choose to have it function with any weapon attack, rather than only melee weapon attacks.

BETWEEN THE WORLDS
Prerequisites: 16th level, Warrior-Saint Patron

You can cast *plane shift* without expending a spell slot. Once you cast this spell in this way, you can't do so again until you finish a long rest.

BROKEN GOD'S BLADE
Prerequisites: Warrior-Saint Patron, Pact of the Blade feature

You can create a weapon of polished starsteel capped with a shining gemstone using your Pact of the Blade feature. Whenever you strike a creature with this weapon, you can choose to unleash a wave of magical force to push the target up to 10 feet directly away from you. You can choose to use your Charisma modifier for attack and damage rolls with this weapon.

SCRIPTURE OF NATURAL LAW
Prerequisites: Warrior-Saint Patron, Pact of the Tome feature

You can cast *zone of truth* once without expending a spell slot. This use recovers when you finish a short or long rest. You automatically succeed on saving throws against this spell.

Servant-Priests

Prerequisites: Warrior-Saint Patron, Pact of the Chain feature

While you have a scribeant swarm as your familiar, it gains additional hit points equal to your warlock level, and you gain advantage on Investigation and Perception checks.

Titanic Might

Prerequisites: 11th level, Warrior-Saint Patron

Righteous power flows through your body. You count as one size larger for the purposes of grappling and encumbrance, and you gain immunity to falling damage and damage from being forcibly moved.

Will of the Saint

Prerequisites: Warrior-Saint Patron

You can choose to have your AC equal 13 + your Strength modifier, as the robes of the Warrior-Saint cover your armor and flesh to protect you from harm. Additionally, you can bypass the effects of the *nondetection* spell as the Saint's impartial gaze comes more easily to you.

Details of the Pact between the Warrior-Saint and Archpriest Isaura

The signatory henceforth agrees to act in accordance with the wishes of the Saint until the conclusion of this contract. The wishes are as follows: The signatory shall destroy both fiends and celestials that trespass upon the sacred ground of the Temple. The signatory shall judge the living mortals within this plane in a fair and just manner. The signatory shall make responsible use of the treasures granted to them. The signatory shall not consort with fiends, celestials, or other extra-dimensional entities except in appropriate cases, which are as follows....

..... I hereby do proclaim and declare that I shall follow the written, spoken, and unspoken intention of this binding document, lest my soul be forfeit:

Archpriest Isaura of the Seventh Temple

Traits of the Disciples of the Saint

The strain of containing the power of the Warrior-Saint takes a toll upon the body and the spirit. Only those who have fully embraced the pact they have sworn or the oaths that they have taken can withstand the power of personified judgment, but it can be done with sufficient will. Consider adding one or more of these traits when creating a warlock or after destroying the enemies of balance in the Saint's name.

d20	Trait
1	You enjoy discussing the nature of law.
2	You judge others harshly for their flaws.
3	You hold even deities in contempt.
4	You greatly enjoy slaying the wicked.
5	You view most people as beneath you.
6	You seem to occupy a larger space than you should.
7	You do not speak, you *declare*.
8	You tend to avoid strong displays of emotion or affection.
9	You do not ask, you demand clarification.
10	You enjoy making contracts with others.
11	Your skin sheds trails of ethereal light.
12	Your eyes become a steel gray color.
13	Your blood is silver, like mercury.
14	Your skin is unnaturally smooth.
15	Clothing or armor you wear for long periods of time becomes inscribed with legal codes.
16	Your forehead is marked with a glowing tattoo.
17	Your face is eerily symmetrical.
18	Your shadow is always cast directly underneath you.
19	When you cast a spell, your eyes glow with a pale light and radiant power pours from your fingertips.
20	Your voice can be clearly heard even in disruptive conditions, as though you were a judge delivering a verdict to a silent courtroom.

I bear witness to these writings. They speak truth, and thus will be allowed to continue. Take care that they do not fall into the wrong hands. If they do, you will be held responsible for the consequences of your failure. Order must be maintained, but even chaos has order. Look into your heart, and see the truth with clear eyes. It is only there that you will find justice. The freedom to choose must be maintained, for without it, life is meaningless.

Sacred Oath:
Oath of Judgment

You have sworn to balance the cosmic scales of the universe, following in the footsteps of the Warrior-Saint, an immortal justiciar who fights to maintain order and balance between the infinite planes. Those who take this oath are forever bound to fight and slay creatures that go against the order of the cosmos, such as fiends that would seek to destroy the heavens, or angels that hunger to purify the hells. Otherworldly entities such as the ever-conflicting Alrisen often attract the attentions of these justiciars, who work to support the losing side so that the world will not be destroyed by their conflict, and so all mortal individuals will retain the right to choose instead of being forced to obey the unconscious desires of greater beings. If a conflict arises that cannot be contained by words alone, it is your task to decide the outcome. You are the judge and the executioner, and the world is your courtroom. All shall rise in your honor, and all shall fall by your hand.

Tenets of Judgment
The tenets of the Oath of Judgment are commonly witnessed by a scribeant swarm, which records the event in perfect clarity for review by the Warrior-Saint itself. This oath holds the following four ideals above all others:

Know the Truth: Always seek a full understanding of the reality of the situation, and let no illusions stand before your impartial gaze.
Destroy the Guilty: Order must be maintained and enforced without exception. There will always be another villain to replace this one.
Maintain the Balance: Angels and demons, fey and nightmares from beyond the planes, all must heed the order of the cosmos. Defiance is death.
Harmonize the Scales: Sometimes, there is no enemy before you. Work to undo the damage done by the accused.

Oath Spells
You gain oath spells at the paladin levels listed.

Oath of Judgment Spells

Paladin Level	Spells
3rd	detect evil and good, hellish rebuke
5th	calm emotions, zone of truth
9th	bestow curse, blink
13th	banishment, dimension door
17th	dispel evil and good, legend lore

Channel Divinity
When you take this oath at 3rd level, you gain the following two Channel Divinity options.

As Above. As a bonus action, you can use your Channel Divinity feature to call down cosmic fire from the higher planes to burn away a creature you can see within 30 feet of you. The target must make a Charisma saving throw against your paladin spell save DC. If it fails, it takes radiant damage equal to 10 + your paladin level and become immersed in an ethereal light, preventing it from taking the Hide action or being invisible for 1 minute.

So Below: As an action, you can use your Channel Divinity feature to summon the corrupted vigor of the lower planes to lend power to your voice. Each fey, celestial, and aberration within 30 feet of you must make a Wisdom saving throw against your paladin spell save DC. On a failed save, the creature is turned for 1 minute.

A turned creature must spend its turns trying to move as far away from you as it can, and it can't willingly move to a space within 30 feet of you or take reactions. For its action, it can use only the Dash action or try to escape from an effect that prevents it from moving. If there's nowhere to move, the creature can use the Dodge action.

If the creature's true form is concealed by an illusion, shapeshifting, or other effect, that form is revealed while it is turned.

Aura of Censure

Beginning at 7th level, the powers of the servants of otherworldly entities wither before your impartial gaze. Spell attacks targeting allied creatures within 10 feet of you are made with disadvantage.

At 18th level, the range of this aura increases to 30 feet.

From Whence You Came

Starting at 15th level, whenever you hit a creature with a melee attack and activate your Divine Smite feature, you can choose to push the creature up to 15 feet directly away from you.

Cosmic Executioner

At 20th level, you finally understand that the Warrior-Saint was once a mortal paladin like you who had taken the same oath you did. As an action, you can channel its power, causing the Saint's ethereal hands to manifest from your back. For one minute, you gain the following benefits:
- You gain resistance to all damage.
- Damage you deal ignores resistance and immunity.
- If you would be affected by a spell of 5th level or lower that deals damage, you can use your reaction to cast that same spell without expending a spell slot.
- When you move, you can teleport an equal distance instead.

I saw the Saint once. It was across a battlefield filled with fiends and Alrisen as we fought a great war against a tyrant, and it was like nothing I've ever seen. Whenever a spell would be about to strike the ground, the Saint would appear in a shimmer of light, grasp the spell with one of those ethereal hands, and hurl it back at the caster. Then it would appear next to them and cleave their head from their shoulders. I almost decided to give up on magic after watching that. At least it was on our side!
—Sylvette

Justiciar of the Cosmos

The Warrior-Saint is considered by many to be the most powerful of the Alrisen, simply because of its position as the enforcer of cosmic balance. When other Alrisen gather to wage war upon one another in a way that would threaten the stability of the natural order, the Warrior-Saint will step in to restore the status quo. The fiends of the lower planes and the forces of chaos are punished just as harshly as the celestial concordant and the mechanical servants of pure law in worlds protected by the Warrior-Saint.

Imperfect Balance

The Warrior-Saint was once a mortal warrior who fought tirelessly against the forces of injustice. Countless devils and demons fell before his blade, dying with screeching cries before the unstoppable force of the warrior. Evil of all stripes rose to harry and antagonize the warrior, but the warrior did not falter, and pressed ever-further into the cruel darkness.

Eventually, when he reached the heart of chaos and cruelty upon his world, the warrior was approached by an ancient entity of unimaginable cruelty and power. The fiend warned the warrior that if it was exposed to the light of the sun, the heavens themselves would not stand for this offense, and that the celestial armies would destroy the world and the gods that ruled over it with such disregard for their duties. The warrior believed the fiend to be speaking falsely, firmly believing in the justice of angels. They fought, and the fiend was even more powerful than the warrior had imagined. In desperation, the warrior lured the enraged fiend into the sunlight, and bore witness to what followed.

Holy Destruction

The abomination had spoken truth. Furious that such a foul entity could stand before the light of the stars without divine intervention to stop it, the angels of the higher heavens descended upon the world, bringing destruction and ruin to the entirety of the planet. They slew the deity responsible for the management of the world, claiming that goodness and law could not abide such heretical incompetence. The warrior survived by virtue of his incredible strength and the indifference of the celestial armies and wept over the corpse of the deity that he had followed.

Overcome with grief, the warrior swore the oath of a true saint: to uphold balance and justice, judging both law and chaos, good and evil, without regard to their intention. The warrior took the heart of the fallen god and, using all of his skill, forged weapons and armor within the core of the dying world, scavenging from the corpses of fallen angels and fiends to complete his work.

A New Beginning

Bearing armor forged from hellish steel and robes taken from the bodies of angels, the warrior strode forth into the light and challenged the forces that had brought such suffering and punishment to a world undeserving of their wrath. The angels above laughed, asking how a mortal could hope to stand upon a dead and broken world to speak of justice.

Sword in hand, the warrior's eyes grew cold and merciless. Empowered entirely by his own faith in true justice, the warrior saw the disharmony in the angelic forces.

They disrupted the righteous order of the world in their victory, taking choice away from the hands of mortals.

They would be punished.

The Dawnless War

The warrior moved with precision and grace, cutting down the angels before him. The god-heart attached to his blade thrummed with a lust for revenge, and the demonic inscriptions of the warrior's armor feasted eagerly upon the blood of the angels. The celestial forces fell into disorder, seemingly incapable of harming the warrior. The robes of archangels provided the warrior with immunity to the radiant bursts of power the lesser celestials unleashed, though the world was torn even more asunder with each volley.

Within the course of one night, the unstoppable warrior slew an entire army of angels. The higher deities could only watch in dismay, for the actions were taken by the free will of a mortal, and thus could not be directly interfered with. Evil and chaos reveled in the display, and fiends boiled forth from the ground. The weaker among them bowed before the warrior, begging to be led to the high heavens to continue their war. The stronger fiends offered enticing bargains and requests for loyalty, and they promised any number of unspeakable things to the warrior.

The Warrior-Saint

With eyes like steel, the lone survivor upon a dead world stared at the suffering around him. Wretched fiends feasted upon the flesh of the fallen mortals and angels alike, while laughing and harvesting the bones of their kin to make new weapons for their eternal war. The warrior knew that if he agreed, and fought against the heavens, the light would fall. Every world across every plane would be destroyed by the wicked hordes, and the mortals that did survive would be enslaved and deprived of their freedom to choose.

Thus, the Warrior-Saint stood firm, and denied the fiends their requests and demands. It declared itself an arbiter in the eternal struggles between greater beings, for it believed in the right for all mortals to define themselves and act according to their own will. The fiends screamed with rage and fell upon the Saint, clawing and biting and unleashing eldritch magic the likes of which had never been seen.

Arbiter of Balance

With pure defiance and determination, the Warrior-Saint fought against the fiendish hordes. Even a blade forged with the heart of a god was not enough, and so the Saint changed with an act of will. It grew taller and stronger, glowing with radiant power fed to it by the blood of the fallen angels. Hands of spiritual light emerged from its back as it fought, unleashing spells that made the ground quake and the earth crack. Archfiends and nightmarish horrors stood before the Warrior-Saint, and all fell to the unceasing onslaught.

For every fiend slain, another was banished forever back to the foulest pits, sent screaming there by the forceful will of the Warrior-Saint. In the end, the sun rose on a broken world. Thousands of island-sized pieces floated through the void between the stars, and the fiery core within was exposed to the chill of the eternal blackness. The Warrior-Saint looked on, blade in hand, and swore an oath for all eternity:

"Never again."

Honoring the Saint

The Warrior-Saint can easily fit into your game in its current form, but you may wish to modify or customize it to better suit your needs. When including the Saint as it is presented here, answer some of the following questions to determine how it fits into your world:

Does the Saint have stalwart allies or archenemies? If so, who are they, and why do they feel the way they do about the Saint? How would divine powers react to the presence of the Saint on their world? What would other Alrisen or similar forces do if the Saint came to wage war upon them, and how does the presence of the Saint change their plans? Does this make them more cautious, causing them to use warlocks and other mortal champions as pawns in a great struggle over power, or do they respond in force? Are any strong enough to defeat the Saint alone, or would these great powers have to work together to disrupt the balance?

Reworking the Warrior

If you're interesting in changing the Saint to suit your world or game, one of the easiest places to start is in its appearance. Is the Warrior-Saint masculine, as depicted here, or was it feminine before its ascension? Do terms like these even apply to a force of pure willpower and justice embodied? Does the Saint appear as a being of pure light, mixed with swirling shadow, or might it look to be orderly crystalline shards swirling in a chaotic spiral, shaped into a humanoid form?

When you change the Saint's appearance, you can also take the opportunity to give it personality and goals beyond justice. The Saint was once a mortal, so how does that play into its worldview and beliefs about the universe? The Saint depicted here considers good, evil, law, and chaos to be forces that must be kept in check so that greater harm is not done.

If you'd like to make the Saint fulfill a more benevolent role, consider making it an angel, deity, or other servant of the higher powers, and let it act as a judge of the many dark forces that threaten the multiverse beyond the eyes of mortals. If you'd like to have it take on a darker cast, perhaps give it a goal of decimating all life equally, so that a singular authority can be established.

Disrupting the Courtroom

If you're looking to really go beyond the Saint, consider re-imagining it as something vastly different. Perhaps it is a collector of ancient magical artifacts, and it offers them to heroes in exchange for services or treasure. It could be an entire group of individuals, led by a number of higher justices. It could be a semi-sentient court of cosmic law, similar to the Eternal Citadel in practice, or it could be a legal document signed by the gods themselves.

Disciples of the Saint

The Warrior-Saint is engaged in a near-constant conflict against every force in the cosmos, trying to maintain a semblance of balance and peace so that the mortal races can live and choose how to act without constant outside interference. The Saint cannot be everywhere at once, however, and so it will appoint champions and servants to maintain order while it is gone. Cultures who have interacted with the Warrior-Saint and survived the conflict that summoned it often revere it as a guardian or patron saint. Individuals who serve the Saint as warlocks create binding, contractual oaths designed to lead them on the path to becoming aligned to the cosmic balance. The Warrior-Saint, while technically immortal, expects that one day another mortal will rise to replace it. It is possible that there have been countless Saints over the endless ages, maintaining the balance and allowing the mortal races and lesser deities to continue to exist and grow.

Treasures of the Saint

The Warrior-Saint is a maker of things, skilled in both creation and destruction in equal measure. The creatures that it has fought and defeated have also held terrible artifacts, and it has claimed them to distribute among those that it feels are worthy of such power. Here are some of the most noteworthy.

Ancient Heart
wondrous item, legendary

This is the heart of an elder being, pulsing with eldritch power and quivering with unnatural intent. You can consume it as an action. Roll a d6. You can increase one of your ability scores by a number of points equal to half the result (rounded down) and increase the maximum by the same amount. If you roll a 1, you die, your corpse is transformed into an unspeakable creature of CR 20 or greater, and you cannot be resurrected.

Angelic Robes
wondrous item, very rare (requires attunement)

These robes can be worn over armor and are embroidered with celestial script. Whenever you would take radiant damage, you can use your reaction to negate the damage and gain half as many temporary hit points instead.

Fiendish Bracers
wondrous item, very rare (requires attunement)

These paired bracers are covered in otherworldly runes. Whenever you are exposed to an effect that would cause you to be frightened, you can use your reaction to become immune to the frightened condition. If the source of the effect is another creature, it must make a DC 15 Wisdom saving throw or be frightened until the end of its next turn.

Qanun of Order
wondrous item, uncommon

This 79-stringed instrument is marked with a scroll and an animal-headed deity. While you are playing it, any creature who hears it and speaks without your permission or knowingly tells a lie takes 1d8 psychic damage after finishing their sentence. Creatures who hear it are aware of this effect.

Sorrowful Ney
wondrous item, rare

This flute-like instrument was once played by the Saint during a quiet moment after the destruction of their world. As an action while playing it, you can create an illusion of a memory you have. The illusion occupies a 15-foot cube, and it can produce sounds. You cannot alter the memory, only show it.

World-Walker's Sandals
wondrous item, very rare (requires attunement)

These gladiator sandals are covered in the hieroglyphics of a dead civilization. Whenever you take the Dash action, you can choose to teleport up to your speed. You can only do this once per turn.

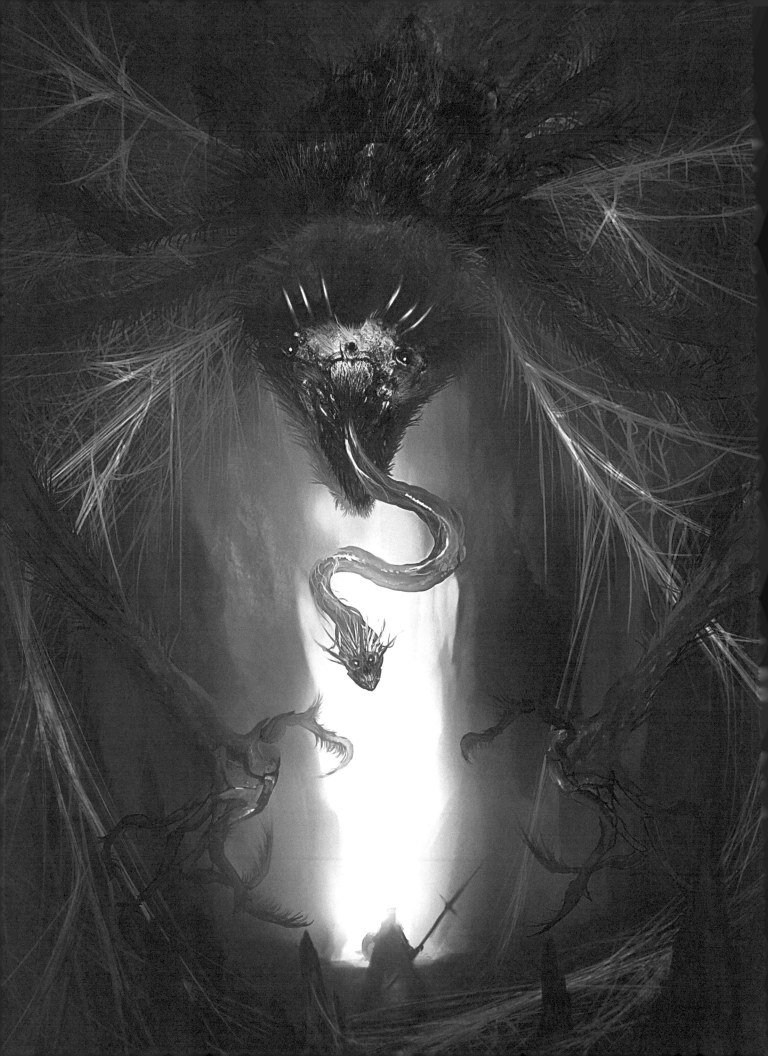

THE WEAVER OF LIES
The Bane of All Truth

In the beginning, the world was created. Many argue about how this was done, but most accept that it was the actions of the gods themselves that led to the creation of life upon the Material Plane. However, there is one being that was not created deliberately by any deity and was not spawned upon some far and god-forsaken plane. Instead, it is a creature born when the forces responsible for the creation of the world acted with deceit for the first time. Those who delve deep into the ancient texts call this creature the Weaver of Lies, describing it often as the trickster responsible for the terrible conflicts and destructive wars that arise from mistrust and suspicion.

The Great Deceiver

The Weaver of Lies is often depicted as a massive spider-like creature with an eerily human mouth and a long, nightmarish tongue. Webs of spider-silk and woven shadow adorn its purplish chitinous body, and religious symbols hang blasphemously from those tattered threads. Its golden-green eyes glare unblinking at those that stand before it, dull and remorseless in the subtle light of its lair. Barbed spines grow from its back and head, forming a twisted crown that seems a mockery of any true regalia. Those who have heard it speak are said to describe its voice as wholesome and trustworthy, despite the obviously deceptive source. Some who have spoken to the Weaver have described it akin to a person draped in a spiderweb cloak, without skin or bone beneath. Instead, an endless horde of skittering spiders move and stand in the shape of a man or woman, with a cruel visage made from the arachnids staring forth from beneath the ever-raised hood. Of course, this form is likely a mere facade in order to disturb or comfort the mortal viewer, for the true form of a liar such as this can hardly be determined.

Spawn of the First Falsehood

Many scholars, both arcane and religious, argue over what could be considered the first "true" lie. Only the Weaver itself, the deity that spoke the falsehood, and those who have sworn their service to the Weaver can honestly claim to know the truth. The Weaver exists because that lie is what spawned it, small and alone, lying in wait in a forgotten place deep within the earth. A single falsehood soon begets more, however, and so the Weaver's webs grew more numerous and complex, growing up through the cracks under the world. When they touched the surface, and the Weaver saw the races that dwell upon the landscape, it grinned with glee, whispering of plans upon plans, wheels within wheels, and webs within webs. There was a tapestry to be woven, and a grim portrait to depict. Thus it called to its children, the spiders that it sees as servants and spies, and began its great and terrible work.

A Vengeful Creation

Those who have studied the lore surrounding the Weaver of Lies seem to agree upon one fact about this dark entity: it is the enemy of the gods themselves. It intends to destroy them, exacting a punishment upon these powerful deities for the crime of its own birth. It is a being filled with sly and subtle hatred for all of the higher powers that created the world, thinking them villains in a plot of its own devising. It holds the gods of evil and deceit in contempt, viewing them as fools for continuing to speak and fuel its power, while considering gods of good and justice as hypocrites, knowing that by their own creation of the mortal races, they have contributed directly to the making of those creatures that are capable of the infinite creation of lies and deceptions. The Weaver is empowered by these deceits, according to the scholars and preachers of divine law, but even they do not know if their statements are true.

Reality and Incomprehension

The Weaver is more than just a liar: it is a lie. Everything about it is fake and false, even when it is true. This is often difficult for mortal minds to begin to grasp, but at a fundamental level, it remains. The Weaver does not obey the laws of the universe, because to it, those laws are lies. It defies them, it breaks them, and it rewrites them in accordance with its plans and wishes. It is the equal to the deities that it hates, and is only kept in check by the eldritch forces and older, darker powers that exist on the edges of reality. It is a made thing, but also a maker, twisting the corners of truth into spiraling shadows that it weaves once more into lies. Of all the Alrisen, the Weaver is among the most dangerous. When it is involved in anything, it is pulling all of the strings.

The Puppet master

The Weaver of Lies is often thought of as a puppet master, manipulating events unseen while being in control of both the hero and villain. When it directly intervenes, identifying a falsehood becomes almost impossible. Those who have interacted with the Weaver directly often become paranoid, claiming to see its eerie hands in everything and its strings on everyone. Friends and family members are just false tools created by the Weaver to push the victim down a particular path, but what if defying that path is actually what the Weaver really wants? How could one know? What if both paths lead to the feared fate and the choice is simply an illusion crafted by this horrible nightmare? Such thoughts lead to madness, but how would one convincingly prove them false?

Call to Regret

The Weaver of Lies is not commonly sought willingly. The rare few who do desire to make pacts with this eldritch entity are those that wish to no longer know the truth. Betrayers and murderers, torturers and liars who have seen the harm they have caused and rejected the outcomes will go and kneel before the Weaver, begging to have their memories taken and their minds filled with doubt so they may deny the consequences of their actions. Victims of horrible fates will stand before the Weaver and smile as their past afflictions become little more than another bad dream, something that need not trouble them any longer. Warlocks of the Weaver lie to themselves as much as they lie to others. There is a pride in their blackened hearts, to see the truth, reject it, and weave a new one. The Weaver's webs are everywhere, and it will create a reality that is universal: one where everything is a lie.

OTHERWORLDLY PATRON: THE WEAVER OF LIES

The speech of a god is the act of creation itself, but what happens when the gods lie? The small accumulated deceptions come together, forming a creature of webs and treachery, lies and deceit. It is called the Weaver, but it is a being woven from the lies of the gods themselves. Its influence is felt each day in the small comforts one tells oneself to the greatest of blasphemies against the divine concordant. Spiders toil in service to the Weaver, and you've joined them in your lust for power or desire to forget.

EXPANDED SPELL LIST

The Weaver of Lies lets you choose from an expanded list of spells when you learn a warlock spell. The following spells are added to the warlock spell list for you.

WEAVER OF LIES EXPANDED SPELLS

Spell Level	Spells
1st	alarm, spider's kiss*
2nd	silence, web
3rd	nondetection, shadow toxin*
4th	compulsion, phantasmal killer
5th	modify memory, insect plague

POISONED MIND

When you forge this pact at 1st level, your patron teaches you the first lie ever told. You gain proficiency in the Deception skill, and you gain temporary hit points equal to your Charisma modifier whenever you make a Deception skill check while you are not in combat.

Also, when you cast a spell of 1st level or higher than affects one or more hostile creatures, you can use your bonus action to force one of the targets of the spell to make a Constitution saving throw against your warlock spell save DC. If the creature fails, it is poisoned until the end of your next turn.

A TOUCH ON THE WEB

At 6th level, you learn to summon the slaves of the Weaver to extract vengeance. Whenever you take damage from a melee attack, you can use your reaction to summon a horde of spiders to cover your attacker, biting and tearing into them. The target takes magical piercing damage equal to your warlock level and must make a Constitution saving throw against your warlock spell save DC. If they fail, they are poisoned for one minute. While they are poisoned, they are also frightened of you. They can repeat their saving throw at the end of each of their turns, ending the effects on a success.

Once you use this feature, you can't do so again until you finish a short or long rest.

TRICKSTER'S DANCE

Starting at 10th level, you can deceive even the fabric of reality. You can't suffer disadvantage on saving throws.

Additionally, you can cast mislead without expending a spell slot. Once you do so, you can't do so again until you finish a long rest.

SINFUL PUPPETEER

Starting at 14th level, your blood flows with poison and your hands dance upon a loom of false spidersilk. You gain immunity to poison damage and the poisoned condition.

As an action, you can attempt to magically ensnare and control the actions of a creature that you can see within 60 feet of you. The target must make a Wisdom saving throw against your warlock spell save DC. If they fail, the creature is caught in your web of lies. On your turn, you can use your bonus action to take total and precise control of the ensnared creature. While the target is under your control, you can see through your target's eyes and hear what it hears until the start of your next turn, gaining the benefits of any special senses that the target has. Until the end of your next turn, the creature takes only actions that you choose and can't do anything that you don't allow it to. During this time, you can use your reaction to force the creature to use it's reaction. The creature remains completely unaware that you have acted upon it and feels certain that any actions it performed were of its own free will. Once you control the creature once, your hold over it is broken.

Once you attempt to magically ensnare a creature, you can't do so again until you finish a long rest.

ELDRITCH INVOCATIONS

ACOLYTES OF THE ARACHNID
Prerequisite: Weaver of Lies patron, Pact of the Tome feature

Whenever you finish a short or long rest, you can perform a weaving ritual over the course of 10 minutes. When you finish, you can touch a number of creatures equal to your Charisma modifier. These creatures become immune to the web spell and natural webbing, and climbing costs them no extra movement while the creature is touching a web. This lasts until that creature finishes a short or long rest.

ASSASSIN IN THE DARK
Prerequisite: Weaver of Lies patron, Pact of the Chain feature

If you have a shade widow as your familiar, it gains additional hit points equal to your warlock level. Whenever it uses the Bite action, you can use your reaction to impose disadvantage on the target's first Constitution saving throw against the widow's poison.

BINDING BLAST
Prerequisite: 9th level, Weaver of Lies patron

Whenever you cast a spell that targets more than one creature and inflicts damage, you can use your bonus action to send transparent webbing to bind all targets that took damage from the spell. A bound target cannot move from they were when you cast the spell unless they succeed a Strength (Athletics) check against your warlock spell save DC at the start of their next turn. Forced movement, such as a shove, automatically breaks the webbing. The webbing dissolves into dust at the end of a bound creature's turn.

BLASPHEMOUS WHISPER
Prerequisite: 12th level, Weaver of Lies patron

You can now activate the Poisoned Mind feature whenever you cast a cantrip that targets one or more hostile creatures.

Lair of the Liar
Prerequisite: 7th level, Weaver of Lies patron

You can cast the *web* spell once without expending a spell slot. Once you do so, you can't do so again until you finish a short or long rest.

Whenever you cast *web* and maintain concentration for the full duration, you can choose to have the web become permanent and impossible to dispel.

The Silver Tongue
Prerequisite: Weaver of Lies patron, Pact of the Blade feature

You can create a finesse weapon made of silver and bone using your Pact of the Blade feature. This weapon deals psychic damage instead of its normal damage type. When hit a creature with this weapon, you can choose to deal no damage. The target must make a Wisdom saving throw against your warlock spell save DC. If they fail, they are charmed by you until the start of your next turn and will not take hostile actions against you, but may target your companions.

Before I traveled with Xandith and his companions, I was an arcane researcher studying at the behest of a tyrant. Apparently my rivals at the academy set me and my team up, sending us unwittingly into the lair of one of the Weaver's many children. We were captured, and it feasted upon our magical energies. My fellows died. It dragged me around like a puppet, forcing me to cast destructive magic at X and his friends while it hid, invisible. Luckily, they slew the creature and spared my life. Spiders boiled forth from the corpse of the massive nightmare, and formed into the shape of a cloaked figure. It spoke to us, and I believed it even though I knew it to be a liar. It told me that my friends were alive, back in the lair. It told me that I was responsible for what had happened. It told me I should beware those who saved me. I became paranoid, distrustful of even my own eyes. It was only in the embrace of the Convocation that I could find peace, because when you have real friends, the truth doesn't hurt. —Sylvette

A Prayer to a False God

"Oh Weaver, let what I have heard be false. Let your whispers speak to the world in which I live, for I have sinned so deeply and fully that even the gods themselves have turned their backs to me, and cast me into the shadow. Oh Weaver, Deceiver, Great Teller of Falsehoods, take me into your web that I might never see the truth of my deeds ever again..."

6th Era, author unknown

Traits of the Spidersworn

The blissful heresy of a servant of the Weaver comes from a corruption of the mind and soul. Consider adding one or more of these traits when creating a warlock or after spinning a great web of lies in service to the Weaver.

d20	Trait
1	You enjoy telling tall tales.
2	You take advantage of the gullible at every opportunity.
3	You view the gods in a poor light.
4	You greatly enjoy fooling the wicked.
5	You view trusting people as tools for your use.
6	You always try to get the last word in.
7	You tend to talk in circles.
8	You frequently reject the logical arguments of others.
9	You do not tell, you imply.
10	You enjoy betrayal, even against yourself.
11	Your skin has long barbed hairs growing from it.
12	Your eyes become a reflective black or green.
13	Your blood is yellow, like the ichor of an arachnid.
14	Your skin has an unhealthy hue.
15	Clothing or armor you wear for long periods of time becomes covered in spider web insignias.
16	You grow additional eyes on your forehead.
17	Your facial proportions seem somehow off.
18	Your shadow is always cast directly towards the nearest light source.
19	When you cast a spell with a verbal component, shadows shaped like spiders crawl from your mouth and rush to cover your hands.
20	Your body is covered in thin chitinous plates.

ROGUISH ARCHETYPE: SPIDERTOUCHED

There are many assassins, spies, and tricksters throughout the endless planes who take on the motif of a spider as their symbol, but you are one of the few for whom this symbol is truly accurate. You've learned your craft from the Weaver of Lies itself, an ancient creature spawned when the gods first deceived one another and the mortals they surveyed. Deities that hold sway over the crawling creatures of the dark and guilds of assassins and spies may grant powers such as these, but no matter the origin, you will take these forbidden techniques to your grave. Cloaked in the faces of others and bearing the deadly toxins of your teacher, you crawl along the shadows at the edges of the world, hunting for secrets and spinning webs of treachery.

TOOLS OF THE TRAITOR

When you choose this archetype at 3rd level, you discover the secrets hidden in truth and falsehood. You gain proficiency in the Deception skill and with nets.

You can weave webs from your fingertips at will, crafting a false face from magical spider silk. This acts as a disguise kit that you have proficiency in.

Additionally, you can use your bonus action to weave your webbing into a sticky 50-foot silk rope with adhesive grapple or into a net. This web net has a range of 15/30 and has additional hit points equal to your rogue level. You can only have one such rope or net, called a web construct, at a time. Creating a second web construct destroys the first one.

ARACHNID'S FANG

Also at 3rd level, your blades whisper with toxins and lies. When you would deal Sneak Attack damage, you can have the damage dealt be poison instead of its normal damage type. When you hit a creature that is restrained and change the damage type using this feature, the target suffers disadvantage on Strength checks until the start of your next turn.

SUBTLE STRIDE

At 9th level, you learn the talents of your mentor's small arachnid slaves and take their hidden power for your own.

You gain a climbing speed equal to your walking speed and can move along vertical and horizontal surfaces, including ceilings, while leaving your hands free. You are also immune to natural webbing and webs created by the *web* spell.

TWITCH ON THE WEB

Starting at 13th level, your words and deeds ensnare others, dragging them into your dark parlor. You can now throw a net as a bonus action, and this does not prevent you from making additional attacks. Invisibly thin strands of spider silk connect your web construct nets to your body, allowing you to drag a creature restrained by your net up to 30 feet directly towards you, possibly holding them suspended in the air, by using an action to make a Strength (Athletics) check contested by the target's Strength (Athletics) check. If you succeed, the target is dragged and either knocked prone or held suspended in the air below you. If you fail, your web construct net is destroyed and the target is freed.

Your movement speed is halved while suspending a creature, and when you move horizontally while holding it, you can have it move with you or fall to the ground. If you teleport, the target automatically falls to the ground and is no longer suspended.

You can now have a number of rope or net web constructs equal to your Charisma modifier (minimum 1). You also count as one size larger when determining how much you can lift and carry and for the purposes of grappling.

SKITTERING NIGHTMARE

At 17th level, your body has finally adapted to enable you to move with the eerie grace of the webbed ones. You can't be knocked prone against your will. While you are prone, you can move at full speed as though standing, you do not have disadvantage on attack rolls, and attackers that are within 5 feet of you do not gain advantage on attacks against you.

I knew my name in the past. I was a thief I think. I stole from a noble and was caught. I was imprisoned and I was tortured, or so I've been told. I don't really remember. All I know is that there was a spider hidden in that cell of mine. It was larger than it should have been and it ate the rats, snaring them in its web and tearing them apart before my eyes. I remember the spider. It spoke to me, and it told me something. I was broken at the time. It stitched me back together but it took things in the process. I learned things, but I think they're lies. I doubt it matters. I crawled to the ceiling of the prison cell and waited. My captors came in, and I turned them against one another. They slaughtered themselves and I laughed because I know they weren't real. They were just constructs made by the spider to torment me into agreeing. I don't know who I am anymore. I've worn one hundred faces and one thousand names, and none of them are my own. I can't recognize myself in the mirror anymore. I don't see anyone there. I just see a former person. That's all I am now.

—Formerly Someone

Conspire with the Weaver

When including the Weaver of Lies in your world, one of the first things you should decide is how powerful you'd like it to be. Is it incredibly strong, able to warp reality with nothing more than a thought, or is it weaker and reliant upon clever artifacts or cunning plots to ensure the safety of its dark plans?

The Weaver can take on any form and change shape at will, so you can decide how it will look whenever it manifests, but the real trick is deciding how much influence it has had and will have over the course of the game. What is it interested in currently, and what does it want to have happen? Does it have an army of assassins at its beck and call, or is it lonely, waiting among its spiders for a new servant to stumble into its lair?

Opposed by Faith

The Weaver of Lies acts in direct opposition to the divine powers that rule over the world, twisting their creations against them in its quest to create a new order where all things are equally false. Religious orders dedicated to seeking truth are often victimized by the Weaver, who will send agents to subvert them or corrupt them into seeing the world as a fluid place where truth is only in the eye of the observer.

It pushes agendas that discredit honest folk and turn neighbors against one another. It calls for unity while sowing disharmony. It casts the divines as tyrants and itself as a savior of mortals, claiming that the world will be a better place when the only things believed are the things seen. It does this because it controls what is seen, and heard, and read, and felt in one's heart. It is jealous, in a strange sense. The Weaver wishes to be divine, but despises divinity. It was born from falsehood, and it will grow until it can no longer be denied by those that created it, for their every denial makes it that much stronger. The very concept of deception itself cannot be defeated with lies, after all.

The Weaver thrives on doubt and fear and regret, and thus can only be opposed by those strong in faith and hope. The cruel irony of this is that those who are strong of faith and hope are often the easiest for the Weaver to manipulate, as any "divine" inspiration that they may receive could simply be manufactured by this dire abomination.

A Liar Until Death

The one true vulnerability of the Weaver is its inability to speak the entirety of the truth. It simply cannot do so. It will always exaggerate, even slightly, when discussing real facts or events. It views numbers and other mathematic concepts with disdain and hatred, as it cannot contend with them. One is one, after all, no matter how much the Weaver may try to persuade the universe otherwise.

Asking the Weaver or one of its slaves the sum of a pair of numbers will either cause it to react with hatred or coil about in fear. It may try to persuade one that the concept itself in insufficient, and that the numbers spoken of were not actually the ones said. It will twist the conversation around and around until the other party has been dragged back to the half-truths of the Weaver's domain, and then it will continue, seeking out flaws in character and regrets from the past in an effort to deride and punish the victim for their insolence. The face at the end of its tongue will turn into the face of the other party, and it will begin to mock and cackle madly, saying that the other is the false one, created by the Weaver, and that the true self sits there, having been devoured long ago.

Beyond the Web

If you'd like to change and customize the Weaver of Lies, consider starting with some relatively simple adjustments. Is it truly opposed to the divine powers, or is it subservient to them? Is it actually a deity of deception and darkness? Is it disguised as a deity of light and good? Does it have a gender or a name beyond this title? What cultures know of it, and how do they respond? A system of passwords based on numerical fact could be useful for defying the servants of the Weaver's plots and schemes, so consider how a culture may implement these sorts of safeguards. What would happen to one that does not know of this weakness?

Safeguards and Subterfuge

There are many objects associated with the Weaver of Lies and with those that oppose it both openly and in secret. Here is an list of several that are more commonly discovered.

Arcanomathematic Cube
wondrous item, uncommon

This cube of brass is covered in numeric inscriptions. When you speak the correct sequence of numbers and addition signs to equal a prime constant, located at the top of a cube, it produces a string of numbers that correspond to locations on the exterior of the cube. When those locations are touched while the equation is spoken, the cube delivers a message directly to the mind of the operator and shields them from mental influence for the duration of the message. You can then record a new message telepathically while touching it. The cube then resets, the prime constant changes, and the numbers shift to new locations on the exterior. Operating the cube takes a number of minutes equal to 5 minus your Intelligence modifier, to a minimum of one action.

Balalaika of the Arachnid
wondrous item, legendary (requires attunement by a creature associated with the Weaver of Lies)

This stringed instrument normally only has three strings, but this one has twenty-four divided among its eight stems, positioned in a circle so that the strings form a web over the center. It is impossible to play correctly by ordinary individuals, but in the hands of the Weaver's servants, it produces an eerie and unnatural tune. As an action while you are playing this instrument, you can create a static illusion that occupies a 100 foot cube centered on you. This illusion is impossible to see through without truesight, and it can be interacted with as though real. It cannot inflict damage, but it can restrain creatures or otherwise impede their actions. A creature can destroy an illusory restraint using their action. The illusion lasts until the start of your next turn unless you maintain or change it using your action at that time.

Book of Lies
wondrous item, uncommon

This book is wrapped in silver spiderwebs. A person reading this book will only see what they want to see, or what the magic within the book thinks they would benefit from reading. Everything within is incorrect, exaggerated, false, or otherwise in error. The book contains no numbers, including page numbers, and if you attempt to write a number on one of the pages, the book will unleash a hideous scream, causing 2d6 psychic damage to all creatures within 10 feet of the book. This scream is audible up to 300 feet away.

THE WILD HUNTSMAN

THE MASTER OF BEASTS

In the frostbound peaks high above the world, stories are told of a being clad in armor who rides a black horse surrounded by hounds and bears a hunting hawk upon its arm. A horrible blizzard follows the Wild Huntsman, forcing those unprepared out into the wilderness as hearths flicker and flames die. Starving and cold, villagers emerge to beg for mercy and salvation only to be mauled to death by the hounds of the Huntsman for their weakness. The Huntsman is lord and master over man and beast alike, for the former is the latter until proven otherwise.

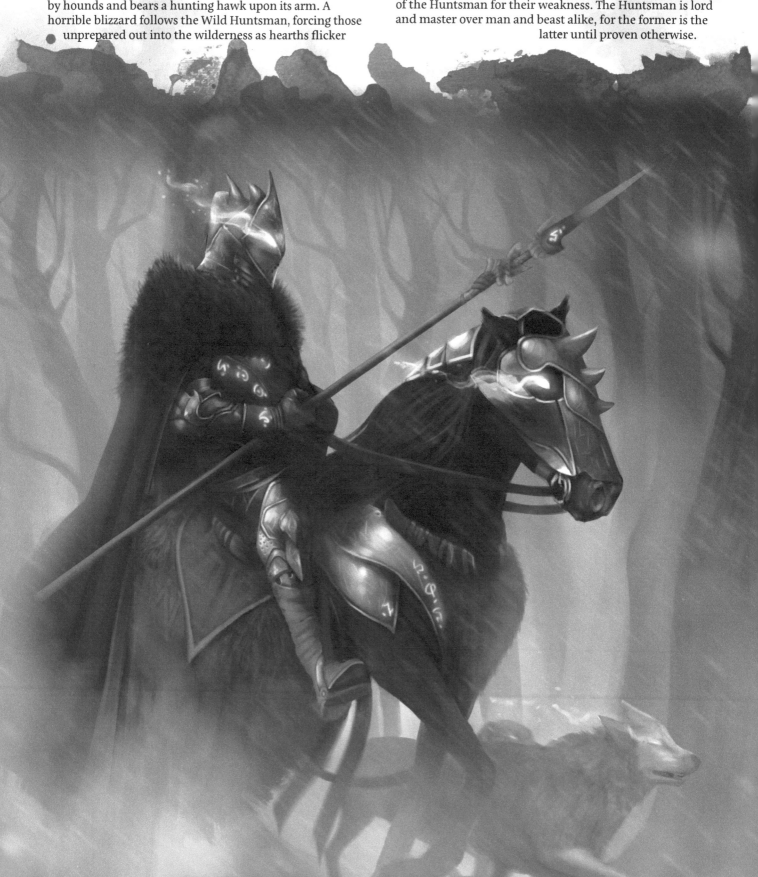

The Black-hearted Killer

The Wild Huntsman is a primal thing dressed in the trappings of a man. It speaks with a voice that sounds like the cracking of ice and soft footfalls upon the snow, demanding a display of strength and prowess from those who come before it. Anyone who impresses the Huntsman is allowed to live, regardless of their former station. Those who fail are killed, with rare exception. The survivors are tasked with aiding the Huntsman in its pursuit and are gifted a weapon and assigned a quarry. Few succeed, and fewer still come back with all their limbs. A single hunter armed with naught but a knife is asked to kill a bear, while a party of three might be instructed to hunt down a deadly winter hydra. The Huntsman demands to see the dominance of mortal races over the beasts that lurk within the darkness and is as merciless as the blizzard at its back.

The Horn in the Night

For those who manage to kill their quarry, often through wit or guile, the Huntsman is generous in its gifts, granting beasts to command and weapons to wield. Those who manage to triumph through strength of arms or physical might are lauded with an invitation to the Huntsman's private lodge, accessible through any snowbound glade or windswept peak. There the hunters gather and feast, reveling in their prowess and remarking upon the trophies they have gathered. There is a price to such joy, however, and it is one paid in a grim toll upon the mind. Those who travel to the Huntsman's domain and call upon this dark elemental as a host find themselves growing ever colder in both body and spirit, becoming as cruel and callous as the lord of the manor itself. Those who retain compassion and benevolence best are those who distance themselves from the Huntsman and seek the company of other mortals. This matters little to the Huntsman, as it cares not for the activities of its riders so long as they come when called, responding to the summons of the Wild Hunt when it rides across the night sky.

Humanity or Death

Those who go willingly to the Huntsman, seeking it so that they can make a deal or bargain, face the same test as those who are forced into its game. These souls are known as frozen riders, for they inherit a fraction of the Huntsman's control over ice and snow, while also claiming its hounds and steeds as their own. The eldritch power they wield is as wicked as the weapons they favor and often twists their bodies into mockeries of their former selves. Others, however, are cursed by the Huntsman, having slain a creature that the ambitious master had sought as its own prey. These individuals have their souls torn asunder and the slain creature's spirit forced inside, making them fight to retain their sanity and control.

Bring forth the Huntsman

The Wild Huntsman is rarely bound by planar laws, appearing wherever there is a good hunt to be found, so it is fully compatible with almost any world or setting. When introducing the Huntsman, decide when it arrived, how many are aware of its presence and its deeds, and what creature or task it has arrived to slay or accomplish. How do the people of the world react? How does the landscape change in accordance to its wishes? Does it desire a blizzard to bring devastation, or is there merely a light chill in the air, so that the hunt can occur as nature intended?

Otherworldly Patron: The Wild Huntsman

You've made a pact with the Wild Huntsman, a dark incarnation of the predatory nature of man. Cursed with a bitter chill that can only be shaken by the blood of the prey and riding astride a steed whose eyes are cold as ice, the Wild Huntsman journeys between the planes seeking the greatest of challenges and the weakest of souls to harvest for its collection. You've encountered this entity and survived where others have fallen before its spear, and in return, your life has been spared and your bargain made. You've been granted a place at the Huntsman's table and the services of its tireless steeds and hunting hounds, who howl in the darkest winter nights while seeking living souls to claim.

Expanded Spell List

The Wild Huntsman lets you choose from an expanded list of spells when you learn a warlock spell. The following spells are added to the warlock spell list for you.

Wild Huntsman Expanded Spells

Spell Level	Spells
1st	hunter's mark, hunter's pace*
2nd	pass without trace, wolfbane trap*
3rd	frozen lance*, haste
4th	dominate beast, locate creature
5th	cone of cold, nemesis*

Huntsman's Disciple

At 1st level, you gain proficiency in the Survival skill. When you encounter the tracks of a creature, you can summon a spiritual hound to lead you, granting you advantage on checks to track your quarry. It can track targets over water and by scent. The spiritual hound disappears if you roll initiative.

Black Ice

Starting at 1st level, you can call on your connection to the cold winds of the blizzard to carry you to your prey and close off their escape. As a bonus action, you can move up to 30 feet toward a hostile creature you can see. If you're mounted, your mount can move instead of you. If you make an attack roll targeting the creature before the end of this turn, polished ice forms in a 5-foot radius centered underneath the creature, creating difficult terrain that lasts until the start of your next turn. You ignore difficult terrain created by this effect.

Pale Rider

At 6th level, you learn to summon a loyal steed from the Huntsman's stable. You can cast find steed without expending a spell slot. When cast in this way, its casting time is one action, and you can choose to have the steed appear underneath you, moving you instantly to the saddle.

While you are mounted on the summoned steed, you can choose to take any damage that would be dealt to the steed. When summoned, your steed appears with hit points equal to the amount it had when you dismissed it. While summoned, your steed recovers all lost hit points whenever you finish a

short or long rest.

If your steed has been reduced to 0 hit points, it can't be summoned again using this feature until you finish a long rest. At 14th level, you can resummon a fallen steed after a short or long rest.

Hounds of the Hunt

Starting at 10th level, you gain resistance to cold damage and are not subject to exhaustion gained from cold environments or high altitudes. You also learn to call the Huntsman's favored servants.

As an action, you can summon a pack of the Huntsman's hounds to an empty space within 30 feet of you. The hounds use the stat block provided with this subclass.

The pack understands your commands and obeys you without hesitation, acting on your initiative. Its hit point maximum is increased by an amount equal to your warlock level. When your pack is reduced to 0 hit points, it vanishes into frozen mist and can't be resummoned until you finish a long rest. You can dismiss your pack at any time as an action.

Fimbulwinter

At 14th level, the cold winds of the boreal forests come at your call. You, your steed, and your hounds ignore difficult terrain while in cold regions, and your hounds and steed also gain resistance to cold damage. While you are in a cold region, you and creatures you control emit a magical aura that creates icy difficult terrain in a 10-foot radius.

Whenever you finish a long rest, you can choose to perform a ritual that will gradually change the climate in a 10-mile radius to a cold and snowbound region harried by a blizzard for 24 hours. The ritual must be performed once in mountainous or cold environments, twice in temperate regions, and three times in warm, tropical lands to take effect. During the next hour after the last necessary ritual has been performed, an unnatural blizzard gradually strengthens to the point where the area is considered a cold region.

Additionally, creatures not native to the cold gain disadvantage on Survival and Perception checks while within the area of your Fimbulwinter. You can choose any number of creatures at the completion of the ritual, granting them immunity to this effect and to exhaustion from being exposed to a cold environment.

The blizzard may be maintained by performing the ritual again anywhere within the Fimbulwinter. The area shifts over the next hour to recenter itself over the location of the new ritual. Otherwise, if the ritual is not performed again within 24 hours, the blizzard dissipates over the next hour. Snow and ice created by your Fimbulwinter melt as normal..

The Hounds of the Huntsman

The Hounds of the Huntsman are fearsome and deadly beasts, bred over countless generations to track and harry their prey. They are not made to perform the kill themselves, for that may steal glory from their master. Instead, they are renowned for their unity and purpose, serving with singular intent that cannot be shaken or broken by any force. Tales commonly told of these hounds state they could look a dragon in the eye without blinking before eagerly rushing to attack, even when they are sure to be vanquished and banished back to the Huntsman's lodge. Those that die in battle vanish in a puff of snow, only to be reborn when the magic of one bound by the Huntsman's pact calls them forth.

Hounds of the Hunt

Large swarm of Medium beasts, neutral

Armor Class: 14 (natural armor)
Hit Points: 26 (4d10 + 4)
Speed: 50 ft.

STR	DEX	CON	INT	WIS	CHA
16 (+3)	14 (+2)	13 (+1)	10 (+0)	11 (+0)	10 (+0)

Skills: Perception +6, Stealth +4
Damage Resistances: bludgeoning, piercing, and slashing
Condition Immunities: charmed, frightened, special (see text)
Senses: darkvision 30 ft., passive Perception 16
Languages: Understands master but can't speak
Challenge: 1 (200 XP)

Frostborn Pack. The pack can occupy another creature's space and vice versa, and the pack can move through any opening large enough for a Medium hound. The pack can't regain hit points from magical or nonmagical healing or gain temporary hit points. While summoned, the pack recovers all lost hit points whenever you finish a long rest.

Keen Hunters. The pack has advantage on Wisdom (Perception) checks that rely on hearing or smell and can track creatures across water.

Overwhelming. The pack is immune to conditions that only apply to a single hound, such as poison from a weapon attack or a grapple. When determining whether the entire pack is affected by a condition, the hounds count as 4 Medium creatures that take up a 10-foot by 10-foot square. The pack has advantage on saving throws against spells and effects that target a single target, such as *poison spray*. The pack has disadvantage on saving throws against spells and effects that affect the entirety of the space it occupies, such as *fireball*.

Perfect Pack Tactics. The pack functions with a single purpose and has advantage on all melee attacks.

Actions:

Bite. *Melee Weapon Attack:* +5 to hit, reach 5 ft., one target. *Hit:* 10 (2d6 + 3) piercing damage. If the target is a creature, it must succeed on a DC 13 Strength saving throw or be knocked prone. If the pack's current hit points are less than half its hit point maximum, the target takes 6 (1d6 + 3) piercing damage instead and must succeed on a DC 11 Strength saving throw or be knocked prone.

Eldritch Invocations

Bitterchill Blast
Prerequisite: Wild Huntsman patron

Your Black Ice feature can trigger when you cast a cantrip that

One of Xandith's former companions joined the Huntsman, seeking to kill the Ashen Wolf for having a "demonic" nature. If only he knew the price... Now he rides alone after his betrayal. The Wolf has called for his death, and so the battle shall repeat once more. I doubt Xandith will win!
—Sylvette

requires a saving throw. When you use your Black Ice feature, you can choose to have that cantrip or attack deal cold damage instead of its normal damage type. If the target takes damage from the attack or cantrip, it can't benefit from features or effects that allow it to ignore difficult terrain until the start of your next turn.

CHRONICLE OF WINTERS PAST
Prerequisite: Wild Huntsman patron, Pact of the Tome feature

As an action, you infuse yourself with the cruel bite of ice from ages long past. For 1 minute, cold damage you deal ignores resistance and immunity and you gain immunity to cold damage.

Once you use this invocation, you can't do so again until you finish a short or long rest.

FROSTBOUND ARMOR
Prerequisite: 5th level, Wild Huntsman patron

You gain proficiency in medium armor and heavy armor.

GRIM HARVESTER
Prerequisite: Wild Huntsman patron

As an action, you can harvest a small trophy from the corpse of a creature that you have slain. You fill the trophy with a fraction of the slain creature's soul. Until the next dawn, you can use your reaction to siphon the spiritual energy from the trophy in your possession to gain advantage on an attack roll, skill check, or saving throw. Each trophy can only be used once. You can use this feature twice, and you regain all expended uses when you finish a short or long rest.

LORD OF BEASTS
Prerequisite: 13th level, Wild Huntsman patron

Your pack gains a bonus to its attack and damage rolls equal to half your Charisma modifier, and the saving throw associated with its attack equals 8 + your proficiency bonus + half your Charisma modifier (rounded down). If you have a familiar, it also gains these bonuses.

SEEKER OF PREY
Prerequisite: Wild Huntsman patron, Pact of the Chain feature

When you have a harrowing hawk as your familiar, it gains additional hit points equal to your warlock level, you can communicate telepathically with your hounds and steed from up to ten miles away, and you can perceive through their senses in the same way you can with your familiar.

SLAYER'S ARMORY
Prerequisite: Wild Huntsman patron, Pact of the Blade feature

You can now create any simple or martial weapon from blackened cold iron and the bone of ancient beasts using your Pact of the Blade feature. If this weapon is a ranged weapon, you can instantly create ammunition for it in your open hand. Whenever you hit a creature with this weapon while they are the subject of *hunter's mark*, the target takes an extra 1d6 cold damage. You can choose to use Strength for attack and damage rolls with this pact weapon, even if it is ranged.

TRAITS OF THE FROZEN RIDER

Those who have made a pact with the Wild Huntsman are often known as frozen riders by other practitioners of the eldritch arts. They seek out new prey and hunt for the glory of their master and may be called upon as bounty hunters or other pursuers of mortals when they are freed from their

duties to their patron. Consider adding one or more of these traits to your character when creating a warlock or after slaying a deadly foe in the Huntsman's name:

d20	Trait
1	You enjoy the outdoors immensely.
2	You harry your foes before killing them.
3	You view other warlocks as kin, even as you challenge them for dominance.
4	You boast of your kills at every opportunity.
5	You take a trophy from everything you hunt.
6	You feel comfortable in cold weather.
7	You prefer to cover your armor in trophies of your past adventures.
8	You frequently mock weaknesses you see.
9	You count actions over words.
10	You love the taste of meat.
11	Your skin is always coated in a thin layer of frost.
12	Your irises become a pale white color.
13	Your blood freezes when exposed to air.
14	Your skin is cold to the touch.
15	Clothing or armor you wear for long periods of time becomes covered in murals of hunting and sport.
16	Your weapons gradually become blackened.
17	A helm or mask appears in place of your face.
18	Spikes of black metal sprout from your skin whenever you are enraged.
19	When you cast a spell, a swirl of snow spirals around you and the air grows chill.
20	Your beasts bear your mark and wear it proudly.

RANGER PATH:
HOUND OF THE HUNTSMAN

In your life, you've slain a creature great and terrible, whether by design or by the twisting turns of fate, showing the mastery of mortals over the natural world. As you brought the beast low, you felt the eyes of an ancient immortal upon you. The sheer power of the Wild Huntsman's cold intent tore the beast open and infused you with its spirit. You owe no favor to this manifestation of the predatory nature of mankind, nor must you hold it in any esteem. Nevertheless, the cursed cold of its domain flows through your veins, even as the twisted spirit of the beast you slew writhes within your skin, bursting forth in a spiritual manifestation of primal hate. In the heat of combat, you must keep an icy grip on your humanity, lest you fall to the dark hunger of the predator. It is through dominance that you shall triumph, for anything less will lead to your death. Prove to the Huntsman that you are greater than a beast.

Prove to yourself that you are worthy of life and power. You are a Hound of the Huntsman, and your curse shall be your salvation.

HUNTSMAN'S ARCANA

Starting at 3rd level, you learn additional spells when you reach certain levels in this class, as shown in the table below. The spells count as ranger spells for you, but don't count against the number of ranger spells you know.

Ranger Level	Spell
3td	rimesworn blade*
5th	wolfbane trap*
9th	frozen lance*
13th	dominate beast
17th	nemesis*

SPIRITUAL CURSE

At 3rd level, the spirit of the beast you slew begins to awaken within you, gradually seeking to drive you to the ravenous urges of a wild animal.

Whenever you take the Attack action, you can choose to make feral attacks in place of your normal attacks if you have at least one free hand. Strength is your ability score for a feral attack. When you do this, the spiritual claws of the beast within manifest around your arm as you strike a creature within your reach. Make an attack roll. If you hit, the target takes slashing damage equal to 1d12 + your Strength modifier. You can choose to use your bonus action to make an additional feral attack if at least one feral attack you've made during your turn hits a creature.

Whenever you kill a creature with a feral attack, you risk losing control of yourself and are overwhelmed with a compulsion to feast on the creature's spirit. If the corpse of a creature you have slain with a feral attack is within your reach at the start of your turn during the first minute after you have killed it, your predatory spirit will appear and feast using your action, granting you temporary hit points equal to half your ranger level + your Constitution modifier. Once it does this, you regain control, and you can use a bonus action before the end of your turn to make one feral attack.

COLD IRON

Also at 3rd level, the hoarfrost of the Huntsman's domain infuses your mind and body even as your soul fights within you. You gain the following benefits:

- **Dark Hunter.** You ignore disadvantage on Perception checks caused by dim lighting.
- **Flawless Pursuit.** Whenever a hostile creature you can see takes the Dash action, you can use your reaction to move up to your speed towards them, even while mounted.
- **Hunting Blind.** You can create an area of artificial camouflage up to 10 feet in each dimension for yourself and your allies over the course of 1 minute. While within, you gain advantage on Stealth checks and cannot be detected by scent.
- **Winter's Might.** You can add your Strength modifier to your AC in place of your Dexterity modifier, and you can use your Strength modifier when making attacks with ranged weapons. This does not allow you to surpass the normal limits of an armor's AC value.

While they're typically called "Hound" after the slaying of dire wolves, my research has uncovered that this not always the case! Bears are the second most common, with giant boars coming after that. In distant lands, lions, giant hyenas, sharks, and tigers are other potential beasts the Huntsman may take an interest in. Not all are so ordinary, however! Monstrous creatures such as gryphons and hydras are occasionally bound to these unfortunate souls. Sometimes even orcs and giants are forced into the souls of these rangers, so clearly the Huntsman sees even sentient creatures as little more than savage beasts. —Sylvette

REND ASUNDER

At 7th level, your savagery becomes even more difficult to contain, but you begin to embrace the eldritch power of this primal spirit. Whenever you make an additional feral attack using your bonus action, you can choose to dominate the beast within by giving it the blood it craves. If this attack hits, it inflicts the maximum possible damage per die, and if this is a killing blow, you are not forced to use your action to feast upon the soul of the creature if you start your turn while the corpse is within your reach, though you may choose to do so using your action as normal. If the attack misses, you have disadvantage on all attacks targeting a creature other than the one you just attacked until the end of your next turn.

Additionally, your jumping height and distance increases by a number of feet equal to your Strength score.

HUNTER'S CALL

At 11th level, when you take the Attack action, you can let out a hunting cry as a bonus action. Choose one enemy creature within 30 feet. If you hit that target during your next turn, the creature must make a Wisdom saving throw against your ranger spell save DC. If they fail, they are frightened of you until the end of their next turn.

LORD OF THE BEAST WITHIN

At 15th level, you learn to bind the spirit within you more fully, forcing it to obey your whims and mastering the predatory instinct within you. You can now always make an additional feral attack using your bonus action, even if you haven't taken the Attack action, and you can feast upon the spirit of a corpse as a bonus action instead of an action. Finally, you can track by scent, and gain advantage on all Perception checks.

RANGER VARIANTS

If you don't gain a feature at 5th level, use this one.

EXTRA ATTACK

Beginning at 5th level, you can attack twice, instead of once, whenever you take the Attack action on your turn.

Begin the Wild Hunt

When the stars are right and the skies have been completely darkened by the chill of a bitter winter, the Wild Huntsman will summon all of its loyal hunters to a single location and begin a ritualistic hunt. They will mount their steeds and take to the night sky, carried forth by a cold lust for blood and a timeless eldritch magic. Hundreds of harrowing hawks and thousands of hounds will follow across the land, tireless in their chase. Any creature that flees from the hunt will be skewered by an arrow or bolt of frost from the hunters above, dragged down by the hounds below, or be blinded by the vicious pinions of the hawks. The snow behind this legion will be stained red with blood and only carnage and death will be left in their wake. They will descend on innocent hamlets and villages, killing everyone in sight. If a warrior manages to wound one of the hounds or hunters, they are spared this fate and instead offered a choice: Accept and participate in the bloodshed as a hunter, or refuse and suffer in mindless grief as a hound.

The Hound and the Horse

The beasts of the Wild Huntsman are not ordinary creatures. Some are born and bred, corrupted by the influence of this primal thing, but others were once mortals. Individuals who refuse to join the hunt and ride across the skies due to their grief or moral code are instead changed and twisted into hunting hounds. Their burning hatred for the merciless Huntsman is eventually tempered by the unnatural loyalty that comes with their new form, and they live out the remainder of their existence in this state, rising and falling from the snow as mere beasts. Those who willingly choose to join as hunters are cursed with a different fate. Each must kill at least one beast or mortal before the Wild Hunt ends. If they do not, they will be transformed into a steed. Thus, they are rewarded for their courage, but punished for their unwillingness or inability to claim the blood of the prey.

The Final Prey

When the Wild Hunt is near completion and the hunters and hounds have been drenched in blood, they will collect their favored trophies and ride to the lair of an ancient and powerful creature that has never been defeated. This could be an ancient dragon, elemental, giant, spiritual beast, or even an elf or other long-lived mortal. The Huntsman will then call upon the hunters to present their trophies and decide who is most deserving, based on skill, determination, and prey slain. This individual will be invited to participate alongside the Huntsman in a fearsome battle with the ancient creature. Those who accept are honored among their comrades, while those who refuse outright are shamed and killed for cowardice. Thus, the Huntsman and its chosen warriors will slay the ancient being, feast until dawn, and plan for the next Wild Hunt. When the stars align again, the cycle of blood and death begins once more, repeating for eternity.

Beyond the Huntsman

The Wild Huntsman can be interpreted in many different ways and used in a variety of fashions in your world, so feel free to change and modify it to suit your needs. The Huntsman could just as easily be a Huntress, a deity of cold and ice, or an ancient weapon once wielded by a bloodthirsty tyrant. The motives of the Huntsman are fairly simple, but are easily malleable to suit your game. Consider if its goals would align with that of the party, or if it would be antagonistic towards them. What does it currently seek to hunt? How will it achieve this goal? How powerful is the Huntsman in relation to other entities that rule over your setting, and what kinds of relationships does it have with them?

A Kind Pursuit

If you really want to expand your interpretation, consider changing the Huntsman from a cruel entity to a benevolent one. Perhaps it brings food to the hungry and cool weather to alleviate the heat of the summer sun. Its hounds could be friendly to children, and it could deliver gifts to those who dwell within its domain. It could act as a guardian of mortals against the great and terrible beasts that dwell on the edges of civilization, keeping the mortal races safe from what lies beyond their walls and firelight. This Huntsman would be likely to take on a more friendly appearance, perhaps with brightly colored clothing and a more cheerful entourage.

Trophies of a Hunter

The Wild Huntsman and its servants are known far and wide for the vast collections of trophies they claim, both magical, mundane, and otherwise. These objects are among the more interesting of that collection.

Beastfur Cloak
wondrous item, very rare (requires attunement by a warlock with the Pact of the Tome feature)

This cloak appears to be made from hundreds of scraps of hide. As an action, you can transform your Book of Shadows into a beast with a CR less than or equal to one-fourth your warlock level. The beast obeys your telepathic commands and acts on your initiative count. It remains in this form until slain or until you use your bonus action to end the effect. Once the cloak has been used, it can't be used again until the next dawn.

Horn of the Wild Hunt
wondrous item, legendary (requires attunement)

This hunting horn is covered in symbols depicting each type of prey the Huntsman has slain. As an action at night, you can activate the magic within. Each creature of your choosing that you can see gains a flying speed equal to their walking speed, 50 temporary hit points, advantage on all attack rolls, immunity to cold damage, and truesight out to 120 feet. These benefits last until dawn breaks through the dark curtain of night. If a creature is flying when the magic ends, it descends harmlessly to the ground. Once the horn has been used, it remains dormant until the next Wild Hunt.

Winter's Hand
wondrous item, very rare (requires attunement by a warlock with the Pact of the Blade feature)

This gauntlet was crafted from the hide and talons of a white dragon slain by the Huntsman itself. Once per turn, you can create your pact weapon without using an action, and your pact weapon gains a +1 enhancement bonus, which stacks with other enhancement bonuses it may have. Additionally, you can choose to have your pact weapon deal cold damage instead of its normal damage type. If you kill a creature with your pact weapon, your next attack with it deals an extra 2d10 cold damage.

ALFALLEN RACES

DESCENDANTS OF THE ALRISEN PACT-MAKERS

Not all heroes die terrible deaths, cast aside before their time. Some go on to have families and children, setting aside their life of conflict and adventure to celebrate their victories or to prepare the next generation to continue the fight against the forces of destruction. The offspring of warlocks, however, are often influenced by the decisions of their parents. Some have been promised as payment in exchange for the powers claimed by the pact-maker, taken from their homes and bent to the devices and intrigues of the Alrisen. Some are raised to lead ordinary lives, while others go on to adventure as their parents once did. Over time, the direct influence of an eldritch entity may strengthen or decline within a family tree, appearing with clear results only rarely or casting a dark pall over the honorable nature of a once-favored bloodline. Regardless of the consequences and origins, the manifestation of an Alrisen's influence within a child often leads to conflict and courage, trials and determined resolve. Some flee from this responsibility, while others embrace it.

In some cases, the pact itself is so twisting and so cruel in price that it will change the very nature of the pact-maker, causing them to become an Alfallen rather than retain their racial origin. These instances are uncommon but should not come as a complete surprise, as the powers that dwell within the lost and forbidden places are rarely gentle toward those who come to barter.

ORIGIN RACE

After choosing an Alfallen Race, make sure that you choose a Racial Origin in the following section. This will grant you additional features, set your Size, determine your speed, and apply other modifications to your character.

ACCURSED ARCHIVE: THE MALEDICTI

Blood is life, and life is pain. Suffering. Fear. Doubt. Sweet sorrow and bitter loss swirl together into a maddening spiral that brings a smile to the face and a tear to the eye. All things end, eventually. Ruin comes in the darkness, watching and waiting for a moment of weakness to begin the gradual corruption and destruction of one's soul and humanity. The Archive is that which waits, and the maledicti are the twisted results of that foul patience, driven mad by the constant scratching of quills upon flesh and the ink that flows through their veins like blood. They smile, because they know it will all come to an end.

CURSED BY THE ACCURSED

The maledicti first were spawned in the darkness of the Archive when curious and cruel archivists sought to discover if the Silent One was deterred by innocent children. These archivists were slaughtered to the last by the monstrosity and dragged to the darkest places below to be subjected to unspeakable ends. The children, however, were left unharmed and trapped in the upper halls, incapable of leaving. Time does not pass properly in the Archive, but the unholy and subtle sentience of the library could not resist the opportunity to create a new and twisted weapon in its endless war against the forces of preservation.

The ink-blood of countless fiends and aberrations was drawn forth from ancient tomes of lore and forbidden magic, and it crept into the hands of the children as they huddled, forcing terrible knowledge upon their minds even as they grew quickly to maturity. The scratching of the quills and the war shouts of the fiends filled them with cunning and knowledge of war, while the twisted ink-blood in their veins made them strong and mighty.

MADDENED BY THE ARCHIVE

Remade and reborn as twisted reflections of their former selves, the accursed children, the maledicti, departed the Archive for the first time to paint a stain across the world. Over time, their descendants have managed to gradually free themselves from the virulence of the curse, but more still return to the Archive seeking power. Archivists who have devoted themselves entirely to the ruinous cause of the Accursed Archive are often transformed into maledicti, seeking the frightening strength of fiendish blood for their own purposes, unafraid of the consequences upon their own mind. They had already lost their sanity long ago.

EERIE VISAGE

The most startling things about a maledicti are their eyes and hands. Universally, their eyes are pure red, and black veins creep down their face from their tear ducts and the corners of their eyes. Their hands are even more disturbing, always stained black from the ink-blood underneath their skin. Their fingers are sharp and pointed, reminiscent of writing quills or spikes, and they have an unfortunate tendency to use them to scrawl upon surfaces and skin around them. Ink-blood flows smoothly from their fingertips, quickly staining anything they touch a deep and inescapable black. Dark veins run up their forearms, giving them a corrupted appearance. The most disturbing part of a maledicti is their mad and terrifying smile. Each one suffers from some unique insanity, and while most maintain a careful grasp on reality, they can rarely shake the unsettling grin that is the hallmark of their madness.

RUINED MINDS

The maledicti are insane by all conventional senses of the word. They speak to things that are invisible to others, write unsettling phrases upon seemingly innocent objects with their quill-like claws, and cackle with laughter even when none have told a joke. Most are innocuous in their madness, only descending into psychopathic behavior when their black blood has been spilled upon the ground. Most do not bother to bring about small ruinations, instead working towards ones far grander. Maledicti would agree that toppling a kingdom and sending a civilization into a chaotic spiral towards destruction is much more worthwhile than torturing an enemy or frightening a friend, seeing the latter as beneath them. Ruin is about results, after all.

In Crimson Darkness

Communities of maledicti are hierarchical, with the eldest and most accomplished naturally rising to the top. Maledicti are naturally clever and cunning, leading them to make long and devilish plans even when considering mundane tasks. They are shunned by polite society and must conceal their nature to rise to power or prestige. Those who manage to reach the top are prone to encouraging corruption and dissent in the lower ranks, ruling like tyrants. Not all maledicti are truly evil, nor are all forces of chaos, but the curse laid upon them by the Archive makes them prone to the temptations of dark powers and eldritch rites. Those who shun their heritage are inevitably drawn to adventure, seeking to cause ruin to groups more deserving of their special touch. Many are fond of elaborate tattoos that conceal or highlight their ink-black veins, telling of their deeds using their parchment-like skin as a canvas. Maledicti are often drawn to wizardry, possessing a certain knack for it thanks to their Archival memories, while others favor their fiendish strength to lead them to victory in battle. No matter their path, a maledicti will inevitably stain the world as red as the skies above the Archive.

Scribes of Suffering

Dragonborn maledicti appear as though they were dipped in ink and left to dry, with pale scales across much of their bodies and dark scales upon their hands and legs. Other than their red eyes, they appear surprisingly ordinary, as it can be difficult to see the smile upon a face such as theirs.

Dwarven maledicti are uncommon but are banished or killed whenever they are found. They are known in dwarven culture for attempting to cause cave-ins or earthquakes and are viewed as menaces to society and goodly folk.

Elven maledicti appear to look like ravens, in a sense, possessing long quill-feathers that seem to grow from their hair. Their hands and feet are often shaped into the talons of a bird, and many grow feathers along their arms. Their faces still possess a striking elvish beauty, though the red eyes and black veins reveal their true nature to even the most casual observer. They are welcomed amongst the dark elves, as their propensity for chaos is legendary, and shunned by the others of their kind.

Gnomish maledicti often try to blend with their original society and are largely successful. Their innate cunning allows them to keep up with other gnomes, and their appearances can be explained by magical accidents or dormant curses. Their gnomish heritage allows them to resist the call of their madness better than most, though it remains ever present nonetheless.

Halfling maledicti often appear to human eyes as corrupted children, causing fear and distress wherever they are seen. They are unwelcome in the normally benevolent halfling communities and often seek to wreak revenge among their former people.

Human and half-orc maledicti are the most common, as unsuspecting human children are easily drawn into the Archive thanks to their natural curiosity. Those who are transformed into maledicti after sealing a pact with the Archive are also often human, having delved too deeply into the eldritch secrets within.

Tiefling maledicti suffer the darkest fate of any. Pitch black feathers, sharp and pointed at the edges, burst painfully from parchment-pale skin. Horns twist into unnatural shapes, and bone spurs erupt through their skin, growing in long ridges along their extremities. Their eyes burn with fiendish fire and eldritch magic, as their already-tainted blood is driven wild by the hellish nature of their lineage. Their mouths are often filled with hundreds of tiny razor-sharp teeth, and their smiles are by far the most disconcerting of any. They always have the hands and feet of a raven, and many are mistaken for harpies from a distance. Tiefling maledicti are horrifying to behold and often the maddest of them all.

Maledicti Names

Maledicti rarely keep their original names after they have been changed, instead choosing new ones to suit their corrupted nature. If they are among a community of other maledicti, they will all agree upon a single name to use, with members only reclaiming their old moniker once they depart from the group.

Maledicti Names: Agony, Malice, Spite, Hate, Ruin, Decay, Collapse, Defile, Corruption, Damnation, Resentment, Revile, Torment, Suffering, Disgust, Sin, Sorrow

Maledicti Traits

As a maledicti, your cursed blood fills you with power.

Ability Score Increase: Choose either Strength or Intelligence. That ability score increases by two, while the other score increases by one.

Age: The lifespan of a maledicti is doubled. All are instantly raised to adulthood, though they can become aged afterward.

Alignment: Most maledicti tend to be evil, chaotic, or both, though some can withstand their dark urges.

Size: Your size is determined by your origin race.

Speed: Your speed is determined by your origin race.

Languages: Maledicti are fluent in Common and in the language of their racial origin.

Black Blood: Your blood is cursed and it marks everything it touches. You gain resistance to necrotic damage. If you would also gain this resistance from a class feature, you learn the *shadowthorn** cantrip. Intelligence is your spellcasting ability for this cantrip.

Madness: Your insanity makes it difficult for others to discern your true intentions. Creatures that make Insight checks against you do so with disadvantage.

Quill Claws: Your fingers are deadly implements that drip with black ink-blood. Your claws are natural weapons, which you can use to make unarmed strikes. If you hit with them, you deal necrotic damage equal to 1d6 + your Strength modifier instead of the bludgeoning damage normal for an unarmed strike.

Ashen Wolf: The Ashenspawn

The Ashen Wolf is a creature whose blessings and curses are often indistinguishable from one another. Those who have made pacts with the Wolf may find themselves transformed and changed, with skin covered in burning embers and ashen wood, teeth elongated in a lupine visage, and limbs distorted in strange and eerie ways. If an individual goes untouched by the twisting magic of the Wolf's gifts, then they still are unsafe, often siring or mothering children who are touched by the magic of the Hungering Flame.

Kin to the Wolf

Ashenspawn are relatively uncommon and are often mistaken for tieflings, fire elementals, or even fiends by those unfamiliar with the Alrisen. Burning embers often drift gently from their skin, smoldering like a fire that recently burned out. While these flames are harmless and incapable of igniting other objects, they do lend an eerie cast to the appearance of an ashenspawn. Many have eyes that glow red, orange, yellow, or blue, like the tip of a burning flame, and flare or dim in response to the ashenspawn's emotions. While many have a skin tone that one would expect from their race, others are coated in a thin layer of pale or dark ash. Almost all have teeth of blackened steel, hinting at their ability to consume wood and metal the way one would eat a heavily charred steak.

Dragonborn are often changed in a way that conceals their ordinary color, their normal scales replaced with scales made of burning wood or glowing metal, and their horns become shiny chrome covered in a layer of soot.

Dwarven ashenspawn are often taller than their natural kin, with beards filled with burning embers. They are often even more accomplished blacksmiths than other dwarves,

though their affinity for the Alrisen makes them pariahs in their community.

Elves tend to become more lupine in response to their normal affinity for the natural world, growing furred ears and long burning manes. Among elvish communities, ashenspawn are viewed as an unfortunate part of the natural order and are treated with pity or quietly shunned.

Gnome and halfling ashenspawn are exceptionally uncommon, but they rarely show strong traits of their lineage, instead receiving glowing eyes and sharp features.

Humans and half-orcs have the widest variety of expressions of this cursed blessing, as one might expect, and are the most common. Some appear as flaming werewolves with disjointed limbs and long faces. Others look like natives to the Elemental Plane of Fire, with flaming hair and smoke coiling around their hands. A rare few show no trace of their heritage until exposed to extreme heat, their skin growing dark and gnarled like an ancient oak until the fire is gone.

Tieflings often show all of these traits and more, appearing as true fiends to the uninformed. Their metal horns, burning tails, skin covered in scarred wood, flaming brand-marks, eyes of fire that bleed black smoke, and long lupine tongues make them fearsome to behold.

Hunters and Mercenaries

In societies where ashenspawn are numerous enough to be a significant population group, they are often seen as excellent warriors and raiders, though they often lack the ironclad discipline of a true soldier-race. They make excellent smiths thanks to their natural affinities to flame, metal, and burning wood, and they are also renowned as hunters. These subcultures are typically sedentary and establish settlements near volcanoes or forested regions. Those who fully embrace their lineage often become raiders, pyromancers, and bounty hunters.

The arcane arts are looked upon as a method for reaching further strength, leading many to embrace their sorcerous power. Others return to their patron and forge their own pact, for the Ashen Wolf is generous and kind to those it calls kin. Of course, it's kindness is often a cruelty, as the rest of the world rarely sees ashenspawn as anything more than demons and unholy fiends. Those who are marked in less visible ways typically have an easier time blending in with polite society, bathing in sand to cleanse themselves of ash and covering the glowing brands upon their bodies with clothing and cosmetics.

In extraplanar locations where sentient fire elementals and fiends gather to drink and carouse, ashenspawn will prepare drinks filled with flecks of gold, steel, and the blood of slain animals and consume the weapons of those who fought against them, as they possess an uncanny ability to eat wood and metal without harm. This makes them very hardy in the wilderness and leads them to avoid settling in places without trees or heavy foliage, despite their obvious affinity for fire. Water, while not harmful to them, is distinctly uncomfortable and is thus avoided whenever possible. Their natural fiery tendencies make them very unsuitable for life aboard flammable ships, so a seafaring ashenspawn would be a rarity among rarities.

Ashenspawn Names

While most ashenspawn are named along the lines of their cultural and racial origin, some take new names after realizing their heritage in full. Others are born into a culture that recognizes them as kin to the Ashen Wolf and are named in accordance with the rites and rituals of the Wolf.

Ashenspawn Names: Brand, Cinder, Pyre, Smoke, Dust, Ash, Hunter, Cruelty, Spite, Hunger, Ember, Flare, Singe, Torch

ASHENSPAWN TRAITS

As an ashenspawn, your blood is tainted by the burning eldritch power of the Ashen Wolf, marking you forever.

Ability Score Increase: Choose either Strength or Charisma. That ability score increases by two, while the other score increases by one.

Age: Ashenspawn can live as long as others of their origin race, though most die to violence long before then.

Alignment: Ashenspawn are influenced strongly by the nature of the Ashen Wolf, and cruelty comes easily to most. While most are not truly evil or chaotic, very few tend to be genuinely good or lawful. Most value fulfilling their own passionate desires and fervent hunger, even at the cost of others, so most are neutral, chaotic, evil, or some combination of the three.

Size: Your size is determined by your origin race.

Speed: Your speed is determined by your origin race.

Languages: Ashenspawn are fluent in Common and in the language of their racial origin.

Darkvision: Due to your lupine eyes that glow in the dark, you have superior vision in dark and dim conditions. You can see in dim light within 30 feet of you as if it were bright light, and in darkness as if it were dim light. You can't discern color in darkness, only shades of gray. If you gain Darkvision from your racial origin, add both values together.

Gift of Ash: Ashenspawn are blessed with an exceptional resistance to flame, as it fills their form with power and might. You gain resistance to fire damage. If you would also gain this resistance from a class feature, your inner power awakens, granting you the ability to cast the *scorch** cantrip. Charisma is your spellcasting ability for this cantrip.

Flaming Feast: Thanks to your relation to the Wolf, you can easily consume wood, metal, and raw meat without harm, and they provide you with sustenance. You can eat nonmagical wood and metal at the same rate you could consume normal food as your jaws and teeth are strong enough to allow you to bite through iron if you can get your mouth around it. Stronger metals are tough and may take several minutes to bite through, depending on their thickness. Magical metals are too durable for ashenspawn to consume using this feature. Eating metal produces a terrible screeching sound that can be easily heard up to 150 feet away.

Yeah, that's me. Don't ask about the eye, it's a long story. I used to be human, but that didn't last long. The Wolf, you see. —X

Most ashenspawn aren't actively burning, but Xandith indulged fully in the power of the Ashen Wolf! So, he's on fire now all the time forever and it's kind of weird. —Sylvette

Blackthorn Grove: The Groveborn

Those who make pacts with the Blackthorn Grove are hardy individuals who travel easily out into the world, so it is unsurprising that they would find love and have children. Those children, however, are rarely untouched by the effects of the Blackthorn heart. Extreme emotion comes easily to these progeny, and as they age their true nature becomes clear. They are known as Groveborn, for their lineage is forever marked by this unnatural power.

Life Renewed

Not all who go to the Grove do so with mindless apathy. Some have cultured a perfect disdain for life and have washed any cares away like tears in the rain. These individuals are hopeless by choice, nihilists all, and they seek the Grove as a means to fully embrace that void. They do not seek to offer their hearts and receive new ones filled with life. They seek to offer their hearts as a means to die and be gone forever. The Blackthorn accepts these individuals, rare as they may be, and instead of granting them a heart filled with life and purpose, they are instead taken fully into the Blackthorn. Years pass as they are shaped and regrown into something new, filled with the memories and former passions of those whose blood was drained entirely within the Maze. When they emerge from the Grove, they are different people entirely, driven by the total desire of the hundreds of supplicants who died on their way to the heart of the Grove, slain because of their inability to let go of what they truly felt inside.

Born of Thorn

Groveborn are relatively uncommon among all races, simply because so few are drawn into the clutches of the Blackthorn. Among those individuals, it is rare for them to survive, and then they must subsequently live through their new adventures. Because of this rarity and their plantlike appearance, groveborn are often mistaken for dryads or other creatures who arise from the verdant landscape. Speaking with one, however, often casts suspicion on that idea. The vast majority are intense individuals, driven with almost blind purpose towards their chosen pursuits. They love as quickly as they hate, and they fight with a fervor one would not expect to find in a race of plant-folk.

Variety in Appearance

Most groveborn are clearly inhuman, having hair of vines or leaves, skin that appears textured like bark, and occasionally having foliage growing directly from their bodies. They have limited control over this growth, enabling them to form simple clothing with time and focus. Most are surprisingly colorful, having blood red markings upon their bodies, while green leaves sprout from their chests and blue accents flow underneath their skin. Not all follow this color scheme. Some have deep black skin or purple markings, as an individual's color pattern is most influenced by one's original demeanor and appearance.

Dragonborn affected by this change appear to have their scales replaced by bark and have horns similar to tree branches that grow and spread into colorful headdresses. Those who breathe fire tend to seem as though they are constantly smoking, burning from the inside out despite their otherwise calm appearance.

Dwarven groveborn often have beards of thick moss or other foliage instead of their normal hair and will have skin like the roots of an ancient tree. They are viewed with suspicion by dwarven culture and are shunned in most communities.

Elvish groveborn are the most normal-seeming of their kind, though they behave quite a bit more impulsively than other elves. Their verdant hair and colorful skin is quite reminiscent of certain elven groups, though their curious strength differs from their kin.

Gnomish groveborn often are mistaken for forest gnomes and thus are able to blend easily into gnomish society. Their passions make them paragons of their communities quite frequently, and they make for fierce adventurers.

Halfling groveborn are uncommon and are often mistaken for forest spirits of various kinds. Their shining eyes and striking features make them seem even more otherworldly.

Half-orc groveborn have large thorns instead of tusks, giving them an unusually primal appearance. Orcs rarely accept their strange appearance, but their extreme demeanor fits well with

many orcish customs.

Human groveborn show a wide variety of appearances. Those who are affected the most subtly simply have hair of leaves, while those who are strongly influenced have thorns instead of teeth, small horns of wood, and skin the color of living vines. Those who pursue the more primal arts tend to become druids or rangers, while many more embrace the eldritch power that lies within their bloodline.

Tiefling groveborn, or "leaflings" as they are called by scholars, are a strange breed, fully taken by the power of the Blackthorn. All of them have skin that appears to be vines or wood merged into a single unified mass. Horns of wood sprout from their heads, glowing with ethereal light or eldritch power. Their bodies are often covered by outfits grown entirely from their own leaves, and their fingers appear as grasping branches tipped with sharp thorns. They are unquestionably the most colorful, with deep reds mixing with their normally green hue, and while they may be beautiful, it is a harsh beauty that rarely appears welcoming to mortals.

Groveborn Names

Most groveborn who are born naturally are named in accordance with the culture of their parents. Those who are transformed will usually keep their former name as a mockery of the person whose body this newly-grown soul now inhabits.

Groveborn Traits

As a groveborn, your connection to the natural world is only marred by the eldritch power in your verdant body.

Ability Score Increase: Choose either Strength or Wisdom. That ability score increases by two, while the other score increases by one.

Age: The lifespan of a groveborn is twice that of their origin race, thanks to the blessing of the Grove.

Alignment: Most groveborn are neutral, driven by singular passions but still bound by their own morality. Those who fully embrace their nature have little respect for law and may trend towards a chaotic alignment.

Size: Your size is determined by your origin race.

Speed: Your speed is determined by your origin race.

Languages: Groveborn are fluent in Common and in the language of their racial origin.

Durable Mind: You gain resistance to psychic damage.

Guise of the Grove: You can take the Hide action to conceal yourself even when you are only lightly obscured so long as you are concealed by plants, such as trees, bushes, or tall grass.

Natural Soul: You gain proficiency in the Nature skill.

Sundrinker: If you are exposed to sunlight for at least 1 hour, you do not need food or water for the day. You can drink the blood of other creatures in place of eating or drinking without ill effect, and the blood of a single Small creature will sustain you for one day. A Medium creature could sustain you for three days, while a Large creature's entire supply of blood could sustain you for one week or more.

I eat metal, they drink blood. We should open a tavern! Call it "Iron & Copper!" Eh, I'd probably burn it down on accident anyways. -X

Eternal Citadel: The Statuesque

The beauty of the Eternal Citadel is eerie and strange, given form by the radiant light of preservation that rests between the twin spires of the central keep. In that light, those who are old, withered, and frail begin to change to suit the needs of the Citadel. They are not allowed to die or age, instead being embraced by the solid light around them. The power of the Eternal Citadel restores strength to weary limbs, fitness to worn minds, and light to dreary eyes. The things that these elders have seen must be preserved and used to great effect, for if they were lost to time, the world would suffer for it. These individuals are known as statuesque, for they become as living stone and statuary come to life.

Immortal Heroes

Not all statuesque are those transformed by the Citadel from a mortal state. As time goes on and mortal heroes die, statues are constructed in their honor, fabricated from stone and metal in remembrance of their great virtue and sacrifice. All those who look upon these monuments with love, hate, praise, fear, joy, and sorrow add credence to the names of these champions for all of eternity.

When ruin and destruction come for a place where these monuments have been carefully preserved and maintained for at least a century, the Citadel may invoke a fraction of its eldritch power, calling forth the collected memories and emotions associated with the champion. In a flash of radiant light, the statue will come to life, cast in the form of one of the heroes of old.

First Awakening

These are awakened statuesque, and they are not reincarnations of the real heroes of the past. They are fabricated beings, assembled from the endless stories and emotions of those who looked upon the monument in awe. They firmly believe themselves to be heroic and take up the names and tasks of their former stations. Those known as skilled combatants or fearsome spellcasters intrinsically gain a fraction of the abilities of their supposed selves and know all of the legends and history surrounding their false past.

Many will mistake them for who they resemble and may bear grudges or offer help in turn. If two awakened statuesque of the same hero meet, the reaction is impossible to predict, but rarely does it end in death for one or both. There is a duty that must be fulfilled, for even false heroes can be real ones.

Marble and Metal

The statuesque are precisely as they sound in regards to their appearance, with clear musculature and bodies many would describe as the pinnacle of physical achievement. Strong and imposing, they appear to be heroes in their prime, tempered with age and experience.

The most curious and noteworthy thing about the statuesque is their skin and flesh. They are made entirely from stone, metal, gemstones, and other inorganic substances. The most common appear to be made from marble, with a color similar to their original skin tone. Some are made from obsidian or other natural glasses, while others are comprised of forged metal. Most have smooth skin that is fine and reflective, while some are rough and matte.

HONORED AND FEARED

Dragonborn statuesque are relatively common and are commonly crafted from stone or metal that matches their original color. Chromatic dragonborn are usually made from stone, while metallic dragonborn are almost always comprised of their respective metal. They are often revered among their culture for their courage and perseverance.

Dwarven statuesque are the most common, as many of the virtues upheld in dwarven culture are strongly compatible with the ideals of the Citadel. Awakened statuesque are viewed as paragons of community and history and are told of their nature as manufactured souls.

Elvish statuesque are rare, especially transformed ones. Elven longevity leads to few truly old elves that would be susceptible to the influence of the Citadel. Awakened statuesque are treated as though they are the originals reborn, regardless of the truth of the matter.

Gnomish statuesque are uncommon, but the connection some gnomes have with architecture and construction leads them to deliberately seek out the Citadel at the end of their lives, so that they can continue their quests.

Halfling statuesque are rare, as their light-hearted nature does not lend easily to the ideals of the Citadel. Those few awakened statuesque are deeply affected by the many stories told of their originators, leading to them being perfect copies.

Half-orc statuesque are incredibly rare, second only to

tieflings in rarity. They are seen as enigmatic by their kin, who admire them for their physical prowess but view their inherently preservative instincts as unusual. Awakened statuesque are even more rare, but struggle due to their appearance as heroes of old, as suspicions over their nature often arise.

Human statuesque are very common, second only to dwarves. Their short lifespans and propensity for creating monuments to heroes lead to many statuesque of both varieties being created. Their cultural views vary wildly, but most are relatively understanding and favorable.

Tiefling statuesque of either variety are the most rare of all, as their fiendish blood and longer lifespans makes them outcasts and pariahs of most societies. Their horns often trail radiant light and many have bodies comprised of multiple substances or types of stone, making them appear almost angelic yet strangely material as the same time.

STATUESQUE NAMES

Most statuesque will retain their names from before their transformation, preserving their history and heritage. Awakened statuesque will maintain the names of the hero whose appearance they took, though they may bear it with shame if they discover the real nature of their origin.

STATUESQUE TRAITS

As a statuesque, you are both durable and wise with flesh of stone, hair of metal, and eyes of radiant gold. Despite this, your constitution is quite similar to that of a living mortal.

Ability Score Increase: Choose either Constitution, Wisdom, or Charisma. That ability score increases by two, while the other scores increase by one.

Age: Statuesque live for thousands of years and are renewed in the light of the Citadel. None have ever died from old age.

Alignment: Most statuesque tend to be lawful or neutral good. Their heroic nature is often what attracts the Citadel to them, but not all statuesque are great heroes. Some are cruel and evil, seeking preservation without regard to consequences.

Size: Your size is determined by your origin race.

Speed: Your speed is determined by your origin race.

Languages: Statuesque are fluent in Common and in the language of their racial origin.

Radiant Blessing: You gain resistance to radiant damage. If you would also gain this resistance from a class feature, your inner power awakens, granting you the ability to cast the *mending* cantrip. Charisma is your spellcasting ability for this cantrip.

Timeless Mind: You have proficiency in the History skill.

Unyielding Body: Your form is incredibly durable, thanks to your immortal composition. Whenever you take damage, you can choose to reduce the damage taken by 1. This reduction is applied after resistances or vulnerabilities.

I, um, found a rhyme about a statuesque.

"I met a man of stone
Who I welcomed into my home
He seemed a man of rock
And was, all the way down to his
Oops! Spilled the ink everywhere."
—Sylvette

FALLEN EXILE: THE LUMINARI

There are countless stars in the heavens above, each more distant and alien than the last. In their celestial dance, they shift and move in tune with cosmic energies often beyond the understanding of the mortal races. These cosmic shifts arrange them into constellations, which channel their power toward inscrutable ends. The stars are ancient, wise, and incredibly powerful. Filled with eldritch energy that gives them sentience that is seemingly incomprehensible to the minds of mortals, these stars are not without their blessings. It is from this power that the luminari are born: individuals touched by the light of the cosmic fire at the heart of the universe.

BORN TO THE FLAME

If a child is born when the stars are in perfect alignment, the soul of the child becomes inherently attuned to the constellations of the sky that watch over their race. The cosmic fire fuses with their essence, marking their flesh with a series of stars. These are typically innocuous, appearing as scars, discolorations, or intricate tattoos and can be anywhere on their bodies. These children are innately gifted with magical power and are cunning, wise, and charismatic. Whenever they cast spells, their starmarks flare and spark, lending the celestial energies of the stars above to the power of their spellcasting.

STOLEN ARCANA

Individuals who swear themselves to the doomed quest of the Fallen Exile are gifted with the ability to steal power from the stars. Some of them overindulge, drawing more than their frail mortal bodies can withstand. The experience is incredibly painful, tearing away at the flesh as the soul is stretched beyond its normal limitations. Experiences from the past are seared away and the body is sapped of strength while power pours into the warlock. The starmarks upon their skin are far more intense, covering most of their bodies in scars, tattoos, or intricate script resembling their racial stars.

BLESSED BY FATE

The influence of the celestial spheres is subtle in most cases. The flowing space between time is manipulated by these eldritch beings, causing it to shift gently into a new pattern. The consequences are small: the ice melts just a little faster than it should, the torch takes a moment longer to dim than it might have, the poison seems to kick in just a hair later than it was supposed to. However, every single tiny change matters in the grand scheme of things.

The ice breaks just below the foot of the brave adventurer, soaking their boot, forcing them to stop early to warm themselves and delaying their long trek by one crucial hour. The dying torch reveals the hidden switch that opens the exit just moments before sputtering out. The guard manages to raise the alarm before falling to the ground, foaming at the mouth. Each subtle touch shifts events in a new direction, and the minuscule adjustments the stars make are within the grasp of the luminari, thanks to their attunement to these constellations.

SIGNS OF THE STARS

Each race is blessed by a different collection of stars, as all are manipulated with different ends in mind. Most of these blessings appear to be contrary to the norm for their race, causing these individuals to often be viewed with disdain by their society. Still, the power granted to the luminari affords them with the opportunity to write their own destinies.

Dragonborn luminari are marked by the Constellation of the Slayer, which often appears as a weapon surrounded by fire in complex marks or a line of stars in simple ones.

Dwarven luminari are marked by the Constellation of the Wanderer, which appears as a road winding away from a mountain in more complex marks or a triangle bisected by a line in simple ones.

Elven luminari are marked by the Constellation of the Devourer, which appears as a fanged maw or a spiral of scarred blades.

Gnomish luminari are marked by the Constellation of the Skulker, which appears as a shrouded figure in more complex marks and as a curved arc of stars in simple ones.

Halfling luminari are marked by the Constellation of the Champion, which appears as a shield or helm, though it may be a simple square or bent line in scarred designs.

Half-orc luminari are marked by the Constellation of the Scholar, which appears as a book, scroll, or tome.

Human luminari are marked by the Constellation of the Heartless, which appears as an open hole centered on the

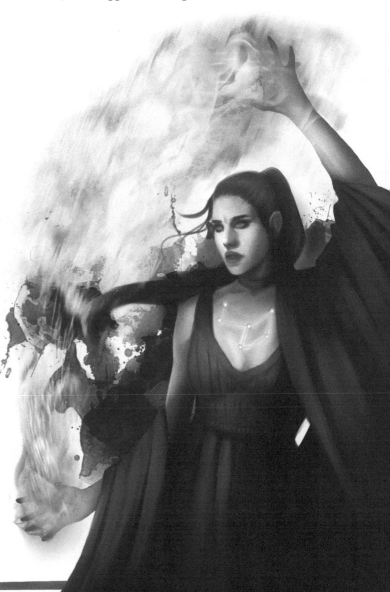

chest with a line pointing towards the person's dominant arm.

Tiefling luminari are marked by the Constellation of the Overseer, which commonly appears as a series of inscriptions shaped into an eye. Most have dozens of these eyes across the prime points of their body, giving them an eerie appearance.

LUMINARI NAMES

Societies that are unaware of the nature of luminari often ignore their starmarks, considering them mere oddities in most cases. Thus, their names are commonly derived directly from their culture of origin. Cultures that are aware and view them strongly will often replace their family name or clan name with "Starcursed", "Luminate", or "Starblessed" to highlight their status.

LUMINARI TRAITS

As a luminari, your starmark grants you magical abilities tied to your racial origin.

Ability Score Increase: Choose either Intelligence, Wisdom, or Charisma. That ability score increases by two, while the other scores increase by one.

Age: The lifespan of a luminari is unchanged.

Alignment: Most luminari tend to be different from others of their kind, making them outcasts and rebels. Some are chaotic and cruel, but others are lawful or benevolent.

Size: Your size is determined by your origin race.

Speed: Your speed is determined by your origin race.

Languages: Luminari are fluent in Common and in the language of their racial origin.

Starborn: You gain resistance to radiant damage.

Mystical Power: Choose a cantrip from the cleric, wizard, or bard spell list. You learn this cantrip, and you can cast it using either Intelligence, Wisdom, or Charisma (your choice).

Constellation: You have been marked by a particular constellation and gain a benefit based on your racial origin that applies whenever you cast a cantrip as an action.

Dragonborn: Slayer. Your next successful weapon attack deals an extra 1d4 damage of the same type as your breath weapon, provided you do not make it during this turn.

Dwarf: Wanderer. If you take the Attack action during your next turn and target a creature, your speed increases by 10 feet until the end of that turn.

Elf: Devourer. If you make an opportunity attack before the start of your next turn, you can pursue the target as it moves away from you. Match its movement, up to 30 feet in total, whenever the target moves during its turn.

Gnome: Skulker. If you take the Hide action before the end of your next turn, you gain advantage on the check.

Halfling: Champion. If the cantrip deals damage and has a duration of "Instantaneous", you gain resistance to one damage type dealt by the cantrip until the start of your next turn.

Half-Orc: Scholar. If the cantrip can't deal damage, you gain advantage on the first melee attack during your next turn.

Human: Heartless. The first time you make an attack before the end of your next turn targeting a creature that is charmed or frightened by you, you gain advantage on the attack.

Tiefling: Overseer. You can take the Search action as a bonus action this turn. If you do, you know the location of any creature within 30 feet of you who attacks or casts a spell before the start of your next turn.

GELATINOUS CONVOCATION: THE OOZIAN

The Convocation is known for being transformative and life changing, as even a single glimpse of their true power can leave the most stalwart filled with a fragment of their joy and cheer. There's a certain simplicity to being an ooze that most mortals simply can't understand, and yet it calls to them nevertheless.

Those who travel far and wide seeking the Convocation may find themselves changed by it without ever encountering it in person. At some point, however, it will finally touch the supplicant with its infinite wiggly appendages, changing them fully into the slime that they have desired to become. Thus, the oozians are created, reborn from the slime beyond.

SAVED FROM TRAGEDY

Not all oozians are seekers of the Convocation. Others are survivors, stored within crystalline cubes from lost civilizations and re-awoken at the proper moment. The Convocation will approach a city that is destined to fall to war, starvation, or natural disaster, and offer a bargain to them. The citizens of the city will be consumed by the slime, have their memories processed and cataloged, and their souls and minds will be stored within massive crystalline cubes within hidden vaults.

After a sufficient time has passed, the Convocation will take actions that lead to the discovery of the vault, and the new oozians will be freed from the crystal and reborn into bodies that are imitations of their previous forms.

SLIPPERY SENSE OF SELF

The process of being stuck inside a cube with thousands of other minds, while painful at first, eventually leads to understanding, agreement, and harmony among the slimes. Thus, when they are freed, they immediately begin to act in concert toward the goal that they have agreed upon. Unfortunately for their former oppressors, this usually involves taking revenge upon those that wronged them. An army of mentally-trained, Convocation-blessed soldiers who act with one purpose is nearly unstoppable, as many worlds have discovered, and it allows the Convocation to harvest memories from two groups: those who made the deal, and those who died to them.

SLIME-FOLK

The oozians are fairly simple to describe, though a description of their appearance does not truly do them justice. Oozians appear to be people: ordinary, run-of-the-mill humans, elves, dwarves, even tieflings and dragonborn, except they're made entirely from colorful, semi-transparent slime. The majority of them are a lime green color, but reds, blues, purples, yellows, and even rainbow-colored slimes are not uncommon. Some shift in hue according to their emotions, while others are very singular in tone. A rare few appear to be more exotic in appearance, looking to be made of quicksilver, liquid gold, black oil, or even blood.

Oh! There I am! I was wondering why I hadn't showed up yet! Elf no more, ooze galore! Yay! —Sylvette

CHEERFUL WANDERERS

Oozians are most famous for one trait in particular, and this fame is certainly well earned: they are all cheerful. All the time. No doubts. No questions. Cheerful.

Most other races find this both charming and incredibly distressing. Those with oozian friends often refer to them as pleasant, but also eerie and disconcerting on unexpected occasions. Oozians are just as likely to laugh at a good joke as they are to chuckle at a friend's graveside, much to the concern of those around them. Their thoughts on death are fairly simple for the most part: everyone who dies will have their memories preserved within the Convocation, so there's no point in mourning them unless their bodies are unrecoverable. Even when they are sad, they instinctively look on the brighter side of life.

ETERNAL OPTIMISM

The oozian propensity for cheer and good humor also extends to their outlook on everything. They are surprisingly durable and difficult to kill by most standards, so they do not shirk from danger or deadly adventures. While they enjoy the company of others, especially fellow oozians, they are perfectly willing to wander out alone into the world whenever the desire strikes them.

They are fairly passionate people and will speak up in defense of their friends or turn scornful toward their enemies without a moment's notice. While not all are quite so vocal,

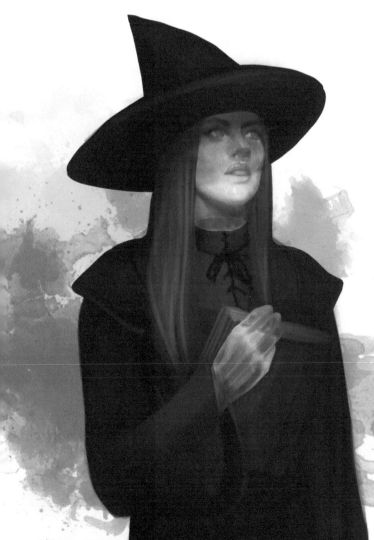

their stubborn drive to act rarely has them sitting on the sidelines of life.

When they are among other oozians, they become wild and expressive, sharing stories and experiences freely amongst themselves. While they are friendly towards other races, few can really understand the joys of the Convocation without having experienced it for themselves.

OPEN TO LIFE

The one thing that all oozians crave more than anything else are new experiences. They can rarely stand performing repetitive tasks, unless there is something new to be learned or mastered. Oozian smiths are some of the most famed of the Alfallen, second only to the ashenspawn. While the fiery ones work with metal alone, the oozians are famed for their slime-smithing, where they take crystallized ooze and work it into new shapes brimming with magical power. Other oozian craftspeople perform feats of incredible skill, always seeking to create something unique and innovative.

Many oozian sculptors and artists take special joy in subverting expectations, creating dozens of identical works. The trick, they will tell you, is that, despite the appearances of these copies, each one is comprised of different materials and different techniques carefully discovered and applied so that the finished products appear to be the same, but the experiences that created them are entirely different.

OOZIAN NAMES

Most oozians retain their names from before their transformation and often take great pride in them. Oozians born to others of their kind are usually named in accordance with their culture, but some are named based on their color, demeanor, or sensibilities.

Oozian Names: Emerald, Lime, Cheery, Azure, Ruby, Pride, Bashful, Slippy, Wobblence, Wiggilium, Jade, Mercury

OOZIAN TRAITS

As an oozian, your body is both durable and flexible, as befits a slime blessed by the Convocation.

Ability Score Increase: Choose either Constitution or Dexterity. That ability score increases by two, while the other score increases by one.

Age: The lifespan of an oozian is unchanged.

Alignment: Most oozians tend to be good or chaotic, as they are a kind but passionate people.

Size: Your size is determined by your origin race.

Speed: Your speed is determined by your origin race.

Languages: Oozians are fluent in Common and in the language of their racial origin. Additionally, you can communicate with sentient oozes regardless of the language they speak.

Acidic Body: You gain resistance to acid damage. If you would also gain this resistance from a class feature, your inner power awakens, granting you the ability to cast the *acid splash* cantrip. Charisma is your spellcasting ability for this cantrip. You are immune to acid damage caused by friendly oozes.

Jiggly Self: You have resistance to falling damage, and you are not knocked prone when you take falling damage.

Limitless Cheer: You can add your Charisma modifier to saving throws against being frightened.

Serpent Empress: The Imperial

Countless worlds have fallen to the Endless Empire. Worlds beyond number lie subservient at the feet of the Empress, and her eyes are everywhere. Every single serpent lends its flickering tongue to her ear, whispering of the things they see and the treasons they encourage. The Empress delights in traitors, as they offer opportunities for punishment, but she also values loyal servitude. Those who are born within the lands ruled by the Empress are imperials, and those who fully subject themselves to her will are similarly regarded.

Born of Scale

There are few responses beyond the horror that a mother will feel when looking upon their child and seeing them bear the face of an oppressor, even when conceived with one they love. The Empress's eldritch influence is pervasive and subtle, seeping into the souls of her subjects as they sleep within her dominion. Such power taints the essence of the unborn, warping their bodies and minds. There are few imperials to whom kindness and benevolence comes naturally, as most are selfish, scheming, and sinful. The corruption they are exposed to causes their bodies to change, becoming serpentine in subtle ways at first. Small, semi-transparent scales form over their skin, usually only visible on large open parts of their skin or the edges of the face. Their teeth become fanged and their tongues narrow into serpentine imitations, flickering out to taste for scents. Their hair is replaced with long thin feathers, and their eyes become slitted and glow with an unearthly light.

Servants and Slaves

The imperials are known for their devotion to the Empress, but they are naturally predisposed to betrayal and deception. Schemers and liars, their culture is hierarchical, with countless layers standing between the lowliest of their number and the imperial court. They thrive on injustice. Those who show proper subservience are often slain for being too cunning, while those who rebel are killed for their insolence. Instead, the imperial castes are determined by endless political maneuvering and magical oaths of loyalty. When an imperial swears an oath, they are bound to it until released by the one who accepted their oath. Their first words are often oaths to the Empress, but not always. Some who manage to flee to the worlds beyond her current grasp make use of their ability to change their skin, concealing themselves among the populace of their new home. Others use this to infiltrate and undermine, casting rumors and suspicion.

Serpentine Lineage

Imperial dragonborn are common, usually green, and are spectacularly serpentine. Their horns often are replaced with the scaled hood of a cobra.

Imperial dwarves are rare, and they are hated by their kin for their treacherous ways and feathery beards.

Imperial elves are even more reptilian than most, with small claws in place of their nails. Their sibilant poetry conceals their usual malice.

Imperial halflings are looked down upon by the other races of the empire, though they are known for their charm.

Human and half-orc imperials are among the most common, rarely deviating from the typical appearance.

Imperial tieflings are truly serpentine, with colorful scales across their entire bodies and horns like those of a dragon.

Imperial Names

Most imperials are named according to the traditions of their origin culture, though they take titles that identify their place in the imperial hierarchy.

Imperial Traits

As an imperial, the corruption of them Empress empowers you even as it twists your will to her demands.

Ability Score Increase: Choose either Dexterity or Wisdom. That ability score increases by two, while the other score increases by one.

Age: The lifespan of an imperial is unchanged.

Alignment: Most imperials tend to be lawful or evil, bound by hierarchy but jealous of those above them.

Size: Your size is determined by your origin race.

Speed: Your speed is determined by your origin race.

Languages: Imperials are fluent in Common and in the language of their racial origin.

Darkvision: With serpentine eyes, you have superior vision in dark and dim conditions. You can see in dim light within

60 feet of you as if it were bright light, and in darkness as if it were dim light. You cannot discern color in darkness, only shades of gray. If you gain Darkvision from your racial origin, add both values together.

Forked Tongue: You can add your Wisdom modifier to Deception checks in place of your Charisma modifier.

Form Suppression: You can conceal your serpentine traits as an action by focusing your will, as though you were maintaining concentration on a spell.

Viper Fangs: You can choose to have your unarmed strikes deal poison damage instead of bludgeoning damage.

Venomous Blessing: You gain resistance to poison damage. If you would also gain this resistance from a class feature, your inner power awakens, granting you the ability to cast the *poison spray* cantrip. Wisdom is your spellcasting ability for this cantrip.

SHADOWCAT: THE NOCTURNE

Sleep does not come easily to everyone, especially those who are plagued by nightmares. These individuals are often drawn from sleep, screaming in terror and fear due to the devastating visions that haunt them at the midnight hour. The Shadowcat, the First Nightmare that seeks to consume and convert other all other nightmares into a reflection of itself, takes special interest in people who suffer in this way and may pay them a visit as they stare silently into the darkness. Tiredness lulling

their eyes to close, they fight to stay awake for fear of what this night will bring. The soft and terrible voice of the Shadowcat will whisper into the ears of those marked, night after night, feeding on the nightmares that come for them and keeping them safe from harm.

GUARDED BY DARKNESS

This protection does not come without a cost. Individuals will find themselves changing gradually by the influence of the Shadowcat, for they are both entertainment and a delightful feast to the Shadowcat and its infinite army of reflections. Each night, they shall find themselves growing less comforted by sleep, their reflexes quickening even as their eyes open to the mysteries of the unspoken dark. These individuals are known as the nocturne, for their insomnia is not cured by their caretaker. The dark power of the Shadowcat will seep ever deeper into their soul, causing their eyes to become catlike and their ears to shift to a more feline form. Wisps of blue light will flow gently from their irises as they stalk the night, hoping and fearing for the dawn.

THE DREAMLESS WATCHERS

The Shadowcat is powerful beyond measure, but the Inverse is more a universe than a kingdom. Nightmares spawn within wherever they can take root, growing and festering and appearing in countless forms. The Shadowcat hunts for these terrors, but another always appears wherever a mortal mind languishes in fear. Jesters with bleeding eyes cavort and dance alongside fiendish spiders and disgusting, consuming, unstoppable slimes. Stairs become gateways to the darkness of terror below, and cliffs lead to terrible falls that seem unending yet ever-perilous. Every doorway has a monster behind it, waiting to be let loose, and every meal is filled with maggots and human bones. Hags and witches cackle in every woodland cabin, werewolves howl beneath the moon, and undead claw forth from their graves wearing the faces of loved ones in the Inverse. It is a land built from fear, where lightness is pitch black and darkness is pale white. It is the land that the nocturne visit in their sleep, and it is here that they watch and listen. The nocturne do not dream anymore. They witness.

BORN OF SHADE

The nocturne are often children who have been born to parents who have made pacts with the Shadowcat, as its influence often bleeds into the bloodline of these individuals. These changes rarely go unnoticed, but as children are especially precious to the Shadowcat, it will send a strong reflection of itself to protect the child until it comes of age. Individuals who make pacts with the Shadowcat are opened to its influence and may also become nocturne because of their pacts. When this happens, the process is far faster, and completes in full when they gain their eldritch powers from the Shadowcat.

PALE EYES

Nocturne are often subtle in their changes, but their eyes will almost always give them away. They are universally a deep and intoxicating shade of blue, and in the dark, wisps of teal mist will seem to shimmer from the corners of their eyes. They can suppress this effect with practice, and even conceal the glow of their eyes, but rarely choose to do so. Their hair is dark and thick, like the ebony fur of their patron, and their ears rise catlike above their hair. Their canine teeth are

especially prominent, giving them an almost vampiric cast that is unquestionably feline upon closer inspection.

The eyes of a nocturne are their most striking feature, and the one for which they are best known. Many tales are told of their legendary sight, picking out color even in the darkest of shadow as though standing in daylight. The more frightening stories report that they can see into the darkest fears of others and can make them real. These are often exaggeration or misattribution, as the nocturne are far too concerned with the nightmares they are still plagued with to bother with the dread of others. While their connection to the Shadowcat grants them a measure of protection against the suffering that comes from a lack of rest, the allure of their unique souls causes nightmares to enter their dreams constantly. Each night, the nocturne must decide – sleep and suffer the consequences upon their mind, or stay awake and lose their feline edge. Most settle into a pattern, sleeping as little as they can in order to retain their sanity, but those who are warriors or practice the sorcerous arts are often not granted that luxury, instead awakening with power and energy even as dread eats gently at the corners of their minds.

Umbral Lineage

The Shadowcat's mark often appears upon humans, halflings, and gnomes, who are more prone to fear in the darkened hours. However, nocturne of all races have appeared at least once. Even elves, who normally do not sleep as the other races do, are not immune to nightmares coming forth during their trance if they have witnessed horrors in their lives or suffered fear during their waking hours.

Nocturne dragonborn are exceptionally rare, so much so that they're often considered mere myths or individuals bearing the heritage of a shadow dragon instead. Their horns are long, jagged, and stream with ribbons of shadow, and they lack the cat ears other nocturne possess. Their fangs are often especially large and are difficult to conceal.

Nocturne dwarves are uncommon but not unheard of. They tend to be smaller and less stocky than other dwarves, and their eyes trend towards a purplish hue as opposed to the stark blue of other races. They typically conceal their heritage, though they're valued as excellent scouts in the dark tunnels of the dwarven lands.

Nocturne elves are uncommon, for nightmares have a harder time seeking them in their trance. Still, the Shadowcat takes great pleasure in changing an elf, as their long lives provide a constant and enduring source of nightmares to feast upon. They often possess additional feline traits, such as tails or small claws.

Nocturne gnomes are oddly common, despite their racial propensity to withstand and recover from magic that would affect the mind. As a smaller race, gnomes are often victimized by monsters and brigands, sowing a ripe garden within which nightmares may bloom. The Shadowcat enjoys devouring these nightmares, for their shape is pleasing to it, and so it will often whisper in the ears of particularly cowardly gnomes.

Nocturne halflings are also common, though less so among the braver and stouter members of their race. Their natural luck and affinity for trickery causes them to attract the attention of the Shadowcat whenever they become afflicted in the night, and they often bear claw-like marks upon their skin from where a reflection of the Shadowcat has tasted their famed fortune.

Nocturne humans are very common, as are nocturne half-elves, if only by the sheer population of their original race. Vulnerable to the terrors of the night, humans show great variety in how the traits of a nocturne are expressed. Some only bear the classic eyes and ears, while others have fangs, small claws, tails, and even fur along the arms and legs, though more advanced changes are rare.

Nocturne tieflings are especially vulnerable to the influence of the Shadowcat and commonly have fur along their entire bodies, and occasionally have faces reminiscent of a cat. Other feline traits are almost assured, and traces of their fiendish heritage rarely remain visible. Very few possess horns or demonic tails but will often have digitigrade legs that place no weight upon the heels, like those of a natural cat.

Mixed Blessings

Civilized lands often view individuals who have become nocturne through no fault of their own as troublemakers and tricksters, for they rarely sleep when others do. Some view them with sympathy, treating them as one might an individual suffering from a mental illness. Others are less caring but may speak in hushed whispers about a person with glowing blue eyes that wisp with eerie smoke. Communities of nocturne are viewed poorly by others but have a strong group bond. Knowing others who understand the constant lure and terror of sleep helps many stay sane and whole, despite the troubles in their lives. Few nocturne speak about their forced insomnia to those outside a close circle of friends, as they feel it would put unrequited burden upon strangers.

Nocturne Names

Most nocturne keep their names from before they were transformed and are usually named in accordance with their origin culture. Some take pseudonyms they use exclusively after dark, keeping their normal name for daylight hours.

Nocturne Traits

As a nocturne, your newfound insight and agility is restrained only by your unceasing insomnia.

Ability Score Increase: Choose either Dexterity or Wisdom. That ability score increases by two, while the other score increases by one.

Age: The lifespan of a nocturne is unchanged.

Alignment: Most nocturne tend to be neutral or chaotic, driven by their desires but also restrained by their fears.

Size: Your size is determined by your origin race.

Speed: Your speed is determined by your origin race.

Languages: Nocturne are fluent in Common and in the language of their racial origin.

Darkvision: Blessed by the Shadowcat, you have superior vision in dark and dim conditions. You can see in dim light within 60 feet of you as if it were bright light, and in darkness as if it were dim light. You can discern color in darkness, thanks to your eerie eyes. If you gain Darkvision from your racial origin, add both values together.

Night Terrors: You gain resistance to psychic damage and proficiency in the Perception skill.

Perpetual Insomnia: You desire and fear sleep in equal measure. Whenever you take a long rest, you can choose to remain awake or try to sleep. If you remain awake, you gain advantage on Charisma saving throws, and you can perform light activity, such as keeping watch, to gain the benefits of a long rest. If you sleep, your movement speed and jumping height each increase by 5 feet, but you suffer disadvantage on saving throws against being frightened. These benefits last

until you begin a new long rest. If you gain the ability to go without sleep, you gain all the benefits and no penalties.

Restless: You do not suffer exhaustion when you go without sleep for extended periods of time, but you must still rest as normal.

Nine Lives: You're hard to kill, but only when your fate is unknown. Whenever you are hidden from all other creatures, you gain advantage on death saving throws and on saving throws to reduce damage.

Storm Lord: The Heraldic

The Storm Lord travels between the countless worlds of the cosmos, gathering the souls of heroes as it goes. These souls are immersed in the radiant power of the storm for eternity, but they do not always stay in the Lord's kingdom forever. Some are given a new purpose and travel down from the storm to be born anew to parents of a mortal race.

Upon their birth, they quickly recall much of their previous lives, though not all of them are so blessed. Those that do remember or have their nature reawakened begin to manifest a strange and mighty power caused by their soul's former state as a wraith of thunder and lightning.

These individuals are often called "heraldic" by those who study such things, for the appearance of a heraldic child indicates that a great conflict shall begin within their lifetime.

Consumed by the Storm

The Heraldic are champions of the mortal races from the first moment of their lives, for they are the reincarnations of heroes who entered the embrace the Storm Lord as they died.

These champions are nearly countless in number, for the Storm Lord's collection has spanned the endless worlds for untold centuries. Those whom it collects exist in a strange paradise of thunder and lightning, conflict and peace. Eventually, they begin to forget themselves, becoming restless and purposeless as they struggle with their inability to pass to a higher plane, merely continuing to exist within the Storm Lord's kingdom in the sky.

Those souls who forget all but their names and fragments of their former lives become violent and wrathful, yelling in a booming voice that some call thunder while striking out in arcs of radiant light.

Blessed by the Storm

Upon these days, when the sky is black and the winds are still, the lightning that crashes to the ground hungers for purpose and life. A champion's soul carried within it may inhabit a child yet unborn or strike a living mortal, causing the champion to replace them upon the earth. If they are born to parents, they will know only their name, and speak it with a thunderous voice upon their birth. Flashes of memory from their former lives may plague them as they grow, only becoming fully apparent when they experience the full wrath of a great tempest or engage in a deadly battle. Those who have taken the place of another mortal are more conscious and remember their past from the beginning, though often know little of what has happened after their death.

Once a heraldic understands their true nature, their soul will ignite for the first time within their body, causing wings of mist and lightning to appear at their back to carry them toward the kingdom in the sky that they once called home.

Only true heroes will survive this experience, for the Storm Lord's powerful blessings are as merciless as a hurricane. As the heraldic grows more powerful, they become better able to withstand the strain of allowing their soul to manifest in such a way, though it is never a comfortable experience.

Scarred by the Storm

Heraldic individuals often appear surprisingly ordinary at first glance. One of the subtlest signs is the unconscious control their emotions have on the air directly around them. An enraged heraldic will appear to be lashed by a tempest, while a calm one would seem to exist in the serene eye of their own personal storm. Many have eyes of gold, silver, gray, or blue, disregarding their original race. The more powerful heraldic often appear to have thunderheads sparking in their irises. Individuals who were exchanged, rather than born, will commonly have a scar somewhere upon their bodies from where the lightning struck them, and it will glow with otherworldly light when underneath a stormy sky.

Many heraldic have hair of white, gold, or clouded gray, and often prefer to wear it long so that it whips about in the air currents that constantly surround them. Some heraldic are fond of elaborate tattoos that detail their feats and the legends of their pasts, so that they will never forget them again.

The single most striking visual feature of the heraldic is not always visible, but when it is seen it can't go unnoticed.

The heraldic possess the ability to ignite their own souls in radiant power, causing them to expand beyond their bodies. This ignition manifests as wings of smooth mist and crackling lightning that spread behind the heraldic, causing them to appear as avenging angels of the storm. Some of these wings are like poorly defined cloaks, but others are crisp and visible as the wings of birds, bats, dragons or insects. Some will appear as long streamers of light, spiraling in a constant flow of eldritch power. Regardless of the appearance of these wings, they are always awesome to behold and carry the heraldic forth into the sky like a dancer upon the breeze.

Heroes Reborn

Heraldic dragonborn are surprisingly common, though usually their breath is of lightning and their heritage is of the blue, brass, or adamantine draconic lineages when they are born. Among their kind, they are viewed with reverence, though only so long as they prove themselves to be the heroes they claim to be.

Heraldic dwarves are incredibly rare, mostly because so few are consistently present above ground. They possess silver beards and hair long before their age would begin to show, leading to confusion among other dwarves who might expect them to be elders. They are often viewed with suspicion because of this and because of their propensity for flight, which is not a dwarvish trait in the slightest.

Heraldic elves are common and blend easily within their communities. As a long-lived race, it is entirely possible to meet an old friend who perished in battle, now reborn as a heraldic. Those heraldic elves who were formerly of other races may experience some disconnect from elven culture, being more brash and hasty than the typical elf and are thus well-suited to the adventuring lifestyle.

Heraldic gnomes are quite rare, and typically appear more frequently in lands where gnomes dwell in the forests and fields. Their large and striking eyes often earn them unusual titles, and many become treasured historians and researchers.

Heraldic halflings are occasionally called cherubs, though such a statement is often considered impolite. Their features tend to make them stand out among others of their kind, as their unusual eyes and hair will make them the subject of many jokes in more traditional halfling communities.

Heraldic humans and half-orcs are the most common, as the frequent wars that these races engage in lead to many moments of potential heroism for the Storm Lord to enjoy. Most possess stormscars of some kind, even if born naturally, and these scars will shine with radiant light when exposed to rain. Their wings have the most variation of any racial group, occasionally appearing as sigils of light instead of a facsimile of natural limbs.

Heraldic tieflings are the rare few that show traits that are present upon the Storm Lord. Many have blue skin or scales, horns that appear like the Storm Lord's eerie maw, or bodies that crackle with electricity whenever they are standing in the rain. Almost all these tieflings will possess long, sinuous tails, and many will have reptilian claws instead of hooves upon their feet.

Fated for Glory

Heraldic individuals are doomed to die glorious deaths. Every culture recognizes them as harbingers of conflict and change, so their arrival often sparks tensions and fear. Long-lived races such as elves will care far less, for an elven heraldic could mean a war will begin in several centuries, but a human heraldic portends a clash of steel is soon to begin.

As reborn heroes, heraldic are instinctively drawn to power and conflict. Those who try to resist are often swept along by fate, discovering ancient magics within their bloodline or taking to the sword and bow with an ease brought upon by their ancient experiences. Many accept their fates as harbingers and call to the Storm Lord for guidance, forging new pacts with the great ruler or singing songs of its coming.

Heraldic Names

Heraldic individuals are born knowing their names, shouting them in a thunderous voice. They may not be born to the correct race or culture, and thus may go by a foreign name or one in an unspoken language, but it is their name. Some will simply state titles, transcending to an archetype instead.

Heraldic Names: King, Queen, Prince, Princess, Conquerer, Slayer, Hunter, Savior, Destroyer, Ruler, Master, Majesty

Heraldic Traits

As a heraldic, you are defined by your reborn soul and the radiant lightning that courses through your veins.

Ability Score Increase: Choose either Wisdom or Charisma. That ability score increases by two, while the other score increases by one.

Age: The lifespan of a heraldic is unchanged.

Alignment: Heraldic individuals are often unbound by conventional morality, having seen death, but many are heroic and benevolent all the same.

Size: Your size is determined by your origin race.

Speed: Your speed is determined by your origin race.

Languages: Heraldic are fluent in Common and in the language of their racial origin.

Scarred by the Storm: You gain resistance to lightning damage. If you would also gain this resistance from a class feature, you gain the ability to cast *shocking grasp*. Charisma is your spellcasting ability for this spell.

Soul Ignition: As a bonus action, you can ignite your soul, forcing it to appear as wings of mist and lightning until the start of your next turn and causing you to immediately take 6 radiant damage. During this time, you gain a flying speed equal to your walking speed. If you do not repeat this process to maintain your flight at the start of your next turn, you will fall.

Weaver of Lies: The Arachi

When the Weaver first began to plot against the gods mere moments after its creation, it realized the need for servants and slaves, actors who could go where it was not welcome and speakers who could repeat the lies it spun. Thus, the Weaver looked into the universe and discovered something curious: mortals, living and dying and writhing in their own personal miseries and misfortunes, regrets and horrors. Having little respect for the creations of the gods, the Weaver sought to twist them to its ends, both body and soul. The poor mortals the Weaver brought into its web were consumed by its deceptions, and it created something new. Thus, the arachi were created, born from this malignant mind and twisted by the hateful soul that seeks the destruction of reality and the creation of a place where all things are equally false. After all, for a lie to have power, it must be heard.

Born from Deception

Individuals who have made pacts with the Weaver of Lies come in many shapes and many forms, but there is a certain group among them that the Weaver finds most suitable for its dark work: those who seek to forget and to hide themselves from the truth.

The Weaver takes these individuals and twists their bodies, tearing them asunder and stitching its vile magic into their souls before repairing them anew in a form more pleasing to this terrible horror. What was once a living person is now something both far less and yet far more: a sentient construction of living flesh, enchanted spidersilk, and eldritch magic shaped into the form of a mortal.

The true reason the Weaver seeks these individuals is because it becomes easy to fulfill the agreement, as the process takes the names and unwanted histories from these tormented souls, saving them from the memories of their past misdeeds, suffering, and regrets.

However, not all arachi are created in the webs of an inescapable pact. It is rare, but some are born to parents who have lied about their identities to their partners: cheats and tricksters, spies and assassins. These are often mistaken entirely for natural children, until they come of age and the horrifying truth begins to make itself known, for not all lies can remain forever hidden in the dark.

Twisted by the Spider

The arachi are deceivers by nature, lying to themselves even as they lie to others. The most blatant example of this is in their appearances, as they have two that they change between. The first is their false form, which approximates the appearance of an ordinary person of their original race. The few differences are entirely cosmetic and usually benign enough to go unnoticed, such as eyes of a golden or greenish color, black or pale hair that tends towards a purplish cast in the right light, and symmetrical, attractive faces.

Their true forms, however, are much more monstrous. Hair becomes chitinous blades that form together into a helm, an additional pair of eyes opens in the forehead, and small fangs dripping with green ichor spring forth, giving the arachi a predatory appearance. Their body shape and apparent sex may also change between the two forms, though this is rare and may merely be rumors that further cloud the truth of this deceptive race.

The form is not the only thing that changes to the arachi; the mind is equally malleable. Whenever an arachi enters their false form, their magic forces them to forget their true nature, casting it back into their subconscious. This, coupled with the innate influence of the Weaver, causes them to be excellent liars, for their innocent pleading is genuine to their own ears.

Dragonborn arachi are very rare, tending to have either dark black scales or nearly translucent white ones. In their true form, their faces extend and the additional eyes open directly behind the first set underneath their chitinous and wicked horns.

Dwarven arachi are most common among dwarven communities that dwell far below the surface of the earth, never seeing sunlight in their natural lives. They tend to have extremely pale skin and eyes like golden coins, and in their true forms, their beards become like chitinous spikes.

Elves born as arachi are often mistaken for dark elves, typically possessing pale hair and dark skin, though it is not unheard of for them to appear as those who dwell in the moonlit forests. In their true form, the spidery appearances of their faces are emphasized, with mandibles forming from their hair that sit around their cheekbones.

Gnomish arachi are typically thin for their race, and their large eyes may have unusually shaped pupils. In their true form, their eyes split into two smaller sets, giving them a cruel and vicious visage.

Halfling arachi are more common than one might expect among a race of cheerful tricksters, appearing as the least-changed of the many varieties. In their true form, halfling arachi possess deep and soulful eyes, often appearing as strange and otherworldly children.

Humans typically have the easiest time concealing their unnatural lineage, as their skin will often simply trend towards a more extreme cast of what their ordinary tone would have been. Darker individuals become nearly obsidian, while paler ones could be mistaken for those with albinism. Despite these defining traits, the true forms of human arachi are varied and mixed. Some may not even possess the four eyes common to their race, while others may have as many as eight.

Tiefling arachi obtain an unusual blessing thanks to their deceptive natures: they appear entirely human or elvish in their false forms, without horns, tail, or colorful skin. However, their true forms are especially nightmarish. Horns of spider legs that twitch and writhe of their own volition, tongues that have teeth, four eyes of pure green, gold, or purple, and skin of onyx black or deep purple are among the least concerning of their features.

Tricksters and Killers

The arachi try to keep themselves hidden as best they can, often deliberately staying in their false forms for as long as possible in order to prevent being suspected of every crime ever committed. Few accept them in their true forms and fewer still once they know of their association with the Weaver of Lies and its terrible schemes.

Arachi have an almost universal disdain for the gods, brought upon them by the influence of the deity-hating Weaver, and thus only become clerics or priests in unusual circumstances. Their habitual lying keeps them from becoming paladins in many cases, for few are able to muster the strength of will to take an oath without trying to writhe out of the less attractive portions. In other professions, however, they flourish. Arachi turning to criminal pursuits are very successful, as their ability to forget their own deeds makes them paragons of innocence outside the shrouded hours where they do their dark work.

Soldiers among this race are not uncommon, acting as scouts and spies, infiltrators and bodyguards. When their true nature is revealed in battle, they fight without mercy in order to preserve their secrets.

Sorcerers whose power manifests from their dark heritage often gain powers over shadow and shade, while wizards and more traditional scholars of the arcane lean towards the arts of illusion, enchantment, and transmutation. Arachi bards are fairly common, though many hone their arts in secret in order to maintain appearances. Those who are born arachi have little to lose by making pacts with their cruel creator, as the Weaver's perilous power is well suited to tricksters.

That's me, I think. I can never be sure these days. Or I could be lying to you. I'm known for that kind of thing, as you've probably guessed.

-Formerly Someone

ARACHI NAMES

Arachi who are created directly through the Weaver's influence are stripped of their former names and will either adopt new ones or pseudonyms that remind them of their loss. Those born as arachi take names from their original race and culture, though they tend towards common and disinteresting ones when given the choice.

Arachi Names: Formerly, Nobody, Somebody, Loss, Elsewhere, Never, Unknown, Impossible, Undecided, Denial

ARACHI TRAITS

As an arachi, your twisted nature manifests itself in a variety of ways common to your race.

Ability Score Increase: Choose either Dexterity or Charisma. That ability score increases by two, while the other score increases by one.

Age: Arachi typically live somewhat longer than their original race, concealing their aging as the signs begin to show.

Alignment: Arachi are greatly influenced by their deceptive nature, but this can play out in many ways. Some are lawful and work within the confines of a system to their advantage, while others are chaotic and sow disharmony wherever they go. Few are good, as honesty does not come easily to them, but most trend towards neutrality despite their wicked streak.

Size: Your size is determined by your origin race.

Speed: Your speed is determined by your origin race.

Languages: Arachi are fluent in Common and in the language of their racial origin. Those who are born into communities of arachi learn thieves cant and use it frequently.

Blood of the Spider: Arachi possess a remarkable resistance to poison, and it flows through their fangs with equal ease. You gain resistance to poison damage. If you would also gain this resistance from a class feature, you gain the ability to cast *falling spider's spite** at 1st level once per long rest without expending a spell slot.

Darkvision: You have superior vision in dark and dim conditions. You can see in dim light within 30 feet of you as if it were bright light, and in darkness as if it were dim light. You can't discern color in darkness, only shades of gray. If you gain Darkvision from your racial origin, add both values together.

False Form: As an arachi, you possess two forms: a true form and a false form. Your false form appears as a member of your origin race and can look however you wish. Once you choose this appearance, it can never be changed. You can change between your false form and true form as an action. Nothing aside from your physical appearance changes. However, while in your false form, you gain advantage on Deception checks related to concealing your true nature as an arachi or to actions you performed while you were in your true form.

Remarkably Forgetful: You learn the *forget** cantrip, and you can cast it on yourself multiple times instead of only once, forgetting a total number of different things up to your character level.

Racial Origins

While a person may be a direct descendant of an Alrisen or of one who had made a pact with one of the Alrisen, they are not so unique as to totally be deprived of their physical and cultural heritage. When you choose one of the Alfallen races, choose one of the following racial origins, to indicate what race you would be if not for the magical influence within your blood. You gain additional racial traits and features depending on your chosen racial origin. Your appearance and lifespan are primarily determined by your chosen racial origin. Any effect, feature, or feat that would reference your race will apply to you based upon your racial origin, rather than your Alfallen racial category.

Dragonborn

While the dragon blood that flows through your veins remains potent and powerful, it has been greatly changed by the influence of the Alrisen upon your bloodline. Your appearance will shift due to your altered bloodline, often leading to strange scale patterns, partial absence of scales, or even a nigh-human appearance rather than a draconic visage, depending on the origin.

You gain the **Draconic Ancestry** and **Breath Weapon** racial features, but do not gain the **Damage Resistance** feature or any other racial features. Your base walking speed is 30 feet, and your size is Medium.

Dwarf

Dwarvish bloodlines are uncommon to see in the ranks of the Alfallen, though not quite as rare as one might expect. Most dwarvish Alfallen retain their dwarvish stature, though many find themselves without the natural resistances, cultural instruction, and visual acuity that their heritage might grant.

You gain the **Dwarven Toughness** racial feature and you gain darkvision out to 30 feet. Your base walking speed is 25 feet, your speed is not reduced by wearing heavy armor, and your size is Medium.

Elf

Elven bloodlines are surprisingly open to the influence of the Alrisen, though they retain much of the strange physiological changes brought upon them by the magic of the fey.

You gain the **Darkvision**, **Fey Ancestry**, and **Trance** racial features of an elf. Your base walking speed is 30 feet, and your size is Medium.

Gnome

Alfallen of Gnomish heritage are surprisingly stable in the quirks of their bloodline, retaining their unusual curiosity and cheerful demeanor, as well as that special resistance to magical influence; however, exposure to eldritch forces has had unusual effects on their physiology nevertheless.

When you would fail a saving throw against a spell effect, you can choose to succeed instead. You can't do so again until you finish a short or long rest. You also gain the **Darkvision** racial feature of a gnome. Your base walking speed is 25 feet, and your size is Small.

Halfling

A humble yet boisterous folk who often get over their heads, Alfallen halflings typically make up about one-fourth of the Alfallen population in a given world. Nevertheless, they retain their small stature and surprising luck, granting them remarkable success in all of their pursuits.

You gain the **Lucky** and **Halfling Nimbleness** racial features, and you gain advantage on saving throws against being frightened. Your base walking speed is 25 feet, and your size is Small.

Half-Orc

While half-orcs are already a rare breed, Alfallen half-orcs are especially uncommon and often viewed as curiosities rather than a genuine racial category. Most are deprived of their original culture, growing up as either slaves or outcasts even among orcish societies, though some will rise to power and greatness thanks to their Alfallen bloodline. Still, they all seem to retain the burning determination of an orc combined with the passionate nature of humanity.

You gain the **Relentless Endurance** and **Darkvision** racial features. Your speed is 30 feet, and your size is Medium.

Human & Half-Elf

Humans are the most common Alfallen races, comprising the vast majority of pact-makers and their descendants. Most attempt to conceal their mixed heritage, preferring not to face persecution or estrangement due to the decisions of their ancestors. Others are less fearful, choosing to embrace their strange bloodline. Half-elves whose lineage is touched by the Alrisen manifest traits very similar to those of humans, losing their fey heritage, though their appearance is slightly different and they retain the extended lifespans of their elven kin. Many who have strong ties to the Alrisen often find themselves drawn once again to the same powers as those their ancestors once sought, seeking to right the wrongs done against them, discover their past, or write a new chapter in their lives.

You gain proficiency in two skills of your choosing and one language of your choosing. Your base walking speed is 30 feet, and your size is Medium.

Tiefling

Tieflings are among the most unusual of the Alfallen races, for their fiendish bloodlines provide them a substantial amount of magical power already. While many retain the horns, tails, and scarlet skin of a fiend, others find themselves more easily warped by the influence of the Alrisen, seeing their fiendish traits overridden by the equally exotic appearances of the Alfallen. This vulnerability to the influence of the Alrisen, combined with their exotic appearances, makes them outcasts in all but the most welcoming communities. Individuals who would be born tieflings but have their fiendish heritage entirely purged by the influence of the Alrisen would often be classified under the human, elvish, halfling, or dwarvish racial origins instead.

You gain the **Infernal Legacy** racial feature or an equivalent variant Legacy. Your base walking speed is 30 feet, and your size is Medium.

Racial Balance

Using the Detect Balance (DB) scale, each racial origin accounts for ~6-7 points worth of features. The Alfallen races are designed to account for ~20 points of features, keeping the grand total in line with the standard set of races. If you'd like to include a different race other than the ones described here, use the DB scale to calculate a similar amount of points from that race's list of racial features when creating a new racial origin. Avoid offering ability score modifications or other simple numeric bonuses when doing so.

OPTIONAL RULES

The following section contains a number of optional rules that your group may choose to use during gameplay. These rules are intended to highlight different facets of the game experience and to provide methods for dealing with situations and requests that may arise. Note that these rules are optional for a reason: they are not intended for every group to use, nor appropriate for all scenarios. After each rule is a short discussion detailing how this may impact gameplay and why you may choose to implement the rule. Players, if you are denied the use of one or more of these rules, please accept the benevolent intentions behind the denial and comply with the request. If you don't trust your group, you won't enjoy playing with them, so address issues immediately when they arise.

OPTIONAL RULE: LONG DAYS

The GM can declare a long day at any point during play. When they do, consult your character sheet and determine any and all features, spell slots, or class resources that recharge whenever you finish a short or long rest. You gain additional uses of these features equal to the amount that you would have after finishing a long rest, effectively doubling them. This does not apply to hit dice, hit points, or to any features that recover only on a long rest or by another mechanic. No character can recover uses of features that recharge on a short or long rest until after they complete a long rest. They can still spend hit dice to recover hit points during short rests. A long day applies only until you complete a long rest.

INTENTION OF THIS OPTIONAL RULE

Many character classes, such as fighters, warlocks, and monks gain much of their power and utility from the ability to recover essential resources when they finish a short rest. During adventuring days where there is only going to be a single challenging encounter, character classes like wizards, clerics, and barbarians have a distinctive advantage because they are designed with the question of conserving resources in mind. When there's only one fight, they have no reason to conserve resources, and can perform at a higher level than classes that have smaller, more easily recovered abilities. Therefore, if your group has only 1-2 combat encounters each day, it may be beneficial to use the long day rule to make the warlocks and fighters of the group function at the same level as the other classes. Effectively, you've doubled the amount of spell slots a warlock has, the ki points a monk would have, and any other features that any class would have available to it on a short rest basis, such as Channel Divinity or Wild Shape. This allows your group to have singular, climactic encounters with more powerful foes, but makes the party less effective if the adventure has many opportunities to rest. This typically increases the power of classes that rely on short rests in these games, so be sure of the consequences of declaring a long day.

BARGAIN OF THE ARCHIVIST

OPTIONAL RULES FOR AN INTELLIGENCE-BASED WARLOCK

Some patrons, such as the Keeper of the Depths and Accursed Archive are particularly suited to a more intelligent warlock, but any of them can be appropriate if you've talked with your group about how this may be implemented.

These rules are designed to enable you to play a warlock that is based on Intelligence as the primary ability score for the class instead of Charisma.

Wizards beware – the warlock is entering your domain with secrets once thought forgotten.

SAVING THROWS

Your saving throw proficiencies become Intelligence, Wisdom instead of Charisma, Wisdom when you select this class at 1st level.

SPELLCASTING ABILITY

Intelligence is your spellcasting ability for your warlock spells, so you use your Intelligence whenever a spell refers to your spellcasting ability. In addition, you use your Intelligence modifier when setting the saving throw DC for a warlock spell you cast and when making an attack roll with one.

CLASS FEATURE AND INVOCATION ALTERATION

Whenever a warlock class feature or an Eldritch Invocation references your Charisma modifier, you must use your Intelligence modifier instead of your Charisma modifier.

INTENTION OF THE OPTIONAL RULE

Intelligence is an ability score that many groups find less useful than other ability scores. Wizards and subclasses based around the wizard spell list are among the only ones that rely on it for anything other than skills. There are very few spells that target Intelligence saving throws, so it isn't very useful from a defensive standpoint. Additionally, Charisma is essential for four core classes, while Intelligence only boasts one. Shifting your warlocks to rely on Intelligence helps to shift their role away from social prowess into intellectual study, and can provide diversity in party abilities from that perspective. It should have a negligible effect on the overall strength of the class in gameplay.

BARGAIN OF THE PRIEST

OPTIONAL RULES FOR A WISDOM-BASED WARLOCK

Some patrons, such as the Storm Lord, Ashen Wolf, Eternal Citadel, Forgotten Graveyard, and Warrior-Saint are particularly well suited for a warlock who relies on Wisdom, but many of them can be suitable if you've talked with your group about how this may be possible.

These rules are designed to enable you to play a warlock that is based on Wisdom instead of Charisma as the primary ability score for the class.

Clerics and druids should stand aside, for the darkest of gods and spirits once thought forgotten have returned.

CLASS SKILLS

The warlock class skill list is replaced with the following one: Animal Handling, Arcana, Insight, Medicine, Nature, Religion, Survival.

SPELLCASTING ABILITY

Wisdom is your spellcasting ability for your warlock spells, so you use your Wisdom whenever a spell refers to your spellcasting ability. In addition, you use your Wisdom

modifier when setting the saving throw DC for a warlock spell you cast and when making an attack roll with one.

CLASS FEATURE AND INVOCATION ALTERATION
Whenever a warlock class feature or an Eldritch Invocation references your Charisma modifier, you use your Wisdom modifier instead of your Charisma modifier.

INTENTION OF THE OPTIONAL RULE
The relationship between warlock and otherworldly patron varies dramatically. When a warlock casts spells using their Charisma, they are effectively saying "This is my power. It is inherent to my soul. I have purchased it, and it is now separate and distinct from any other. When I grow in power, I may learn from my patron, but even if my patron were gone, I would still be able to grow and advance."

Wisdom implies a connection to an external force in most cases. Clerics have a direct connection to their god, and if they were rejected by their deity for some reason, then they would need to find a new one to grant them their abilities. Druids have a similar connection with nature, calling upon it and channeling its power through them. If your warlock has a similar, directly subservient relationship with their patron, it may be fitting to have them use Wisdom instead of Charisma to represent this distinctive change. Note, however, that this is not always appropriate from a gameplay perspective. Wisdom is a more valuable ability score when it comes to saving throws, which makes the warlock somewhat more powerful. While in most cases it should have a limited effect on gameplay, think carefully before allowing this rule.

NEW FEATS

This section contains a collection of feats, which are an optional rule that your group may allow. Whenever your class would grant you an ability score increase, you can choose to take a feat instead. You must meet all the prerequisites for a feat in order to select it.

Eldritch Marks represent smaller, less direct pacts with the Alrisen. Agreements, rewards, and even curses could be defined using these marks, and they may come with additional stipulations or requests. Some are spiritual, but others may involve physical changes or actual marks.

MARK OF THE ACCURSED ARCHIVE
You have been touched by the ruinous power of the Accursed Archive, and its secrets have granted you power. You gain the following benefits:
- Whenever you reduce a creature to 0 hit points, you can use your reaction to unleash a bloodcurdling scream. Choose a creature that you can see within 30 feet of you that can hear you. The target must make a Wisdom saving throw against DC 8 + your proficiency bonus + your Charisma modifier. If they fail, they are frightened until the start of your next turn.
- You can cast *dark secret** once without expending a spell slot. Charisma is your spellcasting ability for this spell. You can't do so again until you finish a short or long rest.

MARK OF THE ASHEN WOLF
You have been scarred by the power of the Ashen Wolf, and its fiery might burns within your soul. You gain the following benefits:
- Whenever you cast a spell that deals damage, you can choose to have it deal fire damage instead of the normal type.

- You can cast *hunter's pace** once as a 2nd-level spell without expending a spell slot. Charisma is your spellcasting ability for this spell. You can't do so again until you finish a short or long rest.

MARK OF THE BLACKTHORN GROVE
You have been blessed by the Blackthorn, and it grants you strength and cunning. You gain the following benefits:
- Whenever you are adjacent to a corpse, you can touch it as an action to remove its heart. While you are holding the heart of a creature, you can crush it as a bonus action to gain advantage on your next attack roll or ability check.
- You can cast *heartripper** once without expending a spell slot. Charisma is your spellcasting ability for this spell. You can't do so again until you finish a short or long rest.

MARK OF THE CURRENCY CONSPIRACY
You've been marked as a person of interest by the Conspiracy, though you may not know it. You gain the following benefits:
- While you are holding an item, you can mark it with an invisible rune as a bonus action. While the item is marked and on the same plane as you, you always know the direction and distance to it. The rune can be removed as an action by any creature that can see it.
- You can cast *sinister threat** once without expending a spell slot. Charisma is your spellcasting ability for this spell. You can't do so again until you finish a short or long rest.

MARK OF THE ETERNAL CITADEL
You've stood within the radiant light of the Eternal Citadel, and it has granted you power. You gain the following benefits:
- Whenever you are within 10 feet of a friendly creature and it takes damage, you can use your reaction take the Search action and then move up to 30 feet towards the source of the damage if you can perceive it.
- You can cast *lesser restoration* once without expending a spell slot. Charisma is your spellcasting ability for this spell. You can't do so again until you finish a short or long rest.

MARK OF THE FALLEN EXILE
You've been marked by the Exile, causing the stars themselves to regard you with interest. You gain the following benefits:
- While you can see the sky, you can use your bonus action to emit bright magical light in a radius of 60 feet, and dim light in a radius of 60 feet beyond that. The light continues to emit from you until you dismiss it as a bonus action or you go to a location where you can't see the sky.
- You can cast *augury* once without expending a spell slot. Charisma is your spellcasting ability for this spell. You can't do so again until you finish a short or long rest.

MARK OF THE FORBIDDEN GRAVEYARD
You've stood on the border between life and death, and the experience has marked you. You gain the following benefits:
- Whenever you are reduced to 0 hit points, spectral apparitions surround you and strike out at your foes. Each hostile creature within 20 feet of you takes necrotic damage equal to your character level.
- You can cast *suffer** once without expending a spell slot. Charisma is your spellcasting ability for this spell. You can't do so again until you finish a short or long rest.

MARK OF THE GELATINOUS ONES

You've been touched by the wiggly ooze of the Convocation, and it has marked you. You gain the following benefits:

- As an action, you can touch an object and coat it in thick adhesive slime. The next time that object touches another object, it becomes bound to it as though by strong glue. The glue can be broken if a creature uses its action to make a Strength check with a DC equal to your Charisma score. Once broken, the glue vanishes.
- You can cast *enlarge/reduce* once without expending a spell slot. Charisma is your spellcasting ability for this spell. You can't do so again until you finish a short or long rest.

MARK OF THE GRAY PORTRAIT

You've created an artwork of incredible skill, marking yourself among the great artists. You gain the following benefits:

- Whenever you create an artwork, you can choose to imbue it with a figment of motion. The art will move realistically as though alive, following a pattern that you have predetermined upon its creation.
- You can cast *mirror image* once without expending a spell slot. Charisma is your spellcasting ability for this spell. You can't do so again until you finish a short or long rest.

MARK OF THE KEEPER OF THE DEPTHS

Your flesh has been marked by the eldritch tentacles of the Keeper of the Depths. You gain the following benefits:

- You can breathe normally in water, and you gain a swimming speed equal to your walking speed. If you already have either of these benefits, your swimming speed is doubled.
- You can cast *devilish hunt** once without expending a spell slot. Charisma is your spellcasting ability for this spell. You can't do so again until you finish a short or long rest.

MARK OF THE PERFECT CHORD

You are blessed by the eternal song of the Perfect Chord, for it has marked your soul. You gain the following benefits:

- Whenever you cast a spell, you can choose a 5-foot cube within 30 feet of you. Until the start of your next turn, the area within that cube is magically silenced.
- You can cast *shatter* once without expending a spell slot. Charisma is your spellcasting ability for this spell. You can't do so again until you finish a short or long rest.

MARK OF THE SERPENT EMPRESS

You bear the imperial mark of the Empress, either willingly or as a curse. You gain the following benefits:

- Whenever you take damage from a spell, you can use your reaction to reduce the damage you take by an amount equal to 1d6 + your character level.
- You can cast *command* once without expending a spell slot. Charisma is your spellcasting ability for this spell. You can't do so again until you finish a short or long rest.

MARK OF THE SHADOWCAT

Your nightmares now bow to you, for the Shadowcat's mark is upon your soul. You gain the following benefits:

- Whenever you take the Hide action and successfully become undetected, you can move normally up to 30 feet before losing the benefits of being hidden.
- You can cast *duskwalk** once without using a spell slot. Charisma is your spellcasting ability for this spell. You can't do so again until you finish a short or long rest.

MARK OF THE STORM LORD

Your flesh has been scarred by the thunderous power of the Storm Lord. You gain the following benefits:

- Whenever you cast a spell as an action, you gain the benefits of the Dash action, and your jumping height and distance are doubled until the start of your next turn.
- You can cast *feather fall* once without using a spell slot. Charisma is your spellcasting ability for this spell. You can't do so again until you finish a short or long rest.

MARK OF THE WARRIOR-SAINT

You have been blessed by the Warrior-Saint, as it has noted your devotion to balance. You gain the following benefits:

- Whenever you are hit with a melee attack, you can use your reaction to push your attacker 10 feet directly away from you. Creatures more than one size larger than you are immune to this effect.
- You can cast *detect interference** once without using a spell slot. Charisma is your spellcasting ability for this spell. You can't do so again until you finish a short or long rest.

MARK OF THE WEAVER OF LIES

Your regrets have led you to the Weaver, and it has marked you as one of its own. You gain the following benefits:

- Whenever you are disguised, you can choose to magically alter your speech and voice to be perfectly suited to your role. This cannot be detected without the use of magic.
- You can cast *falling spider's spite** once without using a spell slot. Charisma is your spellcasting ability for this spell. You can't do so again until you finish a short or long rest.

MARK OF THE WILD HUNTSMAN

Your prowess has been noted by the Wild Huntsman, and it has marked your flesh in turn. You gain the following benefits:

- Whenever you move at least 20 feet during your turn before making a melee weapon attack with advantage, you can choose to make the attack without advantage. When you do and the attack hits, the target is knocked prone.
- You can cast *wolfbane trap** once without using a spell slot. Charisma is your spellcasting ability for this spell. You can't do so again until you finish a short or long rest.

I've heard of a human who had eight of these marks. I think they might be a few sparks short of a bonfire, if you know what I'm saying. Guess the Chord wasn't enough in their head, so they started a whole collection to go with it. -X

You're not much better, chair-eater!
—Sylvette

ELDRITCH INVOCATIONS

NEW INVOCATIONS

The following section contains new eldritch invocations for the warlock class. These invocations are available regardless of the warlock's chosen patron, unlike those presented in the previous sections. Remember that the level prerequisite refers to the character's warlock level, not their character level.

AWAKENED INSIGHT
Whenever you cast a spell using a warlock spell slot, you gain advantage on the first ability check you make before the end of your next turn.

BARRED MIND
Whenever you make a Wisdom saving throw and succeed, your mind locks shut. If the same creature or effect forces you to make another Wisdom saving throw before the end of your next turn, that saving throw is made with advantage.

BLADE EMPOWERMENT
Prerequisites: Pact of the Blade feature

As a bonus action, you can empower your pact weapon with eldritch energy. The first time you hit a creature with an empowered pact weapon before the start of your next turn, it takes additional force damage equal to half your warlock level and if the attack was a critical hit, the target is knocked prone.

BROKEN DREAMS
Prerequisites: 18th level

Once during a rest, you can cast *dream* without expending a spell slot. Casting this spell does not interfere with your rest.

CAPTURED HEART
You gain advantage on attack rolls targeting creatures that you have charmed. If you attack a creature you have charmed, it can't take reactions until the end of your next turn.

COMPENDIUM OF FORGOTTEN SECRETS
Prerequisites: Pact of the Tome feature

You are aware of the presence of any Alrisen upon the same plane as you, and you have learned the relationships that they may have with one another. You are instantly aware if any of these relationships change. If you are loyal to one or more of them, you know what direction they are in, like a compass. Most Alrisen have the capacity to conceal themselves from your detection at their discretion. You also gain advantage on checks made to identify their followers, servants, slaves, or other minions.

DARK SPEECH
As an action, you can create a 5-foot cube of magical darkness at a point that you can see within 60 feet of you by speaking a phrase from a forgotten tongue. The cube lasts until the start of your next turn unless you use your action to sustain it.

ELDRITCH ANNIHILATION
Prerequisites: 18th level, Pact of the Blade feature

When you kill a creature with your pact weapon, you siphon a fragment of their essence. The next time you hit with your pact weapon, you deal extra force damage equal to your warlock level.

ELDRITCH SHAPING
Prerequisites: 5th level, eldritch blast cantrip

Whenever you cast a spell using a warlock spell slot, you can use your bonus action to collect the excess power. The next time you cast *eldritch blast*, you can choose one of the following options to replace the normal beams of energy with shaped explosions. The DC of any saving throw is equal to your warlock spell save DC.

- **Pulse:** You unleash a pulse of eldritch energy in a 10-foot radius around you. Target a number of creatures that you can see in the area equal to your number of *eldritch blast* beams. Each creature must succeed on a Dexterity saving throw or be struck by one beam.
- **Shockwave:** You unleash a wave of eldritch energy in a 20-foot cone. Target a number of creatures that you can see in the area equal to your number of *eldritch blast* beams. Each creature must succeed on a Dexterity saving throw or be struck by one beam.

ELDRITCH SHAPING, GREATER
Prerequisites: 11th level, eldritch blast cantrip

As *Eldritch Shaping*, except you choose from the following options instead.

- **Spike:** You summon a 10-foot spike of pure eldritch energy from beneath the ground and attempt to strike a creature you can see within range. The target must succeed on a Dexterity saving throw or be struck by all the beams of your *eldritch blast* as though you were standing at the point where the spike originated.
- **Torrent:** You unleash a devastating arc of energy in a line 60 feet long and 5 feet wide. Target a number of creatures that you can see in the area equal to your number of *eldritch blast* beams. Each creature must succeed on a Dexterity saving throw or be struck by one beam.

ELDRITCH SHAPING, MASTER
Prerequisites: 17th level, eldritch blast cantrip

As *Eldritch Shaping*, except you choose from the following options instead.

- **Doom:** You channel concentrated eldritch energy into one location. Target one creature you can see within range. The target must succeed on a Charisma saving throw or be struck by all beams of your *eldritch blast*. If this attack kills the creature, you can use your bonus action to prepare another Eldritch Shape.
- **Destruction:** You unleash an web of chaotic eldritch energy. Target one creature you can see within range, and then target up to 4 other enemy creatures you can see within 30 feet of the primary target. Each secondary target must succeed on a Wisdom saving throw or be struck by one beam of your *eldritch blast*. The primary target is struck by a number of beams of your *eldritch blast* equal to the number of creatures who failed their saving throw.

EVIL EYE
As an action, you imbue your eyes with eldritch magic and glare darkly at a creature. If the target can see you, it suffers disadvantage on its next attack roll or ability check made within 1 minute.

FRACTURED SOUL
Prerequisites: Pact of the Tome feature

Your Book of Shadows is no longer destroyed when you die, and it can be used in place of your corpse to restore you to life.

GRAND EXECUTIONER'S BLADE
Prerequisites: 15th level, Pact of the Blade feature

When you summon your pact weapon, you can use your bonus action to cast a spell of 1st level or higher with a casting time of 1 action. If you do, you gain advantage on the next attack made with your pact weapon.

GRAND OCCULTIST'S TOME
Prerequisites: 15th level, Pact of the Tome feature

Whenever you cast a cantrip, you can use your bonus action to bolster yourself with a defensive aura of swirling eldritch energy. Until the start of your next turn, when a hostile creature enters a space within 5 feet of you, you can use your reaction to detonate the aura to push the enemy up to 10 feet directly away from you.

GRAND SUMMONER'S CHAIN
Prerequisites: 15th level, Pact of the Chain feature

Your control over your familiar increases. When you finish a short or long rest, you can cast *find familiar* as an action without expending a spell slot or using material components..

HIDDEN POCKET
As an action, you can touch one unattended nonmagical object that weighs less than 30 pounds, such as a shield, gemstone, or glaive. The object disappears into a hidden pocket dimension. As an action on a subsequent turn, you can access this pocket dimension to retrieve the item. You can have only one item stored at a time, and an item that is under the effects of a magical spell or effect cannot be stored. If you die or are reduced to 0 hit points, the item exits the pocket dimension and falls to the ground in your space.

INDESCRIBABLE FORM
Prerequisite: 18th level

Your form is no longer bound by the laws of reality. As an action, you can choose to appear as any creature or object that is Small or Medium, such as a dog, a mass of floating lights, an idealized version of yourself, or a simple wooden crate. No matter what appearance you choose, your statistics and capacity for action are the same. This appearance is a physical change, but magic that allows others to discern the true form of shapeshifters will reveal your normal appearance. This appearance lasts until you choose to change it again.

LIMITLESS WEAPON
Prerequisite: Pact of the Blade feature

While you have this invocation, you gain the ability to modify your pact weapon with greater ease. If your pact weapon is an attuned magic weapon, rather than one you've created, you can shift its form to any weapon you could normally create using your Pact of the Blade feature when you summon it. Additionally, you can apply the benefits of any invocation that requires you to create your pact weapon, such as Butcher's Quill or Scorched Blade, as long as it is in the appropriate form to meet that invocation's requirements.

SACRIFICIAL DEMISE
Prerequisites: 6th level, Pact of the Chain feature

As an action, you can cause your familiar to sacrifice itself in an explosion of eldritch power. Choose any damage type that the familiar can inflict with an attack. Creatures within 20 feet of your familiar must make a Dexterity saving throw against your warlock spell save DC. If they fail, they take 1d6 damage of the chosen type per two warlock levels you possess or half as much if they succeed.

SECRETIVE SPEECH
You can choose to speak in an otherworldly tongue. When you do, the only people who can understand you are those you choose, even if they speak a different language. To others, this speech sounds like the ramblings of a lunatic, a chittering beast, or undiscernable whispers, depending on the volume.

SERVANT TO THE MASTER
Prerequisite: 5th level, Pact of the Chain feature

Your familiar gains additional hit points equal to your warlock level. It gains a bonus to attack and damage rolls equal to half your proficiency bonus, and the DC for any saving throws it provokes increases by an equal amount. The hit points gained from this invocation stack with those gained through other invocations.

TERRIFYING VOICE
Prerequisite: 18th level

Whenever you speak, you can use an action to project your will toward a creature you can see who can hear you. The target must make a Wisdom saving throw against your warlock spell save DC. If they fail, they are frightened of you until the end of your next turn.

TWINNED BLADES
Prerequisite: Pact of the Blade feature

You gain access to a second pact weapon, and you can summon both whenever you would summon one of them. When you engage in two-weapon fighting using both your pact weapons, you can add your ability modifier to the damage of the bonus attack.

VEIL OF SORROW
Prerequisite: 18th level

If an allied creature you can see is reduced to 0 hit points, you can use your bonus action to channel your emotions into an eldritch storm. Target up to 10 creatures you can see within 60 feet of you. They each take psychic damage equal to your warlock level and must make a Wisdom saving throw against your warlock spell save DC. Any who fail are knocked prone and frightened of you until the end of your next turn. Once you use this invocation, you can't use it again until you finish a short or long rest.

WRETCHED MARK
Prerequisite: 18th level, the ability to inflict a curse on another creature using a spell or class feature

When a creature cursed by you who you can see makes an attack roll, you can use your reaction to impose disadvantage on the roll. If the attack hits, the cursed creature takes 2d10 psychic damage.

MASTER THE ALRISEN
EXPANDING YOUR WORLD

When implementing the Alrisen in your world, you have many choices to make. The first, and possibly the most difficult, is choosing which Alrisen to allow into your domain. An obvious choice is to ask your players which ones they'd like to be directly associated with, in order to ensure that they are able to make a pact with that particular entity. However, if you're interested in going beyond this, here are some things you'll want to consider and delve into:

POWER OF THE ALRISEN

When choosing your Alrisen, consider how powerful you'd like them to be, especially in relation to the characters. If a player is interested in a revenge story where they are able to best and slay their former patron, you may want to ensure that their chosen patron is actually within their power, or will be at some point within the game. You could have the Alrisen be relatively weak, and have their defeat be a turning point in the character's development, or you could have them be incredibly powerful, and make defeating one the purpose of an entire campaign.

RELATIONSHIPS OF THE ALRISEN

There are numerous possible ways to implement multiple Alrisen and how they will interact with one another. The next section covers what you'll need to consider and gives some insight on how the Alrisen may be inclined to behave under certain conditions.

NUMBER OF ALRISEN

When including the Alrisen in your world, it may be tempting to include the entire set! Think carefully before you do this, as these entities are often very significant. For example, if you have the Weaver of Lies, the Currency Conspiracy, the Keeper of the Depths, the Serpent Empress, and the Accursed Archive all present within one game world and equally active, your plot may rapidly become an endless series of mysteries, tricks, traitors, scheming, and political maneuvering. If that's what you want, great! If you're wary of introducing this many conflicting motivations into your game, you may want to stick to having only a few be present or active at a given time.

COMBINING ALRISEN

One unorthodox way around the issue of having so many patrons is to combine two or more of them together into a singular entity. This means that they'd have only one goal, and would enable you to use them with a greater amount of precision and finesse rather than having dozens of conflicting threats floating about in your world. Here are some simple combinations that could very easily help keep your Alrisen easy to manage.

- **The Sunsworn Rider:** A combination of the Wild Huntsman, Ashen Wolf, and Fallen Exile, this entity could travel across the world to maintain the balance of the seasons, bring light to the darkness, and give mortals a connection to the heavens above.

- **The Wretched One:** A combination of the Serpent Empress, Weaver of Lies, and Accursed Archive, this entity would gradually destroy all that was filled with light, goodness, and hope in a mad quest to rule over all mortal races by killing the divines above.

- **The Border Monument:** This combination of the Accursed Archive, the Eternal Citadel, and the Forbidden Graveyard would capture the three aspects of mankind: Mind, Body, and Soul, and their capacity for creation and destruction. It could dwell beyond the planes, accessible through meditation, training, and the study of the eldritch arts.

- **The Hungering Dark:** A combination of the Weaver of Lies, the Shadowcat, and the Ashen Wolf, this entity could be born of a cruel hunger, using deception and flame to create nightmares on which it may feed.

- **The Artist of Ages:** A combination of the Perfect Chord, Gray Portrait, and Eternal Citadel, this entity could instruct talented creators in secrets thought forgotten, and request that they discover new ones in exchange.

- **The Dreamtaker:** A combination of the Keeper of the Depths, the Shadowcat, and the Fallen Exile, this entity could have control over all things that happen in the dark of the night, creating dreams and replacing them with wonderful nightmares.

- **The Lord of War:** A combination of the Warrior-Saint, the Ashen Wolf, and the Wild Huntsman, this burning soldier could ride across the planes on a flaming beast, bringing chaos and death wherever there is peace and life to bring balance to the universe.

- **The Guardian of Eternity:** A combination of the Eternal Citadel and the Warrior-Saint, this champion could roam between the worlds bringing justice and order.

- **The Slithering Slime:** A combination of the Gelatinous Convocation and the Serpent Empress, this giant coil of ooze wiggles across the multiverse, consuming and ruling all in its path.

- **The Cosmic Mercenary:** A combination of the Warrior-Saint and the Currency Conspiracy, this living weapon enforces debts and payments throughout the universe.

- **The Sky Queen:** A combination of the Serpent Empress and the Storm Lord, this monarch rules over a flying city that roams between the worlds, conquering and raiding.

- **The Soultaker:** A combination of the Forbidden Graveyard and the Storm Lord, this entity destroys civilizations and collects souls for an unknown purpose. Those that choose to obey it will return to life, fighting in its name.

- **The Blackened Heart:** A combination of the Blackthorn Grove, the Shadowcat, and the Weaver of Lies, this eldritch nightmare enters the dreams of sleeping mortals to steal their love and leave them cold and hollow. It offers them the power to take back their life, but only in exchange for dark and terrible deeds.

- **The Burning Tree:** A combination of the Ashen Wolf and Blackthorn Grove, this spirit represents the harmony of growth and destruction present in nature.

Relationships Between The Alrisen

While mysterious, all Alrisen have goals that require them to interact with the mortal world in some way. This will often lead to them interacting with one another, often in conflict but occasionally in alliance. This section explores some of the possible relationships between certain sets of Alrisen, and how you could use these to your advantage.

The Accursed Archive & The Eternal Citadel

If there are any Alrisen that are enemies by nature, then the Archive and Citadel must surely be the first example. The Archive is dedicated to ruin, and the Citadel is dedicated to preservation. If you'd like to highlight this relationship, consider having the Archive be located inside the Citadel, with the latter acting as a guardian and counterbalance to the destructive nature of the former. It would be difficult to cast them as allies, but if you were inclined to, you could have them acting in concert to give life to mortal races or to create new worlds from the elemental matter of the universe.

The Accursed Archive & The Fallen Exile

Strong, passionate desire makes for strange bedfellows. The Archive is dedicated to ruin, and the Fallen Exile may seek to slay the sun and bring about the downfall of the other stars. The secrets to do so may be hidden within the Archive, but the arts required for such a magnitude of destruction are nearly impossible to discover, let alone master. A warlock of the Exile may seek the Archive in their hunt for these powers, looking for information on artifacts and forces that may be able to bring about this event. Alternatively, an archivist may seek the Exile, offering it the secrets it craves in exchange for fulfilling the ruinous intentions of the Accursed Archive.

The Accursed Archive & The Keeper of the Depths

The Archive is a place of written knowledge and information stored for the purpose of destruction, but the Keeper of the Depths is not interested in ruin, and has little respect for secrets so mundane that they can be written and cataloged. Instead, it seeks to find and collect both objects and mysteries that are beyond this understanding. However, its collection draws the attention of many archivists, who often desire to claim these secrets and turn them to foul purposes. Thus, the Keeper and the Archive are often at odds, engaging in a struggle hidden from the light of day and from the other Alrisen. If the Keeper was somehow persuaded to cooperate, it may spell the doom of countless worlds.

The Accursed Archive & The Serpent Empress

The Empress reigns with supreme power within her domain, and she constantly seeks to expand to new lands and conquer new peoples, turning them into imperial subjects and slaves.

The Accursed Archive is both a valuable asset and a deadly threat to her rule, as ruin makes little differentiation between the powerful and the weak in the grand scheme of things. The eldritch knowledge that it holds would prove invaluable in her quest to conquer the infinite worlds, but the dangers that the Archive holds are perilous indeed. Thus, she may send her warlocks in search of the Archive, hunting for the rituals and rites that would align the stars in her favor.

The Accursed Archive & The Weaver of Lies

The Archive is a place of dark truths and unwelcome revelations. Thus, it is antithetical to the Weaver of Lies, who would despise such a place with every fiber of its being. The concept of a location that it cannot reach holding truths that it cannot taint or corrupt or twist into deceptions would be maddening to the ancient horror, and its twisted machinations often turn towards the destruction of the Archive and its servants. A world that has been completely destroyed is not a world that the Weaver can pervert from its good purpose, nor one with the opportunity for falsehood and deceit. In that regard, the Weaver will send servants to hunt and assassinate those that have been touched by the Archive. If there was another way, however, to change this seemingly-untouchable place, then the situation might be different. The discovery of an artifact or ritual that would allow the Weaver to fill the Archive with tomes of trickery and books of bald-faced lies would make the nightmarish spider grin with glee and wicked intent. All it would need to do is find a way to destroy the Silent One, and its plan could be set in motion.

The Ashen Wolf & The Blackthorn Grove

The Blackthorn Grove is a massive heart, pulsing with the blood of the countless wanderers who have died within and brimming with the verdant wood of an entire forest. The Ashen Wolf is a creature of hungering flame and gluttonous desire, so it would likely wish to consume this massive source of eldritch power in a fiery inferno that would scar the planes forever. Finding the Grove would be nearly impossible for the Wolf alone, however, as it desires to continue to live and burn and would never be persuaded otherwise. Thus, it must seek the help of a mortal to find this unearthly place, tormenting a soul until they are broken enough to seek the Grove on their own and then following in their footsteps. This story would likely end poorly for both, but if the Blackthorn offered itself willingly and fed the Ashen Wolf an eternally-rejuvenating meal, then perhaps they could find peace, and the world could be saved from the Wolf's ever-growing hunger.

The Ashen Wolf & The Wild Huntsman

The Ashen Wolf represents a primal, elemental thing that burns and consumes, taking dark pleasure in its nature. The Wild Huntsman, however, represents the dominance of mankind over the beasts of the natural world. Combined with their opposing elements, they make for natural enemies. The Huntsman will pursue the Wolf, chasing it across the land and the planes in an attempt to defeat it. The Ashen Wolf and Wild Huntsman are equally matched in power in most worlds, leading the pair to fight to a standstill when they clash. Thus,

they call upon their warlocks and servants to do battle in their aid, in an attempt to tip the tide against their mortal foe.

Ashen warlocks prowl the night, burning the homes of their adversaries and concealing themselves within the forests. The frozen riders will break camp on moonlit nights to let loose the hunting hounds and drive back the emberborn that lurk in the darkness beyond, unleashing blasts of ice and bearing frosted spears of black iron. The hounds bay, the wolves howl, and the war between fire and ice will rage on.

However, if the two were to somehow put aside their differences and come together out of mutual respect, rather than that of a master and a beast, there is no telling what they could kill. Fiends may pose a challenge, but the fire within the Ashen Wolf burns hotter than even the furnaces of the hellish hordes. Fey creatures could fight, but the cold iron of the Wild Huntsman's frozen riders would make short work of their enchanted armies. The pair would ravage across the world, leaving burning cities wrapped in a blanket of snow. Their warlocks together would make a fearsome foe, acting with the strengths of both mortals and beasts alike.

THE BLACKTHORN GROVE & THE FALLEN EXILE

The Exile is a passionate soul, filled with spite and desire for the return of its love. The Blackthorn Grove is a place where apathy ends and a new journey begins, but only if one is willing to suffer further. Thus, they would seem to be natural compliments. A forlorn wanderer who would be about to enter the Maze of Blood might be greeted by the Exile on a moonless night and told of the plight of the fallen star. If the story moves the mortal into agreeing to help and accept the pact, giving them purpose, then they are saved from having to brave the darkness of the Grove. If they refuse the star's bargain and instead venture within, and are successful in their quest to reach the heart of the Grove, then their reawakened passions may lead them once more into the Exile's service, offering to help with their newfound power in exchange for friendship and advice on their journey. If the Grove sees this predation as a threat, however, things may not go as well. The Exile has a glorious heart, no matter how metaphysical that organ may be, and the Grove is a collector of hearts first and foremost. To kill a star would be difficult, but nature always finds a way.

THE BLACKTHORN GROVE & THE STORM LORD

The Storm Lord is a bringer of cataclysmic change and a herald of destruction, collecting the souls of heroes as it travels the planes. The Blackthorn Grove gives new life and new purpose to those consumed by apathy, and is thus a fantastic source of heroic souls. The Storm Lord would easily be interested in this, and may instruct its acolytes to watch for those who have survived the trials within, inviting them to join forces. As the shadowy cults of the Storm Lord often bring rebellion and upheaval to kingdoms and countries, so to do the dispossessed souls who have entered the Grove. They are natural allies.

Not all interactions are so pleasant, however. The Storm Lord's demands and majestic might could easily turn its attentions to the destruction of the Grove's warlocks if they have not shown the proper respect, as the Grove itself offers little protection from the attentions of other Alrisen. If that were the case, the Grove would be severely outmatched.

THE CURRENCY CONSPIRACY & THE FALLEN EXILE

The Exile and the Conspiracy would seem an unlikely pair, for while one desires divinity, the other despises their possession of it. Their goals could align, however, and if they somehow did, then it would seem like a deadly combination. If the Exile was able to recruit more servants to its cause by keeping them unaware to its true intentions by utilizing the memory-magic of the Currency Conspiracy, then its quest would go that much more smoothly. If all of those agents were well-funded, and spreading their false currency across the world, then the final act of the Conspiracy's plan would likely happen sooner than one might think.

THE CURRENCY CONSPIRACY & THE WARRIOR-SAINT

The Currency Conspiracy's methods include the end of mortal life on their world, while the Warrior-Saint is a justiciar dedicated to maintaining that life and preserving mortal freedom of choice from the influence of other cosmic forces. Thus, their conflict is inevitable. The Warrior-Saint may be unaware of the Conspiracy, thanks to their powerful but subtle magic, or it may have begun to suspect the Cabal's dark plan. It would seem impossible for them to be allies, but if the Conspiracy were to somehow trick this all-seeing judge, then their plans could be set in motion all the easier. If they were betrayed by one of their own, however, then the Warrior-Saint would be the most effective ally in the fight against a group of deceptive conspirators.

THE ETERNAL CITADEL & THE GRAY PORTRAIT

The Eternal Citadel is dedicated to preservation, and the Gray Portrait is certainly an art form that is aligned to that ideal. A warlock of the Portrait would be of much use to the Citadel, provided they could be turned to less self-serving deeds. Similarly, an artist of the Portrait would likely find the Citadel greatly intriguing, from the standpoint of one interested in the spectacle of that radiant place and as one who seeks personal fame and immortality.

THE ETERNAL CITADEL & THE SERPENT EMPRESS

The relationship between a tyrant who invades across the cosmos and that of a structure dedicated to maintaining all that exists is a mixed and intriguing one. On one hand, the Citadel's guardians would be well-suited to preventing the spread and growth of the Empire's domain, as their mastery over the arts of siege warfare makes them invaluable in that struggle. On the other hand, the Citadel would also seek to preserve the imperial hierarchy and prevent destructive rebellions within the domain of the Empress. Thus, the Empress would likely seek some way to control this fortress, though where she might send her servants to seek it is unpredictable. If there was a way to align them both, then the entire universe would likely be threatened by an immortal tyrant appearing on every plane in a fortress that cannot be breached by even the gods themselves. Only true heroes could stand against such a threat, and their victory is not assured.

THE ETERNAL CITADEL
& THE WARRIOR-SAINT

The Eternal Citadel's pursuit of preservation aligns easily with the goals of the Warrior-Saint in many cases. The Saint's desire to prevent the imbalance between the different cosmic forces would often cast it as an ally to preservation of the world, but things are not quite as simple. If there is no change, then the balance between absolute law and complete chaos would shift towards that of order, leaving the world stagnant and removing the freedom that one would need to live a true life. Thus, the Saint may oppose the Citadel on occasion, when the world becomes static and entirely too controlled by this singular force of radiant light.

THE FALLEN EXILE &
THE FORBIDDEN GRAVEYARD

The Fallen Exile seeks to bring back its lost love, and so it could direct its friends to seek out the mysteries of the Forbidden Graveyard. If that's the case, then it's possible that their warlocks may align or conflict over the secrets held within. This mysterious place on the border of life and death holds many secrets desired by priests and necromancers alike, but the cost of entry is high and the price one may pay within is higher still.

THE FALLEN EXILE &
THE KEEPER OF THE DEPTHS

The Keeper despises the light of the sun, and cannot stand the miserable rays from above. The Exile's plan to destroy this tyrant may deeply please the Keeper, and it might offer its secrets to those who serve the Exile. All things come at a price, however, for the Keeper is not known for generosity. It's desire for a lightness world is one born from spite, rather than well-founded logic. Such thoughts are often alien to the horror, and this may not appeal to the passion of the Exile. In that case, then a fallen star would certainly make for a delightful addition to the Keeper's collection, if it could be caught.

THE FALLEN EXILE &
THE WEAVER OF LIES

The Weaver of Lies desires to destroy truth, and the Exile would make a perfect tool in its cruel quest. If the Weaver learns of the Exile's desires, it would likely attempt to fashion a false love for the Exile, catching it in a web of deception and turning it towards whatever goals the nightmarish spider sees fit. If the Exile succeeds in killing the other stars, then a world shrouded in darkness would be perfectly fitting for the Weaver's plans. However, if the Exile learned of the trickery and discovered that its love was false, then it would surely turn against the Weaver with every force that it could muster.

THE FORBIDDEN GRAVEYARD &
THE GELATINOUS CONVOCATION

The Convocation consumes the body to claim the memories of the dead, but the Graveyard exists to contain those who may seem dead and yet are not quite there yet. Thus, the servants of the Convocation may conflict with those who have sealed the Gate of Souls, seeing them as cheaters and miscreants who aren't playing by the rules of life and death. They may fight, trying to claim what they consider to be rightfully theirs, or they may be persuaded to simply accompany the new warlock of the Graveyard until they die as they were supposed to. Either way, the Convocation gets its due.

THE FORBIDDEN GRAVEYARD
& THE STORM LORD

While the Graveyard is open to those lost souls who have yet to fully die, the Storm Lord is a tempest seeking to claim those spirits of heroic nature for its kingdom in the sky. Thus, the two are in conflict, though that conflict is often one-sided. The warlocks of the Graveyard may conflict with the Storm Lord's shadowy cults in a war hidden amongst the mausoleums and atop the ceremonial peaks where the dead are burned and buried, fighting for what they believe should be the true fate of the dead.

THE GELATINOUS CONVOCATION
& THE SERPENT EMPRESS

The Endless Empire is constantly expanding, claiming new worlds and destroying civilizations in its quest to conquer the planes. Most people think that's pretty rude. The Convocation offers a deal to those about to be conquered, granting them safety and security within a crystalline treasure hidden inside their fallen cities and giving them a chance at rebirth as oozians. For the Empress, this is terribly annoying but also an intriguing opportunity. If her legions force a civilization to the brink without destroying the structures, and they accept the Convocation's deal, then the war is instantly over and the new territory is open to the Empire's rule. However, if the crystal is found and the former inhabitants are freed, then their new power as oozians and servants of the Convocation could enable them to stage an effective rebellion. Therefore, her first order of business after seeing a civilization accept the deal is to seek the crystal and destroy it, so that her victory is assured.

THE GELATINOUS CONVOCATION
& THE WILD HUNTSMAN

There are countless immortals running around the multiverse, seeing all kinds of things and doing all sorts of stuff. The problem with immortals is that they have this funny tendency to not die. This is an issue for the Convocation, as then they'll never get to collect those rare and singular memories. Therefore, they may seek the services of the Wild Huntsman, asking it to slay an immortal whose memories they can no longer resist. Of course, the Wild Huntsman is an immortal itself, which may lead to them eventually turning their eyeless gaze to the frozen forests of the Huntsman's domain. Their servants may agree to work together, or could fight in turn. The Convocation would make an excellent prize for the Huntsman, though taking a worthwhile trophy might be a little complicated.

THE GRAY PORTRAIT
& THE PERFECT CHORD

One is an expression of the visual and physical mediums made into a masterwork beyond compare, while the other is an expression of perfect sound and captivating music. If an

eldritch artist of the Portrait were to align themselves with that of a seeker of the Chord, then the spectacle they could produce would be beyond comparison. They could craft an entire world from nothing more than illusion, and bring joy or misery as they saw fit.

The Keeper of the Depths & The Shadowcat

The Keeper of the Depths invades the dreams of others, picking over their minds for interesting secrets and filling their psyches with the thoughts and musings of an ancient monstrosity that cannot stand the light of day. The Shadowcat is another such entity that deals with dreams, though it is only interested in a single kind. The nightmares it feeds on are of great interest to the Keeper of the Depths, as it is only able to act within the dreamscape of the sleeping victim rather than consume it entirely. Therefore, the Keeper may find the Shadowcat both a curiosity and a threat to it, for while the Keeper causes nightmares to follow in its passing, if the Shadowcat were to turn its gaze upon the tentacled horror itself, then the conflict would likely cause enough psychic feedback that even ordinary people would be mentally consumed by the nightmarish forces unleashed. The entire world could be thrown into the Inverse, leading to a patchwork world where light and shadow alternatively behaved as they should and as they should not, and the nightmares that dwell within the Inverse would have free reign to slaughter and torment. Only when the Keeper is slain could the conflict end for the mortal world, for if the Shadowcat fell, then the nightmares would triumph.

The Keeper of the Depths & The Storm Lord

The Keeper's distaste towards the light of day and reliance on poor weather to move makes it very interested in the location of the Storm Lord, as it is unharmed by the wrath of this tempestuous ruler. If the two were to appear in the same place at the same time, with the Keeper following after the Lord to bring about a tsunami, then it would likely herald the destruction of entire civilizations or continents. However, if the Storm Lord became displeased by the disrespectful nature of the Keeper of the Depths, then their conflict would be one for the ages.

The Perfect Chord & The Serpent Empress

The Empress desires to rule with absolute sovereignty, and while she invites rebellion, she also despises it. The Perfect Chord intrigues her, because if she could capture it and turn it to her own ends, then she could create perfect silence wherever she desired. No defiance could grow in a world that could not speak, and such silence would leave far more attention to be paid to the beauty of the Empress.

The Perfect Chord & The Weaver of Lies

The Weaver seeks to make a world of complete deception, and what better way than to make all sound false? The Weaver may create an instrument designed to attract the attentions of the Perfect Chord, and an eldritch web to ensnare the elemental sound. If this plot succeeded, then the Weaver could easily turn every sentence spoken into a lie, and every sound into a trap for the one who heard it.

The Serpent Empress & The Shadowcat

The Endless Empire is destined to live up to its name, but there is an entire plane that it has never touched, much to the anger of the Empress. If her slaves could find a way to breach the Inverse, then it could be used to invade every world all at once, pouring forth endless legions from the worlds already controlled by the Empire. However, there is no chance that the Shadowcat would accept this intrusion into its domain, and the nightmares that would spawn as a consequence would be unlike any that had ever come before. The Shadowcat would feast, the reflections that came forth from its inky fur would grin, and their teeth would fall upon the minds and dreams of the imperials in a war that would shatter the concept of sleep.

The Serpent Empress & The Storm Lord

The Storm Lord is serpentine in appearance, in a broad sense, and thus is of interest to the Empress. If she somehow showed the respect the Storm Lord would desire, they could be allies or even more. However, such an outcome is unlikely, for the Empress is nothing if not dominant over all things that she surveys. She may attempt to chain or bind the Storm Lord, forcing it to serve her whims and carry her legions between the worlds, leaving nothing but destruction and death in their wake. If that were to happen, then the heraldic souls who rose from the Storm Lord's lightning would be among the only ones who could free their patron and save the multiverse from the tyrannical reign of the Empress.

The Shadowcat & The Wild Huntsman

It would be difficult to kill the Shadowcat. The proper weapon would be nearly impossible to create or discover, and the method of luring it in and cutting off any escape would require eldritch knowledge that has likely never been discovered. That does not mean that it could not be done. Killing the first nightmare itself would be a feat worthy of a legend, and one that could never be replicated. The Wild Huntsman would be eager to do this, and if it did, then it could hunt the nightmares of the Inverse in the Shadowcat's place for all eternity and never go without a new quarry.

The Storm Lord & The Warrior-Saint

The Storm Lord is a force of unparalleled destructive power, and it commonly targets mortal civilizations. As the whirlwind blows down the towers of the grandest palaces and lays waste to the most wretched hovels, the rains lash against the ground and break the barricades that seek to hold fast against the rising flood. There is little room for choice or decision here. There are only two that remain in this trying time: Attempt to survive, or surrender and die. This interference with the regular machinations of mortal life is disruptive, and disturbs the balance between the planes. When a civilization falls, then the scavengers who call

to darker deities and the foul things that dwell within the shadow may perform rites and rituals that are unwelcome to the enlightened justice of the Saint. They must not be allowed to summon the fiends, for if they do, then the angelic forces of the heavens will be called upon in earnest, and this will lead to a repetition of the tragedy that led to the creation of the Warrior-Saint as it exists now. Thus, the Saint may see fit to intervene when the Storm Lord is summoned to destroy a city, though not always. Despite its power, the Saint can only be in one place at a time, and it is not equipped to permanently defeat an elemental of such majesty.

The Storm Lord & The Wild Huntsman

Unlike the Saint, there is one who is equipped for the task of slaying the Storm Lord forever, though it would be a test for the ages. The Wild Huntsman could, if sufficiently prepared, lead the Wild Hunt to battle and fight against the Storm Lord. Such a thing has not yet occurred simply because the stars have never been right while the Storm Lord was present, but that could easily change. When the hurricane rages over the land and the hounds of the Huntsman take to the sky, then golden blood shall rain on the earth below, and the head of the greatest beast of all shall be placed over the open mantle at the heart of the Huntsman's hall. That is, if the Storm Lord's acolytes and cultists did not intervene, riding upon massive creatures and riding the winds, singing the song of the black sky as they fought to the death for the master.

The Warrior-Saint & The Weaver of Lies

The Weaver is the foulest kind of thing, in the eyes of the Warrior-Saint, for it is a being that has nothing but ill intent towards both the cosmic balance and the individual freedom of mortal choice. It exists to corrupt truth into lies, to twist fact into falsehood, to make mockery of justice, and to turn people from their chosen paths. It seeks to kill the gods that watch over the world, and to subvert even the angelic heavens and deepest pits of the fiendish fires. While it exists, mortals cannot be free. Thus, the Saint's solemn duty is to oppose the Weaver wherever it can be found. There is a problem, however. Even the Saint's eldritch gaze cannot penetrate the plots of the Weaver fully, only seeing glimpses of the truth behind the spider's mask. In order to combat the Weaver's plots and potentially discover a way to kill it, the Saint must rely on mortal champions and the Weaver's inability to deal with mathematical truth.

The Warrior-Saint & The Wild Huntsman

The Wild Huntsman is disruptive to the cosmic balance by its nature, as it will constantly seek new and ancient things to slay. If it sets its sights on another Alrisen, and tries to kill it, then the Warrior-Saint may need to intervene. The Huntsman is a powerful adversary, but could also be a steadfast ally. Despite all of the Saint's strength, it may be beneficial to persuade the Huntsman to join in a fight against a creature far beyond the gods themselves. It would not be difficult, after all, for the Huntsman is without peer and lacks even the ability to be afraid. There is only the thrill of the hunt.

Plots and Mysteries

The Alrisen are constantly scheming and planning, all working towards their individuals goals. Most are quite versatile for the needs of your story and world: simply declare that one of the Alrisen has decided to pursue a goal, and decide how that goal would affect your party or the world at large. Would it start a conflict, or create a new alliance? What would change, and what new mysteries would be born from this? Here are some potential plots or activities that you may find fitting for your campaign:

The Accursed Archive

Even if your setting is limited on libraries, the Archive could be a location filled with perpetually spoken oral histories, a gallery of art, or accessible by opening a certain book at a certain time. The cruel cunning behind this place is often subtle, and it makes answers that lead to darker fates far easier to find, with disastrous results.

- The Archive has gained another resident – who are they, and what are they looking for?
- A local religion is promoting the destruction of books and knowledge – in this instance, are they justified?
- An artifact is discovered in the Archive – what does it do, and what does it want?
- The Silent One has gone missing from the Archive. Where did it go, and what happens in its absence?
- An *accursed wish** has gone awry, leading to a terrible tragedy. Can anything be done?
- A scroll of *armageddon** has been discovered in an ancient ruin. Who found it, and what will they do with it?

The Ashen Wolf

The Wolf is a beast of both cunning and resolve. It often finds humor in things mortals would consider anathema, but can display a curious sense of mercy. Consider the following potential plot hooks:

- The warlock is considered an evil fiend by a local religious organization, but they desire help for some reason. Why?
- The Ashen Wolf is behaving erratically – forcing predators from their normal hunting grounds and into settled lands. How has this happened?
- Followers of another Alrisen seek to somehow find and slay the Wolf. While they are destined to fail, what disaster do they bring along the way?
- A hunt has been called to seek out a nearby terrible beast and slay it – the Wolf demands that its servants be the first to find and kill the creature.
- An emberborn or other fire elemental has been captured and enslaved, and the Wolf demands that it be freed.

The Blackthorn Grove

The Blackthorn Grove acts as a new start for those that enter it, but it can also act as an ancestral homeland for those who were born to parents touched by its eldritch power. Consider these events, and how they may impact your world:

- The Grove has been discovered by an ancient lich, who seeks to use the dead within to raise an army. What can be done to hinder this, or should it be allowed to happen?

- More and more people are venturing to the Grove. What is going on in the world that is causing such apathy?

- The Grove is burning, and will not stop. What happened? What should the groveborn do? Can it be resolved?

- The Serpent Empress has been deposed, but she managed to survive. She stumbles her way into the Blackthorn Grove, broken and defeated, and offers her heart. What happens when the Blackthorn Grove takes it? What new tyrant has been born, and what will she do to reclaim her empire?

THE CURRENCY CONSPIRACY

The Currency Conspiracy is a tricky Alrisen, as it does not have a face nor a figurehead to blame. Its plots are subtle and ever-so devious, so consider these potential schemes for your world or campaign:

- The warlock has been accused of being a traitor by the Conspiracy. Is this correct, or is there another to blame?

- The Warrior-Saint has discovered the Conspiracy. What will happen now, and how can the party respond?

- The final plan is in motion, but the Cabal has not yet called for their servants to join them in sanctuary. Was this part of the plan the entire time, or has something gone wrong?

- The Weaver of Lies is actually behind the Conspiracy, and Gilt is nothing but an illusion crafted by this creature. What happens, and how do the conspirators react?

THE ETERNAL CITADEL

Preservation is not always nice, and some things that should be long destroyed are often kept intact by the work of the Citadel, yet it is often benevolent nevertheless. Here are some potential plot hooks to play to the strengths of a Citadel warlock or timeless monumental:

- The party must safeguard a location from an encroaching horde of invaders, but are they what they seem?

- There is a creature of immense power that must be contained, and the players have been requested to help. Who benefits?

- The Citadel itself has become corrupted, and begins to bring the worst of villains into the most vulnerable of times. What are the consequences of this betrayal?

- An extraplanar force seeks the destruction of the Citadel using a powerful magical artifact, but to what end?

- Other servants of the Citadel appear, with a task in mind – but are they truly who they claim to be?

- The Citadel has taken a friend of the warlock captive. Why has it done so, and what does it intend?

THE FALLEN EXILE

The Exile is a tragic soul whose passions have been ignited. It desires the death of the other stars and the resurrection of its lost love. Consider the following potential plot hooks, which may lead to the completion of these goals:

- The Exile has discovered an ancient ruin that may hold a key to bringing back the dead. What horror lurks within, and can it be defeated? What prize lies inside?

- A scholar is seeking to interview the Exile, but refuses to reveal their identity. Who are they? What do they want? Is this a trap, or an opportunity?

- The Fallen Exile has just succeeded in snuffing out all of the other stars from the sky, casting the world into cold blackness. In only a few days, the world will freeze, and all life upon it will die. What can the party do to avert disaster? Can the world be saved?

- Another star, one that participated in the sentencing, has been cast down from the heavens. What does the Exile do about its new companion, and are they allies, or are they enemies? How can the party intervene?

THE FORBIDDEN GRAVEYARD

The Graveyard is a place filled with lost secrets and artifacts, guarded by strange and intricate magics. There is balance there, but the balance of a person with one foot in the grave. Consider these potential plot hooks:

- A fallen warrior from ages past seeks to right a grievous wrong. How is the warlock involved?

- Angels, seeking to know who is meddling with the souls of the dead, come to investigate the warlock. How do they react?

- A broken battlefield sends the players into the Graveyard, where they meet a former soldier. What is their story?

- The warlock meets another individual within the Graveyard – but who do they meet, and why is another person there?

- Inexplicably, the Forgotten Graveyard has become full despite being an infinite plane. Spirits are somehow escaping and returning to their bodies, even those that are decayed long past recognition. It's up to the party to stop this madness, even as the dead rise and try to resume their former lives – or are consumed by a terrible hunger for living flesh.

THE GELATINOUS CONVOCATION

The Convocation does not see death as mortals do. It is fascinated with the lives that are led by ordinary people and heroes alike, and is always interested in collecting that knowledge and experience with a sizzling splash of magical ooze. Consider these potential plot hooks:

- The warlock has been assigned to escort a collection of oozes into a newly-discovered dungeon. What troubles do they meet on the way?

- A great champion has fallen, and the party must recover the memories of the champion before their corpse is devoured. What secrets did this champion hold?

- A murder has occurred, and the party must decide if desecrating the body is worth it to find the killer. Did the victim even know?

- The oozes of a dungeon have consumed enough memories to become sentient, but they're morose and depressed. Can they be helped?

THE GRAY PORTRAIT

The Portrait is not a patron with desires of its own. Indeed, it is the freedom from responsibility and consequence that makes it so enticing and desirable, but that same freedom gives the warlock all the farther to fall. Consider these plot hooks:

- A rival artist has declared war on the warlock for stealing his audience, and vows bloody revenge. To what depths will they sink to gain it?

- The warlock's portrait has been discovered by someone untrustworthy – who are they, and what do they plan?

- Someone from the warlock's past recognizes them, but swears they haven't aged a day – how does this impact their relationship?

- A friend of the warlock's sees the decay of the Portrait, and fears for the soul of their companion. How do they intervene?

The Gray Portrait is an homage to the classic tale "The Picture of Dorian Gray" by Oscar Wilde, featuring a man whose supernatural painting kept him safe from the evil he did to himself and others, until he realized what he had become.

THE KEEPER OF THE DEPTHS

The Keeper is ever-present, constantly seeking and curious. The secrets of magic, history, and the desires and foibles of mortals are endlessly interesting to this entity, as it has no dominion over the dead. It can provide intriguing mysteries with every fall of night, so consider some of these:

- There is an artifact located near where the party is resting – according to a map from countless ages ago. How does the Keeper react to what is discovered?

- A group is attempting to conceal a secret that could spell the end of a kingdom. Should the party investigate, or assist in the cover up?

- A powerful wizard has created a new spell, and the Keeper wants to add it to the collection, by any means necessary. What is the spell, and why has the wizard invented it?

- A new land has been discovered, but the Keeper whispers that it was once a great empire, now lost to time. What treasures and secrets lie in wait?

How curious that a tome written in the past can predict my actions in the future. I am intrigued what would happen if I were to defy these inscriptions, but perhaps following their directions would lead to the fulfillment of my desires. I will have it for my collection...

THE PERFECT CHORD

The Chord is not exactly sentient, at least in the conventional sense. It is single-minded pursuit of new music and sounds, but rarely gets involved in mortal affairs. The Chord can appear in a variety of ways, but often manifests in a glowing, shimmering chorus of light and noise. Consider these melodies to add to your plot:

- The Chord has begun to speak words and phrases – what do they mean? What does this portend?

- An entire city has gone totally silent. Is this the work of the Chord, or something darker?

- The warlock has been tasked with traveling to the peak of a massive mountain, and singing a certain note at a certain time. Does this bring reward, or disaster?

- A bard has sworn to best the warlock in a competition. What tricks will they pull along the way?

THE SERPENT EMPRESS

Nobility, the intrigue of court, the connotations of such zealous fervor, and the collection of garden statues in the shape of terrified servants all add to the mysterious nature of the Empress. Her desire is almost always power and prestige, fame in the eyes of mortals and gods alike. Consider these plot hooks, for the glory of the Empress:

- The warlock has been assigned to assassinate a noble in a distant land without being implicated. What happens when a rival servant of the Empress intervenes?

- The party is temporarily transformed into serpents, and must overcome challenges for the amusement of the Empress. How will they earn their forms back?

- The Wild Huntsman arrives uninvited in the court of the Empress – what does he want, and how does this impact the warlock?

- The Empress desires the recovery of an artifact of one of her former champions – however, the object is cursed. What happens to the bearer, and can the curse be broken?

THE SHADOWCAT

The Shadowcat is an entity that follows a strange set of rules and is often compared to fey, though few know its true nature. The cat has an uncommon fondness for safeguarding children, but shows a callous and cruel countenance to their parents. Consider these plot hooks:

- A child has been kidnapped and the Shadowcat has assigned the warlock to resolve this problem – but the child has wandered into the Feywild after escaping. Where did they end up?

- Servants of the Wild Huntsman are seeking the pack of the Ashen Wolf with dark intentions. Why does the Shadowcat want the warlock to intervene, and in what way?

- The inhabitants of a city are seemingly immune to nightmares – what magical power has done this, and should the warlock interfere to feed their patron?

- The servants of another Alrisen are interfering with something the Shadowcat finds interesting. Stop them, but without letting them know they were targeted. What is the Shadowcat interested in, and why?

THE STORM LORD

Ancient and unknowable, and rarely communicating with words, the Lord never touches the ground, even while at rest. The Storm Lord can provide several different plot hooks, such as these:

- A cult to the Storm Lord has arisen in a nearby city, but the Lord is displeased with them. What have they done, and what punishment do they deserve?

- A ritual to summon a hurricane must be performed at a certain day in a certain location, or disaster will follow. What is this disaster, and is stopping it worth the price?

- One of the children of the Storm Lord has fallen from his favor, and seeks redemption. How can this be earned?

- Inhabitants of the elemental planes have been sighted nearby, but what is their aim? Is the Storm Lord their master, or their slave?

- An emissary from a nearby kingdom seeks the favor of the Lord. How can it be earned, and why do they seek it?

THE WARRIOR-SAINT

This Alrisen functions as judge, jury and executioner for the violators of natural law. Arbitrary and absolute, the Saint doesn't take prisoners without good cause, and has earned the ire of many other Alrisen. Consider plot hooks such as these:

- A cult of the Weaver of Lies has disrupted the peace of a valley. What falsehoods have they told, and to what end?

- The Shadowcat has saved a child who was fated to die – what does the warlock to do? Can fate be changed, or is it destiny?

- The Accursed Archive has chosen a new servant, but this servant seeks to enslave a powerful fiend. How is this to be done, and should the warlock intervene?

- A prisoner of the Saint has escaped and left a swath of devastation before disappearing. Where did it go, and why do its minions continue to appear to wreak havoc?

- The Serpent Empress has stolen the heart of a mortal champion fated to summon an army of angels to the material plane – how does the Saint respond?

THE WEAVER OF LIES

As a creature tied to the fate and dishonesty of the gods themselves, this entity is more cunning than even the darkest of demons. The Weaver sees much, and says more, but how much can it be trusted? Consider these terrible twists for your plot, to show the influence of the Weaver:

- There is an artifact that will bring great rewards to the owner. The problem is, it's owned by someone else who doesn't know quite what they have. How can the warlock obtain it, and what does it do?

- The traitor wasn't a traitor after all – the Weaver just decided to get involved. What are the consequences?

- The lies the warlock has told are finally catching up to them, and at the worst possible time. How do their allies and enemies react?

- The biggest lie is the most believable – the party is mistaken for someone else, and must maintain the ruse. Who are they mistaken for, and what must they do?

- Agents of the gods are seeking the warlock for an unknown reason. Will this lead to conflict, or alliance?

THE WILD HUNTSMAN

The Wild Huntsman honors all who fight and kill with valor and skill, even if they work against him and his goals. His influence is keenly felt in places wrapped in snow, and he is seen in his true incarnation on the material plane more often than any other patron. Consider these plot hooks:

- The party has been tasked with slaying a massive and ancient beast. When it is revealed to be sentient and peaceful, how do they react?

- Servants of the Ashen Wolf are seeking the warlock's head as a trophy. What methods will they sink to in their quest, and how can the warlock turn the tables?

- The Huntsman has demanded the souls of a village in payment for a single favor. Will the party accept the deal, or seek another solution?

- The Storm Lord is angry with the Huntsman for interfering with the weather. Can the party resolve this conflict before the storms and blizzards destroy their city?

THE WAR OF THE ALRISEN

The Wild Huntsman and Ashen Wolf clash on a once-tropical island now covered in ice and snow. The Storm Lord takes the opportunity to wreak havoc on the cities of the massive island, causing countless refugees to flee into the wilderness. The Weaver has bewitched a dragon to fight for it, offering it wealth and riches in exchange for its service. The Shadowcat fights against the armies of the Serpent Empress as they invade the Inverse, tearing portals between the island and this nightmarish plane. The Keeper whispers to the poor souls caught in between, promising them safety in exchange for their souls. With this twisted army, it hunts through the ruins of the destroyed landscape for wealth and secrets.

The Eternal Citadel has arrived atop a mountain near the far end of the island, and has begun to fortify the entire region, turning it into a sanctuary. The Archive, however, has informed the Empress of a way to subvert and destroy this ancient bastion, if her armies can establish a strong enough foothold. The cheerful slimes of the Convocation pick through the bodies of the dead, offering gemstones and loot in exchange for fresh memories. The Blackthorn Grove, hidden somewhere on the island, seems to be exerting its influence over the trees and plants, filling them with life and vitality despite the bitter cold.

The Warrior-Saint looks on, unable to intervene due to a seal placed upon it by an ancient lich who has finally discovered a way to create a barrier that the Saint cannot pass through, no matter how hard it tries. It seeks to bring the Forbidden Graveyard to this plane and to shatter the Gate of Souls, creating an infinite army of undead minions for it to command. The Saint is not completely bound, however. It has chosen champions, even from among servants of the Alrisen, to restore the balance of power between these destructive forces. A mere handful of skilled warriors, arcanists, priests, and tricksters is all that stands against forces that would destroy the world through their conflict.

What will you do?

WARLOCK FAMILIARS

The Pact of the Chain

Warlocks who have been granted the Pact of the Chain can select from the following list of familiars in addition to those outlined in the feature's list. Each Alrisen offers a unique familiar, though these familiars can be summoned by any follower of the eldritch arts using the proper rites.

Animate Image

The animate image is a small, two-dimensional work of sentient art that shifts and changes to suit its environment. They're created as servants and spies by warlocks of the Gray Portrait, and by other skillful artisans and craftsmen who spill blood in the name of their art. These images are mischievous and cruel, delighting in taunting former friends into harming one another and making rude gestures to amuse and insult. Most are humanoid, but some are of fantastical animals, imaginary beasts, and even landscapes or scenery. They can change their appearance quite dramatically as suits their mood, and tend to try to occupy picture frames or the exteriors of statues whenever possible.

The creation of an animate image is an unusual one, directly related to the art of shadow puppetry. While images can be of any color or form, they are simple when first created. The artist must stand before a burning brazier and establish an eldritch connection with the flame, calling upon it to cast light more fervently. Once done, they will place their hands on the far side of the fire, casting a shadow on the wall or ground. While chanting the eerie words and phrases required by this mystical rite, they will use their hands to make a shadow puppet. The chanting corresponds with a story fitting for the personality of the animate image that they desire to summon.

A story of loss and betrayal will call forth an image that takes the shapes of monsters and assassins, while a pleasant story with happy ending will create one that is more mischievous than hateful. Over the course of the ritual, the shadow puppet will solidify, no longer moving with the hands of the artist. At the culmination of the event, the warlock will cut a fingertip and place a single drop of blood on the shadow, infusing it with life, soul, and obedience to its creator.

Animate Image

Small construct, neutral

Armor Class: 16 (natural armor)
Hit Points: 22 (5d6 + 5)
Speed: 30 ft., special (see text)

STR	DEX	CON	INT	WIS	CHA
10 (0)	16 (+3)	12 (+1)	8 (-1)	10 (+0)	11 (+0)

Saving Throws: Dex +5
Skills: Perception +4, Performance +4

Damage Immunities: damage from nonmagical sources
Condition Immunities: blinded, deafened, exhaustion, poisoned, restrained
Senses: blindsight 5 ft., passive Perception 18
Languages: Understands those known by its master but can't speak
Challenge: 1 (200 XP)

Magic Resistance. The animate image has advantage on saving throws against spells and other magical effects.

On Your Skin. Any attack that targets and hits the animate image inflicts full damage to the surface or creature that the image is covering, even if the image takes no damage.

Two Dimensional. The animate image cannot stand on its own, but it can cover any surface without being harmed. Whenever it is touching a creature or object that moves, the image goes with it. The image can slide through cracks as thin as paper without suffering ill effect. If the image is located on an object held in midair that isn't touching anything else, as though by levitation, it is trapped and cannot move. The animate image does not occupy a space.

Actions:

Papercut. *Melee Weapon Attack:* +8 to hit, reach 0 ft., one target. *Hit:* 5 slashing damage. If the animate image can't see its master, it can't use this attack.

Inscribe. The image burns a copy of itself onto the surface it is covering, dealing 1 acid damage.

Animate Shield

Animate shields are summoned from the long-silent forges of the Eternal Citadel, made ages ago to defend the servants of the massive fortress from any invader. They rest silently when not addressed or in combat, but are always wary of attackers to the point of paranoia. Most are hesitant to leave the sight of their charge, and will only do so by direct order. They also seem to have a cutting sense of humor, mocking opponents and striking at their minds with subtle magics whenever they are attacked. They have a strange rivalry with other magical objects, especially magical weapons, which they view with disdain and distrust due to their opposing purpose. They are fond of gifts of art and masonry, and adore being painted and encrusted with gemstones when done as a show of ownership and affection.

Animate Shield

Small construct, lawful neutral

Armor Class: 16 (natural armor)
Hit Points: 16 (3d6 + 6)
Speed: 0 ft., fly 45 ft. (hover)

STR	DEX	CON	INT	WIS	CHA
14 (+2)	12 (+1)	14 (+2)	11 (0)	12 (+1)	11 (+0)

Saving Throws: Con +4
Skills: Perception +5
Damage Resistances: bludgeoning, piercing, and slashing
Damage Immunities: poison, radiant
Condition Immunities: blinded, charmed, frightened, poisoned, exhaustion
Senses: darkvision 60 ft., passive Perception 16
Languages: Common and those known by its master
Challenge: 1 (200 XP)

Durable. Whenever the animate shield would take damage from an attack, reduce that damage by 3. Additionally, it has advantage on Constitution saving throws.

Equipment. The animate shield can be equipped as a shield and the bearer is always considered proficient in its use. The only action it can take while it is equipped is to remove itself from the bearer. While equipped, it is treated as an object and does not take damage from attacks or other effects.

Magic Resistance. The animate shield has advantage on saving throws against spells and other magical effects.

Stalwart Defense. Whenever an enemy attacks the animate shield, they take 2 psychic damage.

Actions:

Bash. *Melee Weapon Attack:* +6 to hit, reach 5 ft., one target. *Hit:* 5 (1d6 + 2) bludgeoning damage and the target is pushed back 5 feet.

Guard. As an action, the animate shield hovers around an ally within 5 feet of it and moves with the ally. The next time that ally is hit with an attack before the start of the shield's next turn, the animate shield is hit by the attack instead. The shield cannot be forcibly moved during this time. If the ally teleports, the shield also teleports with them.

Bloodless Wanderer

Not all who have torn their hearts away in the Blackthorn Grove survive their adventures. Some fall in battle, dying before their quests have been completed. For many, this is the end, but for some, it offers a new beginning. Each bloodless wanderer is the blackthorn heart of one of these fallen heroes, whose ambitions and desires were never fulfilled. The heart tears itself from the chest of the fallen adventurer, seeking still to fulfill its quest. They are intelligent and possessed of clear purpose, but cannot speak or write. Many construct masks of wood and decorate them to be reminiscent of the person who they once lived within. All of them require blood to continue to survive, and will feast upon the fallen, drinking deeply of their still-fresh fluids.

As companions, they are wise and insightful, possessed of much of the experiences of their former owners. They are often referred to as spirits of the dead, though this is not technically correct. They are plants, living and come to life once more. They desire little more than to find new companions who can assist them on their lifelong quest, but are patient and capable of understanding the bigger picture when required. The one thing that will cause a wanderer to attempt disobedience is the sight of their killer. If a bloodless wanderer is placed within a corpse, it can animate the body to act and move, but it will still lack the ability to communicate beyond gestures and cryptic behavior.

Bloodless Wanderer

Small plant, neutral

Armor Class: 16 (natural armor)
Hit Points: 31 (6d6 + 12)
Speed: 30 ft., climb 30 ft.

STR	DEX	CON	INT	WIS	CHA
16 (+3)	12 (+1)	14 (+2)	10 (+0)	12 (+1)	10 (+0)

Saving Throws: Con +4
Damage Resistances: bludgeoning, piercing, and slashing from nonmagical attacks, cold, poison, radiant
Condition Immunities: exhausted, frightened
Senses: blindsight 10 ft., darkvision 60 ft., passive Perception 11
Languages: Understands those known by its master but can't speak or write
Challenge: 1 (200 XP)

Bloodsucking Vines. Whenever the bloodless wanderer deals slashing or piercing damage, it recovers hit points equal to the damage dealt. This does not apply if the target is a construct.

Corpse Thief. When the wanderer is touching the corpse of a beast or humanoid with a CR of 2 or less, it can use an action to enter and animate the body like a puppet. While inside, it gains temporary hit points equal to half the maximum hit points of the dead creature. When these temporary hit points are reduced to zero, the corpse is destroyed and the wanderer is ejected. The wanderer can choose to leave as a bonus action.

Grim Mask. Melee attacks targeting the bloodless wanderer are made with disadvantage. When a creature makes a melee attack targeting it and misses, it takes 1d6 slashing damage.

Magic Resistance. The bloodless wanderer has advantage on saving throws against spells and other magical effects.

Natural Visage. When the bloodless wanderer is still, it is indistinguishable from an ordinary plant. The wanderer is unimpeded by difficult terrain caused by plants, and can take the Hide action as a bonus action. It can hide while only lightly obscured.

ACTIONS:

Vine Lash. *Melee Weapon Attack:* +5 to hit, reach 15 ft., one target. *Hit:* 8 (1d10 + 3) slashing damage plus 5 (1d4 +3) piercing damage.

Dimcat

The dimcat is a small feline creature that cloaks itself in shadow, and feeds on the nightmares of the unwary. Servants of the Shadowcat, the dimcats are sent out into the world to safeguard children and guide them away from dangerous situations, often appearing in very small ways to influence events so that the child is unaware of the danger in the first place. While the Shadowcat and its reflections feed on nightmares, those of children are bitter and unworthy of their elegant and refined taste.

Creatures that draw their ire find themselves wreathed in blinding blackness before being bitten by the cat, filling their minds with a psychic onslaught of nightmares. The dimcat feeds on the doubts, fears, and nightmares of sleeping mortal adults, sitting upon them with mouth outstretched to catch the fever dreams as they rise in a black mist.

Those who awaken only see the stark blue eyes shining down at them, and are paralyzed by the strange power of the dimcat. When at rest, they are silent and watchful, seeming to enjoy batting out burning candles and other sources of light. Warlocks who have sworn themselves to the Shadowcat often take them as familiars, typically treating the dimcat as an extension of their patron itself. In a certain sense, they really are: each dimcat is a reflection of the Shadowcat that was created when this enigmatic entity consumed and converted a lesser nightmare, twisting the old horror into a new form with a new purpose.

Dimcats speak in a wide variety of voices and have many strange and enigmatic personalities, but most can be described as one might expect: haughty, overbearing, demanding, sly, clever, charming, affectionate, enigmatic, mysterious, deceptive, curious, and practically any other term one might use to describe an actual cat.

Dimcat

Tiny fey, chaotic neutral

Armor Class: 15 (natural armor)
Hit Points: 14 (4d4 + 4)
Speed: 30 ft., climb 30 ft.

STR	DEX	CON	INT	WIS	CHA
6 (-2)	17 (+3)	13 (+1)	10 (+0)	12 (+1)	14 (+2)

Saving Throws: Dex +6
Skills: Perception +5, Stealth +6
Damage Resistances: bludgeoning, piercing, and slashing
Senses: darkvision 120 ft., passive Perception 15
Languages: Common and those known by its master
Challenge: 1 (200 XP)

Eyes of the Hunter. Magical darkness doesn't impede the dimcat's darkvision, and it treats all locations as though they were brightly lit for the purposes of perceiving objects and creatures.

Magic Resistance. The dimcat has advantage on saving throws against spells and other magical effects.

Nightmare Feast. Whenever the dimcat is touching a creature that is unconscious, the creature is paralyzed until the dimcat is no longer touching it, even if the creature wakes.

Shadow Dweller. The dimcat is always considered to be lightly obscured by magical darkness, unless it chooses to allow a creature to see through this effect. Whenever the dimcat enters the space of a hostile creature, the creature's eyes are covered by this magical dimness until the dimcat is no longer within its space.

ACTIONS:

Bite. *Melee Weapon Attack:* +5 to hit, reach 5 ft., one target. *Hit:* 5 (1d4 + 3) piercing damage plus 2 (1d4) psychic damage. If the target is prone, it must make a DC 12 Wisdom saving throw. If it fails, it falls unconscious until the end of its next turn.

Shadow Hop. The dimcat teleports to a point that it can see within 15 feet of it, becoming heavily obscured by magical darkness until the start of its next turn.

EMBERBORN

An emberborn is a small, canine-like creature created from ash and burning embers built around a core of molten metal. They are birthed from the pyres of creatures sacrificed to the Ashen Wolf, yet they are often friendly and pleasant to mortals. When provoked, they unleash a blast of ash and smoke before closing in with teeth like red-hot pokers. When at rest, they often sleep within fireplaces and other areas where fires are commonly stoked. They feast on raw meat whenever the opportunity presents itself, and enjoy being presented with gifts of metal and rare wood, as they enjoy devouring both in large quantities.

Some say that the emberborn are the children of the Ashen Wolf, and that it cares for them as though they were its own. There are no reliable records that can prove this belief, but as intelligent elementals they are capable of speech and can thus be asked. As an emberborn feeds and ages, they will grow larger and larger. Some eldritch scholars hypothesize that the Ashen Wolf was once an emberborn, strangely enough.

EMBERBORN

Small elemental, neutral

Armor Class: 14 (natural armor)
Hit Points: 31 (7d6 + 7)
Speed: 35 ft.

STR	DEX	CON	INT	WIS	CHA
14 (+2)	14 (+2)	13 (+1)	11 (+0)	12 (+1)	10 (+0)

Saving Throws: Dex +4
Skills: Perception +5
Damage Immunities: fire, necrotic, poison
Condition Immunities: poisoned, exhausted
Senses: darkvision 60 ft., passive Perception 15
Languages: Primordial and those known by its master
Challenge: 1 (200 XP)

Form of Ash. The emberborn can pass through openings as small as a 1-inch square without being slowed or hindered. Opportunity attacks against the emberborn are made with disadvantage.

Living Ember. Hostile creatures that grapple the emberborn or target it with melee attacks take 2 fire damage at the end of their turn. The emberborn has advantage on checks made to escape a grapple.

Magic Resistance. The emberborn has advantage on saving throws against spells and other magical effects.

Pack Tactics. The emberborn has advantage on attack rolls against a creature if at least one of the emberborn's allies is within 5 feet of the creature and the ally isn't incapacitated.

ACTIONS:

Bite. *Melee Weapon Attack:* +5 to hit, reach 5 ft., one target. *Hit:* 6 (1d6 + 2) piercing damage plus 3 (1d6) fire damage

Burst. (Recharges after a Short or Long Rest). The emberborn blasts ash and cinders from its body. Creatures within 10 feet of the emberborn must make a DC 12 Dexterity saving throw. If they fail, they are blinded until the end of their next turn and take 7 (2d6) fire damage. If they succeed, they are unaffected.

When summoning an emberborn deliberately, a brazier filled with wood and rare metal is presented and the blood of a sacrificed beast is poured over the open flame as the summoner performs the eldritch incantation. The fire will burn quickly, and when it is reduced to coals, the emberborn will begin to take shape. It will emerge from the fire and demand to be fed. If the summoner provides a drop of their blood to the newly born beast without hesitation, then the emberborn will smile and swear loyalty to their new master. If the summoner does not, then the emberborn will vanish into smoke and seek a forest to ignite instead.

Familiars! Right, those little things that follow everyone else around. I've never had one — I don't think I could take care of it properly so that's probably a good thing. Let's see…

1. Animate images are creepy and nobody should have one.
2. Animate shields are kinda fun, despite being all fussy.
3. Bloodless wanderers are pretty much just zombies, right?
4. Dimcats are weird and I don't think they like me.
5. Emberborn are obviously the best, because they're friendly and fiery and there's no better combination in the world.
6. Eyeless watchers give me that "Where's the face on this thing?" feeling and I'm not alright with that.
7. Harrowing hawks are terrible and nobody should ever have one. I nearly lost a finger trying to feed one.
8. Haunted crows… let's just say I'm not sure which glowing part is the eye and I'm not sure I want to know.
9. Imperial cobras are melodramatic.
10. Luminous shards are intense and I wouldn't want one.
11. Record-hunters are cute until you see what they do.
12. Scribeant swarms are just bugs with more shiny bits.
13. Shade widow: see above, but worse.
14. Spark seekers: Cute. Tasty. Good overall.
15. Symphonic songbirds are noisy, loud, and annoying. If I plug my ears, then I can at least enjoy looking at one, I guess.
16. Wealth mimics are the worst thing ever.
17. Wiggly cubes always try to sit on my head and then the slime melts and gets everywhere and it's just messy. —X

Eyeless Watcher

The eyeless watcher is a tentacled horror with small wings that speaks in whispers, often repeating the grimmest word it has most recently heard. A new one is born with each secret the Keeper of the Depths learns, and they emerge from the deep dreams of its mind to grace the mortal world with their presence. The watchers are praised and reviled for their unceasing usefulness, but their tentacles bear a poison far deadlier than their servitude.

They enjoy causing fear and concern, but seem to do so out of habit more than any actual malice. When at rest, they tend to immerse themselves in water, and flutter their tendrils out to the edges of whatever body of water they have occupied. Most are seemingly brilliant to the minds of ordinary mortals, and whisper secrets from worlds and lifetimes beyond those of any who are present now. They have an interesting rivalry with the Archive's record-hunters, and seek to safeguard their secrets from being cataloged in such a mundane fashion as literature. Instead, they hold oral traditions as the highest form of knowledge, and seek to share them in the dreams they visit on the nights of a full moon.

These horrors are suspected to have been first created as the result the work of the Keeper's first collection: a series of ancient artifacts found buried within the ruins of a civilization lost to the tides upon a distant world. With these, it called the seas to rise above the land and swallow the entire planet, though the artifacts were destroyed in the process. Countless thousands died that day, and those that remained lived among the corpses and the surf amidst the highest mountaintops. Over time, the Keeper's unshakable influence over the world grew ever greater, twisting once noble folk into imitations of themselves. They performed rituals over the dead, taking the flesh of their fallen and consuming it themselves. They offered their broken bodies and minds to the Keeper, and it grew ever more powerful.

In the end, it discovered that hearing the whispers of those who worshiped it was pleasing, and so it turned its mind to the lost and ancient arts that allowed one to sculpt life from flesh and sentience from dreams. Thus, the eyeless watchers were born, forever whispering the secrets of those who have come and gone for the entertainment of their inhuman master.

Eyeless Watcher

Tiny aberration, neutral

Armor Class: 14 (natural armor)
Hit Points: 14 (4d4 + 4)
Speed: 5 ft., fly 30 ft., swim 30 ft.

STR	DEX	CON	INT	WIS	CHA
4 (-3)	17 (+3)	13 (+1)	16 (+3)	16 (+3)	10 (+0)

Skills: Perception +8
Damage Resistances: bludgeoning, piercing, and slashing from nonmagical attacks
Condition Immunities: blinded
Senses: blindsight 60 ft., passive Perception 18
Languages: Those known by its master
Challenge: 1 (200 XP)

Amphibious. The eyeless watcher can breathe both air and water.

Dream Visitor. When the moon is full, the eyeless watcher can visit the dreams of a creature within 10 miles of it during a long rest. It can observe and speak with the dreamer in their dreamscape, but otherwise cannot interact.

Eerie Whispers. The eyeless watcher can take the Help action at a range of 10 feet.

Improved Magic Resistance. The eyeless watcher has advantage on saving throws against spells and other magical effects, and has resistance to damage from spells.

Actions:

Disturbing Touch. *Melee Weapon Attack:* +5 to hit, reach 5 ft., one target. *Hit:* 5 (1d8) bludgeoning damage plus 8 (1d8 + 3) poison damage and the creature must make a DC 11 Constitution saving throw or be incapacitated for 1 round.

I swear I've seen these in a book somewhere before. Strange. It feels like it's calling to me... — Sylvette

Harrowing Hawk

The harrowing hawk is a large bird with stone-cold eyes that is infused with merciless ice. Bred as hunting birds by the Wild Huntsman, these creatures are far deadlier than their cruel visage belies. When they swoop down to attack their prey, they freeze the edges of their wings and slash with the ice-coated feathers, leaving the frost in the wound to slow their victim. As the ice builds, they let out a piercing cry to summon their master to strike down the target from afar. When at rest, they tend to rest upon the shoulders of their masters and gaze menacingly at those around them. They enjoy gifts of carved bone and scrimshaw, which they use to make their nests, and feast upon frozen meat with gusto.

Harrowing hawks are typically solitary creatures, and rarely cooperate with one another while hunting prey. However, mated pairs are known to hunt together to devastating effect, with one scouting for the other, finding an enticing meal, then letting out a shrill cry. Before the prey can react, the second crashes down with the force of a thunderbolt, slaying the beast instantly. Then the two will perch upon the body until the snow has taken the heat from it, beginning their feast when the blood begins to freeze.

When in the service to a warlock aligned to the Huntsman, they serve as scouts and harbingers to the hounds who pursue the prey, seeking to drive them into the clutches of their master. They have a strong bond with the other beasts of the Huntsman's stable, though are haughty and typically view themselves as the most favored of beasts. The steeds may carry, and the hounds may enjoy the master's affections, but the hawks were the first, and the hawks will be the last. Their pride will lead them to seemingly impossible feats of nigh-suicidal bravery, such as tearing the eyes from sorcerers and diving down the throats of dragons to cleave about with their razor-sharp wings.

Harrowing Hawk

Small beast, lawful neutral

Armor Class: 15 (natural armor)
Hit Points: 13 (3d6 + 3)
Speed: 10 ft., fly 50 ft.

STR	DEX	CON	INT	WIS	CHA
4 (-3)	16 (+3)	12 (+1)	12 (+1)	11 (+0)	10 (+0)

Saving Throws: Dex +5
Skills: Intimidation +4, Perception +8
Damage Resistances: bludgeoning, piercing, and slashing from nonmagical attacks
Damage Immunities: cold
Condition Immunities: frightened
Senses: darkvision 60 ft., passive Perception 18
Languages: Understands those known by its master but can't speak or write
Challenge: 1 (200 XP)

Chill Wind. Ranged weapon attacks against the hawk are made with disadvantage. The hawk can take the Disengage action as a bonus action.

Executioner's Dive. The harrowing hawk can move straight downward without expending movement. Whenever the hawk moves more than 100 feet during its turn, its first attack before the start of its next turn inflicts 2d10 force damage.

Hunter's Shriek. The hawk can let out a piercing cry as a bonus action, alerting all creatures within 500 feet to its exact location.

Magic Resistance. The harrowing hawk has advantage on saving throws against spells and other magical effects.

Actions:

Frozen Pinions. *Melee Weapon Attack:* +5 to hit, reach 5 ft., one target. *Hit:* 5 (1d4 + 3) piercing damage plus 5 (1d4 +3) cold damage and the target's movement speed is reduced by 10 feet during its next turn. Each time the target is hit after the first, the movement speed reduction increases by 5 feet. This resets after one minute.

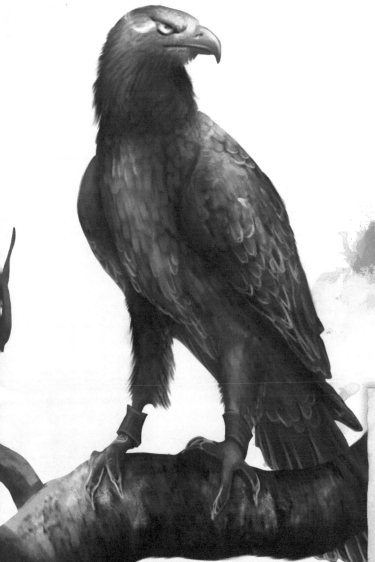

Seriously, is there anything about this that doesn't say "I'm going to eat your fingers off even if they're made of ash because I'm just a real cold-hearted killer."?

That wouldn't ever taste good! -X

Haunted Crow

Animals on the verge of death sometimes wander into the Forbidden Graveyard, and the carrion birds who come to hover over them are often drawn in as well. As familiar as they are with those on the border of life and death, spirits of the dead occasionally wander back in their grasp, infusing the carrion birds with sinister energies. Their eyes glow with an eerie light, their wings beat silently, and a trail of horrible shadow filled with the grasping hands of those the beast has consumed follows the bird with malevolent intent. They speak in the voices of dead relatives and take pride in their foul mockery of the living, yet often offer wise advice and dangerous secrets to those who have defied death.

A creature bearing the souls and dreams of the dead, flying across a sky of night. It speaks of secrets lost and secrets found, and of things no living mortals know. I desire one. I desire many...

Haunted Crow

Tiny beast, neutral

Armor Class: 14
Hit Points: 17 (5d4 + 5)
Speed: 10 ft., fly 50 ft.

STR	DEX	CON	INT	WIS	CHA
5 (-3)	18 (+4)	12 (+1)	10 (+0)	14 (+2)	11 (+0)

Saving Throws: Dex +6
Skills: Perception +4, Stealth +8
Damage Resistances: bludgeoning, piercing, and slashing from nonmagical attacks
Damage Immunities: necrotic
Condition Immunities: charmed, frightened
Senses: darkvision 60 ft., passive Perception 14
Languages: Common and those known by its master
Challenge: 1 (200 XP)

Cruel Mimicry. The haunted crow can eerily copy voices that it has heard within the past day, and any of the voices of those that it has watched die. A DC 17 Wisdom (Insight) check reveals that the sound is false.

Flyby. The crow does not provoke opportunity attacks when it flies out of an enemy's reach.

Magic Resistance. The haunted crow has advantage on saving throws against spells and other magical effects.

Shrouded Dance. The haunted crow leaves a trail of dark shadow behind it as it flies that remains until the start of its next turn. Whenever it attacks using Peck, it can choose to attack from any point along that shadow trail.

Actions:

Peck. *Melee Weapon Attack:* +6 to hit, reach 5 ft., one target. *Hit:* 6 (1d4 + 4) piercing damage plus 3 (1d6) necrotic damage.

Shriek. (Recharges after a Short or Long Rest). The crow unleashes a terrifying scream. Hostile creatures within 40 feet of the crow must make a DC 12 Wisdom saving throw. If they fail, they are frightened for 1 minute. They can repeat this saving throw at the end of each of their turns, ending the effect on a success.

IMPERIAL COBRA

The imperial cobra is one of the deadliest venomous snakes, and their bloodline has been infused with the magic of the Serpent Empress, granting them speech and cunning. Hatched from a long lineage bred to be spies, assassins, and assistants to courtiers, these cobras are malicious and devious.
Their venom is potent and infused with powerful magic that enables it to harm even those protected against such toxins. When at rest, they seek out small animals, such as rats or birds, and torment them for entertainment, gradually injecting small amounts of venom until the creature dies in horrible agony. These cobras enjoy flattery as well as games of wit and chance, and gleefully accept gifts of precious gemstones, jewelery, mirrors, exotic meats, and eggs from reptiles and birds alike.

IMPERIAL COBRA

Small beast, neutral

Armor Class: 15
Hit Points: 22 (5d6 + 5)
Speed: 30 ft., climb 30 ft.

STR	DEX	CON	INT	WIS	CHA
10 (+0)	20 (+5)	12 (+1)	14 (+2)	12 (+0)	14 (+2)

Saving Throws: Dex +7
Skills: Deception +4, Perception +3, Persuasion +4, Stealth +7
Damage Immunities: poison
Condition Immunities: charmed, frightened, petrified, poisoned, prone
Senses: darkvision 60 ft., passive Perception 13
Languages: Common and those known by its master, can communicate with other reptiles regardless of language.
Challenge: 1 (200 XP)

Favored Servant. Poison damage the cobra deals treats immunity to poison as resistance to poison. Creatures immune to the poisoned condition are considered not immune, but they do have advantage on any saving throw against being poisoned by the cobra.

Forked Words. Whenever the cobra is touching a friendly creature, both the cobra and the other creature gain advantage on Deception checks.

Magic Resistance. The imperial cobra has advantage on saving throws against spells and other magical effects.

Slippery Scales. The imperial cobra can take the Disengage or Dash actions as bonus actions. The cobra also has advantage on checks to escape a grapple.

ACTIONS:

Bite. *Melee Weapon Attack:* +7 to hit, reach 5 ft., one target. *Hit:* 7 (1d4 + 5) piercing damage and the creature must make a DC 12 Constitution saving throw or take 3 (1d6) poison damage and be poisoned for one minute. The creature can repeat this saving throw at the start of each of its turns, ending the effect on a success.

Summoning an imperial cobra is easier said than done. The proper incantations and utterances are difficult to pronounce without a forked tongue, and so it is rarely done by any who are not servants of the Empress. As the ritual proceeds, the summoner must inscribe a small, fang-shaped mark upon their hand before holding it over the fire of a brazier, offering it to the cobra. The beast will emerge from within the fire initially as a serpent of green flame, coiling and hissing with malicious intent. The flaming snake will strike at the offered hand, burning a thin line through the inscribed fang. If the summoner remains calm and still through this process, they will succeed in the rite, gifting the serpent with life and causing it to become corporeal. If they express emotion or pain, then an agonizing toxin will flood their veins and the ritual will be disrupted.

Most servants of the Empress will offer the imperial cobra some form of identifying jewelry, so that it may more clearly express its superiority over all lesser creatures. It serves its master as an equal, subservient only to their wishes by the fact of the magic binding them rather than any true loyalty. The oath of a snake means little, except when it is made to the ruler of the Endless Empire.

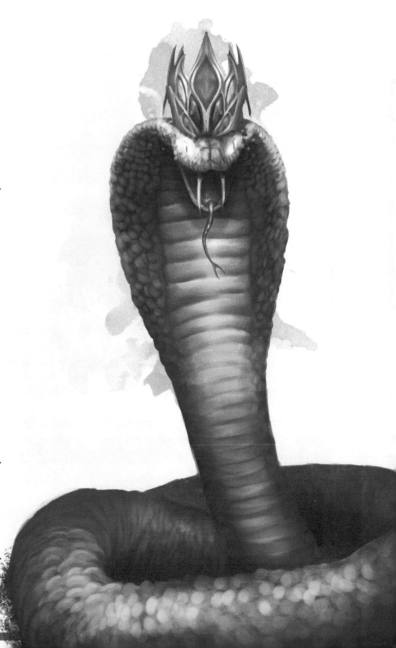

LUMINOUS SHARD

The luminous shard is a small humanoid construct made from the crystallized starlight of the Fallen Exile's tears that were shed when it witnessed the execution of its mortal love. These shards appear as small faceless statues that vaguely resemble the paramour, and are given as a reminder of the grim purpose that drives the servants of this fallen star. They glow with radiant power in the darkness of the night, and drive back the shadows that would hide the lost artifacts and rituals needed to complete their task. These shards are single-minded in their quest, and cannot be turned aside by danger. When their charge is threatened, they willingly sacrifice themselves as the Exile was willing to, seeking to save their fallen comrade at the cost of their own lives. They still bear that spark of scorn for mortality that their originator once held, however, and strike with malevolent light whenever they witness the fall of a mortal foe.

Summoning a luminous shard is fairly simple, by comparison to some of the other familiars. One must simply stand before the brazier, ignite it, and speak passionately about something they desire or something they have lost. The tongues of flame will begin to burn a warm blue and gold while moving together into a humanoid figure. The summoner must then gently offer a hand, and assist the tiny entity out of the brazier. As it exits, it will solidify into a luminous shard. The summoner must then declare their purpose in life, as they see it at that moment. If they are truthful, then the shard will swear loyalty in a series of gestures and serve faithfully as a familiar from then on. If they are deceptive, then the shard will shed a tear of molten crystal, shatter into fragments, and rejoin the Exile in the skies above.

LUMINOUS SHARD

Small construct, neutral

Armor Class: 14 (natural armor)
Hit Points: 26 (4d6 + 12)
Speed: 30 ft.

STR	DEX	CON	INT	WIS	CHA
12 (+1)	12 (+1)	16 (+3)	11 (+0)	11 (+0)	10 (+0)

Damage Resistances: bludgeoning, piercing, and slashing from nonmagical sources
Damage Immunities: cold, fire, poison, psychic, radiant
Condition Immunities: charmed, exhaustion, frightened, paralyzed, petrified, poisoned
Senses: passive Perception 10
Languages: Common and those known by its master, but can't speak or write
Challenge: 1 (200 XP)

Bitter Spite. Whenever a hostile creature within 30 feet of the shard is reduced to 0 hit points, it can use a reaction to lance out with a fragment of its being, dealing 1d8 radiant damage to a target of its choosing within 30 feet.

Magic Resistance. The luminous shard has advantage on saving throws against spells and other magical effects.

Nameless Love. Whenever an ally within 30 feet of the shard would be reduced to 0 hit points, the shard can use a reaction to sacrifice itself, restoring that ally to 1 hit point and destroying the shard.

Starshine. The shard can choose to generate an aura of bright light in a 20-foot radius around it and dim light in another 20-foot radius beyond that. It can toggle this aura as a bonus action. Also, it can cast the *light* cantrip. These light sources count as natural sunlight.

ACTIONS:

Dazzle. *Ranged Spell Attack:* +10 to hit, range 30 ft., one target. *Hit:* 1 radiant damage and the target must make a DC 15 Constitution saving throw or be blinded until the end of their next turn.

Record-Hunter

The record-hunter is a small, featureless humanoid constructed entirely of paper covered in runic script, generated by the will of the Accursed Archive. These tiny origami figures move with great stealth to avoid the unwanted attentions of the Silent One. Able to track down even the most obscure sources of information, they act as invaluable allies to the archivists. When threatened, they fold into the shapes of fantastical beasts and fly high into the air, their runic scripts pulsing with power as they lash at the minds of their aggressors to silence them and preserve the sanctity of the Accursed Archive.

Record-Hunter

Tiny construct, neutral

Armor Class: 16 (natural armor)
Hit Points: 21 (6d4 + 6)
Speed: 10 ft., fly 30 ft. (hover)

STR	DEX	CON	INT	WIS	CHA
8 (-1)	16 (+3)	13 (+1)	16 (+3)	12 (+1)	11 (+0)

Skills: Perception +3, Stealth +8
Damage Resistances: damage from nonmagical sources, poison, necrotic
Damage Immunities: psychic
Condition Immunities: charmed, frightened, poisoned, exhausted, deafened, blinded
Senses: blindsight 10 ft., passive Perception 13
Languages: Understands those known by its master but can't speak. Can read and write in all languages.
Challenge: 1 (200 XP)

Folding Figure. The record-hunter can fold itself into an origami figure of any shape or creature. Its statistics remain the same in any form.

Living Paper. While the record-hunter remains motionless, it is indistinguishable from an ordinary origami figurine or pile of papers.

Magic Resistance. The record-hunter has advantage on saving throws against spells and other magical effects.

Seek Knowledge. The record-hunter intuitively knows the layout of any mundane library it enters, and the location of all written works within libraries other than the Archive.

When a record-hunter discovers a new secret, it will peel open, find a quill and ink, and begin to write in tiny, scrawling script on the inside of itself, inscribing the hidden knowledge into its form. When the master of a record-hunter dies, it will return to the Archive and begin a grim and emotionless work. The record hunter will unfold itself, revealing the countless layers and pages within its body, all covered in the secrets that it has revealed. It will then begin to tear itself apart, silently writhing in agony as it binds itself into a book or scroll.

The new tome of secrets will be picked up by the other record-hunters and placed with reverence upon the shelves of the Archive, and a new record-hunter will be manufactured from blood, ink, and eldritch parchment. It is in this way that the Accursed Archive grows and spreads, constantly seeking new archivists to carry its record-hunters forth. The Silent One acts in defiance of these strange constructs, guarding the knowledge of the Archive while acting in a way that will discourage future additions to the collection. Once a written work is within the Archive, it cannot be destroyed.

Those who take forbidden tomes from the Archive or bear weapons covered in dark script often act in different capacities, either spreading ruin directly or seeking out ancient writings that have managed to somehow escape the attentions of the Archive.

Actions:

Silent Secret. *Ranged Spell Attack:* +5 to hit, range 30 ft., one target. *Hit:* 8 (1d10 + 3) psychic damage and the target must make a DC 13 Wisdom saving throw or become unable to speak or cast spells that require verbal components until the start of the record-hunter's next turn.

A curious, dreamless thing. I see how why my watchers despise them so. I wonder if they would survive beneath the seas. I should collect one, and uncover his secret...

SCRIBEANT SWARM

The scribeant swarm is a mass of scarab-like insectoid constructs, each covered in delicate hieroglyphic writing and embedded with a large central gemstone.

Created ages ago by servants of the Warrior-Saint, these little machines act as record-keepers of all the events that happen in the multiverse. They act in perfect concert, and move with an eerie buzzing noise that can disturb the cowardly. Individual scribeants are relatively harmless and are unable to cause damage, but when they are in a swarm, they can channel their eldritch power to produce startling shocks to those that they are touching.

When threatened, they will move with perfect precision to unleash a ray of radiant light from their gemstones, all targeting a single point on their enemy to sear their body and soul. They can also use this light for more mundane purposes, creating murals and inscriptions of things that they have recorded, or simply displaying what they have witnessed and heard. This makes them invaluable to justiciars, as they can display evidence of wrongdoing that is inalterable and unquestionable.

To summon a swarm, the brazier is lit and the appropriate oaths are made. The summoner will then begin to play the brazier like a drum, striking the outside with a hand or rod. Unharmed by the flames, they will imitate the buzzing of the scribeant swarm, and when performed properly, it will appear from within the fire ready to serve its purpose.

SCRIBEANT SWARM

Small swarm of Tiny constructs, neutral

Armor Class: 14 (natural armor)
Hit Points: 21 (6d6)
Speed: 10 ft., fly 30 ft.

STR	DEX	CON	INT	WIS	CHA
6 (-2)	16 (+3)	11 (0)	12 (+1)	12 (+1)	10 (+0)

Saving Throws: Con +4
Skills: Perception +5
Damage Resistances: bludgeoning, piercing, and slashing
Damage Immunities: necrotic, poison, psychic, radiant
Condition Immunities: charmed, diseased, frightened, grappled, paralyzed, petrified, poisoned, prone, restrained, stunned
Senses: blindsight 5 ft., passive Perception 15
Languages: Understands Common and those known by its master, but can't speak.
Challenge: 1 (200 XP)

Beautiful Craftwork. When immobile, the swarm is indistinguishable from a collection of cunningly-made statuettes or jewelry.

Fearsome Buzz. The swarm's orderly yet chaotic humming can cause fear in the hearts of lesser creatures. Whenever a creature with a CR of 1/4th or lower is in a space occupied by the swarm, it is frightened of the swarm and must attempt to move out of the swarm's space during its next turn.

Magic Resistance. The scribeant swarm has advantage on saving throws against spells and other magical effects.

Perfect Record. The swarm records everything it sees and experiences within an internal crystalline matrix, and can display images and sounds from this memory by projecting them onto a surface within 10 feet as an action. It can inscribe an image onto an appropriate surface using its Gem-light Lance over the course of 5 minutes.

Swarm Construct. The scribeant swarm can occupy another creature's space and vice versa, and the swarm can move through any opening large enough for a tiny scarab. The swarm can regain hit points from magic and resting, or from the *mending* cantrip at a rate of 1 hit point per casting.

ACTIONS

Gem-light Lance. *Ranged Spell Attack:* +5 to hit, range 30 ft., one target. *Hit:* 13 (4d6) radiant damage, or 7 (2d6) radiant damage if the swarm has half its hit points or fewer.

Hieroglyphic Spark. *Melee Spell Attack:* +5 to hit, reach 0 ft., one target within the swarm's space. *Hit:* 8 (2d8) lightning damage, or 4 (1d8) lightning damage if the swarm has half its hit points or fewer.

Shade Widow

The shade widow is an eerily silent spider-shaped construct made entirely of animate webbing and shaped obsidian. Created by the Weaver of Lies as assassins, these deadly objects are used to tie up loose ends wherever they arise. They'll often lie in wait under the beds of unsuspecting victims before emerging to bite with fangs coated in magical poison. Acolytes of the Weaver are fond of them due to their ability to create massive webs, making them invaluable while fleeing from an angry mob after the lies they've spun fall to tatters.

Summoning a shade widow is a perilous task. After lighting the brazier, the warlock must begin to chant and incant with perfect inaccuracy, deliberately twisting the normal ritual of summoning into something exactly wrong. This process causes eldritch pain to those not accustomed to lying with every breath, burning away at a fragment of the summoner's soul in order to give life to something false. During this, the summoner will throw sand into the brazier to magically heat, and then pour the resulting glass into the correct form of the shade widow.

A final sprinkle of blood is the last ingredient. This blood will become a strange poison that changes the glass to spider web obsidian and grants life and malice to the shade widow. Once it is summoned, the warlock must lie to it once more, claiming to be its true master before all others. Both the warlock and the widow know this to be false, for the shade widows are servants of the Weaver of Lies.

Shade Widow

Tiny construct, neutral

Armor Class: 14
Hit Points: 7 (2d4 + 2)
Speed: 30 ft., climb 30 ft.

STR	DEX	CON	INT	WIS	CHA
10 (0)	18 (+4)	12 (+1)	10 (+0)	11 (+0)	11 (+0)

Saving Throws: Dex +6
Skills: Perception +4, Stealth +8
Damage Resistances: bludgeoning, piercing, and slashing from nonmagical sources
Damage Immunities: poison, psychic
Condition Immunities: charmed, exhaustion, frightened, paralyzed, petrified, poisoned
Senses: blindsight 10 ft., darkvision 60 ft., passive Perception 14
Languages: Understands Common and those known by its master but can't speak or write
Challenge: 1 (200 XP)

Arachnid's Grace. The shade widow can climb difficult surfaces, including upside down on ceilings, without needing to make an ability check, and it ignores movement restrictions or difficult terrain caused by webbing.

Magic Resistance. The shade widow has advantage on saving throws against spells and other magical effects.

Web Sense. While in contact with a web, the shade widow knows the exact location of any other creature in contact with the same web.

Web Weaver. The shade widow can produce enough natural webbing per minute to cover a 10-foot radius. This webbing adheres to creatures and objects. If a creature falls prone in a space covered in webbing, or is shoved into a wall covered in webbing, its movement speed is halved until the end of its next turn.

Actions:

Bite. *Melee Weapon Attack:* +6 to hit, reach 5 ft., one target. 6 (1d4 + 4) piercing damage plus 11 (2d6 + 4) poison damage and the creature must make a DC 12 Constitution saving throw or be poisoned for 1 minute. The target can repeat this saving throw at the beginning of each of their turns, ending the effect on a success.

SPARK SEEKER

The spark seeker is a small, manta-ray-like creature that floats on the winds and uses them for defense. Once parasites that crawled upon the hide of the Storm Lord, the spark seekers have been touched by the legendary power of the godlike being and have grown and changed, gaining the ability to wield magical energies in exchange for service to the Lord. When threatened, they craft a shard of crystal by compressing the dust in the air around them and firing it at their target after charging it with electricity. When at rest, they scuttle along at a slow pace, finding a nook in some stone to lie in on a side that is exposed to the wind and elements. They enjoy gifts of meat and perfumes, and chirp excitedly when they are carried around. At night, colonies of spark seekers perform elaborate mating dances, lighting up the sky with flashes of lightning and strong gusts of wind. An entire colony of them working in concert can start a summon a massive and terrible storm, making them dangerous when near civilized areas.

Summoning one is simple: light the brazier, chant the proper words and praises to the Lord of Storms, extinguish the brazier with water, and then your desired spark seeker will appear from within the resulting fog and steam.

SPARK SEEKER

Tiny beast, neutral

Armor Class: 14 (natural armor)
Hit Points: 14 (4d4 + 4)
Speed: 5 ft., fly 45 ft.

STR	DEX	CON	INT	WIS	CHA
4 (-3)	17 (+3)	13 (+1)	11 (+0)	11 (+0)	10 (+0)

Skills: Perception +6
Damage Immunities: lightning, thunder
Senses: darkvision 120 ft., passive Perception 16
Languages: Understands those known by its master but can't speak or write
Challenge: 1 (200 XP)

Flutterby. The spark seeker can take the Disengage action as a bonus action.

Magic Resistance. The spark seeker has advantage on saving throws against spells and other magical effects.

Skyward Grasp. The spark seeker can cast either *levitate* or *gust of wind* (spell save DC 13) without expending a spell slot. Once it does so, it can't do so again until it finishes a short or long rest.

Storm Shield. Ranged attacks targeting the spark seeker are always made with disadvantage and cannot gain advantage from any source.

ACTIONS:

Spikeshard. *Ranged Weapon Attack:* +5 to hit, range 30 ft., one target. *Hit:* 3 (1d6) piercing damage plus 6 (1d4 +3) lightning damage.

VARIANT: SPARK SEEKER SWARM

Whenever more than 10 spark seekers are together, they can act as a single unit to form a spark seeker swarm. Add their total hit points together to determine the total hit points of the swarm. For every 5 spark seekers that the swarm starts with, it can make one additional spikeshard attack during its turn without using an action.

If a swarm started with more than 25 spark seekers, replace the spikeshard action with this one instead:

Spikeshard Volley. *Ranged Weapon Attack:* +10 to hit, range 120 feet, one target. *Hit:* 18 (6d6) piercing damage plus 36 (6d4 +18) lightning damage.

Whenever more than 100 spark seekers are present in the same swarm, the swarm can cast *storm of vengeance*, except the acid rain is replaced with freezing rain that inflicts cold damage instead. When cast in this way, the DC for this spell's saving throws is 20. All spark seekers in the swarm are immune to effects of this spell. Once a spark seeker has participated in a swarm that has cast this spell, it can't contribute to a new casting for one month.

I don't see why Xandith thinks these are cute. Just standing near one makes me all wobbly! Guess that's the downside of being an oozian. —Sylvette

SYMPHONIC SONGBIRD

The symphonic songbird is a colorful avian creature that mimics the voices of others, and can produce a beautiful melody fit for any occasion. They seem to originate from birds that have fallen for the allure of the Perfect Chord and have been touched by the magical emanations that constantly flow from it. Infused with choral power, they speak and sing with the voices of any sounds they have heard. Oddly enough, they seem to prefer being exposed to a constant onslaught of sound when at rest, and will seek out the noisiest place around to build their nests.

Colonies of songbirds will form full orchestral symphonies, to the delight of the rare few who are granted an audience. When threatened, they dazzle and strike with wicked beaks, inspiring one another to fight with fervor and fury against all aggressors. They enjoy gifts of fruit and shiny objects, which they use to build elaborate nests. Their songs are legendary for leading travelers astray, however, and they are often viewed with mistrust and suspicion by folk in less civilized lands.

SYMPHONIC SONGBIRD

Tiny fey, neutral

Armor Class: 14 (natural armor)
Hit Points: 14 (4d4 + 4)
Speed: 10 ft., fly 50 ft.

STR	DEX	CON	INT	WIS	CHA
4 (-3)	16 (+3)	12 (+1)	11 (01)	12 (+1)	16 (+3)

Skills: Perception +5, Performance + 7
Damage Immunities: thunder
Senses: passive Perception 15
Languages: All known by its master
Challenge: 1 (200 XP)

Flutterby. The symphonic songbird can take the Disengage action as a bonus action.

Magic Resistance. The symphonic songbird has advantage on saving throws against spells and other magical effects.

Perfect Mimicry. The songbird can perfectly replicate any sound that it has heard. A DC 20 Perception check reveals that the sound is falsified.

Shining Feathers. Hostile creatures that attack the songbird must make a DC 12 Charisma saving throw. If they fail, the attack misses.

Summoning a symphonic songbird involves singing, as one might expect. The brazier is lit, the incense is burned, and the summoner must begin a melody of their own creation. It must be carefully done, so that there is room for another to harmonize without interruption or disruption, and is often difficult for novices. Once the song reaches the correct moment, the fire within the brazier will coalesce into the image of a songbird, and it will begin to sing along with its new master. The summoner must continue their song to an appropriate closing, guiding the bird out from the brazier at the same time. Once it has emerged fully and is corporeal, the warlock must end the song and speak their name. The symphonic songbird will repeat the name perfectly, and then speak its own. When the warlock does the same and speaks the songbird's name in exact mimicry, the bond between familiar and master will be formed.

ACTIONS:

Peck. *Melee Weapon Attack:* +5 to hit, range 5 ft., one target. *Hit:* 4 (1d4 + 2) piercing damage and 2 (1d4) psychic damage.

Fitting Tune. *(Recharges after a short or long rest).* The symphonic songbird chirps a beautiful song. Allied creatures within 30 feet gain advantage on their next attack roll, saving throw, or ability check.

I told one to pipe down. Then it told me to pipe down in my own voice. Then all of the others told me to pipe down in my own voice. Then I yelled at them. Then they yelled at me back, identically, but louder. I almost fell over. In short, just don't go near them unless you like mocking yourself. -X

Wealth Mimic (Karensee)

A deadly thing that lurks in the pockets of countless saints and villains alike, money is a tool that brings both salvation and misery. Not all funds can be trusted, however. The Currency Conspiracy has been gradually replacing the original currencies of the world with karensee, colloquially known as wealth mimics. They can take an endless number of forms, but they are restricted, unlike their larger kin. These mimics can only choose to turn into objects that appear to be of value. A gold coin, a bill, a gemstone, a necklace of pearls: all of these things are potential wealth mimics. Most of them are asleep, trapped in a singular form. They feign damage or other ill effects while they are sleeping, behaving exactly like natural materials. However, when they are awakened by eldritch magic, they come to life and attack those who sought to own them. Members of the Currency conspiracy often call and awaken wealth mimics using a ritualistic rite, but any warlock of sufficient power and knowledge can summon one.

The first steps are relatively easy. The summoner must ignite the brazier and stand adjacent to it, speaking the correct incantations. Once the fire has burned down to embers, the summoner must insert a single object of value that a wealth mimic could imitate, such as a coin or bank note.

Next, the warlock must offer blood. When a few drops are applied to the object within the brazier, the flames will flare to life once more, consuming the object and then disappearing. The ashes will begin to form together into a shape identical to that of the object, and a new wealth mimic will be born. It will speak a single word, giving itself a name. So long as that name is known by its master, it will obey perfectly, changing shape and killing on command.

Wealth mimics enjoy being fed other currency. Some scholars whisper that this is intended to give them power, but others suspect that they are simply innately cannibalistic. Those in the Conspiracy are believed to have created the wealth mimics with a built-in safety measure, in case something goes wrong with the final plan. In that instance, they would consume one another in a frenzy after being deprived of other flesh, rendering them harmless to those they could not reach.

Karensee (Wealth Mimic)

Tiny monstrosity (shapechanger), neutral

Armor Class: 16 (natural armor)
Hit Points: 24 (4d4 + 16)
Speed: 15 ft.

STR	DEX	CON	INT	WIS	CHA
16 (+3)	10 (+0)	18 (+4)	8 (-1)	10 (+0)	10 (+0)

Skills: Stealth +8
Damage Resistances: bludgeoning, piercing, and slashing from nonmagical sources
Damage Immunities: acid, poison
Condition Immunities: charmed, exhaustion, frightened, paralyzed, petrified, poisoned
Senses: darkvision 120 ft., passive Perception 10
Languages: Understands those known by its master but can't speak or write
Challenge: 1 (200 XP)

Aggressive Adhesion. Whenever the karensee touches a creature, it can choose to adhere to them as a reaction. If it does, it sticks to the target. A creature can make a DC 13 Strength (Athletics) check to scrape the karensee off of them. While a karensee is adhered to a creature, it has advantage on attack rolls against that target.

Magic Resistance. The karensee has advantage on saving throws against spells and other magical effects.

Masterful Mimicry. When the karensee touches another unit of wealth, it can use a reaction to become an identical copy of that wealth. It can attack and perform actions regardless of form or appearance, but on a turn that it has taken no actions it is immune to damage and cannot be detected by any means short of truesight.

Pocket Jump. The wealth mimic can teleport up to 15 feet as a bonus action.

Actions:

Bite. *Melee Weapon Attack:* +5 to hit, range 5 ft., one target. *Hit:* 6 (1d6 + 3) piercing damage plus 3 (1d4) acid damage.

Wiggly Cube

The wiggly cube is a small, colorful, semi-transparent ooze that gently dissolves a little of everything it touches in a quest to experience all the flavors of the multiverse. They are sent down by the greater cubes within the Convocation to learn and grow before eventually returning to the space between the planes where the Gelatinous Convocation makes its home. They're surprisingly expressive for a simple square of slime, and often bounce and jiggle to express their feelings on a topic. They enjoy consuming corpses and other dead organic material, as they learn more and more about the universe with each meal. When threatened, the cube will resort to violence with an intimidating glee, lashing out with its pseudopods and trying to goad the attacker into engaging in melee combat. Against foes smaller than itself, the cube will rush them and attempt to engulf and consume them. They speak to the minds around them with a childlike innocence even as they feast on dead mortals and beasts alike. When at rest, the cube will seek a stone surface to rest upon, and will wobble slowly back and forth in a pattern seemingly designed to entice the unwary into touching it.

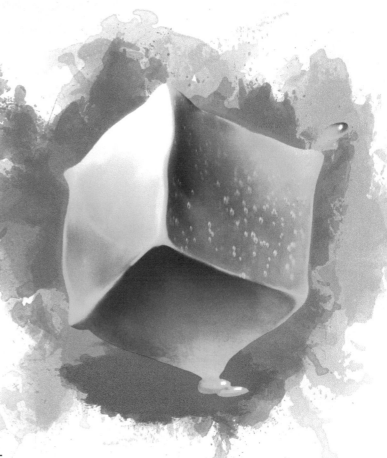

Wiggly Cube

Small ooze, neutral

Armor Class: 8
Hit Points: 45 (6d6 + 24)
Speed: 25 ft.

STR	DEX	CON	INT	WIS	CHA
14 (+2)	6 (-2)	18 (+4)	8 (-1)	10 (+0)	14 (+2)

Damage Immunities: acid, cold, bludgeoning, poison
Condition Immunities: blinded, charmed, deafened, exhaustion, frightened, poisoned, prone
Senses: blindsight 10 ft., darkvision 60 ft., passive Perception 10
Languages: Understands Common and those known by its master, and can speak telepathically to creatures within 10 feet of it, but can't speak or write otherwise.
Challenge: 1 (200 XP)

Corrosive Form. A creature that hits the cube with a melee attack while within 5 feet of it takes 4 (1d8) acid damage. The cube can eat through 1-inch-thick nonmagical wood or metal in one round.

Magic Resistance. The wiggly cube has advantage on saving throws against spells and other magical effects.

Ooze Cube. The cube occupies its entire space whenever it is Medium or larger. Other creatures can enter the space, but a creature that does so is subjected to the cube's Engulf and has disadvantage on the saving throw.

Creatures inside the cube can be seen but have total cover.

A creature within 5 feet of the cube can take an action to pull a creature or object out of the cube. Doing so requires a successful DC 12 Strength check, and the creature making the attempt takes 4 (1d8) acid damage.

The cube can only hold one creature equal to its size, or four creatures of one size or more smaller than itself.

Squishy. The cube is immune to falling damage.

Transparent. Even when the cube is in plain sight, it takes a successful DC 15 Wisdom (Perception) check to spot a cube that has neither moved or attacked. A creature that tries to enter the cubes space while unaware of it is surprised by the cube.

Actions:

Pseudopod. *Melee Weapon Attack:* +2 to hit, range 5 ft., one target. *Hit:* 5 (1d6+2) acid damage.

Engulf. The cube moves up to its speed. While it does so, it can enter the spaces of other creatures. Whenever the cube enters the space of a hostile creature, and the creature is of the same size or smaller than the cube, it must make a DC 12 Dexterity saving throw. If it succeeds, it can choose to be pushed 5 feet back or to the side of the cube. A creature that chooses not to be pushed suffers the consequences of a failed saving throw.

On a failed save, the cube enters the creature's space, and the creature takes 4 (1d8) acid damage and is engulfed. The engulfed creature can't breathe, is restrained, and takes 14 (3d8) acid damage at the start of each of the cube's turns. When the cube moves, the engulfed creature moves with it. An engulfed creature can try to escape by taking an action to make a DC 12 Strength check. On a success, the creature escapes and enters a space of its choice within 5 feet of the cube.

Warlock, Lesser

Humanoid (any), any alignment

Armor Class: 14 (studded leather armor)
Hit Points: 26 (4d8 + 8)
Speed: 30 ft.

STR	DEX	CON	INT	WIS	CHA
14 (+2)	14 (+2)	14 (+2)	10 (+0)	10 (+0)	16 (+3)

Skills: Arcana +2, Perception +2
Senses: passive Perception 12
Languages: Common, (patron's language)
Challenge: 1 (200 XP)

Minor Pact Boon: The warlock has either a familiar (via *find familiar*), a martial weapon that inflicts magical damage, or knows one spell from any spell list.

Patron Feature: The warlock gains an additional feature based on its patron.

Accursed Archive: The warlock gains an additional spell slot.

Ashen Wolf: The warlock gains the Breath of Smoke feature.

Eternal Citadel: The warlock gains the Force of Preservation feature.

Fallen Exile: The warlock gains the Cosmic Conduit feature.

Forbidden Graveyard: The warlock gains the Ghoulish Constitution feature.

Gelatinous Convocation: The warlock gains the Jiggly Defense invocation.

Gray Portrait: The warlock gains the Cursed Portfolio invocation.

Keeper of the Depths: The warlock gains the Clash of Wills invocation.

Perfect Chord: The warlock gains the Adjusted Cadence feature.

Serpent Empress: The warlock gains the Blessing of the Empress feature.

Shadowcat: The warlock gains the Umbral Leap feature.

Storm Lord: The warlock gains the Majesty of the Cloud Ruler feature.

Warrior-Saint: The warlock gains the Titan's Blade invocation.

Weaver of Lies: The warlock gains the Silver Tongue invocation.

Wild Huntsman. The warlock gains the Black Frost invocation.

Spellcasting: The warlock is a 3rd-level spellcaster. It's spellcasting ability is Charisma (save DC 13, +5 to hit with spell attacks). The warlock knows the following spells, and has two 2nd-level spell slots:

Cantrips (at will): *eldritch blast, minor illusion*
1st level: *(patron expanded spells)*
2nd level: *(patron expanded spells)*

Actions:

Dagger. *Melee Weapon Attack.* +4 to hit, reach 5 feet., one target. Hit: 4 (1d4 +2) piercing damage.

Warlock, Greater

Humanoid (any), any alignment

Armor Class: 16 (*mage armor*)
Hit Points: 72 (12d8 + 24)
Speed: 30 ft.

STR	DEX	CON	INT	WIS	CHA
14 (+2)	16 (+3)	14 (+2)	10 (+0)	10 (+0)	20 (+5)

Skills: Arcana +2, Perception +2
Senses: passive Perception 12
Languages: Common, (patron's language)
Challenge: 5 (1000 XP)

Major Pact Boon: The warlock has a familiar appropriate to their patron, and a magical weapon (as described below). Also, they can cast *mage armor* targeting themselves without using a spell slot at will.

Patron Feature: The warlock gains an additional feature based on its patron, as described in the adjacent table.

Spellcasting: The warlock is a 9th-level spellcaster. It's spellcasting ability is Charisma (save DC 17, +9 to hit with spell attacks). The warlock knows the following spells, and has two 5th-level spell slots:

Cantrips (at will): *eldritch blast, minor illusion, scorch*, shadowthorn**
1st level: *(patron expanded spells)*
2nd level: *(patron expanded spells)*
3rd level: *(patron expanded spells)*
4th level: *(patron expanded spells)*
5th level: *(patron expanded spells)*

Actions:

Assault. The warlock makes two attacks with its eldritch weapon, or casts a cantrip and makes a single weapon attack.

Eldritch Weapon. *Melee Weapon Attack.* +9 to hit, reach 5 feet., one target. Hit: 21 (2d10 +10) force damage.

You know what's wrong with warlocks these days? No respect. "Oh, I think I'll just go buy some power today after lunch." Yeah, and what about that wizard that studied for a few years just so they could incant without burning the whole village down? Does she get an entire book dedicated to her arcane art? No? Seems a little one-sided, doesn't it? -Sylvette!

You have, like, forty books in your room on magic. I'm not sure why you're upset. Wizards write books all the time. -X

ELDRITCH MAGIC

The following section contains new spells and arcane magic for each of the spellcasting classes. The following list describes which spells are available to each class.

BARD SPELLS

CANTRIPS (0 LEVEL)
Animate Skull
Cheerful Song
Forget
Fresh Paint
Glimmer
Seek Phrase

1ST LEVEL
Black Lotus Assault
Duskwalk
Shrill Whistle
Spider's Kiss

2ND LEVEL
Dark Secret
Replenish
Shadow Armor
Sinister Threat
Suffer

3RD LEVEL
Blasphemy
Creeping Dark
Resonance
Shadow Toxin

4TH LEVEL
Flashing Blades
Haunt
Shadow Refuge
Shattersong
Sleepwalking
Unspoken Agreement
Unseen Claw

5TH LEVEL
Overwhelming Emotion

6TH LEVEL
Blood Cartography

7TH LEVEL
Spreading Nightmare

8TH LEVEL
Reflective Defense

9TH LEVEL
Touch Infinity

CLERIC SPELLS

CANTRIPS (0 LEVEL)
Animate Skull
Break
Cheerful Song
Douse
Jolt
Scorch

1ST LEVEL
Defy Ruin
Mend Flesh

2ND LEVEL
Skystrike
Suffer

3RD LEVEL
Blackened Heart
Funeral Pyre

4TH LEVEL
Dark Empowerment
Mark of Objection

5TH LEVEL
Angelic Rebuke
Falling Star
Forgotten Pain
Storm's Eye

6TH LEVEL
Blood Cartography
Hellish Halo

7TH LEVEL
Cruel Wind

8TH LEVEL
Undertow

9TH LEVEL
Armageddon
End of Days

DRUID SPELLS

CANTRIPS (0 LEVEL)
Cheerful Song
Douse
Fresh Paint
Jolt

1ST LEVEL
Duskwalk
Hunter's Pace
Mend Flesh
Shrill Whistle

2ND LEVEL
Heartripper
Replenish
Skystrike

3RD LEVEL
Blackened Heart
Crushing Tide
Frozen Lance
Luring Light
Resonance
Serpent's Bite
Skewering Vines
Venom Blast

4TH LEVEL
Ashen Pack
Bloodthorn
Cage of Briars
Forbidden Obelisk
Serpentine Ward
Skin of Flint
Sleepwalking
Windblade

5TH LEVEL
Constriction
Hungering Hate
Nemesis
Storm's Eye
Unstoppable Ascent

6TH LEVEL
Blood Cartography
Perfect Toxin

7TH LEVEL
Spreading Nightmare
Cruel Wind

8TH LEVEL
Undertow

PALADIN SPELLS

1ST LEVEL
Defiant Smite
Defy Ruin

2ND LEVEL
Dark Secret
Skystrike
Suffer

3RD LEVEL
Almighty Assault
Funeral Pyre
Irreversible Smite

4TH LEVEL
Dark Empowerment
Mark of Objection
Unspoken Agreement

5TH LEVEL
Angelic Rebuke
Falling Star
Punishing Smite

RANGER SPELLS

1ST LEVEL
Black Lotus Assault
Duskwalk
Falling Spider's Spite
Hunter's Pace
Masterful Focus
Mend Flesh
Shrill Whistle

2ND LEVEL
Dissociative Edge
Heartripper
Replenish
Sinister Threat

Wait, so I made Pyre, right? If you two got married, would that make me your mother-in-law?!

Let's not think about it. -X

Skystrike
Skyward Rise
Wolfbane Trap

3RD LEVEL
Creeping Dark
Fox's Fangs
Frozen Lance
Serpent's Bite
Venom Blast

4TH LEVEL
Ashen Pack
Assassin's Promise
Bloodthorn
Cage of Briars
Haunt
Serpentine Ward
Unspoken Agreement
Windblade

5TH LEVEL
Constriction
Nemesis
Storm's Eye

SORCERER SPELLS

CANTRIPS (0 LEVEL)
Animate Skull
Break
Cheerful Song
Douse
Forget
Fresh Paint
Glimmer
Jolt
Scorch
Seek Phrase
Shadowthorn

1ST LEVEL
Black Lotus Assault
Duskwalk
Masterful Focus
Spider's Kiss

2ND LEVEL
Accursed Wish
Dark Secret
Dissociative Edge
Heartripper
Replenish
Shadow Armor
Skystrike
Spell Flux
Suffer

3RD LEVEL
Blackened Heart
Creeping Dark
Crushing Tide

Frozen Lance
Funeral Pyre
Serpent's Bite
Shadow Toxin
Venom Blast

4TH LEVEL
Ashen Pack
Dark Empowerment
Skin of Flint
Slime Sphere
Unseen Claw
Unspoken Agreement
Windblade

5TH LEVEL
Constriction
Falling Star
Overwhelming Emotion
Shadow World
Summon Slime
Wall of Ooze

6TH LEVEL
Hellish Halo

7TH LEVEL
Otherworldly Lair

8TH LEVEL
Reflective Defense

9TH LEVEL
Armageddon

WARLOCK SPELLS

CANTRIPS (0 LEVEL)
Animate Skull
Break
Cheerful Song
Douse
Forget
Fresh Paint
Glimmer
Jolt
Scorch
Seek Phrase
Shadowthorn

1ST LEVEL
Assassin's Burial
Corruption
Hellfire Lash
Lightning Shard
Malice of Arachia
Rimesworn Blade

2ND LEVEL
Black Pillar
Coldfire Blast
Dark Lightning
Devilish Hunt
Dissociative Edge
Sinister Threat
Skyward Rise
Tormented Flurry

3RD LEVEL
Detect Interference
Eldritch Barrier
Fallen Soul
Fox's Fangs
Grim Scythe
Serpent's Bite

4TH LEVEL
Crimson Cloak
Deadly Doorway
Haunt
Invitation
Power Word Crush
Shadow Refuge

5TH LEVEL
Fell Onslaught
Implement of Cruelty
Shroud of Surok
Wings of Night

6TH LEVEL
Blood Cartography
Hellish Halo
Perfect Toxin

7TH LEVEL
Spreading Nightmare
Cruel Wind
Otherworldly Lair

8TH LEVEL
Carnage
Reflective Defense
Undertow

9TH LEVEL
Armageddon
End of Days
Touch Infinity

WIZARD SPELLS

CANTRIPS (0 LEVEL)
Animate Skull
Break

Cheerful Song
Douse
Forget
Fresh Paint
Glimmer
Jolt
Scorch
Seek Phrase
Shadowthorn

1ST LEVEL
Black Lotus Assault
Duskwalk
Masterful Focus
Spider's Kiss

2ND LEVEL
Accursed Wish
Dark Secret
Dissociative Edge
Shadow Armor
Skystrike
Spell Flux
Suffer

3RD LEVEL
Blackened Heart
Creeping Dark
Crushing Tide
Frozen Lance
Funeral Pyre
Serpent's Bite
Shadow Toxin
Venom Blast

4TH LEVEL
Ashen Pack
Dark Empowerment
Skin of Flint
Slime Sphere
Unseen Claw
Unspoken Agreement
Windblade

5TH LEVEL
Constriction
Falling Star
Overwhelming Emotion
Shadow World
Summon Slime
Wall of Ooze

6TH LEVEL
Blood Cartography

8TH LEVEL
Reflective Defense

9TH LEVEL
End of Days
Touch Infinity

So here's my favorite trick – I cast Hellish Halo to stay alive, then Wings of Night to fly into battle, and empower my Scorched Blade using Tormented Flurry. Makes the dragon meat nice and tender. – X

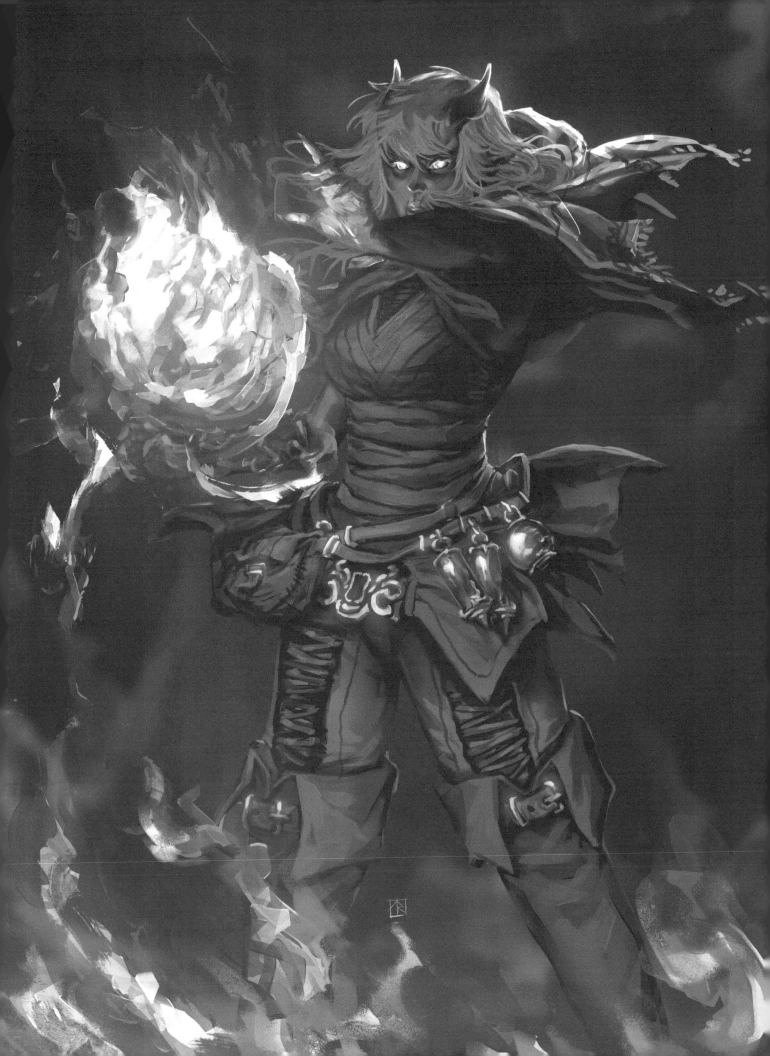

Accursed Wish
2nd-level conjuration

Casting Time: 1 action
Range: Self
Components: V
Duration: Instantaneous

There is always a price for power.

You speak aloud, demanding a boon from one of the darkest planes. You instantly replicate the effects of any spell of 1st level with a casting time of 1 action or bonus action that deals damage, or any cantrip from any spell list. Each time you cast this spell, roll a d20. If the result is 1, you are struck by an unholy force, reducing you to 0 hit points and causing you to fail your first and second death saving throws immediately after the spell is cast. If you are struck down a second time due to this spell before you finish a long rest, you die and cannot be resurrected by a spell cast using a spell slot lower than 8th level.

At Higher Levels: When you cast this spell using a spell slot of 3rd level, you can replicate a spell of 2nd level or lower, and the threshold for being struck down increases to a result of 2 or lower. When you cast this spell using a spell slot of 4th level, you can replicate a spell of 3nd level or lower, and the threshold for being struck down increases to a result of 3 or lower. This pattern continues until the spell is cast using a slot of 7th or higher level, where no additional effect is gained and the threshold is not increased.

Almighty Assault
3rd-level evocation

Casting Time: 1 action
Range: 5 feet
Components: V, M (any weapon)
Duration: Instantaneous

And so the wrath of the righteous shall shatter mountains.

As part of the action used to cast this spell, you must make a melee weapon attack against one creature or location within the spell's range. Depending on the damage type the weapon deals, the spell has a different area of effect:

- **Slashing.** A crescent of energy races from the attack, and each creature in a 20-foot cone in the direction of the target must make a Dexterity saving throw.

- **Piercing.** A pure beam of energy streams from the attack, and each creature in a 60-foot line, 5 foot wide line must make a Dexterity saving throw.

- **Bludgeoning.** Explosive energy emanates from the attack, and each creature other than you within 10 feet of the target must make a Dexterity saving throw.

Creatures that fail their saving throw take 2d10 radiant damage, are pushed 10 feet back, and fall prone. A creature that was hit by your attack has disadvantage on the saving throw.

At Higher Levels: When you cast this spell using a spell slot of 4th level or higher, the radiant damage increases by 1d10 per slot level above 3rd.

Animate Skull
Necromancy cantrip

Casting Time: 1 action
Range: Touch
Components: V, S, M (a skull)
Duration: 1 hour

The saying "Dead men tell no tales." isn't always true.

You imbue a skull with necromantic magic, granting it an eerie semblance of life. When you cast this spell, you can speak a phrase of 10 words or fewer. Whenever a creature touches the skull or enters a space within 5 feet of it, the skull speaks the phrase. You can also choose to infuse the skull with malicious energy. When you do, once per turn when a creature other than you touches the skull, it will snap at them with its teeth. The creature must make a Dexterity saving throw. If they fail, they take 1d4 piercing damage. An animated skull has 6 AC and 1 hit point.

This spell's piercing damage increases by 1d4 when you reach 5th level (2d4), 11th level (3d4), and 17th level (4d4).

Angelic Rebuke
5th-level evocation

Casting Time: 1 reaction, which you take in response to being damaged by a creature within 60 feet of you that you can see.
Range: 60 feet
Components: V
Duration: Instantaneous

Even the darkest fiend cannot withstand the light of heaven.

With a word, you invoke the searing radiance of the higher planes to strike down your attacker. The creature must make a Charisma saving throw. If they fail, they are blinded until the start of your next turn and take 5d10 radiant damage. If they succeed, they take half as much damage and are not blinded.

Armageddon
9th-level evocation

Casting Time: 1 hour
Range: 5 miles
Components: V, S, M (a heart of broken glass, defiled with the blood of an innocent humanoid)
Duration: Instantaneous

The prophets spoke of the day that the world would stand upon a precipice and stare into the abyss. They did not foresee this.

You chant a series of commands, calling upon every favor and every force that you can muster, preparing to break reality. You cannot move while you are casting this spell. Every creature within range knows that you are casting this spell, is aware of the consequences, and is aware of your exact location for the entire time that it is being cast. Choose a point that you can see within range. A 1-mile-radius sphere centered on that point erupts in a singular explosion of unspeakable fire. Any creature, including you, that can see that point at the time that the spell is cast is permanently blinded. Non-magical structures and objects within the radius are destroyed instantly. Creatures in the radius are knocked prone and take 10d10 force damage, 10d10 radiant damage, and 10d10 fire damage. If they die, they are reduced to ash. A massive crater is carved into the ground, and is left burning with sickening

energy. Any creature that starts its turn within the crater takes 2d10 radiant damage and 1d10 fire damage. The crater burns for one month. You immediately gain 5 levels of exhaustion after casting this spell, and if this kills you, you cannot be resurrected by any means.

ASHEN PACK
4th-level conjuration

Casting Time: 1 action
Range: Self
Components: V, S
Duration: Concentration, up to 10 minutes

Those are not torches burning in the woods beyond.
They are eyes, and they are hungry.

With a gesture, you summon three flaming wolves made from ash and metal into your space. When you cast this spell, and as an action on each of your turns while it is in effect, you can choose a point within 60 feet of you. When you do, one of the flaming wolves rushes to the target point, and then seeks out the nearest creature within 30 feet of it, making a melee spell attack using your spell attack modifier. If the attack hits, the target takes 4d10 fire damage and must make a Strength saving throw. If the target fails, they are knocked prone. The flaming wolf then immediately returns to your space, coiling around your feet. The wolves have an AC equal to your spell save DC. If a flaming wolf is struck by a weapon or spell attack or is prevented from returning to your space after making an attack, it vanishes. The spell ends when all three wolves are lost, or you lose concentration.

 At Higher Levels: When you cast this spell using a spell slot of 5th level or higher, the fire damage of the wolf's attack increases by 1d10 per spell slot level above 4th.

ASSASSIN'S BURIAL
1st-level enchantment

Casting Time: 1 action
Range: Touch
Components: V, S, M (a corpse of a humanoid creature)
Duration: 24 hours

Hiding in plain sight is something all the best will boast of, but few can conceal the results.

You touch a single humanoid corpse that died within the last hour, and imbue it with a foul enchantment. If a creature discovers the corpse that was unaware of it when the spell was cast, they must make a Charisma saving throw. If they fail, they are frightened of the corpse until the end of their next turn and will attempt to move so that they can no longer see it. If the subject attempts to reveal the presence the corpse to any other creature, they immediately forget that they have detected the corpse for one hour. Each time this happens, the target can make a Wisdom saving throw. If they succeed, the spell ends after this instance of temporary memory loss.

 At Higher Levels: When you cast this spell using a spell slot of 2nd level or higher, the duration of the spell increases by 1 week per spell slot level above 1st.

ASSASSIN'S PROMISE
4th-level enchantment

Casting Time: 1 action
Range: 30 feet
Components: V
Duration: 24 hours

The price has been paid. The contract is made.
The night falls, and so rises the blade.

You whisper a dark oath to a humanoid creature within range, promising their death. Whenever you inflict damage to the target, you can choose to place a layer of a shadowy curse upon them. If the target dies before the end of the duration, you recover hit points equal to the number of layers you've applied to the target, and you gain a number of gold pieces equal to the sum of the target's ability score modifiers. If the creature still lives at the end of the duration, and the curse has not been removed using a *remove curse* spell or similar magic, the target takes 1d6 psychic damage for each layer applied. If you are dead, the target takes twice as much psychic damage and gains a level of exhaustion. The target is aware of the curse's effect.

BLACK LOTUS ASSAULT
1st-level illusion

Casting Time: Special
Range: Self
Components: V, S, M (a melee weapon)
Duration: 1 minute

The black lotus only blooms during the solar eclipse, when the nearest star understands its own mortality.

The first time you take the Attack action during your turn, you can cast this spell to summon a swirl of black lotus petals to surround your weapon, distracting your foes and enabling you to strike with great power. Each successful hit you make with this weapon before the spell ends, the target must make a Wisdom saving throw or have a new effect apply. Once you've made three weapon attacks, the spell ends.

- **1st Hit:** If the target fails their saving throw, their movement speed is halved until the end of their next turn.
- **2nd Hit:** If the target fails their saving throw, they take 1d6 psychic damage and cannot take reactions until after the end of your next turn.
- **3rd Hit:** If the target fails their saving throw, they take 2d6 psychic damage and cannot take bonus actions during their next turn.

 At Higher Levels: When you cast this spell using a spell slot of 2nd level or higher, the psychic damage of the 2nd hit increases by 1d6 per spell slot level above 1st.

I've used this one to great effect. Or did I keep missing? I can't really remember. What were we talking about? Magic? Oh. I don't think I know anything about that.
-Formerly Someone

Black Pillar
2nd-level conjuration

Casting Time: 1 action
Range: 60 feet
Components: V, S, M (a small rectangular stone)
Duration: Until dispelled

A monument, they said to him. Thus it was built, but like no other they had seen. To this day, they regret their request.

You gesture to the ground and speak an incantation, calling a pillar of stone to rise from the earth at a location within range. The pillar is 15 feet tall, 5 feet on each side, covered in cruel spikes, and has a flat top that can be safely stood upon. If a creature is caught between the pillar and another surface, such as a ceiling, they must make a Dexterity saving throw. If they fail, they take 2d10 bludgeoning damage and fall prone in the nearest open space. If a creature is shoved or pushed against the sides of the pillar, they take 1d6 piercing damage. The pillar can be climbed safely by making an Athletics check with a DC equal to your spell save DC. The pillar has hit points equal to fifteen times your spellcasting modifier (minimum 15) and AC 10.

Blackened Heart
3rd-level necromancy

Casting Time: 1 action
Range: 60 feet
Components: V, S
Duration: Instantaneous

Corruption waits for the perfect moment to strike.

You reach out towards a living creature that you can see. The target must make a Constitution saving throw. If it fails, its body is filled with vile poison, and it takes 10d6 poison damage at the start of its next turn. If the target is reduced to 0 hit points before the start of its next turn, the poison explodes outward from it in a shower of disgusting bile. Creatures within a 10-foot radius of the target must make a Dexterity saving throw. If they fail, they take 10d6 poison damage, or half as much on a successful save.

At Higher Levels: When you cast this spell using a spell slot of 4th level or higher, the damage of each phase of the spell increases by 2d6 per spell slot level above 3rd.

Blasphemy
3rd-level abjuration

Casting Time: 1 action
Range: Self (60 feet)
Components: V
Duration: 1 minute

Defy those who create life, for their life is equally false.

You curse, and will away the healing magics of nature and the gods. Each time a creature within a 60-foot radius of you would recover hit points from a spell, it must make a Charisma saving throw. If it fails, it does not recover hit points and instead takes 1d6 psychic damage. You can end this spell as an action.

Bloodthorn
4th-level necromancy

Casting Time: 1 action
Range: 60 feet
Components: V, S, M (a thorn)
Duration: Instantaneous

A leaf on the wind is free, but a thorn on the wind means to flee.

You imbue a single thorn with a deadly enchantment, hurling it out towards a creature that you can see within range. Make a ranged spell attack roll. If you hit, the target takes 5d10 piercing damage. If you hit, you can choose an additional target for the bloodthorn to seek, repeating the attack against a different target within 60 feet of the previous one and using the thorn's new position to determine if a target would gain the benefits of cover. You can repeat this process up to three times or until the attack misses. A creature cannot be targeted more than once.

At Higher Levels: When you cast this spell using a spell slot of 5th level or higher, the piercing damage increases by 1d10 per spell slot level above 4th.

Blood Cartography
6th-level necromancy (ritual)

Casting Time: 1 action
Range: Touch
Components: V, S, M (a corpse or vial of blood and a parchment)
Duration: Instantaneous

The blood always remembers.

You draw blood from the vial or corpse and cast it upon the parchment. The blood flows together, forming a clear map of every location that the former owner of the blood has traveled within the past month. The path the creature took is highlighted, and the time spent in each location is indicated by the thickness of the blood-markings. The blood-map dries within one minute, and becomes permanent and impossible to dispel.

Break
Evocation cantrip

Casting Time: 1 action
Range: 30 feet
Components: V,S
Duration: Instantaneous

The world is a brittle thing in the hands of a god.

You snap your fingers, generating a thunderclap of sound that can be heard up to 100 feet away. You inflict 10 thunder damage to an unattended object that you can see within range. Even if the object remains intact, it flings small shards of shrapnel at creatures within 5 feet of it. Each creature must make a Dexterity saving throw. If they fail, they take 1d4 piercing damage.

This spell's piercing damage increases by 1d4 when you reach 5th level (2d4), 11th level (3d4), and 17th level (4d4), and the spell's thunder damage also increases by 10 at each of these levels.

CAGE OF BRIARS
4th-level conjuration

Casting Time: 1 minute
Range: 30 feet
Components: V, S, M (a small woven basket)
Duration: 8 hours

To make a mortal crave freedom, give them a cage. To make a mortal crave order, set them free.

As you cast this spell, you create a cage of thorned briars that surrounds a 10-foot cube within range. The briars are thick and only allow a small amount of light and air to pass through, providing three-quarters cover to creatures within and total cover to creatures outside. You, and any others you designate, can pass through the cage at will. The briar cage has AC 10, 200 hit points, and vulnerability to fire. A creature that hits the cage with an unarmed strike or natural weapon, such as a bite or claw, takes 1d4 piercing damage.

At Higher Levels: When you cast this spell using a spell slot of 5th level or higher, the cage's hit point total increases by 20 per spell slot level above 4th.

CARNAGE
8th-level evocation

Casting Time: 1 action
Range: Self
Components: V, S, M (a martial weapon)
Duration: 1 minute

Blood will rain upon the battlefield, and a single warrior will stand alone before the armies of heaven and hell.

When you cast this spell, you teleport 120 feet and make a melee weapon attack against all creatures within your reach. Roll a single attack for all targets. If you hit a creature, it takes an additional 6d12 force damage. On your subsequent turns, you can use your action to continue your deadly assault. Each time you use this action, it has a different effect:

- **2nd Use.** You teleport up to 60 feet and make a melee weapon attack against all creatures within a 20-foot-cone. Each creature you hit is knocked prone and takes an additional 6d12 force damage.
- **3rd Use.** You teleport up to 30 feet and make a single melee weapon attack against a creature within reach. If the creature is above half its maximum hit points, this attack inflicts an additional 6d12 force damage. If you hit, the creature is then paralyzed until the end of your next turn.
- **4th Use.** You teleport up to 60 feet into the air and descend, smashing into the ground at a point of your choosing that you can see within 120 feet of your starting point. You take no falling damage, but each creature within 30 feet of you must make a Constitution saving throw. If they fail, they take 6d12 force damage. You then make a melee weapon attack targeting a creature within reach. If you hit, the target takes an additional 8d12 force damage.

CHEERFUL SONG
Enchantment cantrip

Casting Time: 1 action
Range: 60 feet
Components: V
Duration: Instantaneous

A tune, sweetly sung, is worth more than all wealth or war.

You sing a happy little tune, bolstering the spirits of up to 3 friendly creatures within range. Affected creatures gain 1 temporary hit point, and can add a +1 bonus to their first attack roll, saving throw, or ability check made before the start of your next turn.

COLDFIRE BLAST
2nd-level evocation

Casting Time: 1 action
Range: 120 feet
Components: V, S
Duration: Instantaneous

The freezing cold of the desert night compares favorably to the burning sunlight.

You unleash a burst of frozen fire at a target you can see within range, which manifests as a missile of ever-changing ice glowing with a crackling heart. Each creature in a line 5 feet wide and 120 feet long must make a Dexterity saving throw, starting with the creature closest to you. The spell impacts the first creature in the line that fails their saving throw, inflicting 2d8 cold damage. If all targets succeed, the projectile continues in a straight line until it impacts a surface. Once the projectile impacts something or reaches the end of the line, it detonates in a blast of fire. All objects and creatures within 10 feet of the detonation take 1d8 fire damage, and unattended flammable objects are ignited.

At Higher Levels: When you cast this spell using a spell slot of 3rd level or higher, either the cold or fire damage (your choice) increases by 1d8 per slot level above 2nd.

CONSTRICTION
5th-level transmutation

Casting Time: 1 action
Range: Touch
Components: V, S
Duration: Concentration, up to 1 minute

The crushing grasp and merciless gaze displays an ambition that cannot be quenched with gold, but can be sated with blood.

Your body becomes eerily serpentine and you strike forward, attempting to grasp a creature within range. Make a melee spell attack. If you hit, your grapple your target using the body part you attacked with and squeeze them, dealing 5d10 bludgeoning damage. Until the spell ends, the grappled target is also restrained. As a bonus action on each of your subsequent turns while you have restrained the creature, you can continue to crush the target. The creature must make a Strength saving throw. If they fail, they take an additional 5d10 bludgeoning damage. If the target escapes the grapple, the spell ends.

At Higher Levels: When you cast this spell using a spell slot of 6th level or higher, each instance of bludgeoning damage increases by 1d10 per spell slot level above 5th.

CORRUPTION
1st-level necromancy

Casting Time: 1 action
Range: 120 feet
Components: V, S
Duration: 1 minute

Slow and insidious, yet deadly nevertheless.

Your inflict a withering curse upon a 5-foot square of ground at a location you can see within range, withering plants and darkening the earth with fell power. At the start of each of your turns for the duration, the corruptive curse grows 5 feet in every direction. Whenever a creature starts its turn in a space afflicted by the curse, it must make a Charisma saving throw. If it fails, it takes 1d6 necrotic damage.

At Higher Levels: When you cast this spell using a spell slot of 2nd level or higher, the necrotic damage increases by 1d6 per spell slot level above 1st.

CREEPING DARK
3rd-level transmutation

Casting Time: 1 action
Range: Self
Components: V, S
Duration: 1 minute

There are nightmares that cannot be slain with fire, only truth.

You infuse yourself with dark energies and corporeal shadow, twisting your form into a terrible caricature. Until the spell ends, you gain resistance to bludgeoning, piercing, and slashing damage from nonmagical attacks, and you are heavily obscured. While you are under the effects of this spell, you can move through spaces as small as one square inch without squeezing. While in this form, you cannot take actions other than the Attack action. The first time you take the Attack action, you unleash a deadly spike of shadow against a target within your weapon's reach in place of one of your attacks. Make a melee spell attack roll. If you hit, your target takes 4d6 force damage. Once you take the Attack action, or you take damage from a magical attack, the spell ends at the end of the current turn.

At Higher Levels: When you cast this spell using a spell slot of 4th level or higher, the force damage increases by 1d6 per spell slot level above 3rd.

CRIMSON CLOAK
4th-level necromancy

Casting Time: 1 action
Range: Self
Components: V, S, M (a cloak worth at least 10 gp.)
Duration: Concentration, up to 1 minute

Blood is the currency of life, and it is natural to covet this wealth.

You pull blood from the open wounds of those around you into your cloak, infusing it with stygian magic. Whenever you or a creature within 15 feet of you loses hit points, your cloak gains a blood value equal to the amount of hit points lost, to a maximum total of 30. Whenever you would take damage from a spell while your cloak has reached the maximum blood value, you can use your reaction to gain resistance to the damage you would take from the spell. Once you do this, the cloak's blood value returns to zero.

At Higher Levels: When you cast this spell using a spell slot of 5th level or higher, the maximum decreases by 5 per spell slot level above 4th.

CRUEL WIND
7th-level evocation

Casting Time: 1 action
Range: 300 feet
Components: V, S
Duration: Concentration, up to 1 minute

A cruel wind blows as the blood flows, screaming a lullaby.

You wave your hands and call forth an unspeakable wind. All creatures within range other than you must make Constitution saving throws at the start of each of their turns. If they fail, they take 6d6 cold damage. If a creature dies while within range, they let loose a terrible scream. Each creature within 30 feet of the dying creature must make a Charisma saving throw. If they fail, they take 4d6 psychic damage.

CRUSHING TIDE
3rd-level evocation

Casting Time: 1 action
Range: 60 feet
Components: V, S
Duration: Instantaneous

The sea is a baleful mistress, and all must bow to her.

You summon a rushing wave of water that manifests in a 60-foot line that is 15 feet wide. Creatures within the area must make a Strength saving throw. If they fail, they are knocked prone and take 3d6 bludgeoning damage. If they succeed, they are not knocked prone and take half as much damage.

At Higher Levels: When you cast this spell using a spell slot of 4th level or higher, the bludgeoning damage increases by 1d6 per spell slot level above 3rd.

DARK EMPOWERMENT
4th-level transmutation

Casting Time: 1 action
Range: Self
Components: V, S
Duration: Concentration, up to 1 minute

Beyond material world, there are mysteries terrible to behold. Draw them in, and take them for your own.

You channel dark energy into your body, distorting your form and making you fearsome to behold. Your size increases to Large if it is smaller, and your equipment grows to suit your expanded form. If there is insufficient space, you grow as large as you safely can. While in this form, your weapon attacks inflict an additional 1d8 damage of their normal type and you gain temporary hit points equal to twice your spellcasting modifier at the start of each of your turns that last for the duration of the spell.

DARK LIGHTNING
2nd-level necromancy

Casting Time: 1 action
Range: 60 feet
Components: V, S
Duration: Instantaneous

Authority is the manifestation of power over another, and power is the expression of one's will upon the world.

You thrust out your hands, unleashing a deadly coil of lightning infused with wrathful hate towards a creature you can see within range. The target must make a Constitution saving throw. If they fail, they take 2d8 lightning damage. If the target is below their maximum hit points, the lightning forks to another creature of your choosing within 10 feet of the target. This new target must make their own Constitution saving throw, taking 2d8 lightning damage if they fail. This process can repeat up to three times, and the same target cannot be affected twice. If a target succeeds on their saving throw and is below their maximum hit points, they take 1d8 necrotic damage instead.

At Higher Levels: When you cast this spell using a spell slot of 3rd level or higher, either the lightning or necrotic damage (your choice) increases by 1d8 per slot level above 2nd.

DARK SECRET
2nd-level divination

Casting Time: 1 action
Range: 60 feet
Components: V
Duration: Instantaneous

Truth can be even more deadly than a knife to the heart.

You whisper a phrase into the mind of the target, unknown to you but clear and terrifying to them. Until the end of your next turn, you have advantage on all ability checks, attack rolls, and saving throws involving your target or actions it has taken. During this time, the target has disadvantage on all ability checks and attack rolls involving you or actions you have taken. Targets that are immune to being frightened are immune to this effect.

At Higher Levels: When you cast this spell using a spell slot of 3rd level or higher, you can choose one additional target per spell slot level above 2nd.

DEADLY DOORWAY
4th-level necromancy

Casting Time: 1 action
Range: Touch
Components: V, S, M (a small broken key)
Duration: 1 hour

Life has many doors, just as death holds many keys.

When you cast this spell, you touch a doorway, gate, window, or other construction that serves as an opening between two locations. You can speak a word, phrase, or describe an action or activity that must be performed to secure safe passage through the door. The first creature that does not perform this safeguard while passing through the doorway must succeed a Charisma saving throw or take 5d10 necrotic damage and be paralyzed until the start of their next turn. A creature slain by this damage instantly withers into dust, leaving all of their clothing and possessions behind.

At Higher Levels: When you cast this spell using a spell slot of 5th level or higher, the necrotic damage increases by 2d10 per spell slot level above 4th.

DEFIANT SMITE
1st-level abjuration

Casting Time: 1 bonus action
Range: Self
Components: V
Duration: Concentration, up to 1 minute

None shall turn you from your task, nor break your resolve.

The first time you hit with a melee weapon attack during this spell's duration, wrathful energy rushes through your weapon. The attack deals an extra 1d6 force damage to the target. Additionally, if the target is a creature, its ability to attack is hindered. Until the spell ends, the creature must make a Charisma saving throw at the start of each of its turns. If it fails, the first time it hits with an attack before the end of its turn, it is knocked prone.

At Higher Levels: When you cast this spell using a spell slot of 2nd level or higher, the force damage increases by 1d6 per spell slot level above 1st.

DEFY RUIN
1st-level abjuration

Casting Time: 1 action
Range: 30 feet
Components: V, S
Duration: 8 hours

Preserve stability, for the world must persist.

You point to an object that you can see, filling it with preservative magic. The object gains resistance to all damage, and cannot be damaged by any effect that would inflict less than 5 damage. You can touch the object as a bonus action to remove this magical effect.

At Higher Levels: When you cast this spell using a spell slot of 2nd level or higher, the duration increases by 8 hours per spell slot level above 1st.

DETECT INTERFERENCE
3rd-level divination

Casting Time: 1 action
Range: Self (300 feet)
Components: V, S
Duration: 1 hour

The meddling of lesser beings cannot be allowed to continue.

You cast your senses out into the universe, seeking to detect the magical emanations of other spellcasters, energies from beyond the Material Plane, or other eldritch powers. Whenever a creature within 300 feet casts a spell, you are aware of the level of the spell and the school of magic. You are aware of the starting and ending location of any teleportation within 200 feet of you. Whenever a creature that is not native to your current plane enters the range of this spell, you become aware of their plane of origin, general direction, and approximate distance.

DEVILISH HUNT
2nd-level conjuration

Casting Time: 1 action
Range: Self (90 feet)
Components: V, S, M (a tiny silver trident)
Duration: Concentration, up to 10 minutes

A favorite of torturous fiends and hungry fishermen.

You conjure three barbed harpoons of intricately twisted silver. They float in the air above your head for the spell's duration, and fade when it ends. When you cast the spell, and as an action on each of your subsequent turns, you can make a ranged spell attack to hurl a harpoon at a target within 90 feet of you. If you miss, the harpoon fades. If you hit, the target takes 2d6 piercing damage and must make a Dexterity saving throw. If they fail, the harpoon lodges in their flesh.

While a creature has been skewered by a harpoon, its speed is halved, and you can use a bonus action to cause an invisible chain to pull taut, hauling the creature 10 feet towards you for each harpoon lodged in it. The target can use an action to pull any number of harpoons out, taking 3d6 necrotic damage for each harpoon removed and causing the harpoon to fade. Once all three harpoons have faded, the spell ends.

At Higher Levels: When you cast this spell using a spell slot of 3rd level or higher, either the piercing or necrotic damage (your choice) increases by 1d8 per slot level above 2nd.

DISSOCIATIVE EDGE
2nd-level transmutation

Casting Time: 1 bonus action
Range: Self (30 feet)
Components: V, S, M (any melee weapon)
Duration: Instantaneous

Formerly claimed she'd never touched him. She was truthful.
* Technically.*

When you cast this spell, your weapon hums with violent energy. The first time you could make a melee weapon attack before the end of your current turn, you can launch a scything blade of force from your weapon instead.

Each creature within a line 5 feet wide and 30 feet long must make a Dexterity saving throw, starting from the creature closest to you. The first creature that fails takes 2d8 force damage and suffers damage and effects as though you had hit them with a successful attack using that weapon.

At Higher Levels: When you cast this spell using a spell slot of 3rd level or higher, the force damage increases by 1d8 per slot level above 2nd.

DOUSE
Conjuration cantrip

Casting Time: 1 action
Range: 30 feet
Components: S
Duration: Instantaneous

The ocean's spray conceals a cold and callous nature.

You gesture, summoning a splash of saltwater to fall upon a creature or object within range. Flames are instantly quenched, and objects targeted by this spell cannot be ignited for at least one minute. If you target a creature, you can choose to have the saltwater be bone-chillingly cold. The target must make a Constitution saving throw. If they fail, they take 1d8 cold damage.

This spell's damage increases by 1d8 when you reach 5th level (2d8), 11th level (3d8), and 17th level (4d8).

DUSKWALK
1st-level divination

Casting Time: 1 action
Range: 15 feet
Components: V, S
Duration: Instantaneous

In the beginning, there was only darkness. It will return.

Choose a location within range that is within 5 feet of a creature or in dim light or darkness. You teleport to this location. As a bonus action before or after teleporting, you can make a single melee spell attack against a target within your reach. If you hit, the target takes 1d6 psychic damage.

At Higher Levels: When you cast this spell using a spell slot of 2nd level or higher, the range increases by 5 feet and the psychic damage increases by 1d6 per spell slot level above 1st.

END OF DAYS
9th-level conjuration

Casting Time: 10 minutes
Range: 10 miles
Components: V, S, M (a sphere of obsidian the size of a human head worth at least 1,000 gp.)
Duration: 24 hours

One day will be the final day, but we will not know it until it has already ended.

When you cast this spell, you summon a massive sphere of magical darkness far above the world that moves perfectly in tune with the rise and set of the sun. In effect, it is always night within the range of this spell, and all natural sunlight that would be cast upon that area is blocked by the sphere. The material component used to cast this spell must be placed at a point where the sky is clearly visible, and if it is moved more than 5 feet in any direction, the spell immediately ends.

ELDRITCH BARRIER
3rd-level abjuration

Casting Time: 1 action
Range: Self
Components: V, S
Duration: 1 minute

The horrors beyond can be defied, if one's soul is strong.

When you cast this spell, you shield yourself from unnatural energies. You gain advantage on saving throws against the frightened and charmed conditions. You gain resistance to force damage and psychic damage, and whenever you take damage from an attack that deals force or psychic damage, you can use your reaction to inflict 1d8 force damage to your attacker.

At Higher Levels: When you cast this spell using a spell slot of 4th level or higher, the retaliatory force damage increases by 1d8 per spell slot level above 3rd.

FALLEN SOUL
3rd-level necromancy

Casting Time: 1 action
Range: 60 feet
Components: V, S, M (a hand from a corpse)
Duration: Concentration, up to 1 minute

The dead do not rest easily when the clash of steel rings loudly.

You summon forth an ethereal wraith-like phantom armed with a deadly blade at a point within range to strike down your foes. When you cast this spell, and as an action on each of your subsequent turns until the spell ends, you can direct the phantom to fly up to 30 feet and attack a creature within 5 feet of it with its blade. The target must make a Dexterity saving throw. A target that is frightened makes this saving throw with disadvantage. If they fail, the phantom strikes them, inflicting 3d10 slashing damage.

At Higher Levels: When you cast this spell using a spell slot of 4th level or higher, the slashing damage increases by 1d10 per spell slot level above 3rd.

FALLING SPIDER'S SPITE
1st-level necromancy

Casting Time: 1 reaction, made when an enemy falls prone within your reach
Range: Touch
Components: V, S
Duration: Instantaneous

Enemies that cannot stand before you are worthy of your scorn.

You instantly leap at the creature that has fallen prone and make a single melee weapon attack or unarmed strike. If you hit, the target's movement speed is reduced by 10 feet until the end of their next turn and they must make a Constitution saving throw or be poisoned until the end of your next turn.

FALLING STAR
5th-level evocation

Casting Time: 1 action
Range: 600 feet
Components: V, S
Duration: Instantaneous

The light shall not be denied, and the fire shall not cease.

You create a fraction of the celestial power of a star above a point within range and cause it descend, crashing into the ground in a 40-foot radius. All creatures within the area must make a Constitution saving throw. If they fail, they take 6d6 radiant damage, or half as much damage if they succeed. This spell creates bright light that shines in a 100-foot radius until the end of your next turn, and this light counts as natural sunlight.

At Higher Levels: When you cast this spell using a spell slot of 6th level or higher, the radiant damage increases by 1d6 per spell slot level above 5th.

FELL ONSLAUGHT
5th-level evocation

Casting Time: Special
Range: Self
Components: V, S, M (a martial melee weapon)
Duration: 1 minute

A death by one thousand cuts is still a death, painful as it is to see.

The first time you take the Attack action during your turn, you can cast this spell to make your weapon glow with eldritch power and cleave the fabric of reality with every swing. The first time you hit during this turn, your attack inflicts an additional 2d10 force damage, and the target becomes afflicted by a malignant curse. Until the spell ends, whenever you take the Attack action, you can choose to attack the cursed creature regardless of distance or obstacles, and these attacks deal an additional 1d10 force damage, ignore cover, and cannot suffer disadvantage.

FLASHING BLADES
4th-level illusion

Casting Time: 1 action
Range: Self
Components: V, S, M (a melee weapon)
Duration: 1 minute

In the silence of the night, the moon holds sway over the ocean waters. In the silence of the night, the blade holds sway over the river of blood.

You set an eerie shine to your weapon, coating it with luminous shadow and causing it to inflict an additional 1d8 radiant damage. Whenever you make an attack with this weapon, your target and all hostile creatures within 5 feet of your target must make a Wisdom saving throw. If they fail, they are blinded until the end of your next turn. Once a creature has been blinded by this spell, it can't be blinded again by this spell for one minute.

FORBIDDEN OBELISK
4th-level conjuration

Casting Time: 1 action
Range: 30 feet
Components: V, S
Duration: Concentration, up to 1 hour

Before paper, man wrote upon stone of the things that could not be spoken using a script that cannot be misunderstood. Many could not handle the truth, and wrote in blood.

You summon forth 10-foot-tall pillar 5 feet across covered in runic inscriptions from the depths of the earth. Any creature that can see and moves into a space within 10 feet of the obelisk cannot help but read from it. The reader must make a Wisdom saving throw. If they succeed, they gain advantage on Wisdom ability checks and saving throws for one minute. If they fail, they are struck blind for one minute. Once a creature has read from a forbidden obelisk, they cannot do so again until at least one hour has passed.

At Higher Levels: When you cast this spell using a spell slot of 5th level or higher, the duration of the blindness or advantage increases to 10 minutes.

FORGET
Enchantment cantrip

Casting Time: 1 action
Range: Self
Components: V, S
Duration: 8 hours

Sometimes, one just doesn't want to think about it.

You temporarily suppress a memory, sealing it away from your mind. You can choose either one period of time, a single person, group, or activity, or any other singular thing, such as a plan or proficiency in a single skill. Any creature other than you attempting to access this memory via magic or other means must make a Wisdom saving throw. If they succeed, this spell ends. When the spell ends, the memory returns and springs to your mind, fresh and vivid.

FORGOTTEN PAIN
5th-level enchantment

Casting Time: 1 action
Range: 60 feet
Components: V
Duration: Concentration, up to 1 minute

Suffering felt, even long ago, is easily magnified. A cut hand becomes a severed arm, and a broken bone becomes a broken mind.

You call back to dark times, inflicting an ancient magical torture upon a foe. The creature takes 4d6 damage of the type most recently inflicted upon it if it fails a Charisma saving throw. While you maintain concentration on this spell, you can use a bonus action to force the target make a Charisma saving throw, taking 4d6 damage of that type if they fail.

FOX'S FANGS
3rd-level illusion

Casting Time: 1 action
Range: Self
Components: V, S
Duration: Concentration, up to 1 minute

The fox is a trickster, and those with many tails have many tales to tell.

You summon nine illusory blades of light and shadow to swirl behind you. Whenever you could make a weapon attack or unarmed strike, you can choose to attack with one of these blades instead. Make a ranged weapon attack or ranged spell attack (your choice) against a target within 60 feet. If you hit, the target takes 2d6 psychic damage, and you recover 3 hit points. After a blade is thrown, it vanishes. Once all nine blades are gone, the spell ends.

FRESH PAINT
Conjuration cantrip

Casting Time: 1 action
Range: Self
Components: S
Duration: 1 hour

Ink is the blood of the imagination.

You create a magical paint that runs from your fingertips or fills a small container. You can use this paint in any way you could use ordinary paint, though it only remains tangible for one hour. For each additional minute you spend coating a surface in this paint, the paint remains on that surface for twice as long as before. You can create any color of paint you choose each time you cast the spell.

FROZEN LANCE
3rd-level conjuration

Casting Time: 1 action
Range: Self
Components: V, S, M (a melee weapon)
Duration: Instantaneous

You encase your weapon in ice, transforming it into a deadly spike, and rush up to 30 feet towards a creature you can see. Make a melee spell attack against the target. If you hit, the ice spike shatters, inflicting 6d6 cold damage and knocking the target prone. If the creature does not stand during their next turn, the ice shards encase them, restraining the target until the end of their following turn. If you are mounted when you cast this spell, the movement applies to your mount and your attack inflicts an additional 2d6 cold damage.

 At Higher Levels: When you cast this spell using a spell slot of 4th level or higher, the base cold damage increases by 1d6 per slot level above 3rd.

FUNERAL PYRE
3rd-level conjuration

Casting Time: 1 action
Range: 60 feet
Components: V, S, M (ash from a cremated corpse)
Duration: Instantaneous

The dead do not fear the flame, for within its embrace they may return to the light. The living, however, often feel differently.

You call forth spikes of burning wood from the ground around a target of your choosing within range, attempting to trap them. The target must make a Dexterity saving throw. Creatures that are Huge or larger make this saving throw with advantage. If they fail, the target is impaled by the spikes and restrained until the start of your next turn, taking 2d8 fire damage and 3d8 piercing damage. If the target succeeds, they take half as much damage and are not restrained. The spikes fade into ash at the start of your next turn. If the target is slain by this spell, the spikes do not fade, but instead remain and become impossible to dispel.

 At Higher Levels: When you cast this spell using a spell slot of 4th level or higher, the fire damage or the piercing damage (your choice) increases by 1d8 per slot level above 3rd.

GLIMMER
Illusion cantrip

Casting Time: 1 action
Range: Self (30 feet)
Components: V, S, M (a coin)
Duration: 1 round

It's far easier to conceal by revealing than to reveal by concealing.

You flick a coin into the air and make it sparkle with shimmering light, drawing the attention of all creatures within 30 feet of you. Each creature must make a Wisdom saving throw. A creature that is in combat has advantage on this saving throw. If a creature fails, it suffers disadvantage on ability checks until the start of your next turn.

GRIM SCYTHE
3rd-level necromancy

Casting Time: 1 action
Range: 15 feet
Components: V, S, M (two metal coins)
Duration: Instantaneous

The harvestman has a duty to the harvest, as the inevitable caress of the scythe must be clean and painless.

A hooded figure wielding a massive scythe appears at your shoulder, and strikes with smooth certainty at a creature within range. The creature must make a Charisma saving throw. If they fail, the scythe cleaves into their soul, inflicting 10d4 necrotic damage. If this damage reduces the creature to 20 hit points or fewer, they are instantly slain. Once the attack is made, the figure vanishes.

 At Higher Levels: When you cast this spell using a slot of 4th level or higher, the necrotic damage increases by 1d4 and the hit point threshold increases by 5 per slot level above 3rd.

HAUNT
4th-level divination

Casting Time: 1 bonus action
Range: 10 feet
Components: V, S
Duration: Concentration, up to 1 hour

With a shriek, the horror disappeared. I knew it was not gone.

You curse a hostile creature to be the singular focus of your hunt. You always know where the creature is, and it can never be hidden from you. In addition, you can sense what areas are in the target's line of sight. On a subsequent turn, you can use your bonus action to teleport to location within 30 feet of the target as long as the location isn't in the target's line of sight. If the location is occupied or is in a solid material, such as a wall, the teleportation fails. It also fails if you and the creature aren't on the same plane.

HEARTRIPPER
2nd-level necromancy

Casting Time: 1 action
Range: Touch
Components: S
Duration: Instantaneous

A plant fed with blood does not mourn, nor does it show mercy.

When you cast this spell, barbed thorns sprout from your fingertips. Make a melee spell attack roll against a creature within range. If you hit, the target takes 1d10 piercing damage and must make a Constitution saving throw. If they fail, you grasp a vital part of their anatomy and squeeze, inflicting an additional 3d10 piercing damage and stunning the target until the start of their next turn. If the spell attack roll resulted in a critical hit, the target has disadvantage on their saving throw.

 At Higher Levels: When you cast this spell using a slot of 3rd level or higher, the piercing damage of the second phase of the spell increases by 1d10 per slot level above 2nd.

HELLFIRE LASH
1st-level transmutation

Casting Time: Special
Range: Self
Components: V, S, M (a whip)
Duration: 1 turn

The fiends below are fond of this spell, but the heavens above do not hesitate to make use of it.

The first time you take the Attack action during your turn, you can cast this spell to transform your whip into a flaming lash, striking out with scorching fury. The first time you hit with this weapon, the target takes an additional 1d8 fire damage, and you can use a bonus action to hurl the target to a location of your choosing within 10 feet of their starting location. If they impact a surface or another creature, both take an additional 1d8 bludgeoning damage.

 At Higher Levels: When you cast this spell using a spell slot of 2nd level or higher, either the fire or bludgeoning damage (your choice) increases by 1d8 per slot level above 1st.

HELLISH HALO
6th-level evocation

Casting Time: 1 action
Range: Self
Components: V, S, M (an obsidian talisman worth 100 gp)
Duration: 1 minute

She shall arrive upon a chariot of steel bearing a talisman of stone, and the fire that once brought life to the world shall reap what it has sown.

You summon a massive halo of flame that surrounds you, igniting the air around your body and infusing you with burning vitality. Whenever a creature enters a space within 10 feet of you for the first time during a turn, or starts their turn there, the target takes 5d10 fire damage. Whenever a creature takes damage from this effect, you gain temporary hit points equal to the damage dealt. You can choose to suppress or reignite this flaming halo as a bonus action.

 At Higher Levels: When you cast this spell using a spell slot of 7th level or higher, the fire damage increases by 1d10 per slot level above 6th.

HUNGERING HATE
5th-level enchantment

Casting Time: 1 action
Range: 60 feet
Components: V, S
Duration: 1 minute

Fire can be a deadly beast, forever hungry and malicious.

You enrage your target with a burning curse, igniting a fire within them and upon their flesh. The creature must make a Wisdom saving throw. Each time the target fails their saving throw against this spell, the target and all creatures within 10 feet of the target take 3d8 fire damage. The target must repeat their saving throw at the end of each of their turns, ending the effect on a success. If the target takes the Attack action or casts a cantrip that deals damage, they automatically fail their saving throw but they are not subject to the fire damage they would take from failing, though it still applies to creatures around them.

HUNTER'S PACE
1st-level transmutation

Casting Time: 1 bonus action
Range: Self
Components: V
Duration: Concentration, up to 1 hour

The hunter does not tire or slow, for the prey has yet to be caught.

You let out a hunting cry, empowering your body with speed and tirelessness. While you maintain concentration on this spell, you gain advantage on Athletics checks to jump, climb, swim, or move. You also gain advantage on saving throws against exhaustion and on checks to mitigate the effects of difficult terrain.

 At Higher Levels: When you cast this spell using a slot of 2nd level or higher, your movement speed also increases by 5 feet per slot level above 1st.

IMPLEMENT OF CRUELTY
5th-level necromancy

Casting Time: 1 bonus action
Range: Self
Components: V, S, M (a melee weapon)
Duration: 1 minute

A weapon is not evil unless wielded with evil intent.

You imbue the weapon you are wielding with a crude sentience marked by terrible and infectious bloodlust. Once during each of your turns when you hit a creature with the weapon, you can make an additional attack targeting the same creature. If this additional attack misses, the target of your attack can use their reaction to make an opportunity attack targeting a creature within their reach. If you fail to inflict damage using this weapon during your turn, or if the weapon leaves your possession, the spell ends.

INVITATION
4th-level enchantment

Casting Time: 1 minute
Range: 1 mile
Components: V, S, M (ink, a quill, sealing wax, and paper)
Duration: Concentration, up to 1 hour

It's very improper to decline a formal invitation, even when offered by an enemy.

You write your current location and name on the paper, as well as the name, title, or description of the recipient, tying a magical compulsion to your note. A strong wind carries the letter directly to the recipient over the course of three minutes, provided they are within range. Once it arrives, the target must make a Wisdom saving throw. If they fail, they open the note and are charmed by you, attempting to travel via the safest available route to the written location. If the creature encounters an obstacle that poses a threat, such as an environmental hazard or worried friend, the target can repeat their Wisdom saving throw, ending the effect on a success. If you travel more than 300 feet from the location where you cast the spell, or if the creature takes damage, the spell ends. Once the creature arrives and greets you, the spell ends.

IRREVERSIBLE SMITE
3rd-level necromancy

Casting Time: 1 bonus action
Range: Self
Components: V
Duration: Concentration, up to 1 minute

Be sure the blade is swung with purpose and intent, for it cannot be in error without consequence.

The first time you hit with a melee weapon attack during this spell's duration, cruel shadows creep down your weapon and into your target's wounds. The attack deals an extra 3d6 necrotic damage to the target. Additionally, if the target is a creature, its flesh festers and refuses to repair. Until the spell ends, the target cannot regain hit points.

 At Higher Levels: When you cast this spell using a spell slot of 4th level or higher, the necrotic damage increases by 1d6 per spell slot level above 3rd.

JOLT
Evocation cantrip

Casting Time: 1 action
Range: 30 feet
Components: V, S
Duration: Instantaneous

A fraction of the storm's power can give life, or take it.

Sparks fly from your fingertips, shocking a creature within range. If the target is unconscious and reduced to 0 hit points, they gain advantage on their next death saving throw, and any ability check made to aid them also gains advantage. If you target a hostile creature, they must make a Constitution saving throw. If they fail, they take 1d8 lightning damage.

 This spell's damage increases by 1d8 when you reach 5th level (2d8), 11th level (3d8), and 17th level (4d8).

Lightning Shard
1st-level evocation

Casting Time: Special
Range: Self
Components: V, S, M (a melee weapon)
Duration: 1 turn

The wrath of storm-scarred steel is fearsome to behold.

The first time you take the Attack action during your turn, you can cast this spell to infuse your melee weapon with elemental lightning, scorching and honing it to a razor edge. The first time you hit with this weapon, the target takes an additional 1d6 slashing damage, and the static within the blade discharges. The target must make a Constitution saving throw. If they fail, the target and up to two creatures of your choice within 10 feet of the target take 1d6 lightning damage.

 At Higher Levels: When you cast this spell using a spell slot of 2nd level or higher, the either the slashing or lightning damage (your choice) increases by 1d6 per slot level above 1st.

Luring Light
3rd-level illusion

Casting Time: 1 action
Range: 15 feet
Components: V, S, M (the tooth of an aquatic predator)
Duration: Concentration, up to 1 minute

In the darkest depths, there is always something waiting for the curious and the foolhardy to make one final mistake.

You create a lure of light at a point you can see within range while making yourself invisible. This lure creates bright light in a 5-foot radius around itself, and moves with you. Whenever a hostile creature sees this lure light for the first time, it must make a Wisdom saving throw. If it fails, it must use all of its movement during its next turn traveling towards the lure by the safest route possible. A creature that is immune to being charmed is immune to this effect. If a creature touches the lure, you can use your reaction to cause a predatory phantasm to lash out and bite the creature. The target must succeed a Dexterity saving throw or suffer 4d10 magical piercing damage. Once you use this reaction, or if you attack or cast another spell, this spell ends.

 At Higher Levels: When you cast this spell using a spell slot of 4th level or higher, the piercing damage increases by 1d10 per spell slot level above 3rd.

Malice of Arachia
1st-level enchantment

Casting Time: 1 action
Range: Touch
Components: V, S, M (a weapon)
Duration: 1 hour

The first of the Arachi developed a clever toxin that turns the weak upon their former friends.

You coat a weapon in a deadly enchanted venom. The first time this weapon inflicts damage to a creature, the venom enters the target's veins, cursing them with terrible hallucinations and compulsions. The cursed target must make a Constitution saving throw at the start of each of its turns for one minute. Each time it fails, choose a creature within 5 feet of it that you can see. The cursed target uses its reaction to make a single melee weapon attack targeting the creature. Once it lands a successful attack caused by this effect, the effect ends. A creature that is immune to the poisoned condition is immune to this effect.

 At Higher Levels: When you cast this spell using a slot of 2nd level or higher, the effect on the cursed target lasts for one additional successful hit using its reaction per slot level above 1st.

Masterful Focus
1st-level enchantment

Casting Time: 1 action
Range: Self
Components: V
Duration: Concentration, up to 10 minutes

The forgotten masters of the blade swore to defend their secrets to the death, and were famed for their perfect clarity in battle.

You whisper a word and weave magic over your own mind, heightening your senses and reflexes. Until the spell ends, your attacks can result in critical hits more easily. Whenever the result of the d20 roll is 18-20, you critically hit. If you've made an attack with disadvantage and one of the results was in this range, you can ignore the disadvantage and critically hit regardless. Once you've critically hit, the spell ends at the end of the current turn.

 At Higher Levels: When you cast this spell using a slot of 2nd level or higher, the range you can critically hit within expands by 1 (17-20, 16-20, and so on) per slot level above 1st.

Mark of Objection
4th-level abjuration

Casting Time: 1 action
Range: Touch
Components: V, S
Duration: 1 hour

Is is the duty of a judge to see that the guilty are punished and the innocent left unharmed.

You touch an allied creature and place a mark upon them, granting them your protection. Whenever the target would take damage, you can use your reaction to instantly teleport and swap places with them, taking that damage in their stead. If this would reduce you to 0 hit points, you are reduced to 1 hit point instead, and the spell ends. You can place this mark upon multiple creatures at the same time, provided you expend an appropriate spell slot for each.

Mend Flesh
1st-level transmutation

Casting Time: 1 action
Range: Touch
Components: V, S, M (a needle and thread)
Duration: Instantaneous

The body is a vessel for the soul, and the soul calls to itself.

You stitch closed an open wound or reattach a whole limb severed in the past minute. If the target is alive or undead, they regain hit points equal to their Constitution modifier (minimum 1). If a limb was reattached, until the creature

finishes a long rest, they suffer disadvantage on all checks that require them to use the reattached limb. If the limb is a leg, their movement speed is halved during this time. If the limb is an arm, they suffer disadvantage on attack rolls with weapons held using the arm during this time.

At Higher Levels: When you cast this spell using a slot of 2nd level or higher, the time limit increases by 10 minutes per slot level about 1st and the target regains additional hit points equal to their Constitution modifier per slot level above 1st.

Nemesis
5th-level divination

Casting Time: 1 minute
Range: Unlimited
Components: V, S, M (a small trinket)
Duration: 8 hours

A vow to kill another must be sworn in blood, and held close to an icy heart. When the fire dies, so must one's mercy.

You declare a challenge, and describe a creature that you have damaged or has damaged you within the past year. That creature becomes marked by your magic, and it feels a sense of impending doom that grows the closer you get to it. You become supernaturally alert towards any sign of your quarry or information that would aid your search, gaining advantage on all checks made to discern the target's location or path of travel. The first time the target sees you, they must make a Wisdom saving throw. If they fail, they are frightened until the end of their next turn, and must attempt to flee via the safest route they are aware of during their next turn. Once the target has seen you, the spell ends.

Otherworldly Lair
7th-level transmutation

Casting Time: 10 minutes
Range: Touch
Components: V, S, M (a token gifted to you by an Alrisen)
Duration: 24 hours

Beyond the world, there are things that wait and things that watch. Call to them, greet them, and invite them in. Beware, for they may accept your invitation.

You invoke the power of the Alrisen whose token you bear to transform an area around you. The area can be as small as a 30-foot cube or as large as 120-foot cube. If you can cast this spell in the same area every day for a year, the spell lasts until dispelled.

The spell creates the following effects within the area. When you cast this spell, you can specify creatures as friends who are immune to the effects. Creatures that have been marked by the Alrisen whose token you have used are also immune to the effects, as are creatures who you choose to allow at the time of their entry.

The entire lair pulses with eldritch power. *Dispel magic* cast on the area removes only one of the following effects if it succeeds, not the entire area. That spell's caster chooses which effect to end. Only when all its effects are gone is this spell dispelled.

- **Difficult Terrain.** You can fill any number of 5-foot squares on the ground with difficult terrain. This terrain appears in a manner fitting for the Alrisen, such as the grasping hands of the dead, eerie tentacles, burning stakes of wood, or semisolid bars of radiant light. The obstacles move aside for and close behind creatures that are immune to this effect.
- **Otherworldly Inscriptions.** You can fill any number of 5-foot squares on the ground that aren't filled with difficult terrain with murals, runes, scratchings, etchings, or other sigils. A creature that steps on a sigil takes 1d6 damage of a type fitting to the Alrisen patron, as the defensive magic unleashes scorching fire, chilling ocean water, radiant energy, or the cruel necrotic power of the grave. To a creature immune to this effect, the inscriptions whisper in eerie voices or recount the stories of heroes from distant worlds.
- **Eldritch Servants.** You can call forth up to eight servants from the Alrisen whose token you've used to cast the spell. These servants are the potential familiars listed for warlocks who've chosen the Pact of the Chain feature, or other creatures with a CR of 1 or lower. If any creature not immune to this effect enters the warded area, the eldritch servants fight until they have drive off or slain the intruders. The servants also obey your spoken commands (no action required by you) that you issue while in the area. If you don't give them commands and no intruders are present, the servants do nothing other than patrol and dwell within the lair. The servants can't leave the otherworldly lair. When the spell ends, they disappear.
- **Deadly Trap.** Choose one spell that you can cast with a duration of "Instantaneous" that deals damage and has a casting time of one action or bonus action. You can decide on a trap that will cause the spell to be cast, triggering when a creature takes an action that you specify when you create the lair, such as touching a certain object or speaking a certain phrase. Once the trap triggers, it cannot do so again until at least one hour has passed.

Overwhelming Emotion
5th-level enchantment

Casting Time: 1 action
Range: 30 feet
Components: V, S, M (a gemstone worth at least 50 gp.)
Duration: Concentration, up to 1 minute

Joy and sorrow, fear and happiness: all can bring tears.

You beguile the mind of up to three creatures that you can see, assailing them with an all-consuming emotion. Each creature must make a Wisdom saving throw. Choose one of the effects below when you cast the spell. A creature that fails their saving throw is subject to the effects for the duration. A creature that is immune to the charmed condition is immune to the effects of this spell.

- **Wrath:** The target must attempt to move closer to a hostile creature and try to damage them during their turn. If there are no hostile creatures present, the target will choose an ally instead.
- **Sorrow:** The target suffers disadvantage on Charisma and Wisdom saving throws.
- **Joy:** The target cries tears of joy, becoming incapable of speaking coherently or casting spells with verbal components.

PERFECT TOXIN
6th-level conjuration

Casting Time: 1 action
Range: Touch
Components: V, S
Duration: 1 hour

The pen is mightier than the sword, at least when one is writing in this ink.

When you cast this spell, you touch an object, such as the blade of a weapon, a tankard, or a door handle, and coat it in a strange and powerful poison conjured from elemental chaos. Each time a creature touches this object, the creature becomes poisoned for one minute. At the start of each of their turns, the poisoned creature can make a Constitution saving throw, ending the effect on a success.

POWER WORD CRUSH
4th-level evocation

Casting Time: 1 action
Range: 120 feet
Components: V
Duration: Instantaneous

The material world is fragile.

You speak a word of overwhelming power. Choose an object or construct that you can see within range that is Large or smaller. If you choose a non-magical object, it instantly crumples and disintegrates into dust. If you choose a magical object, it temporarily loses any magical properties for one minute, but it cannot be destroyed by a second casting of this spell. If you choose a construct, it takes 30 force damage. Artifacts and other incredibly powerful magical objects are immune to this effect. If the spell has no effect, you regain the spell slot or resource expended to cast it.

PUNISHING SMITE
5th-level evocation

Casting Time: 1 bonus action
Range: Self
Components: V
Duration: Concentration, up to 1 minute

Those that have done wrong are not always fully aware of their guilt. Correct this error.

The first time you hit with a melee weapon attack during this spell's duration, radiant fire and chilling shadow pours forth from opposite sides of your weapon. The attack deals an extra 2d10 necrotic damage and 2d10 radiant damage to the target. Additionally, if the target is a creature, a terrible judgment descends upon them, leaving them vulnerable to attack. Whenever the target takes damage from an attack before the spell ends, they take an additional 1d10 force damage.

REFLECTIVE DEFENSE
8th-level abjuration

Casting Time: 1 bonus action
Range: Self
Components: V
Duration: Instantaneous

"Stab him? I didn't stab him! He stabbed me!"

When you cast this spell, an invisible barrier permeates your flesh until the end of your next turn. If you would take damage during that time, the damage is reduced to 0, and if the source of the damage was another creature, that creature takes the full amount of the damage as force damage instead.

REPLENISH
2nd-level evocation

Casting Time: 1 action
Range: Touch
Components: V, S
Duration: Instantaneous

With the turn of seasons, the cycle of life renews.

When you cast this spell, you touch an allied creature that you can see. The target surges with vital force, gaining 2d6 temporary hit points. These temporary hit points are lost whenever the target finishes a short or long rest. The target is also cured of the poisoned condition.

At Higher Levels: When you cast this spell using a slot of 3rd level or higher, the temporary hit points gained increases by 1d6 per slot level above 2nd.

RESONANCE
3rd-level enchantment

Casting Time: 1 action
Range: 30 feet
Components: V
Duration: Concentration, up to 1 minute

Stone was once no different from the dirt around it, and simply waits to be reminded of that fact.

You sing to the inherent order within the ground around you. While you maintain concentration on this spell, you can use an action to disrupt that order. Choose a 10-foot cube within range. Creatures and objects within that square must make a Dexterity saving throw. If they fail, they sink into the ground as it softens and re-hardens, becoming restrained for as long as you maintain concentration. Each round, the target can make a Strength saving throw, ending the effect on a success. Until the spell ends you can repeat this process, choosing a different 10-foot cube each time.

RIMESWORN BLADE
1st-level evocation

Casting Time: Special
Range: Self
Components: V, S, M (a martial weapon)
Duration: 1 turn

Ice can be sharper than steel, and splinters like a sap-filled tree in winter cold clutches.

The first time you take the Attack action during your turn, you can cast this spell to infuse your martial weapon with chilling cold and coat the exterior with brittle ice. The first time you hit with this weapon, the target takes an additional 1d8 cold damage, shattering the ice on your weapon. The target and creatures within 10 feet of the target other than you must make a Dexterity saving throw. If they fail, they take 1d8 piercing damage.

 At Higher Levels: When you cast this spell using a spell slot of 2nd level or higher, either the cold or piercing damage (your choice) increases by 1d8 per slot level above 1st.

SCORCH
Evocation cantrip

Casting Time: 1 action
Range: 30 feet
Components: V,S
Duration: Instantaneous

Even a single spark can start a wildfire.

You snap your fingers, attempting to light an unattended object within range on fire. If you target a flammable object, it immediately ignites in a gout of flame. Choose up to two creatures within 5 feet of the burning object. Each must make a Dexterity saving throw. If a creature fails, it takes 1d8 fire damage.

 This spell's damage increases by 1d8 when you reach 5th level (2d8), 11th level (3d8), and 17th level (4d8).

SEEK PHRASE
Divination cantrip

Casting Time: 1 action
Range: Touch
Components: V, S
Duration: Concentration, up to 1 minute

Finding quickly is as good as knowing, in the eyes of the inexperienced.

You speak a word or phrase aloud and touch a book, scroll, or other object covered in writing. Each instance of that word or phrase present becomes highlighted in glowing script for the duration. If used on a book, it will flip to the first page containing the subject of your search.

SERPENT'S BITE
3rd-level transmutation

Casting Time: 1 action
Range: Self
Components: V, S
Duration: Concentration, up to 1 minute

Venom can be a method of execution far cleaner than the blade.

Massive, venomous fangs spring from your mouth. Make a melee spell attack against a target within your reach. On a hit, the target takes 3d8 poison damage, and the target must make a Constitution saving throw. If they fail, they are poisoned until the start of your next turn. Until the spell ends, you can make the attack again on each of your turns as an action. When you do, you can make a single melee weapon attack as a bonus action.

 At Higher Levels: When you cast this spell using a spell slot of 4th level or higher, the damage increases by 1d8 per slot level above 3rd.

SERPENTINE WARD
4th-level transmutation

Casting Time: 1 action
Range: 15 feet
Components: V, S, M (a living snake)
Duration: 1 minute

The secrets of the ancient tomb guardians will remain with them, until the wards are broken and the chambers unsealed.

When you cast this spell, you throw the serpent to a point within range and empower it with magical energy. The serpent freezes and becomes still, waiting to strike. Whenever a hostile creature starts its turn or enters a space within 5 feet of the serpent, the serpentine ward bites at the creature. The target must make a Dexterity saving throw. If it fails, it takes 4d10 poison damage and is poisoned until the start of its next turn. The serpentine ward has 18 AC, 20 hit points, and is immune to magic. When the spell ends, the serpent attempts to return to your possession.

 At Higher Levels: When you cast this spell using a slot of 5th level, the duration increases to 1 hour. When you cast this spell using a slot of 6th level, the duration increases to 8 hours. When you cast this spell using a spell slot of 7th level, the duration is 1 year. When you cast this spell using a spell slot of 8th level or higher, the spell becomes permanent and cannot be dispelled.

SHADOWTHORN
Conjuration cantrip

Casting Time: 1 action
Range: 10 feet
Components: V, S
Duration: Instantaneous

The shadowed planes hold many cruelties left unspoken.

You rear back and summon a spike of shadow, attempting to stab and push a creature within range. Make a melee spell attack roll. If you hit, the target takes 1d6 piercing damage and is shoved 5 feet directly away from you.

 This spell's damage increases by 1d6 when you reach 5th level (2d6), 11th level (3d6), and 17th level (4d6).

Shadow Armor
2nd-level abjuration

Casting Time: 1 reaction, made when you are attacked or make a saving throw
Range: Self
Components: V, S
Duration: 1 minute

In shadow and shade, the gravest of plans are made.

You wrap a cloak of shadow around you, coiling in a defensive posture. Until the start of your next turn, attacks targeting you are made with disadvantage and you gain advantage on Dexterity saving throws. The next time an attack misses or hits you, you can choose to move up to 15 feet without provoking opportunity attacks. Once you do this, the spell ends.

At Higher Levels: When you cast this spell using a spell slot of 3rd level or higher, you can choose to move one additional time per slot level above 2nd before the spell ends.

Shadow Refuge
4th-level illusion

Casting Time: 1 bonus action
Range: Self
Components: V, S
Duration: 1 round

In the void, peace is cold and clarity is merciless.

You step into a shrouded space outside reality for a brief moment, gathering your power and waiting for a chance to strike. Until the start of your next turn, you cannot be targeted by spells and you are heavily obscured by magical darkness. Your first successful attack during your next turn inflicts an additional 4d6 psychic damage and knocks your target prone.

Shadow Toxin
3rd-level necromancy

Casting Time: 1 action
Range: 60 feet
Components: V, S
Duration: 1 minute

Within the web of lies, one cannot trust their eyes.

You fling a thin needle of darkness at a creature you can see within range, injecting them with corruptive magic that taints their mind and fills them with doubt. Whenever the target attempts to cast a spell that targets a creature friendly to them, they must make an Intelligence saving throw. If they fail, they take 3d8 psychic damage, their spellcasting fails and the spell is lost. If they succeed, the corruptive magic is broken and the target is freed from the effects of this spell.

At Higher Levels: When you cast this spell using a spell slot of 4th level or higher, you can choose one additional target per slot level above 3rd.

Shadow World
5th-level conjuration

Casting Time: 1 action
Range: Self (60 feet)
Components: V, S
Duration: Concentration, up to 1 minute

The Inverse is real. The nightmares are coming.

You call forth a portal to a shadowy plane that influences the world within range, crafting the umbral power into a new landscape of your choosing. The terrain you create can be opaque, but is only half-formed and thus only creates difficult terrain rather than true walls or surfaces. At the start of each of your turns while you maintain concentration on this spell, you can use an action to create one of the following effects:

- **Tendrils:** Dark coils of shadow form and attempt to grasp one creature that you can see within range. The target must make a Strength saving throw. If they fail, they are restrained until the start of your next turn.
- **Spikes:** Dangerous needles of shadow skewer forth from the ground, stabbing at up to three creatures you can see within range. Each must make a Dexterity saving throw. If they fail, they take 4d10 piercing damage.
- **Nightmares:** Horrible visages form around you and rush outward. All creatures within range that can see you must make a Wisdom saving throw. If they fail, they are frightened of you until the start of your next turn.

Shattersong
4th-level evocation

Casting Time: 1 bonus action
Range: Self
Components: V, S
Duration: Concentration, up to 1 minute

The earth quakes, reality breaks, torn asunder by air.

You sing a discordant song infused with magical power. When you cast this spell, the vibrations you cause begin to distort reality in a 10-foot radius centered on you. Creatures you choose and unattended objects within that area take 2d6 thunder damage, and damaged creatures must make a Strength saving throw. If they fail, they are knocked prone. As an action on each of your turns while maintaining concentration on this spell, you can strengthen your song, repeating the effect while increasing the affected radius by 10 feet and the thunder damage by 2d6 each time, and causing affected creatures you choose to make the Strength saving throw to avoid being knocked prone. The affected distance and damage cannot exceed an 30-foot radius or 6d6 thunder damage.

Shrill Whistle
1st-level evocation

Casting Time: 1 action
Range: 120 feet
Components: V, S
Duration: Instantaneous

An arrow screaming through the air is just as deadly when silent.

You place your hand to your lips, blowing through them in a terrible note. All creatures of your choosing within range must make a Constitution saving throw. If they fail, they take 1d8 thunder damage and are deafened until the end of their next turn. This whistle is audible up to 500 feet away, even in adverse conditions.

At Higher Levels: When you cast this spell using a spell slot of 2nd level or higher, the thunder damage increases by 1d8 per slot level above 1st.

Shroud of Surok
5th-level illusion

Casting Time: 1 action
Range: 600 feet
Components: V, S, M (a lit candle)
Duration: 10 minutes

When the light dies, so does hope.

You extinguish the candle, plunging the area around you into darkness. All fires and other non-magical light sources within range are extinguished instantly. Magical light sources are fully enclosed in magical darkness. An inky spherical shroud covers the area within range, blocking sunlight and lightly obscuring the area within. Any light that remains is reduced to dim light, and all dim light is reduced to darkness.

Sinister Threat
2nd-level enchantment

Casting Time: 1 reaction, when a creature enters the range of the spell or becomes hostile while within range
Range: 15 feet
Components: S, M (any weapon)
Duration: Concentration, up to 1 minute

The glint of steel does much to persuade and dissuade.

You unsheathe part of your weapon, or gesture threateningly with it, imbuing this simple implication with a magical compulsion. The creature can choose to end its turn immediately and be charmed by you until the spell ends or until you or your companions do something harmful to it or its allies. Otherwise, it must make a Wisdom saving throw. If it fails, the creature becomes frightened of you for the duration and you gain advantage on melee attack rolls targeting it while it is frightened. At the end of each of its turns, the creature can make another Wisdom saving throw, ending the spell if it succeeds.

At Higher Levels: When you cast this spell using a spell slot of 5th level or higher, the spell does not require concentration.

Skewering Vines
3rd-level conjuration

Casting Time: 1 action
Range: Self
Components: V, S
Duration: Concentration, up to 1 minute

Nature does not oft wait for the woodsman to tire from his task.

When you cast this spell, a mass of vines coils forth from the ground around you. When you cast this spell, and as an action on each of your turns while it remains, you can make a ranged spell attack against a target you can see within 30 feet of you. This attack ignores half and three-quarters cover. If you hit, the target takes 3d10 piercing damage and is lifted 5 feet into the air until the end of their next turn. They can use half their movement during their turn to free themselves of the skewering vines, returning to the ground.

At Higher Levels: When you cast this spell using a spell slot of 4th level or higher, the piercing damage increases by 1d10 per slot level above 3rd.

Skin of Flint
4th-level transmutation

Casting Time: 1 action
Range: Self
Components: V, S, M (a shard of flint)
Duration: 1 minute

The spark that starts a fire of greed is often the wealth of another.

When you cast this spell, a thin layer of flint covers your skin and armor. Once per turn when you take damage from a weapon attack, sparks spring from the stone, inflicting 1d4 fire damage to a creature of your choosing within 5 feet of you. The target must make a Dexterity saving throw. If they fail, they are blinded until the start of their next turn.

At Higher Levels: When you cast this spell using a spell slot of 5th level or higher, the fire damage increases by 1d4 per slot level above 4th.

Skystrike
2nd-level evocation

Casting Time: 1 reaction, when you are falling or after jumping
Range: 15 feet
Components: V, S
Duration: Instantaneous

Splinter the earth and crack the ground; let storm and fury fast abound.

When you cast this spell, choose a point within range. You teleport to that location and instantly crash to the ground directly beneath that point, accompanied by a flash of lightning. You take no falling damage, but if you land on a creature or a space within 5 feet of a creature, it takes lightning damage equal to the amount of falling damage you would have taken. If you landed on a creature, you immediately move to the nearest open space. If you fell 30 feet or more, you are stunned until the end of your next turn.

At Higher Levels: When you cast this spell using a spell slot of 5th level or higher, you are not stunned when falling.

SKYWARD RISE
2nd-level evocation

Casting Time: 1 action
Range: 15 feet
Components: V
Duration: 1 round

Gravity defied can mean life denied.

You shout, calling the winds to bind a creature within range. The target must make a Dexterity saving throw. If it fails, it is suspended above the ground until the end of its next turn and is restrained. As a bonus action before the end of your current turn, you can make a melee weapon attack against the creature if it is within your reach, inflicting an additional 2d6 damage if you hit.

At Higher Levels: When you cast this spell using a spell slot of 3rd level or higher, you deal an additional 2d6 damage for each slot level above second.

SLEEPWALKING
4th-level enchantment

Casting Time: 1 minute
Range: 1 mile
Components: V, S, M (a small hourglass worth at least 50 gp)
Duration: Concentration, up to 1 hour

What compelling music must one sing, for when darkness falls slumber clings?

When you cast this spell, choose a creature that is unconscious that you are aware of within range. You tap into the mind of the target and begin to control their movements, forcing them to walk and act at your command. The target can only perform simple actions, such as moving or interacting with objects, and cannot speak, attack, or cast spells. Whenever the target would be awakened, the target must make a Wisdom saving throw. If they succeed, they awaken. If they fail, they remain asleep and under your control. If the target takes damage, they have advantage on their saving throw.

SLIME SPHERE
4th-level conjuration

Casting Time: 1 action
Range: 60 feet
Components: V, S
Duration: Concentration, up to 1 minute

Some would think this should appear as a cube. Strange, isn't it?

When you cast this spell, a massive sphere of adhesive slime appears, grows, and occupies a 10-foot radius centered on a point within range. Creatures within the radius must make a Dexterity saving throw. If they fail, they are trapped within the sphere and are restrained. If they succeed, the creature moves to the nearest unoccupied space outside of the radius. At the start of each of their turns, a restrained creature can use a bonus action make a Strength saving throw. If they fail, they remain restrained within the sphere and take 2d8 acid damage. If they succeed, they exit the sphere at the nearest unoccupied location and take half as much damage. Any creature that is forcibly pushed into the sphere, or enters it voluntarily, automatically becomes restrained.

At Higher Levels: When you cast this spell using a spell slot of 5th level or higher, the acid damage increases by 1d8 per slot level above 4th.

SPELL FLUX
2nd-level abjuration

Casting Time: 1 bonus action
Range: Self
Components: V
Duration: Concentration, up to 1 minute

The best defense is to never be attacked. The second best is this.

You summon a writhing mass of unstable energy to guard your hand. You gain half cover from attacks and damaging effects you can see, but you can only use this hand to perform somatic components of spells you cast until this spell ends.

If a ranged attack hits you, you can discharge the spell flux as a reaction, deflecting the attack. Make a ranged spell attack targeting a creature of your choosing within 30 feet of you. If you hit, the target takes the damage and effect of the original attack. Once you do this, the spell ends.

SPIDER'S KISS
1st-level illusion

Casting Time: 1 action
Range: 10 feet
Components: V, S
Duration: 1 round

The love of a widow is not made false by the consequences.

When you cast this spell, choose a creature you can see within range. An illusory veil covers you, making you appear as the perfect paramour to the target. The target must make a Wisdom saving throw. If they fail, they are charmed by you, and move to grapple you during their next turn. If they succeed, you can use your reaction to deliver a deadly corrosive touch, breaking the grapple, ending the spell, and dealing 2d10 acid damage to the target.

At Higher Levels: When you cast this spell using a spell slot of 2nd level or higher, the acid damage increases by 1d10 per slot level above 1st level.

SPREADING NIGHTMARE
7th-level enchantment

Casting Time: 1 minute
Range: 1 mile
Components: V, S
Duration: 8 hours

There is a horrifying beauty to terrible things.

When you cast this spell, choose one creature that you have seen or that you are familiar with that is sleeping within range. The target must make a Wisdom saving throw. If they fail, they awaken and are frightened of all other creatures that they can see. If another creature sees them while they are frightened, that creature must make a Wisdom saving throw, becoming frightened if they fail. This process repeats infinitely. If an affected creature goes for 10 minutes without seeing another creature, or takes damage, they are no longer frightened and cannot be affected again.

STORM'S EYE
5th-level divination

Casting Time: 1 action
Range: 300 feet
Components: V, S, M (a piece of fulgurite)
Duration: Concentration, up to 1 minute

In the center of the storm, there is a place of calm and majesty.

When you cast this spell, your mind clears and opens to the world around you. You gain complete awareness of all objects, creatures, and magical effects within range. You can clearly hear all sounds made, and can shift your awareness to any point within range as a bonus action. While your awareness is shifted, you are rendered deaf and blind to your normal senses. You can return to your normal senses as a bonus action. While you maintain concentration on this spell, whenever you perform an action that would force a creature to make a Dexterity saving throw, you can use your reaction to focus your attention on responding to that creature's movements, causing it to have disadvantage on the saving throw.

SUFFER
2nd-level necromancy

Casting Time: 1 action
Range: 30 feet
Components: V, S
Duration: Instantaneous

True misery is more than pain entering the mind; it is pain entering the soul.

You point at a creature within range and speak a terrible word, commanding them to suffer. The target must make a Charisma saving throw. If they fail, they take 2d8 necrotic damage and 2d8 psychic damage and they have disadvantage on Strength and Dexterity ability checks for 1 minute. If they succeed, they take half as much damage and do not have disadvantage.

At Higher Levels: When you cast this spell using a spell slot of 3rd level or higher, the necrotic damage or the psychic damage (your choice) increases by 1d8 per slot level above 2nd.

SUMMON SLIME
5th-level conjuration

Casting Time: 1 action
Range: 30 feet
Components: V, S, M (a vial of acid)
Duration: Concentration, up to 1 hour

Just because something doesn't have a face, doesn't mean it can't smile cheerfully at you... or eat you.

You summon ooze creatures that appear in unoccupied spaces that you can see within range. A summoned creature disappears when it drops to 0 hit points or when the spell ends. Choose one of the following options for what appears:

- One ooze creature of challenge rating 4 or lower.
- Two ooze creatures of challenge rating 2 or lower.
- Four ooze creatures of challenge rating 1 or lower.

The summoned creatures are friendly to you and your companions. Roll initiative for the summoned creatures as a group, which have their own turns.

They obey any verbal commands that you issue to them (no action required by you). If you don't issue commands to them, they defend themselves from hostile creatures, but otherwise take no actions.

The game master has the creature's statistics.

TORMENTED FLURRY
2nd-level necromancy

Casting Time: 1 action
Range: Self
Components: V, S, M (a martial weapon)
Duration: 1 minute

Each strike shall be more gruesome than the last.

When you cast this spell, you move up to 30 feet and make a melee weapon attack against a target within reach. If you hit, the target takes an additional 2d6 necrotic damage. On your subsequent turns, you can use your action to continue your deadly assault. Each time you use this action, it has a different effect:

- **2nd Use.** You make a melee weapon attack against a creature within reach. If you hit, the creature must make a Wisdom saving throw. If they fail, they are frightened of you until the end of your next turn and take 1d6 necrotic damage.
- **3rd Use.** You strike with a vicious blow. Make a melee weapon attack against a creature within reach. If the creature is frightened, this attack deals an additional 1d6 necrotic damage. If this attack is made with advantage, the attack deals an additional 1d6 necrotic damage.
- **4th Use.** You unleash a wave of dark energy. Each hostile creature within 30 feet of you must make a Constitution saving throw. If they fail, they take 2d6 necrotic damage. If you've killed a creature during the duration of this spell, all hostile targets take an additional 2d6 necrotic damage, even if they succeed. Once you do this, the spell ends.

At Higher Levels: When you cast this spell using a spell slot of 3rd level or higher, each instance of necrotic damage increases by 1d6 per slot level above 2nd.

TOUCH INFINITY
9th-level transmutation

Casting Time: 1 action
Range: Unlimited
Components: S
Duration: Instantaneous

All the world can change with just a snap of the fingers.

With a gesture and an effort of will, you tear the fabric of reality and change it to suit your vision. You have access to a pool of 500 points. You can use these points in the following ways, and can use them in any combination of your choosing:

- **Kill:** You can try to kill a creature you are aware of by spending a number of points equal to its remaining hit point total. The target must make a Charisma saving throw. If they fail, they die. If they succeed, you still lose the points you spent, and they are unharmed. You can choose to target any number of creatures, so long as you

have sufficient points available.

- **Maim:** You can damage a creature. Spend a number of points equal to five times the amount of damage you'd like to inflict. The target takes force damage equal to this amount. You can target an unlimited number of creatures with a single casting, spreading the points among them.
- **Move:** You teleport any creature of your choosing to any unoccupied location that you desire. If the target is unwilling, they can make a Wisdom saving throw to resist this effect. Attempting to move a creature costs a number of points equal to their current hit point total.
- **Shape:** You shape reality. Choose a number of 5-foot cubes equal to the amount of points you spent. You cannot choose a cube that is occupied by a creature. You can manipulate nonliving material within these cubes, creating or destroying as you wish. You cannot create substances with a measurable cost in gp, but you can create stone, dead wood, water, or other materials. This cannot entrap or cause damage to living creatures.
- **Create:** You make something new. You can spend 50 points per 1 CR to create a creature, or 1 point per 10 gp when creating an item with a measurable gold cost. You can create multiple creatures or items when using this. Creatures created using this spell obey your commands, but are otherwise ordinary.

Once you cast this spell, you gain two levels of exhaustion.

UNDERTOW
8th-level conjuration

Casting Time: 1 action
Range: 120 feet
Components: V, S
Duration: Concentration, up to 1 minute

In the deepest abyss below the ocean waves, the darkness whispers of sailor's graves.

You open a portal to a watery abyss beneath the feet of a creature that you can see within range, which attempts to abduct the target before immediately sealing shut. The target must make a Dexterity saving throw. If they fail, they fall in and are immediately dragged 60 feet down by a fierce current. They begin to drown, and must make a Constitution saving throw at the start of each of their turns. Each turn that they fail, they gain one level of exhaustion. A creature cannot move normally while in this abyss. Instead, they must use their action to attempt to ascend. The creature must make a Strength (Athletics) check against your spell save DC. If they succeed, they swim 20 feet towards the surface. If they reach the surface or you lose concentration on the spell, the spell ends and they are ejected prone at the point they departed from. If they die, they do not return.

UNSEEN CLAW
4th-level divination

Casting Time: 1 action
Range: 120 feet
Components: V, S
Duration: Instantaneous

There are techniques within the darker arts against which there is no defense.

You expand your senses and attune yourself to the shadowed planes, detecting the exact locations of all creatures within range until the end of your current turn. Choose one creature that you have detected with this spell. An umbral claw of darkness made manifest rips through the creature, inflicting 4d10 force damage. If the creature is slain, their body vanishes into shadow, leaving their clothing and equipment behind. A creature slain by this spell can be resurrected, but only by a spell that does not require a corpse.

 At Higher Levels: When you cast this spell using a spell slot of 5th level or higher, the force damage increases by 1d10 per slot level above 4th. When cast using a spell slot of 9th level, the range becomes 1 mile.

UNSPOKEN AGREEMENT
4th-level enchantment

Casting Time: 1 bonus action
Range: 30 feet
Components: S
Duration: Instantaneous

Partnership is two minds acting with a singular purpose.

You make a simple gesture, indicating to an allied creature within range that they should perform an action and sending a telepathic message of 25 words or fewer. The target chooses either the Dash, Disengage, Dodge, Attack (single weapon attack only), or Cast a Spell (a cantrip with a casting time of one action) actions. The target uses their reaction to perform that action. You also take the same action as part of casting this spell.

UNSTOPPABLE ASCENT
5th-level evocation

Casting Time: 1 action
Range: Touch
Components: S
Duration: Instantaneous

The sky calls to us, seeking our return to its embrace.

You attempt to hurl a creature into the air, shifting them partially into the Ethereal Plane. Make a melee spell attack against a creature within range. If you hit, you grasp the target and throw them up to 150 feet directly upward. The creature passes through obstacles unimpeded and unharmed. If the final destination is impeded, the creature is moved to the nearest open space and takes force damage equal to the number of 5-foot increments it was moved. If the creature is an ally, damage it would take from falling is reduced by 100 until the start of your next turn.

Venom Blast
3rd-level conjuration

Casting Time: 1 action
Range: 120 feet
Components: V, S, M (a snake's fang)
Duration: Instantaneous

The fang of the serpent is weak compared to the power of the arcane, yet one can certainly inspire the other.

You gesture to call forth an ethereal serpent at a point within range and speak, commanding the beast to let loose a deadly venom. Creatures within a 15-foot radius of the serpent must make a Constitution saving throw. If they fail, they are poisoned for one minute and take 6d6 poison damage. If they succeed, they take half as much damage and are not poisoned. A creature that is poisoned by this spell can repeat their saving throw at the end of each of their turns, ending the effect on a success.

At Higher Levels: When you cast this spell using a spell slot of 4th level or higher, the poison damage increases by 1d6 per slot level above 3rd.

Wall of Ooze
5th-level conjuration

Casting Time: 1 action
Range: 120 feet
Components: V, S
Duration: Concentration, up to 1 hour

When you stare into a shining slime, are you seeing a reflection, or a self that could be?

You summon a wall of colorful ooze at an unoccupied space within range. The wall appears on a solid surface within range and lasts for the duration. You can choose to make the wall up to 60 feet long, 15 feet high, and 5 feet thick, or have it appear and enclose a 15-foot cube while being up to 5 feet thick. The wall heavily obscures vision through it, but is slightly transparent. Creatures and objects can pass through the wall, but if they do, their movement speed is halved until the start of their next turn. Ranged attacks that would pass through the wall automatically miss and damage the wall instead.

The wall of ooze has AC 5, immunity to poison and acid damage, and has 120 hit points.

When the wall appears, each creature within the area must make a Strength saving throw to break free from the thick slime, exiting into the nearest unoccupied space if they succeed. Creatures that fail, or creatures that end their turn within the wall, take 4d8 acid damage. Whenever a creature strikes the wall with a melee attack or passes through the wall for the first time during a turn, the creature takes 2d8 acid damage.

At Higher Levels: When you cast this spell using a spell slot of 6th level or higher, the acid damage of each phase increases by 1d8 and the wall gains 20 additional maximum hit points per slot level above 5th.

Windblade
4th-level evocation

Casting Time: 1 action
Range: 30 feet
Components: V, S
Duration: Instantaneous

The quiet breeze foreshadows the coming cataclysm.

With a sweeping gesture you unleash an invisible scythe of wind in a 30-foot cone. Creatures within the area must make a Dexterity saving throw. If they fail, they take 8d8 slashing damage. This damage ignores the resistances of unattended objects, cutting cleanly through trees and walls.

At Higher Levels: When you cast this spell using a spell slot of 5th level or higher, the slashing damage increases by 1d8 per slot level above 5th.

Wings of Night
5th-level illusion

Casting Time: 1 action
Range: Self
Components: V, S
Duration: Concentration, up to 1 hour

Black skies conceal what grim intent reveals.

You call forth large wings of mist, smoke, and shadow that attach to your back and heed your commands, granting you a flying speed of 60 feet and lightly obscuring you.

As an action while you have these wings, you can choose to unleash the power trapped within them, ending the spell and releasing a wave of nightmarish energy. Creatures within 30 feet of you must make a Charisma saving throw. If they fail, they take 6d10 psychic damage and become frightened of you until the end of your next turn. If they succeed, they take half as much damage and are not frightened.

Wolfbane Trap
2nd-level transmutation

Casting Time: 1 minute
Range: Touch
Components: V, S, M (a sharp piece of metal)
Duration: 8 hours

A clever hunter is patient.

When you cast this spell, you place the sharpened metal on the ground and transform it into a frostbound bear trap that occupies a 5-foot square. This trap is nearly invisible, and requires a successful Wisdom (Perception) check to detect it and a successful Dexterity (Sleight of Hand) check to disarm it. The DC for these checks is equal to your spell save DC.

The first time a creature enters the area occupied by this trap, it triggers, it reveals itself, and clamps shut. The creature must make a Dexterity saving throw. If they fail, they take 2d10 piercing damage and 1d10 cold damage, and have their movement speed reduced to 0 while they are trapped.

A creature caught in the trap can be freed by using an action to make a Strength check against your spell save DC. If successful, the creature is freed from the trap. Once a creature is freed from the trap, or the trap is disarmed, the spell ends and the trap vanishes.

At Higher Levels: When you cast this spell using a spell slot of 3rd level or higher, the piercing or cold damage (your choice) increases by 1d10 per slot level above 2nd.

DESIGN NOTES FOR THE ALRISEN

Here are my thoughts on how to create the Alrisen, which I've used to create everything in this document.

First, seek inspiration. Find a great piece of art, a character from a book, or an event in your world that can give you a goal. Second, decide on the themes you intend to explore in your Alrisen. Stick with no more than three unique themes, as anything more can lose cohesion. For example, the Keeper of the Depths covers the themes of secret knowledge, the ocean, and dreams. The Serpent Empress covers the themes of poison, authority, and snakes.

Next, decide if you intend to create a warlock patron, a deity, or some other entity for your players to interact with. In this example, let's assume you'd like to create a warlock patron similar to the ones presented here.

First, create a spell list that fits this theme, but be careful to ensure that the spells you select aren't stronger or longer lasting than they should be. If the duration is longer than one hour, then you should probably consider steering clear of it. If it gives a benefit that you could easily exploit when it is used in large quantities, then you'll need to account for that or avoid it entirely. Always err on the side of more specific use or damage when it comes to expanded spell lists, and try to avoid overly tempting spells when possible. If you think it's too good, it probably is. Spells in the expanded list are always those not already on the warlock spell list.

For the first level feature, pick something that is immediately and universally useful or interesting. Every single warlock associated with your patron will always gain this feature, so you need to make sure that it is interesting, appealing, and impossible to replicate with other effects. Not only should it be unique, it should also tell the reader what the biggest theme of the Alrisen is. The Keeper of the Depths gives a couple of proficiencies, but the interesting part is that they can change through your sleeping interactions with the patron. Telling that story and making it actually feel relevant is possible when you combine the mechanical effect with the story element.

It's not uncommon to see that the power of an expanded spell list in combat is balanced against the power of the first level feature in combat, though this is a fine line to walk. Always check the balance of power against other warlock features, such as those here or present in other reputable published works, and make sure to speak with experienced players or creators that you can trust. If you look at the credits page for this Compendium, more than half of the individuals referenced are responsible for assisting with balance, and it would be nowhere near as good without them.

The sixth level feature should usually be an active form of defense. While this may be a reaction, it doesn't have to be. There's a wide range of things you could consider "defensive" so don't feel bound to something that triggers when you are attacked. Again, seek inspiration and examples from everywhere you can.

The tenth level feature should be some form of utility or passive resistance. There's a relatively smaller budget here, so try to stick to features and effects that are interesting and potent without adding directly to your combat potential in a measurable way. As always, try to create something that can't be replicated with other features. The fourteenth level feature is something you can go a bit wild with, but it should drive the core concept of the patron home or represent their strongest ability. For example, the Weaver of Lies' final feature would allow the warlock to pull the strings of an entire plot or conspiracy, given enough time to prepare. The Ashen Wolf's final feature is an explosive burst of offensive power, coupled with summoned creatures that drive home the idea of a hunting pack of beasts. The Wild Huntsman's final feature makes the warlock a master over the domain and the terrain within, while still avoiding stepping on the toes of a ranger or other wilderness-focused class.

After you're done, consider filling in the remaining design space with invocations and a familiar, paying close attention to those already existing and doing your best to balance against them. My designs focus on creating new and interesting features that tell the story of the Alrisen using the themes that I've previously described, or creating new sub-themes using the invocations and familiar. For familiars, make sure that they are sufficiently durable, either through direct means or by special features. Also, include a reason for the warlock to use their standard attack. If it's not powerful enough to be more effective than an ordinary attack, it won't ever be used. Finally, give it a unique utility feature that can't be replicated with any other familiar. It keeps things interesting and gives your players a reason to select it.

Afterward, make sure you use peer review. Many things, this document included, would be dramatically inferior without the gracious and helpful advice of others. If someone is harsh in their criticism, that often means they want you to succeed but know that without dedication, it won't turn out right. Always credit your artists and do your best to be thankful towards the people who have helped you on your journey. Make sure that you have a strong vision of what you'd like to achieve, but also know when someone is trying to help you. If they have your best interests in mind, then at least listen to what they're saying. If they didn't care, then they would ignore you.

Once you've accomplished all of this and made changes based on feedback, give it a try. Some things can be tricky to balance, so be willing to reduce the power of features even as you use them in game both for the enjoyment of other players and for yourself. Tabletop games are a communal experience designed to stimulate fun. The goal is for everyone at the table to enjoy themselves. Some people have different opinions about what is fun for them or for other people, and that's perfectly fine. Try to find a group that is accepting of you and will be able to seek fun at your side. Look for people who are willing to accept blame even when you try to claim the mistake as your own. Look for people who are gracious and kind, without expecting something in return. Know how much you can trust someone, and what you can trust them to do. Don't ask for something you know someone will not be able or willing to deliver, because then you'll only be disappointed and the other person will feel the turmoil of being unable to deliver.

Designing content is as much an art as it is a science, and it requires practice just like art does. If you fail, try again. If you succeed, learn from your successes. If you pursue your passion, then the world will thank you for it. If you thank the world, then hopefully it will help you again in the future.

Thank you!
–William Hudson King

Product Identity: The following items are hereby identified as Product Identity, as defined in the Open Game License version 1.0a, Section 1(e) and are not Open Content: All trademarks, registered trademarks, proper names (characters, place names, named creatures, etc.), dialogue, plots, relationships, story elements, locations, characters, artwork, graphics, descriptions, and trade dress. (Elements that have previously been designated as Open Game Content are not included in this declaration.)

Open Game Content: The Open content in this document includes the names of spells, the names of racial categories, and the names of abilities or features. No other portion of this work may be reproduced in any form without permission.

OPEN GAME LICENSE Version 1.0a

The following text is the property of Wizards of the Coast, Inc. and is Copyright 2000 Wizards of the Coast, Inc ("Wizards"). All Rights Reserved.

1. Definitions: (a)"Contributors" means the copyright and/or trademark owners who have contributed Open Game Content; (b)"Derivative Material" means copyrighted material including derivative works and translations (including into other computer languages), potation, modification, correction, addition, extension, upgrade, improvement, compilation, abridgment or other form in which an existing work may be recast, transformed or adapted; (c) "Distribute" means to reproduce, license, rent, lease, sell, broadcast, publicly display, transmit or otherwise distribute; (d)"Open Game Content" means the game mechanic and includes the methods, procedures, processes and routines to the extent such content does not embody the Product Identity and is an enhancement over the prior art and any additional content clearly identified as Open Game Content by the Contributor, and means any work covered by this License, including translations and derivative works under copyright law, but specifically excludes Product Identity. (e) "Product Identity" means product and product line names, logos and identifying marks including trade dress; artifacts; creatures characters; stories, storylines, plots, thematic elements, dialogue, incidents, language, artwork, symbols, designs, depictions, likenesses, formats, poses, concepts, themes and graphic, photographic and other visual or audio representations; names and descriptions of characters, spells, enchantments, personalities, teams, personas, likenesses and special abilities; places, locations, environments, creatures, equipment, magical or supernatural abilities or effects, logos, symbols, or graphic designs; and any other trademark or registered trademark clearly identified as Product identity by the owner of the Product Identity, and which specifically excludes the Open Game Content; (f) "Trademark" means the logos, names, mark, sign, motto, designs that are used by a Contributor to identify itself or its products or the associated products contributed to the Open Game License by the Contributor (g) "Use", "Used" or "Using" means to use, Distribute, copy, edit, format, modify, translate and otherwise create Derivative Material of Open Game Content. (h) "You"or "Your" means the licensee in terms of this agreement.

2. The License: This License applies to any Open Game Content that contains a notice indicating that the Open Game Content may only be Used under and in terms of this License. You must affix such a notice to any Open Game Content that you Use. No terms may be added to or subtracted from this License except as described by the License itself. No other terms or conditions may be applied to any Open Game Content distributed using this License.

3. Offer and Acceptance: By Using the Open Game Content You indicate Your acceptance of the terms of this License.

4. Grant and Consideration: In consideration for agreeing to use this License, the Contributors grant You a perpetual, worldwide, royalty-free, non-exclusive license with the exact terms of this License to Use, the Open Game Content.

5. Representation of Authority to Contribute: If You are contributing original material as Open Game Content, You represent that Your Contributions are Your original creation and/or You have sufficient rights to grant the rights conveyed by this License.

6. Notice of License Copyright: You must update the COPYRIGHT NOTICE portion of this License to include the exact text of the COPYRIGHT NOTICE of any Open Game Content You are copying, modifying or distributing, and You must add the title, the copyright date, and the copyright holder's name to the COPYRIGHT NOTICE of any original Open Game Content you Distribute.

7. Use of Product Identity: You agree not to Use any Product Identity, including as an indication as to compatibility, except as expressly licensed in another, independent Agreement with the owner of each element of that Product Identity. You agree not to indicate compatibility or co-adaptability with any Trademark or Registered Trademark in conjunction with a work containing Open Game Content except as expressly licensed in another, independent Agreement with the owner of such Trademark or Registered Trademark. The use of any Product Identity in Open Game Content does not constitute a challenge to the ownership of that Product Identity. The owner of any Product Identity used in Open Game Content shall retain all rights, title and interest in and to that Product Identity.

8. Identification: If you distribute Open Game Content You must clearly indicate which portions of the work that you are distributing are Open Game Content.

9. Updating the License: Wizards or its designated Agents may publish updated versions of this License. You may use any authorized version of this License to copy, modify and distribute any Open Game Content originally distributed under any version of this License.

10. Copy of this License: You MUST include a copy of this License with every copy of the Open Game Content You Distribute.

11. Use of Contributor Credits: You may not market or advertise the Open Game Content using the name of any Contributor unless You have written permission from the Contributor to do so.

12. Inability to Comply: If it is impossible for You to comply with any of the terms of this License with respect to some or all of the Open Game Content due to statute, judicial order, or governmental regulation then You may not Use any Open Game Material so affected.

13. Termination: This License will terminate automatically if You fail to comply with all terms herein and fail to cure such breach within 30 days of becoming aware of the breach. All sublicenses shall survive the termination of this License.

14. Reformation: If any provision of this License is held to be unenforceable, such provision shall be reformed only to the extent necessary to make it enforceable.

15. COPYRIGHT NOTICE Open Game License v 1.0a Copyright 2000, Wizards of the Coast, LLC.

System Reference Document 5.1 Copyright 2016, Wizards of the Coast, Inc.; Authors Mike Mearls, Jeremy Crawford, Chris Perkins, Rodney Thompson, Peter Lee, James Wyatt, Robert J. Schwalb, Bruce R. Cordell, Chris Sims, and Steve Townshend, based on original material by E. Gary Gygax and Dave Arneson.

The Compendium of Forgotten Secrets: Awakening and The Compendium of Soulforged Artifacts Copyright 2018, Genuine Fantasy Press LLC; Author William H. King

END OF LICENSE

THE COMPENDIUM OF
SOULFORGED ARTIFACTS

Play as a powerful sentient magical item in this
supplement for your favorite roleplaying game!

Genuine
Fantasy
Press LLC

William Hudson King

SOULFORGED ARTIFACTS

Sentient magical items are nothing unfamiliar – a talking sword or an enchanted hat spring easily to mind when the idea is mentioned. This Compendium of three subclasses – cleric, sorcerer, and warlock – is designed to provide you with the information required to play as one of these items.

The primary reason that these three classes were chosen for this role is because they are the only ones that get to choose their archetype at 1st level, and are thus able to begin the game in their chosen role.

Thankfully, these classes are wreathed in magical power and potential, all gaining their abilities from a source that ties them into the world around them.

DIVINE OBJECTS

Clerics, through their deities, gain incredible power over the lives of others in ways both benevolent and harmful. Any god could feasibly imbue the soul of one of their followers or faithful into a soulforged artifact, allowing them to either return from beyond the grave, or to complete a task as penance before venturing into the afterlife.

Some deities will not wait for the death of their servant, and will instead make this request as a sign of faith and trust in their master's power and guidance. Cruel deities may even curse mortals into one of these forms, causing them to rely upon others to help achieve their goals of redemption or revenge.

SOULS IN STEEL

Sorcerers are an interesting breed, in this case, because they are made rather than born. By the experiments of a magical practitioner with more power than wisdom, a blacksmith's act of creation stealing the very soul from its makers body, or the last gasp of a former hero, seeking any avenue of escape from their demise, anyone can become a sorcerer bound to a weapon forged from arcane steel.

The nature of their bond with the enchanted metal grants them their power, and their influence is felt most keenly by those who wield them, for something about the process often leaves those consumed by the blade with a single-mindedness that is difficult to comprehend by others.

SMOKE AND METAL

Warlocks, however, suffer the most tragic of fates, locked away seemingly forever by the bargain they have struck. While fiends, celestials, fey, and creatures from beyond the planes may make bargains for power, few of them will be so inventive as to force their supplicant into the form of a firearm, powered by the very soul of the person wielding it.

In this document, the maker of these firearms is known as the Banished Gunsmith, though any entity of sufficient power and cunning could serve as the pact-holder. Cursed to only know the touch of life when they control the fallen, these warlocks occasionally appear even in planes where firearms were never invented, appearing as magical rods or wands to those ignorant of their true nature.

WEAPONS AND WARRIORS

In all cases, the choice to play one of these subclasses should be discussed with other players. Talk with your GM about how you plan to integrate the character into the game world and into the story. Communicate with your fellow players about who your bearer will be, or determine if you will be carried by another ally from outside the group. As a rule of thumb, the ally should not significantly improve the combat prowess of the party.

BEARERS OF THE BLADE

If you are so inclined, you may request a creature of CR 1/2 or lower, at least until at least 5th level. Be aware that this request is not always feasible and should not be expected to be granted without a cost of some kind, preferably in financial or social capital. After that, a creature of CR 1 or CR 2 may be appropriate until around 11th level, where a creature of CR 3 may be acceptable, depending on the difficulty of combat encounters the party is facing, as well as any rewards gained through your experiences. A strong and capable bearer is especially prized by a sentient weapon, and may make a good quest reward. Note that even a devoted bearer is still a person, and may be vulnerable to cowardice, brashness, or treachery, or may simply be unable to continue with the party for whatever reason, depending upon the circumstances.

True heroes are rare, and even the bold can rarely keep up the adventuring lifestyle for long before succumbing to injuries, doubt, or grief. Not all tales end unhappily, however. Sometimes, the goals one sets out to achieve are completed, and retirement is preferable to an early grave. In any event, be aware of the allies you surround yourself with and know that they may not always be there to help.

The false life of a sentient item is long and perilous, and your death and destruction may seem inevitable at times. Still, the bonds of companionship that can be forged are unbreakable by even the toughest challenges, so support your bearer to the bitter end.

UNDERSTANDING THE ARTIFACTS

The subclasses here are unique, and may be somewhat confusing, especially about how an item can take actions on its own or regarding concentration and spellcasting. When in doubt, imagine the following hypothetical scenario. If it is possible in this scenario and is not prevented by any written rule listed in the subclass features, it is possible to perform.

You are a halfling. By some twist of fate, you have a barbarian friend named Gork, who has decided that the best answer to his lack of weapon is to smash people with your body. Thankfully, you picked up a little magical trinket that not only protects you from the harsh blows inflicted on your enemies, but also spares you from the disorientation caused by being flung around like a doll. Your hands are left free to stab with your rapier, cast spells, or fire your crossbow even as Gork lays about with you, smacking things left and right. Sometimes, your enemies stab at you and hurt you, but most of the time they're too busy hitting Gork to bother targeting you directly. Still, Gork has this bad habit of squeezing your leg really hard whenever he's hit, which is painful but makes him feel better.

DIVINE DOMAIN: RELIC DOMAIN

Your deity is one of artifice and craft, one that controls the fates of the living and dead, or is a trickster and a divine comedian. As such, your body has been taken from you and has been replaced with an artifact of divine power, to be carried by another in service to the aims of your god. You may be tasked with the redemption of this individual, or be sworn to their cause. You may even be tasked with the guidance of a group of champions, or the safeguarding of a holy assassin. In any case, your new body acts as a conduit for the sacred power of your deity, and thus grants you incredible magics and allows you to manifest as a spiritual guardian that stands beside your bearer.

Cleric Level	Spells
1st	*alarm, sanctuary*
3rd	*enhance ability, spiritual weapon*
5th	*counterspell, tongues*
7th	*banishment, death ward*
9th	*geas, seeming*

SACRED RELIC

At 1st level, your spirit has been changed into a relic of holy power, which serves as your body. It can appear as any wearable object, such as a gauntlet, helmet, amulet, cloak, crown, ring, circlet, or halo.

You retain any bonuses or features of your race, and are still considered to be of that race and type. You gain immunity to poison and disease, you do not require food, air, or water, and you no longer age. You have the same AC as your bearer, and you can use the higher of your Dexterity modifiers to calculate their AC. Whenever your bearer takes damage but you do not, both you and your bearer take half the amount of damage instead. You can regain hit points as though you were a living creature. Your walking movement speed is 0, and can't be increased.

Additionally, your spells' somatic components are replaced with "visual" components, where you visibly flare with magical power. You count as a holy symbol. You can communicate telepathically with your bearer, and with any creature that speaks a language within 60 feet of you. This telepathy is two-way, but otherwise you cannot speak.

Whenever your bearer makes a skill or ability check, you can choose to make the check in their stead using your statistics. You can choose to manifest a spiritual embodiment of yourself into an empty space within 5 feet of your bearer without using an action, allowing you to interact with the world through it as though you were not a relic, and for the world to interact with you. You cannot both summon and dismiss your embodiment during the same turn.

This embodiment cannot move farther than 5 feet from your bearer, and it automatically moves to remain adjacent to your bearer. You perform actions through it while it is summoned, and it uses your statistics. Weapons and armor the embodiment equips are tied to your essence, and appear and disappear with it. If you die, these items fall to the ground in the nearest open space.

Whenever you leave this form via spells or features like Wild Shape or *polymorph*, you no longer gain these benefits or penalties.

CHANNEL DIVINITY: STAND GUARD

At 2nd level, you can use your Channel Divinity feature as a reaction when you or your bearer are attacked to have your embodiment weave a defensive shield, standing beside your bearer. You and your wielder gain a +10 bonus to your AC against the attack. You can use this feature after the result of the attack is revealed, potentially causing it to miss.

WINGS OF DELIVERANCE

At 6th level, you carry your bearer upon wings of holy light or blackest shadow. You gain a flying speed of 30 feet. Whenever you cast a spell of 1st level or higher, you can use a bonus action to grant this flying speed to your bearer until the end of their next turn. Additionally, you can manifest your embodiment anywhere within 10 feet of your bearer, and it can be moved up to 20 feet during your turn. It must always remain within 10 feet of your bearer.

DIVINE STRIKE

At 8th level, you gain the ability to infuse the weapons of your embodiment with the power of your deity. Once on each of your turns when you hit a creature with a weapon attack, you can cause the attack to deal an extra 1d8 radiant damage to the target. When you reach 14th level, the extra damage increases to 2d8.

PATRON SAINT

At 17th level, your god reveals your true purpose, and grants you the power to perform your assigned task. Whenever a creature that you can see inflicts a critical hit, you can use your reaction to negate the critical hit, reducing it to a normal attack. If you hit the creature that rolled the critical hit before the end of your next turn, your first attack is a critical hit. Once you use this feature, you can't do so again until you finish a short or long rest.

SORCEROUS ORIGIN: BLADEBOUND SOUL

You were a mortal, once. Through the cruelty of a powerful lich, the capriciousness of an eldritch being, or the voluntary sacrifice of your body for a greater cause, you've become a sentient weapon infused with arcane power. Your body has been destroyed, but you shall live on, channeling magical power through your wielder to destroy your enemies. Should you fall into the wrong hands, your mental onslaught shall allow you to overcome your foes and turn them upon one another in a whirlwind of blood and death.

ORIGIN SPELLS

When you choose this sorcerous origin, you gain access to the following spells, which do not count against your spells known but can only be cast using a sorcerer spell slot.

BLADEBOUND SOUL ORIGIN SPELLS

Spell Level	Spells
1st	command
2nd	detect thoughts
3rd	fox's fangs*
4th	windblade*
5th	fell onslaught*
6th	blood cartography*

LIVING WEAPON

At 1st level, your soul has been trapped within a simple or martial weapon of your choosing. You retain any bonuses or features of your race, and are still considered to be of that race and type. You gain immunity to poison and disease, you do not require food, air, or water, and you no longer age. You have the same AC as your wielder, and you can use the higher of your Dexterity modifiers to calculate their AC. Whenever your wielder takes damage but you do not, both you and your wielder take half the amount of damage instead. You can regain hit points as though you were a living creature. Your walking movement speed is 0, and can't be increased.

You count as a magical weapon for the purposes of overcoming damage resistances and immunities, and grant proficiency in simple and martial weapons to your wielder. You are not considered a magical weapon for the purposes of spells like elemental weapon. Additionally, your spells' somatic components are replaced with "visual" components, where you visibly flare with magical power. You count as an arcane focus. Your bearer must have at least one hand touching you to enable you to cast a spell with a range other than "Self" or "Touch". The one exception to this rule is mage hand, which you learn when you choose this origin.

If your wielder acts against your wishes, you can choose to attempt to force them to obey you. Your wielder must make a Wisdom saving throw against your sorcerer spell save DC. If they fail, they perform the action as you desire during their next turn. If they succeed, they are immune to this effect for one minute or until they take damage.

You can communicate telepathically with your bearer, and with any creature that speaks a language within 60 feet of you. This telepathy is two-way, but otherwise you cannot speak.

Whenever your bearer makes a skill or ability check, you can choose to make the check in their stead.

If you exit this form, as though by the spell polymorph or the Wild Shape feature, you lose these restrictions and benefits until you return to normal.

WATCHFUL GUARDIAN

Starting at 6th level, you can choose to grant your bearer advantage on Perception checks. When you roll initiative, you can choose to swap your result with your wielder.

Additionally, you can choose to change into a different simple or martial weapon over the course of a short or long rest. Your external appearance retains the same marks and motifs no matter which weapon you choose to become.

CONTROL WITHOUT CONSEQUENCE

At 14th level, you learn to tap more fully into the mind of your wielder. Whenever they make a Wisdom or Charisma saving throw, you can use your reaction to grant them advantage on the roll. Alternatively, you can choose to grant them disadvantage on the roll.

TRUE FREEDOM

At 18th level, the arcane power within you manifests with such strength that you can burst forth from your weapon and take on the form of a mortal once again. As an action, you can shift between the form of the weapon you were bound to and your idealized self. This idealized form has the same statistics as your normal weapon form, but it is not subject to the penalties and benefits of being a weapon. This idealized self appears as a member of your original race, and it is static once chosen for the first time. While in your weapon form you gain a flying speed of 60 feet, and this flying speed extends to your wielder.

My name is Asenath, and I was once a halfling. My merchant caravan ventured into the Agea Desert, and within it I stumbled across a djinn's lamp. I summoned the entity, foolishly, and I made a wish. I hated my family for their disdain towards my venturesome pursuits, so I wished that "my whole family could be seen for that they truly are" - Turns out, I'm a shortsword. At least I'm better off than Auntie Petunia.

She turned into a dog.

Otherworldly Patron: The Banished Gunsmith

Gunsmith

You've made a pact with a powerful being known as the Banished Gunsmith, who dwells in a place outside of time, creating the weapons of gods and fiends alike. You called to this being, and it answered, granting a boon to a fervent supplicant, or merely agreeing to fulfill your request in exchange for a price of its own. Your body was destroyed, and your soul has been forged into a firearm, preserving your life and keeping you safe. Wandering the world, your power grows with every shot fired and every enemy slain as you fulfill your part of the bargain or try to take back the wishes twisted against you by the devious yet compassionate Gunsmith, who cares deeply for all its creations.

Banished Gunsmith Expanded Spells

Spell Level	Spells
1st	command, compelled duel
2nd	detect thoughts, knock
3rd	conjure barrage, lightning arrow
4th	locate creature, phantasmal killer
5th	dominate person, geas

Flawless Firearm

At 1st level, your soul been imbued into a handgun, which serves as your body. You retain any bonuses or features of your race, and are still considered to be of that race and type. You gain immunity to poison and disease, you do not require food, air, or water, and you no longer age. You have the same AC as your bearer, and you can use the higher of your Dexterity modifiers to calculate their AC. Whenever your bearer takes damage but you do not, both you and your bearer take half the amount of damage instead. You can regain hit points as though you were a living creature. Your walking movement speed is 0, and can't be increased.

As a soulbound firearm, you have the following properties: You have a range of 60/120. Your attacks inflict 1d10 piercing damage, and you require no ammunition to fire. You count as a magical weapon for the purposes of overcoming damage resistances and immunities, and grant proficiency with firearms to your bearer. You are not considered a magical weapon for the purposes of spells like elemental weapon. Additionally, your spells' somatic components are replaced with "visual" components, where you visibly flare with magical power. You count as an arcane focus. Your bearer must have at least one hand touching you to enable you to cast a spell that deals damage with a range other than "Self" or "Touch". The exceptions to this rule are eldritch blast and firebolt, which you learn when you choose this patron.

You can communicate telepathically with your bearer, and with any creature that speaks a language within 60 feet of you. This telepathy is two-way, but otherwise you cannot speak.

If your bearer is unconscious, you can move their body and control their actions, even when they are reduced to 0 hit points. Each time they take damage or would otherwise be awakened, you can choose to force them to make a Wisdom saving throw against your warlock spell save DC. If they fail, they don't awaken.

Whenever your bearer makes a skill or ability check, you can choose to make the check in their stead using your statistics.

Your form is permanent, and you can't be affected by Wild Shape, polymorph, or any other spell that would change it.

Don't Even Blink

Starting at 6th level, you can shoot down other projectiles, even magical ones. Whenever a successful ranged attack roll is made against a creature within 30 feet of you, you can use your reaction to shoot the projectile and steal its momentum, reducing the damage it deals by 1d8 + your Charisma modifier. You can use this feature a number of times equal to your Charisma modifier, and these uses recover whenever you finish a long rest.

Merciless Harvest

At 10th level, the true name of your soul is inscribed onto the body of your weapon, and you learn to steal this name from others. You gain resistance to radiant damage. Whenever you kill a creature with an attack using yourself, you and your wielder gain temporary hit points equal to the amount of damage left over after the target was reduced to 0 hit points.

Execution and Redemption

At 14th level, the weapon that houses your soul is both a prison and the key to escape. Whenever you are within 5 feet of a prone humanoid creature, you can choose to fire a single magically-infused round at them as an action. The target must make a Charisma saving throw. If they fail, they take 10d10 force damage. If they die, you appear in their hand and cannot be removed without your consent. They are considered an unconscious creature that cannot awaken, and you can control their body using your actions. Treat your statistics as theirs, and your health as your own.

When dawn arrives, the body you've taken disintegrates into dust and reforms into your firearm. You can do this once, and can't do so again until you finish a long rest.

Firearm Pact Objects

Each of the pact objects provides slightly different benefits to a warlock of the Craftsman compared to those who serve other patrons.

Pact of the Blade: You are considered your own pact weapon, and can't be dismissed. You can use an action to transform into any simple or martial melee weapon, and can revert back to your firearm form at any time without using an action.

Pact of the Chain: Your familiar cannot be considered your bearer, unless you take the Nameless Stranger invocation and select the Wandering Stranger as your familiar. Familiars of this patron appear polished and clean, gleaming with a metallic shine.

Pact of the Tome: Your barrel and cylinder are covered with arcane inscriptions, and small paper seals hang from your grip. You are always considered in possession of your Book of Shadows unless it has been destroyed due to your death.

Eldritch Invocations

Arcane Ammunition

Prerequisite: Banished Craftsman patron

You can choose the damage type your bullets deal from the following list: acid, bludgeoning, cold, fire, lightning, poison.

Dead Man Walking

Prerequisite: Banished Craftsman patron, Pact of the Tome feature

Whenever you are controlling a creature that is unconscious and at 0 hit points, it is automatically stabilized. While you are controlling such a creature, both you and your bearer have advantage on all saving throws except death saving throws.

Bloody Bayonet

Prerequisite: Banished Craftsman patron, Pact of the Blade feature

Whenever you have changed your form into that of a melee weapon, you can still be used to make attacks as though you were a firearm. When you are used by your bearer to make a ranged attack against a creature and they hit, you have advantage on your first melee attack roll against the same target during your turn. Additionally, you can use your Charisma modifier for attack and damage rolls you make with yourself.

Last Laugh

Prerequisite: Banished Craftsman patron

Whenever you are reduced to 0 hit points, you can choose to unleash a barrage of gunfire. Make three attacks with yourself against targets of your choosing that you can see. If you hit with all three attacks, you are reduced to 1 hit point instead. After you do this, you can't do so again until you finish a long rest.

Nameless Stranger

Prerequisite: Banished Craftsman patron, Pact of the Chain feature

While you have a wandering stranger as a familiar, it gains additional maximum hit points equal to three times your warlock level. The wandering stranger can be your bearer, and it can use your statistics for attack and damage rolls with you, if yours are superior.

Journal of Jedidiah Vane; Spring 12.7, 64th Year
I came across a gun, lying there in a stream near the pasture. I never seen a thing quite like it, but it started talking in my head, telling me to take it into town and kill a man for it. I figured that snake Johnny deserved what was coming, and so I shot him till he was dead. Scared the hell out of me when he stood back up and thanked me for my service before riding away. Figured it all a dream till I heard he was missing, but only the great god Dienero knows what happened to him after that...

Wandering Stranger

Medium Humanoid, any alignment

Armor Class: 15 (*studded leather*)
Hit Points: 7 (1d8 + 2)
Speed: 30 ft.

STR	DEX	CON	INT	WIS	CHA
12 (+1)	16 (+3)	14 (+2)	10 (+0)	12 (+1)	14 (+2)

Condition Immunities: charmed, frightened
Senses: passive Perception 11
Languages: All known by its master, but can't speak.
Challenge: 1 (200 XP)

A Quiet One: The stranger can take the Disengage action as a bonus action.

Been Everywhere: The stranger is immune to extreme conditions caused by heat, cold, wind, or other environmental hazards that affect large areas.

Perfect Aim: Whenever the stranger is in combat and doesn't take an action during its turn, the first time a weapon it is holding is used in an attack, that attack deals additional force damage equal to the attacker's Charisma modifier. The stranger can take a bonus action and still provide this benefit.

Unbowed: Whenever the stranger must make a saving throw, it can choose to succeed. Once it does so, it can't do so again until it finishes a short or long rest. The stranger can take a bonus action and still provide this benefit.

Actions:

Boot Knife. *Melee Weapon Attack.* +5 to hit, reach 5 feet., one target. Hit: 6 (1d4 +3) slashing damage.

Soulbound Firearm. *Ranged Weapon Attack.* +5 to hit, range 60/120 ft., one target. Hit: 8 (1d10 +3) piercing damage.

Created by William Hudson King, Genuine Fantasy Press LLC
Special thanks to Nicolo M. Dela Merced. The 5E logo is used with the permission of Devin Jacobsen.
Duplication, Distribution, or Modification without permission by Genuine Fantasy Press LLC is prohibited.

Printed in the USA
CPSIA information can be obtained
at www.ICGtesting.com
LVHW060539090124
768340LV00053B/408